MODERN

■ ■ ■

AMERICAN

■ ■ ■

MEMOIRS

MODERN
AMERICAN
MEMOIRS

SELECTED AND EDITED BY
Annie Dillard and Cort Conley

HarperPerennial
A Division of HarperCollinsPublishers

A hardcover edition of this book was published in 1995 by HarperCollins Publishers.

Since this page cannot legibly accommodate all the copyright notices, pages 447–49 constitute an extension of this copyright page.

First HarperPerennial edition published 1996.

Designed by Nancy Singer

The Library of Congress has catalogued the hardcover edition as follows:

Modern American Memoirs / [selected by] Annie Dillard, Cort Conley
 p. cm.
 ISBN 0-06-017040-9
 1. Authors, American—20th century—Biography. 2. American prose literature—20th century. 3. United States—Biography. 4. Autobiographies.
I. Dillard, Annie. II. Conley, Cort, 1944–.
PS129.M63 1995
810.9'005—dc20 95-30755

ISBN 0-06-092763-1 (pbk.)

96 97 98 99 00 ❖/RRD 10 9 8 7 6 5 4 3 2

FOR ROSY, AND FOR KEATS

CONTENTS

Introduction ix

Harry Crews
 from **A Childhood** 1

Eleanor Munro
 from **Memoir of a Modernist's Daughter** 19

Wallace Stegner
 from **Wolf Willow** 24

Kate Simon
 from **Bronx Primitive** 40

Russell Baker
 from **Growing Up** 49

Maureen Howard
 from **Facts of Life** 68

Frederick Buechner
 from **The Sacred Journey** 80

Vivian Gornick
 from **Fierce Attachments** 91

Richard Selzer
 from **Confessions of a Knife** 100

Cynthia Ozick
 from **Art and Ardor** 108

Hamlin Garland
 from **A Son of the Middle Border** 116

Frank Conroy
 from **Stop-time** 132

Malcolm X
 from **The Autobiography of Malcolm X** 142

Harry Middleton
 from **The Earth Is Enough** 158

Reynolds Price
 from **Clear Pictures** 172

Richard Wright
 from **Black Boy** 178

Tobias Wolff
 from **This Boy's Life** 193

Don Asher
 Shoot the Piano Player 205

Wright Morris
 from **Will's Boy** 222

Maxine Hong Kingston
 from **The Woman Warrior** 231

James Baldwin
 from **Notes of a Native Son** 248

William Owens
 from **This Stubborn Soil** 269

Ralph Ellison
 from **Going to the Territory** 280

Geoffrey Wolff
 from **The Duke of Deception** 288

Chris Offutt
 from **The Same River Twice** 297

Left Handed
 from **Left Handed** 315

Anne Moody
 from **Coming of Age in Mississippi** 321

James McConkey
 from **Court of Memory** 345

William Kittredge
 Who Owns the West? 355

Barry Lopez
 Replacing Memory 372

Zora Neale Hurston
 from **Dust Tracks on a Road** 390

Margaret Mead
 from **Blackberry Winter** 396

John Edgar Wideman
 from **Brothers and Keepers** 407

Loren Eiseley
 The Star Thrower 416

Henry Adams
 from **The Education of Henry Adams** 433

Afterword 441

Acknowledgments 447

INTRODUCTION

Edwin Muir, the poet, and translator of Kafka, wrote the magnificent first two thirds of his *Autobiography* just before World War I, thinking he would get killed. He recounted the story of his early years on Orkney; he put the manuscript in a drawer. As the Second World War broke out, Muir again assumed he would die; he wrote the final third, and again he survived. An inevitable worldliness marks his adult life. Muir's *Autobiography* is one of the most vivid and thoughtful memoirs in English, but only because he wrote about his childhood while he could still remember it and before he became a well-known figure describing other well-known figures.

There is something to be said for writing a memoir early, before life in society makes the writer ordinary by smoothing off character's rough edges and abolishing interior life. Tolstoy published the beginning of his three-part autobiographical novel, *Childhood, Boyhood, Youth,* when he was twenty-three years old. Anne Moody was twenty-seven when she wrote *Coming of Age in Mississippi.* Frank Conroy was thirty when he wrote *Stop-time.* Recently, Bernard Cooper, Deborah Digges, Albert Goldbarth, Lucy Grealy, Patricia Hampl, Teresa Jordan, Alice Kaplan, Paul Monette, Chris Offutt, and Susan Allen Toth have written good memoirs while still young.

Memoirs offer a powerfully fixed point of view. From a picket in the past, the retrospective narrator may range intimately or intellectually across a wide circle of characters and events. The memoirist may analyze ideas or present dramatic scenes; the memoirist may confess, eulogize, reflect, inform, and persuade. By convention, memoirists tell true stories about actual people. Their tones may be elegiac, confiding, scholarly, hilarious, or all of these seriatim. In addition to such brilliant advantages, the memoir form naturally has a few pitfalls.

Some memoirists berate themselves in public, all too convincingly. Sometimes the writer parades his faults and sins manipulatively: You forgive these, do you not? Sometimes the memoirist con-

fesses in a pure spirit, but the incidents that purge the writer may nauseate the reader. The aftertaste of John Cowper Powys's bizarre *Autobiography* may scare a reader from his good novels, like *A Glastonbury Romance*. Ford Madox Ford omits his actual misdeeds, and admits disingenuously to harmless faults, apparently that the reader may admire, among his other virtues, his frankness. The otherwise excellent Ellen Glasgow, in *The Woman Within*, confesses, "At the very beginning of the war in Europe, I did not feel the fullness of its impact, all at once."

Irony about oneself, at any age, becomes the memoirist better. Henry Adams is steadily ironic. His *Education of Henry Adams* scants a lifetime of extraordinary achievement; he claims to be puzzled throughout, and "trying to get an education." Geoffrey Wolff describes dining out as a boy with his father and stepmother; he learned to request oil and vinegar with salad, and to order his steak rare. "I was almost ready for an artichoke."

The Duke of Deception, about Wolff's father, is one of many great memoirs in which the narrator is not the object of all attention. In fact, one may leave oneself out of one's memoirs altogether, or use the first person only sparingly, as a fixed viewpoint, to good effect, for the chief danger memoirists face is starring in their own stories, and becoming fascinated.

Memoirists may leave out family members, possibly to lingering resentments. Martin Van Buren left his wife out of his autobiography; Victorians considered such a gap a delicacy, and it was usual. Henry Adams understandably omitted from his *Education of Henry Adams* his twenty-year marriage, which ended in his wife's suicide. More recently, from his gargantuan *Autobiography*, already 672 pages long, John Cowper Powys excluded, with apologies, all the women in his life. Loren Eiseley excluded his wife from *All the Strange Hours;* both Eiseleys prized their privacy. From his beautiful *A Walker in the City*, Alfred Kazin omitted all mention of his sister.

In the eighteenth and nineteenth centuries, nonfiction had more literary cachet than fiction. Novelists like Defoe, Melville, and Poe peddled some of their fabrications as memoir (*Journal of the Plague Year; Robinson Crusoe; Typee; The Narrative of A. Gordon Pym*). Twain's first title for his novel was *Huck Finn's Autobiography*—

to distinguish it from mere romance, and thereby presumably to plead for a serious reading. In this century, opinion shifted for a time; a writer may well call a memoir "fiction" to stress its bonds with imaginative narrative. Consequently, some of this century's finest works of fiction have strongly autobiographical elements, and may be more or less autobiographical: Tolstoy's *Childhood, Boyhood, Youth;* Proust's *Remembrance of Things Past;* Henry Roth's *Call It Sleep;* Fred Chappell's *I Am One of You Forever;* William Maxwell's *Billy Dyer and Other Stories;* James Agee's novels; early John Updike stories; much of Henry Miller's fiction; Louis D. Rubin, Jr.'s *The Golden Weather;* Somerset Maugham's *Of Human Bondage;* Paul St. Pierre's *Smith and Other Events;* J. G. Ballard's *Empire of the Sun;* V. S. Naipaul's *A Way in the World;* Norman Maclean's *A River Runs Through It;* Peter Taylor's *A Summons to Memphis;* Elena Castedo's *Paradise.* On the other hand, which of those memoirs published as fact have strongly fictional elements is anybody's guess.

The writer usually has the privilege, or onus, of labeling the work. Calling it memoir vouches for its veracity; calling it fiction may, on a good day, alert the world to its literary qualities. The writer may vacillate. Louise Bogan published part of her memoir, *Journey Around My Room,* in *The New Yorker* as fiction. One of the chapters of Edward Dahlberg's classic memoir, *Because I Was Flesh,* appeared in *Best Short Stories of 1962.* Editors may step in. Albert Goldbarth calls those perfectly structured narrative prose pieces in *A Sympathy of Souls* and *Great Topics of the World* poems; his publishers call them essays. Bernard Cooper, who wrote the grand *Maps to Anywhere,* says he tends to call it nonfiction. Magazine and journal editors called various selections from it poetry, fiction, fable, or essay. *Best Essays of 1988* reprinted one chapter. The book won the 1991 PEN/Faulkner Ernest Hemingway Award for fiction.

Certain classic memoirs evoke whole generations of American life; one can survey history by leaping, as it were, from memoir peak to peak: Franklin's *Autobiography,* the *Narrative of the Life of Frederick Douglass, Walden,* Ulysses S. Grant's *Personal Memoirs,* Twain's *Life on the Mississippi,* Booker T. Washington's *Up from Slavery*—and in this century *The Education of Henry Adams,* Hamlin

Garland's *Son of the Middle Border*, Helen Keller's *The Story of My Life*, Jack Kerouac's *On the Road* (not a great book, but an iconic one), and *The Autobiography of Malcolm X*.

Of the recent spate of memoirs, some are fast becoming classics: Frank Conroy's *Stop-time*, Harry Crews's *A Childhood*, Alice Kaplan's *French Lessons*, Alfred Kazin's *A Walker in the City*, James McConkey's *Court of Memory* trilogy, Geoffrey Wolff's *The Duke of Deception*.

It is possible to imagine the writers in this disparate volume as a single, composite American of any heritage or gender, who appears in a family, grows up somewhere, and somehow watches, learns, falls in love, works, and perhaps has children and grandchildren. The writer celebrates, as Charles Wright did in a poem, "all the various things that lock our wrists to the past." Because the collection represents only seventy-five years of published memoirs, and then only of memoirs whose action takes place in this century and on this soil, the editors excluded many great favorites. An afterword lists these.

A.D.

HARRY CREWS
(1935–)

*Harry Crews was born the son of a farmer in Bacon County, Georgia,
and grew up there. He served in the U.S. Marine Corps as a sergeant,
then attended the University of Florida, where he became a professor of
English in 1974.*

Author of more than a dozen novels, from The Gospel Singer
(1968) to Scar Lover *(1992), Crews has also written stories, essays,
and nonfiction.*

Crews's memoir, A Childhood: The Biography of a Place,
*describes the first six years of his life, under circumstances "where there
wasn't enough money to close up a dead man's eyes." His family lived
on a series of tenant farms in Bacon County. His father died when he
was two. The "daddy" in this memoir is his stepfather, whom he loved.
Later he learned that this man was his uncle.*

■ ■ ■

from A CHILDHOOD

It has always seemed to me that I was not so much born into this
life as I awakened to it. I remember very distinctly the awakening
and the morning it happened. It was my first glimpse of myself, and
all that I know now—the stories, and everything conjured up by
them, that I have been writing about thus far—I obviously knew
none of then, particularly anything about my real daddy, whom I
was not to hear of until I was nearly six years old, not his name, not
even that he was my daddy. Or if I did hear of him, I have no mem-
ory of it.

I awoke in the middle of the morning in early summer from the
place I'd been sleeping in the curving roots of a giant oak tree in
front of a large white house. Off to the right, beyond the dirt road,
my goats were trailing along in the ditch, grazing in the tough wire
grass that grew there. Their constant bleating shook the warm sum-
mer air. I always thought of them as my goats although my brother

usually took care of them. Before he went to the field that morning to work, he had let them out of the old tobacco barn where they slept at night. At my feet was a white dog whose name was Sam. I looked at the dog and at the house and at the red gown with little pearl-colored buttons I was wearing, and I knew that the gown had been made for me by my Grandma Hazelton and that the dog belonged to me. He went everywhere I went, and he always took precious care of me.

Precious. That was my mama's word for how it was between Sam and me, even though Sam caused her some inconvenience from time to time. If she wanted to whip me, she had to take me in the house, where Sam was never allowed to go. She could never touch me when I was crying if Sam could help it. He would move quietly—he was a dog not given to barking very much—between the two of us and show her his teeth. Unless she took me somewhere Sam couldn't go, there'd be no punishment for me.

The house there just behind me, partially under the arching limbs of the oak tree, was called the Williams place. It was where I lived with my mama and my brother, Hoyet, and my daddy, whose name was Pascal. I knew when I opened my eyes that morning that the house was empty because everybody had gone to the field to work. I also knew, even though I couldn't remember doing it, that I had awakened sometime in midmorning and come out onto the porch and down the steps and across the clean-swept dirt yard through the gate weighted with broken plow points so it would swing shut behind me, that I had come out under the oak tree and lain down against the curving roots with my dog, Sam, and gone to sleep. It was a thing I had done before. If I ever woke up and the house was empty and the weather was warm—which was the only time I would ever awaken to an empty house—I always went out under the oak tree to finish my nap. It wasn't fear or loneliness that drove me outside; it was just something I did for reasons I would never be able to discover.

I stood up and stretched and looked down at my bare feet at the hem of the gown and said: "I'm almost five and already a great big boy." It was my way of reassuring myself, but it was also something my daddy said about me and it made me feel good because in his mouth it seemed to mean I was almost a man.

Sam immediately stood up too, stretched, reproducing, as he always did, every move I made, watching me carefully to see which way I might go. I knew I ought not to be outside lying in the rough curve of root in my cotton gown. Mama didn't mind me being out there under the tree, but I was supposed to get dressed first. Sometimes I did; often I forgot.

So I turned and went back through the gate, Sam at my heels, and across the yard and up the steps onto the porch to the front door. When I opened the door, Sam stopped and lay down to wait. He would be there when I came out, no matter which door I used. If I went out the back door, he would somehow magically know it and he would be there. If I came out the side door by the little pantry, he would know that, too, and he would be there. Sam always knew where I was, and he made it his business to be there, waiting.

I went into the long, dim, cool hallway that ran down the center of the house. Briefly I stopped at the bedroom where my parents slept and looked in at the neatly made bed and all the parts of the room, clean, with everything where it was supposed to be, just the way mama always kept it. And I thought of daddy, as I so often did because I loved him so much. If he was sitting down, I was usually in his lap. If he was standing up, I was usually holding his hand. He always said soft funny things to me and told me stories that never had an end but always continued when we met again.

He was tall and lean with flat high cheekbones and deep eyes and black thick hair which he combed straight back on his head. And under the eye on his left cheek was the scarred print of a perfect set of teeth. I knew he had taken the scar in a fight, but I never asked him about it and the teeth marks in his cheek only made him seem more powerful and stronger and special to me.

He shaved every morning at the water shelf on the back porch with a straight razor and always smelled of soap and whiskey. I knew mama did not like the whiskey, but to me it smelled sweet, better even than the soap. And I could never understand why she resisted it so, complained of it so, and kept telling him over and over again that he would kill himself and ruin everything if he continued with the whiskey. I did not understand about killing himself and I did not understand about ruining everything, but I knew the

whiskey somehow caused the shouting and screaming and the ugly sound of breaking things in the night. The stronger the smell of whiskey on him, though, the kinder and gentler he was with me and my brother.

I went on down the hallway and out onto the back porch and finally into the kitchen that was built at the very rear of the house. The entire room was dominated by a huge black cast-iron stove with six eyes on its cooking surface. Directly across the room from the stove was the safe, a tall square cabinet with wide doors covered with screen wire that was used to keep biscuits and fried meat and rice or almost any other kind of food that had been recently cooked. Between the stove and the safe sat the table we ate off of, a table almost ten feet long, with benches on each side instead of chairs, so that when we put in tobacco, there would be enough room for the hired hands to eat.

I opened the safe, took a biscuit off a plate, and punched a hole in it with my finger. Then with a jar of cane syrup, I poured the hole full, waited for it to soak in good, and then poured again. When the biscuit had all the syrup it would take, I got two pieces of fried pork off another plate and went out and sat on the back steps, where Sam was already lying in the warm sun, his ears struck forward on his head. I ate the bread and pork slowly, chewing for a long time and sharing it all with Sam.

When we had finished, I went back into the house, took off my gown, and put on a cotton undershirt, my overalls with twin galluses that buckled on my chest, and my straw hat, which was rimmed on the edges with a border of green cloth and had a piece of green cellophane sewn into the brim to act as an eyeshade. I was barefoot, but I wished very much I had a pair of brogans because brogans were what men wore and I very much wanted to be a man. In fact, I was pretty sure I already was a man, but the only one who seemed to know it was my daddy. Everybody else treated me like I was still a baby.

I went out the side door, and Sam fell into step behind me as we walked out beyond the mule barn where four mules stood in the lot and on past the cotton house and then down the dim road past a little leaning shack where our tenant farmers lived, a black family in which there was a boy just a year older than I was. His name was

Willalee Bookatee. I went on past their house because I knew they would be in the field, too, so there was no use to stop.

I went through a sapling thicket and over a shallow ditch and finally climbed a wire fence into the field, being very careful of my overalls on the barbed wire. I could see them all, my family and the black tenant family, far off there in the shimmering heat of the tobacco field. They were pulling cutworms off the tobacco. I wished I could have been out there with them pulling worms because when you found one, you had to break it in half, which seemed great good fun to me. But you could also carry an empty Prince Albert tobacco can in your back pocket and fill it up with worms to play with later.

Mama wouldn't let me pull worms because she said I was too little and might damage the plants. If I was alone in the field with daddy, though, he would let me hunt all the worms I wanted to. He let me do pretty much anything I wanted to, which included sitting in his lap to guide his old pickup truck down dirt roads all over the county.

I went down to the end of the row and sat under a persimmon tree in the shade with Sam and watched as daddy and mama and brother and Willalee Bookatee, who was—I could see even from this distance—putting worms in Prince Albert cans, and his mama, whose name was Katie, and his daddy, whose name was Will, I watched them all as they came toward me, turning the leaves and searching for worms as they came.

The moment I sat down in the shade, I was already wondering how long it would be before they quit to go to the house for dinner because I was already beginning to wish I'd taken two biscuits instead of one and maybe another piece of meat, or else that I hadn't shared with Sam.

Bored, I looked down at Sam and said: "Sam, if you don't quit eatin my biscuit and meat, I'm gone have to cut you like a shoat hog."

A black cloud of gnats swarmed around his heavy muzzle, but I clearly heard him say that he didn't think I was man enough to do it. Sam and I talked a lot together, had long involved conversations, mostly about which one of us had done the other one wrong and, if not about that, about which one of us was the better man. It would be a good long time before I started thinking of Sam as a dog instead of a person, but I always came out on top when we talked

because Sam could only say what I said he said, think what I thought he thought.

"If you was any kind of man atall, you wouldn't snap at them gnats and eat them flies the way you do," I said.

"It ain't a thing in the world the matter with eatin gnats and flies," he said.

"It's how come people treat you like a dog," I said. "You could probably come on in the house like other folks if it weren't for eatin flies and gnats like you do."

That's the way the talk went until daddy and the rest of them finally came down to where Sam and I were sitting in the shade. They stopped beside us to wipe their faces and necks with sweat rags. Mama asked if I had got something to eat when I woke up. I told her I had.

"You all gone stop for dinner now?"

"I reckon we'll work awhile longer," daddy said.

I said: "Well then, can Willalee and me go up to his house and play till dinnertime?"

Daddy looked at the sun to see what time it was. He could come within five or ten minutes by the position of the sun. Most of the farmers I knew could.

Daddy was standing almost dead center in his own shadow. "I reckon so," he said.

Then the whole thing had to be done over again. Willalee asked his daddy the same question. Because my daddy had said it was all right didn't mean Willalee's daddy would agree. He usually did, but not always. So it was necessary to ask.

We climbed the fence and went across the ditch and back through the sapling thicket to the three-track road that led up to the shack, and while we walked, Willalee showed me the two Prince Albert tobacco cans he had in his back pockets. They were both filled with cutworms. The worms had lots of legs and two little things on their heads that looked like horns. They were about an inch long, sometimes as long as two inches, and round and fat and made wonderful things to play with. There was no fence around the yard where Willalee lived and the whole house leaned toward the north at about a ten-degree tilt. Before we even got up the steps, we could smell the food already cooking on the wood stove at the back

of the house where his grandma was banging metal pots around over the cast-iron stove. Her name was Annie, but everybody called her Auntie. She was too old to work in the field anymore, but she was handy about the house with ironing and cooking and scrubbing floors and canning vegetables out of the field and berries out of the woods.

She also was full of stories, which, when she had the time—and she usually did—she told to me and Willalee and his little sister, whose name was Lottie Mae. Willalee and my brother and I called her Snottie Mae, but she didn't seem to mind. She came out of the front door when she heard us coming up on the porch and right away wanted to know if she could play in the book with us. She was the same age as I and sometimes we let her play with us, but most of the time we did not.

"Naw," Willalee said, "git on back in there and help Auntie. We ain't studying you."

"Bring us the book," I said.

"I git it for you," she said, "if you give me five of them worms."

"I ain't studying you," said Willalee.

She had already seen the two Prince Albert cans full of green worms because Willalee was sitting on the floor now, the lids of the cans open and the worms crawling out. He was lining two of them up for a race from one crack in the floor to the next crack, and he was arranging the rest of the worms in little designs of diamonds and triangles in some game he had not yet discovered the rules for.

"You bring the book," I said, "and you can have two of them worms."

Willalee almost never argued with what I decided to do, up to and including giving away the worms he had spent all morning collecting in the fierce summer heat, which is probably why I liked him so much. Lottie Mae went back into the house, and got the Sears, Roebuck catalogue and brought it out onto the porch. He handed her the two worms and told her to go on back in the house, told her it weren't fitting for her to be out here playing with worms while Auntie was back in the kitchen working.

"Ain't nothing left for me to do but put them plates on the table," she said.

"See to them plates then," Willalee said. As young as she was, Lottie Mae had things to do about the place. Whatever she could manage. We all did.

Willalee and I stayed there on the floor with the Sears, Roebuck catalogue and the open Prince Albert cans, out of which deliciously fat worms crawled. Then we opened the catalogue at random as we always did, to see what magic was waiting for us there.

In the minds of most people, the Sears, Roebuck catalogue is a kind of low joke associated with outhouses. God knows the catalogue sometimes ended up in the outhouse, but more often it did not. All the farmers, black and white, kept dried corncobs beside their double-seated thrones, and the cobs served the purpose for which they were put there with all possible efficiency and comfort.

The Sears, Roebuck catalogue was much better used as a Wish Book, which it was called by the people out in the country, who would never be able to order anything out of it, but could at their leisure spend hours dreaming over.

Willalee Bookatee and I used it for another reason. We made up stories out of it, used it to spin a web of fantasy about us. Without that catalogue our childhood would have been radically different. The federal government ought to strike a medal for the Sears, Roebuck company for sending all those catalogues to farming families, for bringing all that color and all that mystery and all that beauty into the lives of country people.

I first became fascinated with the Sears catalogue because all the people in its pages were perfect. Nearly everybody I knew had something missing, a finger cut off, a toe split, an ear half-chewed away, an eye clouded with blindness from a glancing fence staple. And if they didn't have something missing, they were carrying scars from barbed wire, or knives, or fishhooks. But the people in the catalogue had no such hurts. They were not only whole, had all their arms and legs and toes and eyes on their unscarred bodies, but they were also beautiful. Their legs were straight and their heads were never bald and on their faces were looks of happiness, even joy, looks that I never saw much of in the faces of the people around me.

Young as I was, though, I had known for a long time that it was all a lie. I knew that under those fancy clothes there had to be scars, there had to be swellings and boils of one kind or another because

there was no other way to live in the world. And more than that, at some previous, unremembered moment, I had decided that all the people in the catalogue were related, not necessarily blood kin, but knew one another, and because they knew one another there had to be hard feelings, trouble between them off and on, violence, and hate between them as well as love. And it was out of this knowledge that I first began to make up stories about the people I found in the book.

Once I began to make up stories about them, Willalee and Lottie Mae began to make up stories, too. The stories they made up were every bit as good as mine. Sometimes better. More than once we had spent whole rainy afternoons when it was too wet to go to the field turning the pages of the catalogue, forcing the beautiful people to give up the secrets of their lives: how they felt about one another, what kind of sicknesses they may have had, what kind of scars they carried in their flesh under all those bright and fancy clothes.

Willalee had his pocketknife out and was about to operate on one of the green cutworms because he liked to pretend he was a doctor. It was I who first put the notion in his head that he might in fact be a doctor, and since we almost never saw a doctor and because they were mysterious and always drove cars or else fine buggies behind high-stepping mares, quickly healing people with their secret medicines, the notion stuck in Willalee's head, and he became very good at taking cutworms and other things apart with his pocketknife.

The Sears catalogue that we had opened at random found a man in his middle years but still strong and healthy with a head full of hair and clear, direct eyes looking out at us, dressed in a red hunting jacket and wading boots, with a rack of shotguns behind him. We used our fingers to mark the spot and turned the Wish Book again, and this time it opened to ladies standing in their underwear, lovely as none we had ever seen, all perfect in their unstained clothes. Every last one of them had the same direct and steady eyes of the man in the red hunting jacket.

I said: "What do you think, Willalee?"

Without hesitation, Willalee said: "This lady here in her step-ins is his chile."

We kept the spot marked with the lady in the step-ins and the man in the hunting jacket and turned the book again, and there was

a young man in a suit, the creases sharp enough to shave with, posed with his foot casually propped on a box, every strand of his beautiful hair in place.

"See, what it is," I said. "This boy right here is seeing that girl back there, the one in her step-ins, and she is the youngun of him back there, and them shotguns behind'm belong to him, and he ain't happy."

"Why he ain't happy?"

"Cause this feller standing here in this suit looking so nice, he ain't nice at all. He's mean, but he don't look mean. That gal is the only youngun the feller in the jacket's got, and he loves her cause she is a sweet child. He don't want her fooling with that sorry man in that suit. He's so sorry he done got hisself in trouble with the law. The high sheriff is looking for him right now. Him in the suit will fool around on you."

"How it is he fool around?"

"He'll steal anything he can put his hand to," I said. "He'll steal your hog, or he'll steal your cow out of your field. He's so sorry he'll take that cow if it's the only cow you got. It's just the kind of feller he is."

Willalee said: "Then how come it is she mess around with him?"

"That suit," I said, "done turned that young girl's head. Daddy always says if you give a man a white shirt and a tie and a suit of clothes, you can find out real quick how sorry he is. Daddy says it's the quickest way to find out."

"Do her daddy know she's messing round with him?"

"Shore he knows. A man allus knows what his youngun is doing. Special if she's a girl." I flipped back to the man in the red hunting jacket and the wading boots. "You see them shotguns behind him there on the wall? Them his guns. That second one right there, see that one, the double barrel? That gun is loaded with double-ought buckshot. You know how come it loaded?"

"He gone stop that fooling around," said Willalee.

And so we sat there on the porch with the pots and pans banging back in the house over the iron stove and Lottie Mae there in the door where she had come to stand and listen to us as we talked even though we would not let her help with the story. And before it was over, we had discovered all the connections possible between the girl

in the step-ins and the young man in the knife-creased suit and the older man in the red hunting jacket with the shotguns on the wall behind him. And more than that we also discovered that the man's kin people, when they had found out about the trouble he was having with his daughter and the young man, had plans of their own to fix it so the high sheriff wouldn't even have to know about it. They were going to set up and wait on him to take a shoat hog out of another field, and when he did, they'd be waiting with their own guns and knives (which we stumbled upon in another part of the catalogue) and they was gonna throw down on him and see if they couldn't make two pieces out of him instead of one. We had in the story what they thought and what they said and what they felt and why they didn't think that the young man, as good as he looked and as well as he stood in his fancy clothes, would ever straighten out and become the man the daddy wanted for his only daughter.

Before it was over, we even had the girl in the step-ins fixing it so that the boy in the suit could be shot. And by the time my family and Willalee's family came walking down the road from the tobacco field toward the house, the entire Wish Book was filled with feuds of every kind and violence, maimings, and all the other vicious happenings of the world.

Since where we lived and how we lived was almost hermetically sealed from everything and everybody else, fabrication became a way of life. Making up stories, it seems to me now, was not only a way for us to understand the way we lived but also a defense against it. It was no doubt the first step in a life devoted primarily to men and women and children who never lived anywhere but in my imagination. I have found in them infinitely more order and beauty and satisfaction than I ever have in the people who move about me in the real world. And Willalee Bookatee and his family were always there with me in those first tentative steps. God knows what it would have been like if it had not been for Willalee and his people, with whom I spent nearly as much time as I did with my own family. . . .

The inside of their tiny house was dark on the brightest day and smelled always of ashes, even in the summer. Auntie did not like much light inside the house, so most of the time she kept the cur-

tains drawn, curtains she had made from fertilizer sacks and decorated with bits of colored cloth. Bright light was for the outside, she said, and shade—the more the better—was for the inside.

I ate with them often, as often as mama would let me, and the best thing I ever got from their table was possum, which we *never* got at home because mama would not cook it. She said she knew it would taste like a wet dog smells. But it did not. Auntie could cook it in a way that would break your heart. Willalee and I would stand about in her dark, ash-smelling little kitchen and watch her prepare it. She would scald and scrape it just like you would scald and scrape a hog, gut it, remove the eyes, which she always carefully set aside in a shallow dish. The head, except for the eyes, would be left intact. After she parboiled it an hour and a half, she would take out the teeth, stuff the little body with sweet potatoes, and then bake the whole thing in the oven for two hours.

The reason mama would never cook a possum, of course, was because a possum is just like a buzzard. It will eat anything that is dead. The longer dead the better. It was not unusual to come across a cow that had been dead in the woods for three or four days and see a possum squeezing out of the swollen body after having eaten a bellyful of rotten flesh. But it never occurred to me to think of that when we all sat down to the table and waited for Willalee's daddy to say the only grace he ever said: "Thank the Lord for this food."

The first possum I ever shared with them was in that first summer in my memory of myself, and with the possum we had fresh sliced tomatoes and steamed okra—as well as fried okra—and corn on the cob, butter beans, fried pork, and biscuits made out of flour and water and lard.

Because I was company, Auntie gave me the best piece: the head. Which had a surprising amount of meat on it and in it. I ate around on the face for a while, gnawing it down to the cheekbones, then ate the tongue, and finally went into the skull cavity for the brains, which Auntie had gone to some pains to explain was the best part of the piece.

After we finished the possum, Willalee and Lottie Mae and I stayed at the table sopping cane syrup with biscuits. Will and Katie had gone out on the front porch to rest, and we were left alone with Auntie, who was already working over the table, taking plates to the

tin tub where she would wash them, and putting whatever food had been left over into the screen-wire safe.

Finally, she came to stand beside where I sat at the table. "Come on now, boy," she said, "an ole Auntie'll show you."

"Show me what?" I said.

She was holding the little shallow saucer with the possum's eyes in it. The eyes were clouded in a pink pool of diluted blood. They rolled on the saucer as I watched.

"Nem mind," she said. "Come on."

We followed her out the back door into the yard. We didn't go but a step or two before she squatted down and dug a hole. The rear of the house was almost covered with stretched and nailed hides of squirrels and rabbits and coons and even a fox which Willalee's daddy had trapped. I would find out later that Auntie had tanned the hides by rubbing the animals' hides on the flesh side with their own brains. It caused the hair to fall out of the hide and left it soft and pliable.

"You eat a possum, you bare its eyes," she said, still squatting beside the little hole she had dug.

I motioned toward Sam where he stood at my heels. "You gone bury it," I said, "you better bury it deeper'n that. Don't he'll dig it up. You might as well go on and give it to'm now."

"Won't dig up no possum's eyes," she said. "Sam's got good sense."

Sam did not, either.

"Know how come you got to barum?" she said.

"How come?" I said.

"Possums eat whatall's dead," she said. Her old, cracked voice had gone suddenly deep and husky. "You gone die too, boy."

"Yes," I said, stunned.

"You be dead an in the ground, but you eat this possum an he gone come lookin for you. He ain't ever gone stop lookin for you."

I could not now speak. I watched as she carefully took the two little clouded eyes out of the dish and placed them in the hole, arranging them so they were looking straight up toward the cloud-less summer sky. They seemed to watch me where I was.

Auntie smiled, showing her snuff-colored gums. "You ain't got to think on it, boy. See, we done put them eyes looking up. But you

gone be *down*. Ain't never gone git you. Possum be looking for you up, an you gone be six big feets under the ground. You gone allus be all right, you put the eyes lookin up."

Auntie made me believe we live in a discoverable world, but that most of what we discover is an unfathomable mystery that we can name—even defend against—but never understand.

My fifth birthday had come and gone, and it was the middle of the summer, 1940, hot and dry and sticky, the air around the table thick with the droning of house flies. At supper that night neither my brother nor I had to ask where daddy was. There was always, when he had gone for whiskey, a tension in the house that you could breathe in with the air and feel on the surface of your skin, and more than that, there was that awful look on mama's face. I suppose the same look was on our faces, too, worried as we all were, not knowing what the night would bring, not knowing if it would be this night or the next night, or the morning following the second night, when he would come home after a drunk, bloodied, his clothes stinking with whiskey sweat.

We sat at the supper table, eating quietly, nobody saying a word, and when we finished, my brother and I went just as quietly into the fireroom and sat in ladder-back chairs, staring into the cold hearthstone where there had been no fire for two months. By the time mama came in to sit with us we had already brought in the foot tub full of water. The only thing we seemed to wash for long periods of time on the farm was our face and hands at the water shelf on the back porch and our feet in front of the hearthstone.

That night as we sat silently together, everybody thinking of daddy, thinking of where he was and how he might come home, I— for reasons which I'll never know—turned to mama and said: "I want to preach."

She immediately understood that I didn't mean that I wanted to be a preacher or to become a preacher, but rather that I wanted to preach right then. She said: "Well, son, if you want to preach, just get up there and preach to us."

She was always open and direct with us, always kind and loving, even though she was always strict. She believed that if a child did something he knew was wrong, had been told was wrong, he had to

be whipped. And she did throughout my childhood throw some pretty good whippings on my brother and me. But she never whipped us when we did not know that we deserved it and, more, when we did not expect it.

Mama and my brother sat there in front of the cold fireplace while I got up and turned my ladder-back chair over and got the crocheted doily off the pedal-driven Singer sewing machine to cover the chair with. The chair covered with the doily made a fine altar from which to preach. I took hold of it with both hands, looked out at them, and started my sermon.

I said: "We all of us made out of dirt. God took Him up some dirt and put it in his hands and rolled it around and then he spit in the dirt and roll it some more and out of that dirt and God spit, he made you and me, all of us."

That is the way my preaching began. I don't remember how it ended, but I know it went on for a long time and it was made pretty much out of what I had heard in church, what I had heard the preacher say about hell and God and heaven and damnation and the sorry state of the human condition. Hell was at the center of any sermon I had ever heard in Bacon County. In all the churches, you smelled the brimstone and the sulfur and you felt the fire and you were made to know that because of what you had done in your life, you were doomed forever. Unless somehow, somewhere, you were touched by the action of mercy and the Grace of God. But you could not, you must not, count on the Grace of God. It probably would not come to you because you were too sorry.

I was exhausted by the time it was over, and I was asleep the moment my head touched the pillow. But I heard the pickup truck when it came in. And I heard daddy come through the front gate, the plow points banging and his own drunk-heavy feet on the steps and the front door slamming, and then I heard, as I already knew I would, querulous voices as mama and daddy confronted each other there beyond the thin wall. Finally, their voices raised to shouts and even screams, but since there was nothing breaking, no pots hitting the wall, no glass splattering on the floor, no furniture turning over, I could stand lying in my bed if I concentrated on hell and damnation. This was nothing compared to the eternal fires of hell that God might someday demand that I endure. With

my whole self firmly immersed in hell, I could usually go back to sleep.

I woke up sometime in the middle of the night. An enormous and brilliant moon shone over the cotton field where I was standing, still in my gown. It was not a dream and I knew immediately that it was not a dream. I was where I thought I was, and I had come here by walking in my sleep. I came awake that night the way I always have when I've gotten up in my sleep and walked. Terrified. Terrified almost beyond terror because it had no name and was sourceless. My heart was pounding, and my gown was soaked with sweat and sticking to my freezing skin. My mouth was full of the taste of blood where I'd chewed my lips.

The cotton bolls were open all about me. As far as I could see, all the way to the dark wall of trees surrounding the field, was a white sheet of cotton, brilliant and undulating under the heavy moon. I stood there for a long time, unable to move. Off there to the left was the enormous oak tree that I had slept under that morning, it, too, brilliant in the moon, and behind the tree was the house, dark in its own shadow. I did not know what to do. I did not cry and I did not scream. I did not think that I could go back there to the dark house where my family slept. I somehow knew they would not receive me. I knew that I was guilty of something neither man nor God could forgive. But it would always be so when I walked in my sleep.

I stood utterly still and waited because I knew if I waited long enough, the terror would find a source and a name. Once it had a name, no matter how awful, I would be able to live with it. I could go back home.

Gradually, the terror shapes itself into a school bus. I can see it plainly. It is full of children. Stopped by the side of a road. I am in the ditch by the side of the road. They do not see me. It is broad daylight and many of the children are looking right at me. But they don't— they can't—see me. I have something in my hand. I do not know what it is. I cannot tell what it is. I come slowly out of the ditch and touch the school bus with the thing in my hand. The moment contact is made, the whole bus disintegrates in my eyes. There is no explosion, no sound at all. The disintegration is silent as sleep. When I can see again, the bus is on its back, broken children hang from open windows, and some—the ones toward the back—are drenched in gas

from the ruptured tank and they are frying, noiselessly frying. I can smell them frying. And I am terrified at the probable consequences that will follow what I have done, but I am glad I have done it.

Now I can go home, and I start off in a dead run between the rows of cotton toward the dark house beyond the oak tree.

When I got to the door, I opened it quietly and went down the hall to the little room where I knew daddy was sleeping on a pallet. It was where he often had to sleep when he came in drunk and out of control and mama would not let him into their room. He lay, still dressed, curled on the quilt spread across the floor under an open window through which bright moonlight fell. I sat down beside him and touched his face, traced the thick scar of perfect teeth on his flat high cheekbone. The air in the room was heavy with the sweet smell of bourbon whiskey. Sweat stood on his forehead and darkly stained his shirt.

"Daddy," I said. He made a small noise deep in his chest, and his eyes opened. "Daddy, I'm scared."

He pushed himself onto one elbow and put an arm around me and drew me against him. I could feel the bristle of his beard on my neck. I trembled and tried not to cry.

"Sho now," he whispered against my ear. "Everybody's scared now and then."

"I was in the cotton field," I said. "Out there."

He turned his head, and we both looked through the window at the flat white field of cotton shining under the moon.

"You was dreaming, boy," he said. "But you all right now."

"I woke up out there." Now I was crying, not making any noise, but unable to keep the tears from streaming down my face. I pushed my bare feet into the moonlight. "Look," I said. My feet and the hem of my gown were gray with the dust of the field.

He drew back and looked into my eyes, smiling. "You walked in your sleep. It ain't nothing to worry about. You probably got it from me. I'as bad to walk in my sleep when I was a boy.".

The tears eased back. "You was?" I said.

"Done it a lot," he said. "Don't mean nothing."

I don't know if he was telling the truth. But hearing him say it was something that he had done and that I might have got it from him took my fear away.

"You lie down here on the pallet with your ole daddy and go to sleep. Me an you is all right. We *both* all right."

I lay down with my head on his thick arm, wrapped in the warm, sweet smell of whiskey and sweat, and was immediately asleep.

ELEANOR MUNRO
(1928–)

Eleanor Munro has written several volumes of nonfiction, including
On Glory Roads: A Pilgrim's Book About Pilgrimage *(1987),*
Originals: American Women Artists *(1979), and* Through the
Vermilion Gates *(1971).*

A graduate of Smith College, Munro completed graduate studies at
Columbia University and the Sorbonne.

Her fascinating Memoir of a Modernist's Daughter *(1988)*
largely concerns her father, Thomas Munro, a curator of the Cleveland
Museum of Art, who wrote Scientific Method in Aesthetics, *and her*
first husband, Alfred Frankfurter, who edited Art News.

This section describes her paternal grandfather, the son of Scottish
immigrants, who grew up farming in Nebraska. He married a New
England woman, Mary Spaulding, and later retired with her to a
"little homestead" in the Catskills.

■ ■ ■

from MEMOIR OF A MODERNIST'S DAUGHTER

There it was that our grandfather, by then a knobby, sour-faced
Scot with the deferential manners of some country people,
would take me and my brother on his knee when we begged him to
tell us a story.

"Bappa, tell us about Rip van Winkle!"

"What? That one again?" He would settle into his rocker cov-
ered with old scarves and a crocheted afghan. He would raise his
head, lean back against the chair and close his eyes while he called
up the lines. I looked up into the long deep pleats of his throat. I
jabbed my brother as we settled ourselves in his lap. My brother
jabbed me.

"Soo, soo," our grandfather would say, stroking our arms and our
hair. "Settle down and listen. There was a man a long time ago . . . "

(Our eyes were closing, my brown head leaning on my brother's
curly gold one.)

". . . and he lifted his hand to his face and felt a long beard. 'Oh, what is this?' he cried. 'What has happened? I just lay down for an hour, and now I am changed . . . and where is my home, and my wife and my son? . . . '

"Then came a lady . . .

"'I remember a Rip, a long time ago,' said she, 'but he went away into the woods and his family is gone to the ends of the world. But come into my house, old man, and I'll care for you till you die.'"

Thus did our grandfather weave for us the first intimation we had of the exile's lament, the pain of separation and the impossibility of finding one's way back to the place of beginning. So much had been lost out of his own life by then, a whole clan vanished on the winds, his sisters Flora and Ferny, his mother and dad, and behind them in memory, the patriarch, Big Alexander of the Prayers, an evangelical preacher-teacher born on Skye after the catastrophe of Culloden.

On us, our grandfather shed the love those clansmen shed on their children and the lore he had learned by the sea and on the prairie. He taught us the Indian walk and how to lift birch bark with a penknife, bend it and seal it with candlewax for a toy canoe. He gave me my name, Hiawatha Painted-feather, and ordered me moccasins and a bow and arrow from the Sears, Roebuck catalogue. One day when the rain was blowing in sheets, he strode out into the storm to cut me Indian grass for a basket.

"Because he loves you," said Mary, biting off a thread. I watched through the window as he leaned against the wind. He came back stamping, shaking rain all over the kitchen, his eyes grave behind spotted glasses, speaking in a brogue full of tenderness, "It rains on the housetops and all through the land . . . "

When I dropped my doll, old and floppy, down the outhouse, he raked it up and washed it. "Because he loves you," said Mary tightly, watching it blow on the line. It must have hurt her to see how such small acts touched us while her demanding labors left us unaware.

He seemed very wise and knew all the tales, and even those he may not have known I attribute today to his telling, for they all come out of the same well. "Pison, Giheon, Hiddekel and Phrath,"

he would begin, "four are the rivers that run toward the sea." He would reach over to the enormous black teacher's desk that stood by his chair, pull out from among his Testaments and Psalms, his Homer, his Tennyson and Longfellow, his Emerson, Darwin and Spencer, a yellow tin box of licorice. His hands would move like rusty farm machinery to work off the lid. With slow farmer's hands, he would grope out two tiny black squares for us and go on playing on the strings of our imagination.

The old names lay soft on his tongue—Gilgamesh and Abraham, Theseus and Odysseus, Mowgli and Ab, and the one who went into the pit and whose coat was dipped in blood.

"Man was born in a cave and lived in a tree. Man sailed in a boat dug out with fire, curved like the moon. Man wrote on a stone in letters called runes.

"What is man?" he would ask us children, looking away over our heads into the distance through his heavy glasses. Then he would answer. "He struggles upward. He pushes on. He reaches his level. He will live on that spiritual height forever."

"You are so wise, Bappa," I said more than once, standing by his knee, looking up into his face. And he would correct me gently, "Remember the man who walked by the sea and picked up a stone.

"'This stone,' he said, 'is what I know,' and he threw it into the waves.

"'The ocean is what I do not know.'"

There came a time, after Mary died, when he came down from the mountain to live with us in Ohio. I was then an adolescent, and he seemed to me pulled out from the roots, an aged melancholic in black clothes and ill-fitting false teeth. For a while, he wanted to chop wood for exercise, as he had once done for necessity. So my father ordered cords of it, and every afternoon he would take his stance in the backyard, fix the log with solemn gaze, lift the ax and let it fall. All afternoon, *chop chop* would echo down the backyards of our suburban block, *chop chop* like the sounds of country lands. So he would chop while the hours went by, and it came to me, young as I was, that he was holding time at bay.

Then his mind began to go. "The Overflowing Fountain bathes us all," he would intone. "The spirit lives on. We can communicate

beyond the grave. I often feel the presence of my beloved Mary." At parties in our house, he would lift a finger to a circle of guests. His impassioned brogue brought them to a halt. "What is man? A wind that passeth away and cometh not again. . . ."

Witness to such scenes, my brother and sisters and I stood helpless in pity and shame. "He is old, he is sad, he is mystical," our father instructed us children, four in number by then. "He believes in things people no longer do. Don't hurt him by arguing, but remember there's no truth to them." I saw our father had no way to approach his father or to alleviate his own pain. It was then our mother, usually so diffident and self-involved, who would reach out to the old man, quiet him and lead him off to his room at the back of the house. So that finally we children, busy in any case with our schoolwork, our sports, parties and friends, were uncertain how to behave and drew away, leaving our grandfather in his loneliness.

During my first winter at college, he died. He left me a little black notebook in which year by year he'd copied out poems he loved. In it, I found again William Carruth's once-famous, swelling lines I had first heard spoken in his Gaelic accent:

A fire-mist and a planet, a crystal and a cell,
A saurian and a jellyfish, and a cave where the cave-men dwell.
Then a sense of law and order, and a face turned from the sod.
Some call it Evolution. Others call it God. . . .

and so also of Autumn, and Longing, and Consecration, all of which some others "call God."

Then I put the book away in guilt and sorrow and also in silence, for my father's resistance to talking about death or the dead spread an anesthesia throughout our household. For him, it would never wear off. After he carried his father's ashes back to the mountain in a box, he would never return or mention the place again, nor would he speak of his mother. But many years later, when I picked up the black notebook again, I found my grandfather had inscribed one poem twice, first in his youth, and then, on the last, unfinished page, tremblingly he had traced its first words, "Help of the helpless, O Lord, abide with me. . . . "

Only nine words they were, but placed just before the silence of the book's end, they sank deep into my mind, evoking the thoughts even a young person has of the dark distance into which all things are swept. And as life goes on, other deaths and losses add to this store of darkness, so it deepens, until the smallest natural happening—a roll of thunder, the edge of a wind lifting the hair, an animal cry at night—can open, again, the sluiceway behind which waits one's own death, ahead.

"It is gone, the beloved clan," I imagine my grandfather saying, sitting on his narrow iron bed in Ohio, staring down at his black, bulbous city shoes.

It would be twilight of a winter evening. His little room at the back of the house was pleasant enough in summer, for it overlooked the garden. But in February, it surveyed a desolate scene of flower beds in burlap, icicles along the windowframe.

A frozen branch rattles against the roof, the radiator bubbles and begins to knock. The old man remembers the harsh, sweet smell of woodsmoke and peaches cooking.

"The land lies behind, covered in mist," he thinks. "The river will find the sea.

"I believe we shall meet again.

"But where is the past, and what is the shape of the world to come—these are mysteries."

The radiator falls silent. A pall of cold air falls from the window onto the old man's knees, drifts down to his shins.

"Mudwayushka, little firefly," he mutters, laying his hands on his knees, fingers outstretched, his gaunt head sinking, his eyes big behind heavy lenses.

A whippoorwill calls. A bobcat screams.

The children are on his knees, pressed shoulder to shoulder.

"O Bappa, when will you die? You are so old, your eyes are red."

Golden is gone, brown is gone.

How then shall we all come back together in the end?

WALLACE STEGNER
(1909–1993)

For over fifty years, Wallace Stegner wrote short stories, novels, essays, biography, and history. In 1972, his boldest novel, Angle of Repose, *won the Pulitzer Prize in fiction, and in 1977,* The Spectator Bird *won the National Book Award in fiction.*

He taught at Harvard University from 1939 to 1945; from 1946 to 1971 he directed the creative writing program at Stanford University. He served on the National Parks Advisory Board, and was assistant to the secretary of the interior (1961).

His last book concerns living and writing in the West: Where the Bluebird Sings to the Lemonade Springs *(1992).*

Wolf Willow, his 1955 memoir, is experimental and mixed in form. He subtitled it "A History, a Story, and a Memory of the Last Plains Frontier." Here he describes the part of his boyhood he spent homesteading on the Saskatchewan plains in Canada. The nearby town he calls Whitemud. Wheat farming went poorly, and after five years the family moved to Montana.

■ ■ ■

from WOLF WILLOW

What we did on the homestead was written in wind. It began as it ended—empty space, grass and sky. I remember it as it originally was, for my brother and I, aged eight and six, accompanied my father when he went out to make the first "improvements." Except for the four-foot iron post jutting from the prairie just where our wagon track met the trail to Hydro, Montana, and for the three shallow holes with the survey stake at their apex that marked the near corner of our land, there was nothing to distinguish or divide our land from all other, to show which 320 acres of that wind and grass were ours.

That was our first experience of how flat land could spread from the wagon and tent by which we attempted to demonstrate ownership—flat to the horizon and beyond, wherever we looked, except

that, halfway to our western line, a shallow, nearly imperceptible coulee began, feeling its way, turning and turning again, baffled and blocked, a watercourse so nearly a slough that the spring runoff hardly flowed at all, its water not so much moving as pushed by the thaw behind it and having to go somewhere, until it passed our land and turned south, and at the border found another coulee, which carried in most seasons a little water—not enough to run but enough to seep, and with holes that gave sanctuary to a few minnows and suckers. It was called Coteau Creek, a part of the Milk-Missouri watershed. In good seasons we might get a swim of sorts in its holes; in dry years we hauled water from it in barrels, stealing from the minnows to serve ourselves and our stock. Between it and our house we wore, during the five summers we spent vainly trying to make a wheat farm there, one of our private wagon tracks.

Coteau Creek was a landmark and sometimes a hazard. Once my father, gunning our old Model T across one of its fords, hit something and broke an axle. Next day he started walking the forty miles into Chinook, Montana, leaving me with a homesteader family, and two days later he came back carrying a new axle on his back and installed it himself after the homesteader's team had hauled the Ford out of the creek bed. I remember that high, square car, with its yellow spoke wheels and its brass bracing rods from windshield to mudguards and its four-eared brass radiator cap. It stuck up black and foreign, a wanderer from another planet, on the flats by Coteau Creek, while my father, red-faced and sweating, crawled in and out under the jacked-up rear end and I squatted in the car's shade and played what games I could with pebbles and a blue robin's egg. We sat baldly on the plain, something the earth refused to swallow, right in the middle of everything and with the prairie as empty as nightmare clear to the crawl and shimmer where hot earth met hot sky. I saw the sun flash off brass, a heliograph winking off a message into space, calling attention to us, saying "Look, look!"

Because that was the essential feeling I had about that country—the sense of being foreign and noticeable, of sticking out. I did not at first feel even safe, much less that I was helping to take charge of and make our own a parcel of the world. I moped for Whitemud, nearly fifty miles north and east on its willowed river, where all my friends were and where my mother was waiting until we could get a

shack built. Out here we did not belong to the earth as the prairie dogs and burrowing owls and gophers and weasels and badgers and coyotes did, nor to the sky as the hawks did, nor to any combination as meadowlarks and sparrows and robins did. The shack that my father built was an ugly tarpaper-covered box on the face of the prairie, and not even its low rounded roof, built low and round to give the wind less grip on it, could bind it into the horizontal world.

Before the shack was finished we lived in a tent, which the night wind constantly threatened to blow away, flapping the canvas and straining the ropes and pulling the pegs from the gravelly ground. And when, just as we were unloading the lumber to start building, a funnel-shaped cloud appeared in the south, moving against a background of gray-black shot with lightning forks, and even while the sun still shone on us the air grew tense and metallic to breathe, and a light like a reflection from brass glowed around us, and high above, pure and untroubled, the zenith was blue—then indeed exposure was like paralysis or panic, and we looked at the strangely still tent, bronzed in the yellow air, and felt the air shiver and saw a dart of wind move like a lizard across the dust and vanish again. My father rushed us to the shallow section holes at the corner, and with ropes he lashed us to the stake and made us cower down. The holes were no more than a foot deep; they could in no sense be called shelter. Over their edge our eyes, level with the plain, looked southward and saw nothing between us and the ominous bent funnel except gopher mounds and the still unshaken grass. Across the coulee a gopher sat up, erect as the picket pin from which he took his nickname.

Then the grass stirred; it was as if gooseflesh prickled suddenly on the prairie's skin. The gopher disappeared as if some friend below had reached up and yanked him down into his burrow. Even while we were realizing it, the yellow air darkened, and then all the brown and yellow went out of it and it was blue-black. The wind began to pluck at the shirts on our backs, the hair on our heads was wrenched, the air was full of dust. From the third section hole my father, glaring over the shallow rim, yelled to us to keep down, and with a fierce rush rain trampled our backs, and the curly buffalo grass at the level of my squinted eyes was strained out straight and whistling. I popped my head into my arms and fitted my body to

the earth. To give the wind more than my flat back, I felt, would be sure destruction, for that was a wind, and that was a country, that hated a foreign and vertical thing.

The cyclone missed us; we got only its lashing edge. We came up cautiously from our muddy burrows and saw the tent collapsed and the sky clearing, and smelled the air, washed and rinsed of all its sultry oppressiveness. I for one felt a little better about being who I was, but for a good many weeks I watched the sky with suspicion; exposed as we were, it could jump on us like a leopard from a tree. And I know I was disappointed in the shack that my father swiftly put together. A soddy that poked its low brow no higher than the tailings of a gopher's burrow would have suited me better. The bond with the earth that all the footed and winged creatures felt in that country was quite as valid for me.

And that was why I so loved the trails and paths we made. They were ceremonial, an insistence not only that we had a right to be in sight on the prairie but that we owned and controlled a piece of it. In a country practically without landmarks, as that part of Saskatchewan was, it might have been assumed that any road would comfort the soul. But I don't recall feeling anything special about the graded road that led us more than half of the way from town to homestead, or for the wiggling tracks that turned off to the homesteads of others. It was our own trail, lightly worn, its ruts a slightly fresher green where old cured grass had been rubbed away, that lifted my heart. It took off across the prairie like an extension of myself. Our own wheels had made it: broad, iron-shod wagon wheels first, then narrow democrat wheels that cut through the mat of grass and scored the earth until it blew and washed and started a rut, then finally the wheels of the Ford.

By the time we turned off it, the road we followed from town had itself dwindled to a pair of ruts, but it never quite disappeared; it simply divided and subdivided. I do not know why the last miles, across buffalo grass and burnouts, past the shacks we called Pete and Emil, across Coteau Creek, and on westward until the ruts passed through the gate in our pasture fence and stopped before our house, should always have excited me so, unless it was that the trail was a thing we had exclusively created and that it led to a place we had exclusively built. Here is the pioneer root-cause of the

American cult of Progress, the satisfaction that *Homo fabricans* feels in altering to his own purposes the virgin earth. Those tracks demonstrated our existence as triumphantly as an Indian is demonstrated by his handprint in ochre on a cliff wall. Not so idiotically as the stranded Ford, this trail and the shack and chicken house and privy at its end said, "See? We are here." Thus, in the truest sense, was "located" a homestead.

More satisfying than the wagon trail, even, because more intimately and privately made, were the paths that our daily living wore in the prairie. I loved the horses for poking along the pasture fence looking for a way out, because that habit very soon wore a plain path all around inside the barbed wire. Whenever I had to go and catch them, I went out of my way to walk along it, partly because the path was easier on my bare feet but more because I wanted to contribute my feet to the wearing process. I scuffed and kicked at clods and persistent grass clumps, and twisted my weight on incipient weeds and flowers, willing that the trail around the inside of our pasture should be beaten dusty and plain, a worn border to our inheritance.

It was the same with the path to the woodpile and the privy. In late June, when my mother and brother and I reached the homestead, that would be nearly overgrown, the faintest sort of radius line within the fireguard. But our feet quickly wore it anew, though there were only the four of us, and though other members of the family, less addicted to paths than I, often frustrated and irritated me by cutting across from the wrong corner of the house, or detouring past the fence-post pile to get a handful of cedar bark for kindling, and so neglected their plain duty to the highway. It was an unspeakable satisfaction to me when after a few weeks I could rise in the flat morning light that came across the prairie in one thrust, like a train rushing down a track, and see the beaten footpath, leading gray and dusty between grass and cactus and the little orange flowers of the false mallow that we called wild geranium, until it ended, its purpose served, at the hooked privy door.

Wearing any such path in the earth's rind is an intimate act, an act like love, and it is denied to the dweller in cities. He lacks the proper mana for it, he is out of touch with the earth of which he is made. Once, on Fifty-eighth Street in New York, I saw an apartment dweller walking his captive deer on a leash. They had not the plea-

sure of leaving a single footprint, and the sound of the thin little hoofs on concrete seemed as melancholy to me as, at the moment, the sound of my own steps.

So we had an opportunity that few any longer can have: we printed an earth that seemed creation-new with the marks of our identity. And then the earth wiped them out again. It is possible that our dam still holds a reservoir behind it, that our family effort has endowed the country with one more small slough for which nesting ducks and thirsty coyotes may bless us. It may be that some of the ground cherries my mother brought as seed from Iowa and planted in the fireguard have grown and fruited and been spread by wind and birds. If so, field mice opening the papery husks and dining on the little yellow tomatoes inside may bless us too. There is not much else that we can be blessed for. Because of us, quite a lot of the homestead's thin soil lies miles downwind. Because of us, Russian thistle and other weeds that came in with the wheat have filled the old fields and choked out the grass and made much more difficult the job of bringing back the old natural range. But with those exceptions, we are erased, we are one with Fort Walsh. Though it established itself permanently in more favored parts of the region, the wheat frontier never got a foothold in "Palliser's Triangle," at whose base our homestead lay, and we ourselves helped corroborate Palliser's 1858 prediction that agriculture would prove impracticable there. Our dream of a wheat bonanza, or failing that, of a home, is as lost as the night wind that used to blow across the prairie's great emptiness and, finding a little human box in its way, moan and mourn under the eaves and through the screens.

The homestead, though it was a stead of sorts, was never a home. There was only a handful of real homes on either side of the Line. Most houses were like ours, shacks made to be camped in during the crop season; and some were like Pete and Emil, never meant to be lived in at all, but only to satisfy the law's requirement. (The grass grows more sweetly on Pete and Emil than on our place, for during their simple-minded effort to cheat the government out of title to 320 acres their owners plowed no prairie, imported no weeds, started no dust bowl.) Those of us who really tried to farm lived on the prairie as summerers, exact opposites of the *métis* winterers who knew that country first, and anyone who tries to farm

there now will still be a summerer. Nobody, quite apart from the question of school, wants to risk six hard lonely months thirty or forty miles from fuel, supplies, medical care, and human company.

As agriculturists we were not inventive. We used the methods and the machinery that were said to be right, and planted the crops and the varieties advised by rumor or the Better Farming Train. At least once, tradition did well by us. Because my parents had brought from Dakota the notion that flax is the best crop in a newly broken field, we endowed our prairie briefly, in 1916, with twenty acres of bluebells. I remember the pleasure their beauty brought us all; that was a green and rainy summer, and the sight of lush grass and wild-flowers and the blue wave of flax persuaded us for a little while that we did indeed live in the Garden of the World. But I remember them also for the evidence they give me now of how uneventful and lonesome the homestead must have been for two boys who had read everything in the shack ten times, had studied the Sears Roebuck catalog into shreds, had trapped gophers in increasing circles out from the house until the gopher population was down to bare sur-vivors, had stoned to death the one badger they caught in a gopher trap, had lost in a big night windstorm their three captive weasels and two burrowing owls, and had played to boredom every two-man game they knew. We couldn't even take our .22's and go killing things, for we had no money for cartridges, not even shorts, not even the despised BB's.

To keep us from our interminable squabbling, my father said we could reap as our own crop all the flax that had grown up too close to the pasture fence for machinery. We cut our flax with butcher knives and threshed it by beating it against the inside of a washtub. It took half an hour to realize a cupful, but we kept at it until we had filled two flour sacks. It brought us, as I recall, about four dollars— memorable money. But I have a more lasting souvenir of that piece of bored laboriousness. Cutting at flax stalks with my knife, I slammed my hand into a cactus clump and drove a spine clear through my middle finger. There was no pulling it out, for it was broken off at the skin, and so I waited for it to fester out. It never did. It is there in the X-rays yet, a needle of authentic calcified Saskatchewan, as much a part of me as the bones between which it wedged itself.

When he first broke sod, my father took pride in plowing a furrow six inches deep, as straight as a string, and nearly a mile long. He started at our pasture fence, plowed straight south to the Line, turned east, plowed a few rods along the border, and turned north again to our fence, enclosing a long narrow field that in a demonic burst of non-stop work he plowed and disked and harrowed and planted to Red Fife wheat.

It was like putting money on a horse and watching him take the lead at the first turn and go on pulling away to the finish. That first summer, 1915, the wheat came up in thin rows—a miracle, really, considering that we ourselves had done it, and in so short a time. Rains came every few days, and were followed by long hot days with sixteen hours of sun. The earth steamed, things grew like plants in trick photography. We looked away from the field for a minute and looked back to find the wheat ankle high, looked away again, and back, and found it as high as our knees. Gophers mowed big swaths, cutting it to get at the tender joints, and so we went up and down the mile-long field with traps and .22's and buckets of sweet-smelling strychnine-soaked wheat. That summer, according to the prize they gave us, my brother and I collected more gopher tails than anybody in southern Saskatchewan.

We lived an idyl of miniature savagery, small humans against rodents. Experts in dispensing death, we knew to the slightest kick and reflex the gophers' ways of dying: knew how the eyes popped out blue as marbles when we clubbed a trapped gopher with a stake, knew how a gopher shot in the behind just as he dove into his hole would sometimes back right out again with ridiculous promptness and die in the open, knew how an unburied carcass would begin within a few hours to seethe with little black scavenger bugs, and how a big orange carrion beetle working in one could all but roll it over with the energy of his greed, and how after a few days of scavengers and sun a gas-bloated gopher had shrunk to a flattened wisp of fur.

We were as untroubled by all our slaughter as early plainsmen were by their slaughter of buffalo. In the name of the wheat we absolved ourselves of cruelty and callousness. Our justification came at the end of that first summer when my father, who was just six feet tall, walked into the field one afternoon and disappeared.

The wheat overtopped and absorbed him. From a field of less than thirty acres he took more than twelve hundred bushels of Number One Northern.

It was our last triumph. The next spring my father went out early to prepare another field and plant the old one. We joined him late in June, after driving all day in a drenching downpour—load soaked, us soaked, horses streaming, old Red the cow splashing along behind with her hipbones poking up under her slicked wet hide like a chairback under a sheet. My father had barely got the crops in—thirty acres of wheat, twenty of flax. Then we sat for two weeks in the mouse-smelling shack, playing checkers and reading, while the rain continued to come down. We wondered if the seed would be washed out of the ground, it rained so. The cat prowled unhappily and lost his reputation for being house-broken, because he would not go out in the wet.

Between soakers we inspected the fields. A thin combing of green, then sturdy rows, then ankle high—it grew like weeds. Though I trapped for gophers, I caught few; they had drowned in their holes. The cat grew thin for lack of field mice. Going to the vegetable garden for our usual summer job of picking off potato bugs and piling them at the ends of the rows and burning them with kerosene, we found hardly a bug on the vines. Nothing throve on that rainy prairie but wheat and flax. Rich farmer's sons, we grew lavish in our selection of next Christmas's gifts from the Sears Roebuck catalog. For weeks on end water stood in the burnouts; every low spot was a slough; the rezavoy lapped the top of the dam. Like effete visitors to a summer resort area, we swam in water over our heads. We had no hot winds, no hailstorms, no twisters, no grasshoppers. Every natural pest and hazard was suspended. Except one. Rust. We got a flax crop, but no wheat at all, not a bushel. In town, where my father had planted his potato field and hired the Chinese to look after it, we had a bumper crop of spuds, so big that storage had to be found for a good part of it. Those were the potatoes that were in the cellar of Joe Knight's hotel when it burned down.

Bad luck, surely. And yet if bad luck had not begun for us in 1916 we would simply have been a year or so longer on the hook. As it was, 1917 gave us our seed back, 1918 gave us only a little better, and 1919 served us up such blistering hot winds that we didn't even

bother to call in the threshers. One more year and we would have proved up on the homestead and been Canadians all the way instead of only halfway. But when you have stood for three summers in a row turning from the rainy east to the windy southwest, and propitiated one and cursed the other, and every time, just when you have been brought to the point of hope by good spring rains, have felt that first puff out of the southwest, hotter by far than the air around you, you are not likely to require further proofs. My father did not grow discouraged; he grew furious. When he matched himself against something he wanted a chance to win. By 1920 he was already down in Montana scouting around for some new opportunity, and we had stopped walking the paths and making our marks on the face of the prairie.

But how much of my remembering senses is imprisoned there where I would not for a thousand dollars an hour return to live! I retain, as surely as a salmon returning to its spawning grounds after six years at sea knows its native stream, and turns in unerringly from salt water, the taste and smell of the rezavoy when we swam in it among the agitated garter snakes and frogs. (Where *they* came from, God alone knew. There were none in that semi-desert when we built the dam, but next spring there were pollywogs. My mother firmly believed it rained them.) I could detect just as surely, if someone offered me a cup of it now, the clay-tasting, modified rezavoy water that we drank—the water from a well-hole dug eight or ten feet from shore so that the seepage from the open slough would be filtered by earth. It took a good amount of earth and earth flavors with it in passage, and it was about as full of wigglers as the rezavoy itself. In late summer we boiled it, but it never lost its taste. The water of Coteau Creek, by contrast, had a slick, soapy taste of alkali about it, and if we had to drink it for any length of time, as we did the last two summers, it gave us the trots.

There was a whole folklore of water. People said a man had to make a dipperful go as far as it would. You boiled sweet corn, say. Instead of throwing the water out, you washed the dishes in it. Then you washed your hands in it a few times. Then you strained it through a cloth into the radiator of your car, and if your car should break down you didn't just leave the water to evaporate in its gullet, but drained it out to water the sweet peas.

We learned to drink with an eye on the dipper so as to keep from sucking down wigglers. When we went on a day's visit to some farm and had a good clean drink out of a deep well, we made jokes that the water didn't seem to have much *body* to it. All we lacked to put us into the position of the surveyors and hunters who had drunk slough water in that country in the 1870's was a few buffalo to fill our tank with urine and excrement.

As much as we starved for a decent drink we starved for shade. No one who has not lived out on a baking flat where the summer days are eighteen hours long and the midday temperatures can go up to a hundred and five degrees has any business talking about discomfort from heat. The air crisps the skin and cracks the lips. There is not a tree for fifty miles in any direction, not even a whisker of willows, to transpire moisture into the air or shade one inch of the scorched ground. The wind that hundreds of miles to the west started up the mountains warm and wet had dropped its moisture on the heights and come down our side wrung dry—dry and gaining temperature at the rate of one degree for every four hundred feet of altitude lost. It hits the Plains and comes across Alberta and Saskatchewan like the breath of a blowtorch. There is no cloud, not one, to cut off the sun and relieve the glare even for a minute. The horizons crawl with mirages. Maybe, far back along the crest of the mountains, out of the straining sight of Plains dwellers as far east as ourselves, there may lie the pearly bank called the Chinook Arch, but that would be no comfort to us even if we could see it—only a confirmation of the foehn wind.

Searing wind, scorching sky, tormented and heat-warped light, and not a tree. The band of shade thrown by the shack narrows as the sun climbs, until at noon it is gone. It will be two hours before it is wide enough on the other side to shelter a boy's body. There is no refuge except inside. The green blinds are drawn, the canvas flaps are rolled down over the screens of the sleeping porch; the light is dusky and comforting to the eyes. But the still air is hotter, if anything, than that outside. Outside, the wind dries sweat before it ever bubbles through the little wells of the pores; inside we are sticky and labor for breath. The wind bellies the canvas in the porch, leaks past. Driven from the still heat of the shack, we look out the door into the white glare of the yard and the hallucinatory writhing of the horizon, and are driven back in again.

On such a day my mother would not try to cook anything on the Florence kerosene stove. She would have milk, butter, eggs, anything perishable, down in the semi-cool hole under the trapdoor in the floor, down among the spiders. Bacon, ham, dried beef, about the only meats we can use because they are the only ones that will keep more than a day, are buried deep in a box of oats to keep them cooler and moister. Hung in the air they would grow rancid, be blown by the flies, harden like rock. During the hot-wind days the gingersnaps that are our standard cookies are so dry and hard they fly into fragments when we take a bite; if they should grow soft we would take it as an almost certain sign of coming rain.

At meal time the trapdoor is raised and up come crocks of tepid milk, often "on the turn," and the dish of butter. We dine, these days, primarily on homemade bread and butter, sometimes with peanut butter, sometimes with brown sugar, sometimes with a slather of Karo syrup or molasses. But eating, ordinarily our purest pleasure, is no fun. There is a headachy crankiness around the table, the flies are infuriating. Before it has been on the table five minutes, the butter is ghee, yellow liquid that we scoop up with spoons to spread our bread. Put down into the hole again, it will harden into a flat, whitish, untasty-looking sheet sprinkled with a rime of salt like an alkali flat. When spread, it is coarse and crumbly, without buttery consistency and with a rancid taste. Sometimes, in spite of the twists of flypaper hanging in a dozen places from the ceiling, and the big treacherous sheets spread around on tables and boxes, all of them murmurous with trapped flies, we will find in the melted-and-congealed-again butter a black kinked leg or a transparent wing.

And what of the insects caught in that heat-softened, incredibly sticky flypaper? I used to watch for minutes at a time as some fly, gummed and stuck with glue, his wings plastered to his body, his legs fused, dragged himself with super-fly effort toward the edge of a sheet, and made it, and rested there, slimed with the death he had dragged with him, and then tried with his stuck-together forefeet to wipe his head and clean himself. A fly could often drag himself a good way through the warmed glue, but even if he made it to the edge he didn't have a chance. I used to put pencil circles around some struggler still hopefully mopping his head with his slimed feet, and come back later to see if he had got clean and got away. He

never had. Once I caught my mother watching *me,* and together, for a while, we stared at the sheet of gummed paper loud with the buzzing of flies whose feet were caught but whose wings were still free. We watched a few get their wings caught too, so they could only slide and crawl. My mother's lips drew up as if she tasted something nasty. "What's the matter, sorry for the old flies?" I said. "It's a parable," she said, and crumpled the sheet up and stuck it in the sheep-wagon stove we used in chilly weather.

A parable, indeed. In spite of my mother's flimsy pretense that we were farmers of the kind her Iowa parents were, drawing our full sustenance from the soil and tending the soil as good husbandmen should; in spite of her cow and her dasher churn and her cloths of cottage cheese dripping from the clothesline; in spite of her chickens and eggs and vegetable garden, she was not fooled. It was not a farm, and we were not farmers, but wheat miners, and trapped ones at that. We had flown in carelessly, looking for something, and got ourselves stuck. The only question now was how to get free.

She knew it was failure we were living; and if she did not realize, then or ever, that it was more than family failure, that it was the failure of a system and a dream, she knew the family failure better than any of us. Given her choice in the matter, she might have elected to go on farming—get some better land somewhere, maybe in the Cypress Hills, and become one of the stickers. She had the character and the skills for it as my father did not. But she likewise had impulses toward a richer and more rewarding life, and ambitions for her sons, and she must have understood that compared to what a Saskatchewan homesteader considered his opportunity, five years of Siberian exile would have been a relatively comfortable outing. She had gone to school only through the sixth grade. It would never have occurred to her to think that her family and thousands of others had been betrayed by homestead laws totally inapplicable on the arid Plains; or that she and hers had been victimized by the folklore of hope. She had not education enough to know that the mass impulse that had started her parents from Ulvik on the Hardanger Fjord, and started her and my father from Iowa into Dakota and on across the border, had lost its legitimacy beyond the hundredth meridian. She knew nothing about minimal annual rainfall, distribution of precipitation, isohyetal lines. All she knew was that we were trapped and

licked, and it would not have helped her much to be told that this was where a mass human movement dwindled to its end.

For her sake I have regretted that miserable homestead, and blamed my father for the blind and ignorant lemming-impulse that brought us to it. But on my own account I would not have missed it—could not have missed it and be who I am, for better or worse. How better could a boy have known loneliness, which I must think a good thing to know? Who ever came more truly face to face with beauty than a boy who in a waste of characterless grass and burnouts came upon the first pale primrose on the coulee bank, or on some day of great coasting clouds looked across acres of flax in bloom? Why, short of exile, would anyone ever submit to the vast geometry of sky and earth, to the glare and heat, to the withering winds? But how else could he have met the mystery of nights when the stars were scoured clean and the prairie was full of breathings from a long way off, and the strange, friendly barking of night-hunting owls?

There may be as good ways to understand the shape and intensity of the dream that peopled the continent, but this seems to me one good one. How does one know in his bones what this continent has meant to Western man unless he has, though briefly and in the midst of failure, belatedly and in the wrong place, made trails and paths on an untouched country and built human living places, however transitory, at the edge of a field that he helped break from prairie sod? How does one know what wilderness has meant to Americans unless he has shared the guilt of wastefully and ignorantly tampering with it in the name of Progress?

One who has lived the dream, the temporary fulfillment, and the disappointment has had the full course. He may lack a thousand things that the rest of the world takes for granted, and because his experience is belated he may feel like an anachronism all his life. But he will know one thing about what it means to be an American, because he has known the raw continent, and not as tourist but as denizen. Some of the beauty, the innocence, and the callousness must stick to him, and some of the regret. The vein of melancholy in the North American mind may be owing to many causes, but it is surely not weakened by the perception that the fulfillment of the American Dream means inevitably the death of the noble savagery

and freedom of the wild. Anyone who has lived on a frontier knows the inescapable ambivalence of the old-fashioned American conscience, for he has first renewed himself in Eden and then set about converting it into the lamentable modern world. And that is true even if the Eden is, as mine was, almost unmitigated discomfort and deprivation.

I saw the homestead just once after we left it to go back into town in the bitter fall of 1919. In the spring of 1920 we came past it on our way to Montana and camped in the shack for one night. We did not even take the boards off the windows or roll up the canvas blinds, but went about in the familiar, musty place, breathing the heavy air, in a kind of somnambulism. Our visit was not meant to change anything, or restore for an instant the hope we had given up. We merely passed through, picked up a few objects that we wanted, touched things with our hands in a reminding way, stood looking from the doorway down across the coulee. My brother and I walked up the pasture and saw where a badger had been busy, but did not get out our traps. Our pasture fence was banked high as the posts with tumbleweed blown in from the next farm, two miles west. Our own fields were growing, in addition to spears of volunteer wheat, a solid mat of Russian thistle that by fall would be bounding and rolling eastward ahead of the frolic winds, to scatter their seed broadcast and lodge eventually in someone else's fences. The gophers that our wheat had allowed to increase prodigiously, and that our traps and poison had kept artificially in check, would thrive a year or two on whatever wheat volunteered in old fields, and then shrink gradually back to a population in balance with the hawks, owls, coyotes, badgers, and weasels that lived on them. And our house would begin—had already begun—its process of weathering and rusting and blowing away.

When we drove away we closed the gate carefully on our empty pasture, shutting in shack and privy and chickencoop and the paths connecting them, hooking shut three strands of barbed wire around the place we had made there, enclosing our own special plot of failure from the encroaching emptiness. We congratulated ourselves that it was such a tight, firm fence. Wandering stock couldn't get in and camp in the chicken house, or rub anything down scratching

off winter hair. We told ourselves that some day we would be back. We memorized the landmarks of five years.

But we knew, we all knew, that we wouldn't be back any more than the families of our acquaintance who had already left; and I imagine we obscurely felt that more than our personal hope had died in the shack that stayed in sight all the time we were bumping down along the field to the border. With nothing in sight to stop anything, along a border so unwatched that it might have been unmapped, something really had stopped there; a crawl of human hope had stopped.

As we turned at the Line, headed for the country road that began at Hydro, we could still see the round roof of the shack lifting above the prairie north of us. There was nothing else in sight up there but empty prairie. My mother drew in her breath and blew it out again with a little laugh, and said the words that showed us how such a departure should be taken. "Well," she said, "better luck next time!"

KATE SIMON
(1912–1990)

Born in Poland, Kate Simon immigrated to New York City when she
was four, as a steerage passenger with her mother and younger brother.
Her father, who had made the journey three years earlier, was a shoe
designer; her mother was a corsetiere.

Simon earned her B.A. at Hunter College, then worked for the
Book-of-the-Month Club, Publishers Weekly, *and Alfred A. Knopf. She*
reviewed books for The New Republic *and* The Nation, *and wrote*
personal, urbane, and witty travel guides to New York, Paris, London,
and Rome. It was as a memoirist, however, that she showed the fullness
of her literary gift.

This is a section of Simon's first memoir, Bronx Primitive *(1982).*
A second volume, A Wider World, *appeared in 1986, and a third,*
Etchings in an Hourglass, *in 1990.*

■ ■ ■

from BRONX PRIMITIVE

When my brother was born, I was eighteen months old. My
father, for whom I was still searching, had been in New York
for six months. Our Warsaw apartment turned dark, the singing
stopped. It need hardly be said that I was jealous, felt abandoned,
unloved, coldly shadowed while the full warm light that was mine
now circled him. It cannot have been that my grandmother and
aunts and mother suddenly stopped loving me, and I might in time
have grown interested in him, beginning with the gallant way he
peed, upward in a little shining arch, out of a finger in a peculiar
place. But he was a very sick child and the household alternated
between sad, quiet staring and frantic dashing to rescue him from
death. His head was bright, alert, and very large compared to the
arms and legs that would not develop beyond thin, boneless ropes.
He was a classic picture of the rachitic famine child who still tears
the heart of the newspaper reader, the television viewer. We were

not too poor to buy the food he needed; it was simply unavailable, grabbed up by the military for its soldiers. My mother took the baby from doctor to doctor, all of whom gave her the same short answer: "All this child needs is a steady, normal diet." Because her food intake was meager, the milk she gave him was insufficient; my aunts scoured the city, offering large sums for an orange or two, an egg, a pint of milk, with no success. I grew thin and listless.

The last doctor my mother saw in Warsaw, made blunt by the misery he could not remedy, shouted at her, "Leave the boy, he's going to die anyway. Take the girl to America while there's still time. Or do you want to sit with two dead children in this graveyard city?"

We left for America. My brother was two and a half, a babbler in several languages, a driven entertainer and flirt. His arms and hands were weak but usable, his legs not at all; he moved with amazing, mischievous rapidity by shuffling on his behind when he wasn't being carried. I was four, grown silent and very capable. I could lift him to the pot, clean him, and take him off. I could carry him to bed and mash his potato. I knew where he might bump his head, where he might topple, how to divert him when he began to blubber. It was a short childhood. I had my first baby at not quite four, better trained in maternal wariness and responsibility than many fully grown women I later observed. At four I also knew one could intensely love and as intensely hate the being who was both core and pit of one's life.

The month-long journey across devastated Europe to reach our ship, the *Susquehanna,* in Rotterdam remains with me as snatches of dream. I am sitting with my brother on my lap, in a room full of heavy dark furniture that I have never seen before. I am telling him that our mother went to buy food and will be back soon. I hope that she will come back, but I'm not sure; over and over, in every dark dream, I am not sure. I don't say this to him but wonder what I will do, where we will go, if she doesn't come back, as our father didn't. I continue to talk to him. We'll soon be on another choo-choo train and then the big, big ship that will take us to our father in America. He is silent in these dreams, his face old, serious, as if he were listening to the fears under my bright optimistic patter.

The next vision is actual recollection: a long cobbled quay marching into a world of water, more water than I had ever imagined. On the side of the quay a stall at which a woman shining with smiles and sweat stands frying small cakes. My mother buys three and hands me one. I expect it to be sweet and it tastes like fish. The vomit leaps out of my mouth, down my clean dress, and into the cracks around the cobblestones. What do they do in this place to girls who vomit on their streets? Will they keep me off their ship? The pink sweaty lady washes it away with a bucket of water. My mother thanks her in the Dutch she has picked up, I say my best Polish thank you, my smarty brother dazzles her with a "*Merci beaucoup*" someone had taught him on a train, and we go to look for the *Susquehanna,* my mother carrying my brother and one big valise and I two big bundles.

Just as I find it a great loss not to know my grandparents' first names, I feel deprived of what should have been an unforgettable sight: the big ship as it swayed on the waterfront and, later, the endless corridors, the stairs, the crowds of people, the disorder, the shouting, the weeping in terror, in relief, in joy, that my mother described. We were on the ship a full month, listed in steerage. I don't know where my brother and I actually stayed, however. As if our lives were designed to fill every requirement of the classic immigrant hegira, typhus raged through steerage, my exhausted mother one of the victims. We children must have been taken care of in some other part of the ship by strangers whom I cannot remember except as sensations of pleasure: an India rubber ball whose lovely colors played hide and seek with each other and the man who gave it to me, a slight man in a brown hat who limped. I searched for him for years after. A slight man in a brown hat who limped was the dream lover of my adolescence, a steady image through the short, searing crushes, the unbuttoned blouse and the frightened crawl of boys' fingers.

Knowing that there would be a long wait at Ellis Island, my father had equipped himself with a couple of Hershey bars to nibble on, and when he finally picked me up to kiss me, I tasted the chocolate and announced to my mother, "Our father has a sweet mouth." It was frequently quoted as an example of my dainty, feminine grace, and only four years old, mind you. I have often

thought it was an act of propitiation: I am eager to love you; love me, please.

At Ellis Island we were questioned and examined by immigration officials and told our English names. Because my Polish birth certificate said "Jew-child Carolina" I was dubbed and registered as "Caroline," a barbed-wire fence that divided me from myself throughout my school years. I hated it and would never answer my father when he tried to be fancy and American in public, addressing me by a name that belonged entirely to P.S. 58, P.S. 57, P.S. 59, to Theodore Roosevelt High School, to James Monroe High School, to Hunter College, not to me. How we got to Kate I don't know. My mother must have sought it out to keep as clear as possible the link to her grandmother Kaila, not realizing how intensely Catholic a name it then was. Being serenaded as "K-K-K-Katy, my beautiful Katy" was a flattering bewilderment until I realized it was not written for me and then grew bored and irritated with the repetition from elderly relatives. (As bored as I later became with their descendants and their witty greeting, "Kiss me, Kate.") My brother, the master mimic, learned "K-K-K-Katy" immediately and learned, too—our weaponry of injuries that were deep and yet unpunishable was uncannily sophisticated—how much it annoyed me, and he sang it constantly to the admiration of the old uncles and aunts who never ceased to wonder at the speed with which he picked up English songs and the pretty, true voice on which they floated clear, loud, and incessant.

Instead of a city of silver rivers and golden bridges, America turned out to be Uncle David's flat on Avenue C in which my father had first lived when he came to America. We walked up several flights of dark stairs and knocked on a door pasted over with glazed patterned paper of connecting rectangles and circles in blue and red and green, whose lines I liked to trace with my eye while the others talked. That door led to a large kitchen with a round table in the center, a few chairs around it, and, off to a side, a brown wooden icebox. At another side, a shining black stove whose cooking lids were lifted by a clever long black hook when pieces of coal had to be added to the waning fire. From the kitchen ran a narrow dark alley with divisions that made niches for beds and then opened into a small living room at whose end there were two windows with views

of clouds and chimneys. Only once were we held to look down to the street below; never were we to try on our own, and we couldn't, so thoroughly were we watched by our entranced Uncle David, who looked like God and Moses and, more often, Old King Cole. He had a long white beard and puffs of white hair leaping from the edge of his skullcap and a magical skill of putting his finger inside his cheek and pulling it out to make a big popping sound. He laughed a lot, told incomprehensible stories about Italians whose only English was "sonnomabitz," drank great quantities of tea, sipped from a saucer and drained through a cube of sugar held in his teeth. Everything about him was wonderful: the black straps and boxes he wrapped on his arms and forehead and the rhythmic bowing of his prayers when he was God; the fluttering old fingers and light touch of his gray carpet slippers as he paced a Chassidic dance when he was Old King Cole.

The rest of his household consisted of two middle-aged spinster daughters. Rachel was a plump, bustling, talkative woman who addressed us as her little sheep, which made us feel pathetic and affecting and sure we could get anything out of her—another candy and yet another—and we played her. In spite of her bounty and mushy vulnerability, I was afraid of her. She wore glasses so thick that her eyes were invisible behind concentric circles of shine. Though her cheeks were high-colored and her teeth strong and yellow, she looked like a mechanical woman, a machine with flashing, glassy circles for eyes. The third member of the household was completely apart from us and truly fearsome. Yentel (a name, I was later told, that derived from the Italian "Gentile") was tall and gaunt, blind and deaf. She moved through the small apartment deftly, measuring her spaces with long, constantly moving fingers. She made the beds, pulling, smoothing, lining up the edges with her subtle, restless fingers. She shelled peas, she peeled potatoes and plucked chickens. While my brother sang and shuffled around Rachel and Uncle David, I watched her out of the corner of my eye. I didn't know what blind really meant; anyone who was so dextrous could not be entirely without vision and I was afraid she would see me staring at her if I watched her with my eyes wide open.

Though I was relieved of some of the care of my brother, I still had to be in charge many times. Uncle David and Rachel could keep

him from banging into Yentel and would prepare his food, but we had confusing language difficulties that I had to unsnarl when my parents went out, my mother wildly eager to see everything and now, particularly while she had such devoted baby-sitters. My brother and I spoke Polish, Uncle David and Rachel had been brought up in Yiddish with a few Polish words they no longer remembered accurately. When my brother sleepily mumbled "*Spatch* [sleep]" they briskly rushed him to the cold toilet in the hall, vaguely remembering a similar Polish word that they thought meant shit, *sratch*. Unable to explain, I resorted to rough pantomime: run into the toilet, shake my head vigorously, pull him, confused and weeping, off the seat, and carry him to one of the beds, where I dump him and his lush glorious howling, to let them take care of the rest. Conversely I had to watch for the suffused worried face and the shifting buttocks that they tried to settle in bed while he yearned for a toilet. The story of bed and toilet was frequently told in our household to considerable laughter; my brother and I were never amused, it gave us both anxious bellyaches.

Force-fed like a Strasbourg goose by everyone who looked at him, my brother began to strengthen and even to take a few tentative steps now and then. An early talker, his only strengths his brain and speech, he was prodigious at three. He might easily have learned to read but he preferred talk, preferably oratory. The first time we were taken out on a sled one winter afternoon, he declared when we came home that so small a child (as he) must not be taken out in snowy cold. People had to realize that a small body got colder faster, that snow was for animals with fur and not for people with skins. And so on and so on, in his adept combination of splashing guilt as he charmed. And how he could cry, high wide luxuriant wails to which his whole body danced, and to which everyone responded anxiously, except one time when we were taken on an elevated train and, at one station, a black man walked in and sat opposite us. I didn't know how to feel: maybe he was a charred man, darkened like wood in a fire and I must be sorry for him, maybe he ate coal, maybe he was some sort of monkey like those in a picture book and I should be afraid of him. While sorting it out, I admired the light palms of his hands against the dark backs, the big purple lips, and the wide holes in his nose. My brother shrieked in terror, scream-

ing—in Polish, fortunately—"Take him away, take that black giant away! He's going to eat me! Kill him, Papa, kill him!" It was a crowded train; to give up our seats and move to stand in another car would have been foolish. My father slapped the small pointing finger and with his hand stifled the howling. The child thrust his head into my mother's armpit and, shuddering, rode that way the rest of the journey.

My brother's fear of blacks dispelled itself in the stellar entertainment we found on 98th Street, between Lexington and Third avenues where we had moved from the Lower East Side. At the top of the street there were three tall-stooped narrow tenements and below, running to Third, small houses with crooked porches. These were black houses and to us places of great joy and freedom. My brother was already walking quite well and we were allowed the street—I was always to hold his hand and watch that he didn't go into the gutter and see that he didn't get dirty and not to talk to strange men and not wander around the corner. We watched, at a distance, the black children fly in and out of their houses, calling strange sounds, bumping, pummeling, rolling, leaping, an enchantment of "wild beasts" my father never permitted us to be. The best of the lower street were the times when everyone, adults and children, marched up and down, carrying bright banners, and to the sound of trumpets and drums sang, "Ohlly Nohly, Ohlly Nooo. Bumpera bumpera bump bump bum, Ohlly Noooo." Ohlly Nohly became our favorite rainy-day game, my brother banging on a pot with a clothespin, I tootling through tissue paper on a comb, highstepping jauntily, roaring from hallway to kitchen to bedroom our version of a revival hymn that must have begun with "Holy Lord, Oh Holy Lord." We never could reconstruct the bumpera bumpera words though we never forgot the tune.

It was on 98th Street, across from the tall long sinister stone wall on which the Third Avenue El trains came to rest, that I began to know I would never get to America. Though I learned in the kindergarten on 96th Street, among the many other English words that I taught my brother with a prissy, powerful passion, that I lived in America, it was not the America promised me in Warsaw or by the chocolate sweetness of my father's mouth. There were no sacks of candy and cookies, no dolls, no perennial summer that meant

America. America was a stern man whose duty it was to cure us of being the cosseted spoiled little beasts our mother and her idiot sisters had allowed to flourish. At the far remove of decades, I can understand how infuriating it was for this indulged semibachelor to be saddled with a wife and two noisy children whom he hadn't the courage to abandon nor the wish to live with. Nothing to do but mold us with speed and force into absolute obedience, to make his world more tolerable and, I often suspected, to avenge himself on us for existing.

It was his habit to take a constitutional after dinner every night, a health measure he clung to all his life, as he clung to the bowel-health properties of the cooked prunes he ate every morning. One autumn twilight, when my brother was about four and I five and a half, we walked down 98th Street, toward Third Avenue, I averting my eyes from the tall black wall that deadened the other side of the street. Somewhere on Third Avenue we slowed at a row of shops, one of them a glory of brilliantly lit toys. Carefully, deliciously, my brother and I made our choices. He wanted the boat with big white sails to float in the bathtub or maybe the long line of trains that ran on tracks or maybe the red fire engine with a bell. I chose a big doll whose eyes opened and closed and a house with tiny beds and chairs and a clothes wringer in the kitchen. Or, maybe, the double pencil box crammed with coloring pencils, serious school pencils, a pen holder, and three pen points. As my brother lilted on in gay covetousness, the wariness that was already as much a part of me as blue eyes and wild blond hair made me suddenly turn. It was night. There was no mother, no father, on the dark street and I didn't know where we were. Feeling my fear, my brother turned, too, and began to cry heartbreakingly—no imperious shrieks for attention now, this was deep sorrow, the sorrow of the lost and abandoned. I felt, too, the cold skinlessness, the utter helplessness, the sickness of betrayal. I wanted to cry but I must not. As in the heavy rooms of my later dreams, as on the ship when we were separated from our sick mother, I told him not to worry, I would take care of him. Look—I wasn't afraid, I wasn't crying. By the time—and I cannot possibly estimate its length because the overwhelming fear and the effort to control it filled all dimensions—my mother burst out of a doorway to run to us, I had become, in some corner of my being, an

old woman. It didn't matter that she hugged and kissed us and that my father carefully explained that it was merely a lesson to teach us to walk with him and not linger. I held them to be bad strangers and would not talk to either for days.

My brother sloughed off the incident, as he did many others; I remembered and judged, accumulating a sort of Domesday Book on my father's deeds. He sensed and feared it, and it was that fear on which I battened, the tears he could not make me shed freezing as an icy wall between us.

RUSSELL BAKER
(1925–)

Writer Russell Baker was born in Loudoun County, Virginia, the son of a stonemason and a schoolteacher. After graduating from Johns Hopkins University, he began his career as a journalist for the Baltimore Sun. *Now his "Observer" column for the* New York Times *runs in hundreds of other newspapers; it won the Pulitzer Prize for commentary in 1979. He won another Pulitzer Prize for his popular memoir* Growing Up *(1982).*

Growing Up *touches on his own life almost glancingly. His subsequent memoir,* The Good Times *(1989), covers his years of marriage and parenthood.*

In 1931, his mother, Lucy Elizabeth Baker, was a young widow. With her son and daughter, she moved to Newark, New Jersey, to live with relatives. The Depression was on; she could not find a permanent job.

■ ■ ■

from GROWING UP

My mother brought us to Newark in January 1931. The stock market had collapsed fifteen months earlier, but though business was bad, Washington people who understood these things did not seem alarmed. President Hoover refused to use the scare word "recession" when speaking about the slump. It was merely "a depression," he said. Nothing to panic about. Good times were just around the corner.

My mother intended to live with her brother Allen a few months until she could find work and rent a place of her own. Allen was twenty-eight, five years younger than she, and blessed with the optimism of youth. He was shocked when she arrived in Newark without Audrey and scolded her gently for breaking up her family.

"Three can starve as cheap as two," he told her.

Uncle Allen had no intention of starving. He had left school in tenth grade after "Papa" died and had worked since he was fourteen

years old, moving from job to job and always improving his income, and he was now confident he could cope with whatever lay ahead.

The daily news stories of deepening hard times did not unnerve him. For Uncle Allen the truly hard times seemed all behind him. He had been a day laborer in a Virginia sawmill crew, fished in New England waters aboard a commercial trawler, jerked sodas in a cigar store, and sold groceries over the counter in Washington. In his early twenties he had moved up to a suit-and-necktie job as a salesman in New York.

He was short—scarcely five feet six inches tall—and spoke in a quiet southern drawl. After the men of Morrisonville, who were cut to the long-shanked mountaineer pattern and sat down to supper in overalls, he seemed to me the complete city slicker with his dapper manners and his white shirts with sleeve garters and detachable collars starched stiff as iron. I studied him in fascination as he polished his shoes each night after supper and inspected his suits for wrinkles and stains. He owned two suits, which was a sign of great wealth in my eyes, and pressed them on an ironing board in the basement every Sunday, with a gallon jug of benzine and a white cloth at hand to remove spots encountered along the way.

Like my mother, Uncle Allen believed that with hard work, good character, and an honest nature a man could make something of himself in spite of bad times, and he worked at the salesman's trade with total dedication. He had sold wholesale groceries in Brooklyn and cheap tobacco in Yonkers and Staten Island. An oleomargarine distributor gave him a chance to improve himself with a $25-a-week route in north Jersey and he moved to Newark, but after giving haven to my mother, Doris, and me, he went looking for something that would pay him even more.

The daily firings produced by the withering economy offered loopholes of opportunity for a young man who kept his eyes open. One night just before we arrived from Virginia, Uncle Allen called at the Newark plant of the Kruger Beverage Company to ask if they needed a salesman.

"I don't need anybody right now, but there may be an opening in the morning," the sales-crew chief told him. This was Depression code talk. Uncle Allen had heard it before. Translated, it meant: "We're going to fire a couple of men later tonight and will need a

new salesman tomorrow who will do the work of both for less salary than we're paying either one." The man suggested he come back in the morning to speak to the manager, and added a piece of advice: "And be dressed like you're going to your own wedding." That evening Uncle Allen bought a pair of spats and put $5 down on a black overcoat with a velvet collar. Next morning he had a $30-a-week job selling carbonated beverages.

His optimism was more than matched by his wife's. She was a sassy, rambunctious New York girl he had met while living in Brooklyn. Aunt Pat was now twenty-four. They had been married four years and were as yet childless. Uncle Allen awed me with his cool elegance, but Aunt Pat I loved from the start. She and Uncle Allen were a study in the attraction of opposites. He was short, quiet, neat to the point of fussiness. She was big, noisy, and relished messy human combat. He was a country boy from Virginia with a southern drawl and a dry laconic wit, a Protestant whose family had been in Virginia since 1666 and produced several generations of colonial gentry. She was a New Yorker, half Irish and half Cuban, who had grown up in a Catholic orphanage and knew so little of country life that she proposed cutting the milk bill by buying a cow, keeping it in the backyard, and feeding it on scraps from the table. After her orphanage childhood she roomed in Brooklyn boarding-houses, working at a variety of jobs: waiting on tables in Wall Street lunchrooms, running an elevator at Gimbel's department store, working telephone switchboards.

What she and Uncle Allen had in common was the waif's child-hood, but, instead of hardening them against the world, it had left them sympathetic to life's other losers. And so, cheerfully, on $30 a week, they took us in.

During those first weeks in Newark I was enchanted by Aunt Pat's ebullient city style. Morrisonville women were reticent and weary. Not Aunt Pat. The house rang to her cry of "Jesus, Mary, and Joseph!" which she uttered whenever something startled her, whether it was splashing grease, a neighbor's loud radio, or the landlord at the door trying to collect the rent a day before it was due. She was a full-time combatant in the battle of life and flung herself into it with zest, and when she encountered an enemy or a challenger she gave him "a piece of her mind."

"They'd better not tangle with your Aunt Pat," my mother would say, "because she'll give them a piece of her mind."

Childless, she doted on children and rarely left the house without dragging Doris or me behind her to introduce us to the marvels of urban living. She hauled me with her to the corner delicatessen one day to buy three slices of bologna, and when the counterman gave her the wrong change she gave him a tongue lashing that had him whining apologies before she relented. Storming back to the house, flushed with satisfaction, she shouted back at me—I always seemed to be five feet behind and running to catch up with her— "You've got to give these cheap chiselers a good piece of your mind."

It was Aunt Pat who first stirred my love of newspapers. A hopeless news junkie, she was powerless to resist when a newsboy came up the street yelling, "Extra! Extra! Read all about it!" Rushing onto the sidewalk, surrendering two pennies for the paper, she stood there staring in wonder at the wet black headlines.

"Jesus, Mary, and Joseph!" she cried if the news was sensational enough, and when I asked what was wrong she patiently explained the news and why it was grave.

"Jesus, Mary, and Joseph!"

"What's it say, Aunt Pat?"

"Somebody sent Dutch Schultz a red rose."

Dutch Schultz was Newark's most notorious gangster. But a red rose?

"It means they're going to bump him off," she explained. "When a gangster is going to bump off another gangster he sends him a red rose to warn him." For days afterwards I waited for an "Extra" about the bumping off of Dutch Schultz, but it did not come in my time.

Days when there were no news sensations the newsboys lived by their wits. Rushing out with her two cents one day at the cry of "Extra! Extra! Read all about it!" Aunt Pat unfolded the paper and studied the front page in puzzlement. There was no wet black headline, only the routine daily humdrum.

She shouted at the newsboy speeding off up the street.

"Hey, what's the big news?"

"Barney Google just shot Sparkplug," the boy yelled back.

Barney Google was a comic strip character and Sparkplug was his racehorse, a stolid square-cut hay burner to whom Barney was

devoted. Aunt Pat eagerly opened the paper to the comic strips, then showed it to me. Sparkplug was as sound as ever, and Barney was chatting peaceably with him.

"Barney Google didn't shoot Sparkplug," I said.

"No, dear," she said. "Your Aunt Pat's been played for a sucker." She laughed and laughed at that, and when Uncle Allen came home she told him the story and Uncle Allen laughed too.

Except for Aunt Pat, my transition to city life was a series of agonies. The apartment to which she and Uncle Allen welcomed us was in a declining row house on Wakeman Avenue. There was a kitchen in the basement, where we ate, and on the first floor a parlor and two bedrooms. Everything was slathered over in a depressing dark green paint. A brass chandelier hung from the parlor ceiling, and a naked light bulb illuminated two overstuffed chairs, a lumpy brown sofa, and a glistening black table on which sat an Atwater Kent radio. We had the use of a narrow backyard, enclosed by board fences, in which soil as hard as rock produced nothing but a sickly crop of weeds.

On my first day in Newark when I went out front to play and stepped off the curb, a car came within inches of killing me. The driver cursed me violently, leaped from his car, and carried me howling to the door. The screech of brakes had brought Aunt Pat on the run, and when the driver made the mistake of screaming at her, too, Aunt Pat gave him a piece of her mind and sent him packing, but days passed before I dared step out front again.

The sidewalk swarmed with streetwise children. One, a girl of ten or so, lured me into her house one afternoon by promising me a piece of cake. She towered over me and seemed authoritative and maternal, so I did not object when she said before I could have any cake she would have to take off my pants. Being only five years old, I still wore short pants, and since authoritative maternal women had been removing my pants all my life, I let her have her way. I was uneasy though when, having dropped the pants to my ankles, she stepped back and asked if I wanted her to remove hers, too.

I had the timid five-year-old's desire to be agreeable and must have said yes, for she was out of her underwear in a twinkling and standing before me with her petticoat raised to her shoulders. The passion that wakened in me was anger, for I knew then that she had

duped me. I knew then that her promise of cake was false, that there was no cake. She had promised it only to trick me into playing this silly girl's game. Angrily I buckled my trousers and hurried home to report the fraud to Aunt Pat. Aunt Pat smiled as I started to relate how I had been cheated, but the smile faded as I elaborated details.

"Jesus, Mary, and Joseph!" she roared.

After that I was forbidden the sidewalk without supervision and sentenced to confinement in the backyard with Doris. I hated that backyard. I hated the ugly board fence, I hated the sickly weeds, I hated the stone and brick walls and dirty windows that glowered down at me when I searched for the sky, and I hated the laundry that dangled from the overhead clotheslines as far as I could see.

I especially hated the cod liver oil, a nauseating goo tasting of raw liquefied fish, which was spooned twice a day down my gullet and Doris's. It was good for us, it would ward off dreadful diseases, or so Aunt Pat had persuaded my mother. There were plenty of diseases. Scarlet fever, mumps, chicken pox, and whooping cough floated in the air. Polio was around too, killing and crippling. Every neighborhood had a child with a twisted stick of a leg encased in metal braces. Cod liver oil was the defense.

"It's good for you," Aunt Pat declared sweetly twice each day, advancing into the backyard with her potion of bottled fish oil in one hand and tablespoon in the other.

"I hate it. It makes me throw up."

"Be a good boy now. You don't want to get infantile paralysis, do you? It's good for you."

It had the viscosity of axle grease. It did no good to gulp it down quickly, because it coated the lining of mouth and esophagus like a thick layer of glue. It did no good to vomit it up either. Aunt Pat did not become angry when this happened. She did not give me a piece of her mind, but simply poured another tablespoon full and smiled sweetly. "Come on now, it's good for you."

The cod liver oil failed, and there was more misery. Both Doris and I came down with whooping cough. The Newark health authorities nailed a quarantine notice on the front door to warn the neighborhood against us. The whooping cough passed, but humiliation lingered on. The authorities forbade us to go outside without wearing broad yellow arm bands marking us as disease carriers.

I hated the yellow arm band that made me a figure of shame. Very soon I hated the entire Newark health department. This bureaucracy, for reasons still obscure, had decided that my posture was a disgrace and had to be corrected. Accompanied by my mother, I was hauled before bureaucrats and stripped naked, pummeled, poked, and photographed by white-clad posture experts. There were worried scowls from doctors, nurses, and photographers studying the photographs.

"Something has to be done about this posture," the doctor said.

If not corrected immediately, well . . . Various consequences were mentioned. The most dreadful was "curvature of the spine." A corrective gymnastic program was proposed: somersaults, headstands, backflips, vigorous exercise on the chinning bar, flying rings, parallel bars. These would straighten me up.

I resisted, for I already knew I could not do a somersault, much less a headstand or cartwheel, and I sensed that I would never be anything but a ludicrous spectacle at gymnastics.

"Young man, do you want to grow up and get curvature of the spine?" The doctor opened a drawer and produced a book. There was a photograph of an adult case of advanced curvature of the spine. Was that what I wanted to look like when I grew up?

It was not for me to answer. My mother had seen enough. I began reporting to a gymnasium to be saved from curvature of the spine. I hated that gymnasium. My God-given physical gracelessness immediately made me an object of derision among the other boys, most of whom had the agility of chimpanzees and found it hilarious that my efforts should always end in a clatter of crashing bones.

After months of this torment, parents were invited to a gymnastic exhibition. My mother brought Aunt Pat. When it was over and we were walking home Aunt Pat congratulated me on a wonderful performance. Not my mother. Lying was not in her.

"I think it'd be better if you learned to play baseball, Buddy," she said. A few days later she went to Woolworth's and bought a bat, a ball, and two gloves for Doris and me to use in the backyard. She never took me to the gymnasium again.

While I was experiencing the routine miseries of childhood, my mother was discovering the Depression. She quickly learned that

her hope of finding a job and renting a place of her own was foolish. There were no jobs to be found.

She hoped to resume teaching. The school administrators told her Virginia credentials were no good in New Jersey and no jobs were likely to be available even if she qualified. The story was the same everywhere. No jobs. No jobs for saleswomen in the department stores. Department stores were firing, not hiring. No jobs in the factories. Factories that weren't laying off workers en masse were shutting down entirely. All that year she walked the streets, combed the classified ads, sat in offices waiting to talk to possible employers, and always heard the same refrain: No jobs.

In December she found temporary holiday work in a Newark five-and-dime store. Twelve hours a day, $18 a week. It was good pay; any pay was good pay by then. It enabled her to contribute to the budget for Wakeman Avenue, and that was good for her self-respect, but there was no longer any deceiving herself about becoming independent.

Of course there was always the chance she could marry again. As 1931 went from bad to worse the possibility of another marriage began to seem her best hope of salvation. Tucking me into bed one night, she lingered an unusually long time, then asked out of the blue, "Do you think Oluf would make a nice father?"

It was a troubling question, and she must have noticed my uneasiness because she immediately said, "Oluf is a good man."

This was her official seal of approval, for there were few "good men" in her catalogue. "Papa" of course had been a "good man," and Uncle Allen was a "good man," but there weren't many others.

I was vaguely aware of Oluf. He came to the house now and then, arms filled with bags of pastries which he jovially pressed on Doris and me. I knew he and my mother occasionally went out together for walks. Beyond that I paid him little attention. To me he was little more than a jolly stranger with a funny way of talking. He was certainly not my idea of a father.

Uncle Allen had met him while selling oleomargarine. Oluf was a skilled baker who had graduated to traveling salesman. With his sample cases full of margarine he traveled through the northeastern states demonstrating and selling his goods in large plants and small neighborhood shops. Uncle Allen brought him home one evening and introduced him to my mother.

He was a Dane, a big, yellow-haired, outgoing man in his late forties, and a widower. He had emigrated to the United States after his wife's death. There was a son who was married and living in western Pennsylvania. Oluf had the venturesome business spirit my mother admired. He had borrowed from the banks to buy three or four houses in Pennsylvania and considered himself a developing American success story. He was a man of high good humor, well-pressed double-breasted suits, manicured nails, and glossily polished shoes. He had risen above the labor of bake ovens, traveled from city to city, talked business deals with bankers. My mother, looking at him, saw a man with a future.

And though I did not know it at the time, she loved him.

I did not. Though I liked Oluf's jovial spirits and ate his pastry with gusto, the possibility of having a new father scared me. My great terror then was of losing my mother. I had constant nightmares, ghastly nightmares in which she was dead and Doris and I were left alone. Her marrying, I thought, would be another way to lose her, though I never told her so.

Oluf's work kept him on the road much of the time. During his absences he wrote two or three times a week to my mother. The graceful flourish of his handwriting contrasted oddly with the fractured grammar and exotic spelling of his prose. Still, his discomfort with the mysteries of English did not diminish his power to make himself felt when he took up the pen. Through the comical spelling, eerie grammar, and devil-may-care punctuation a distinctive voice emerged, full of sweetness, despair, earnestness, love, and loneliness, all expressed in a graceful Scandinavian lilt.

The first note of fear was sounded in a letter he wrote her from Boston May 9, 1932. He had visited his home office that day. Back at his hotel that night he wrote her about it.

"Dear Elizabeth," he began. "Today I have been together with our Manager all day, and he told me that it look like I will have to go June first. Business is so bad and getting worse for us, he let four salesmen go here May first so now there is only seven left. Last year there was seventheen. Well it don't help to worrie, like you said, I have to start a bakery somewhere, do you want to help me if I get one?"

The following week he called on customers in Providence and Newport, then came back to Boston and began his letter with bad news.

May 21, 1932:

"Dear Elizabeth: Just was at our office, they showed me letters they had written to Swift trying to keep me, but Swift said no, so I am out."

He was answering a letter from her in which she said Aunt Pat was going to find her a job.

"How in the world could Pat get a job for you? You know jobs today don't hang on trees."

And then, the abrupt switch to a more pleasant subject that typified his instinct to look on the bright side:

"New Port is the nicest place I ever seing."

And in the next sentence, the relapse into fear:

"Do you know Elizabeth down in Baltimore is a baker who wanted me affoul bad last time I was there maby I will take the job for a while, how would you like that, would you come and see me, or I come and see you. Business is affoul bad, now they are going to stop this office and only keep three Salesmen, last Summer they hat 32 men here, how people are getting over next vinter, I can't unther-stand. Again thanks for your letter you are a sweet Girl, I will Kiss you when I see you, how is that, love to you and the Children from Oluf."

By the summer of 1932 President Hoover's mere "depression" had become "the Depression" with a capital D. Campaigning for reelection, the President declared, "Prosperity is just around the corner." Oluf, however, was adjusting his goals downward.

May 26, 1932:

"Dear Elizabeth, I will try to see that Baker in Baltimore on Monday June 6, today I was offered a job here with a Baker he would pay me 45 dollars per week, I told him I would think it over but oh how working in a Bakeshop in the Summer months is hard work."

Then, a burst of romantic teasing:

"That Widow in Pittsburgh has heard about I loosing my job, now she offers me all there is in this world if I will come and run her shop, but I don't think it will be so great, do you, no I know, you say no, oh how worm it is here this days, and today we hat a Storm a bad one to, a Cann of Blue Berries exploted today in a shop and I got it all over my Close, how is that—not so good,

"Love to you and the Children from Oluf."

My mother was writing back to him letter for letter. She kept his stored away for years, not because she realized they constituted a personal history of the Depression, but because she valued them among her most precious treasures. What she said in her letters to him is all lost except for echoes and resonances in his replies. It was not a conventional lovers' correspondence, despite Oluf's frequent attempts to strike the chord of passion. He in growing fear, she in her mid-thirties, impoverished, widowed with small children, both were using the mails to shelter them against loneliness.

Earlier that year Aunt Pat had her first child, a daughter she named Kathleen. By mid-June Oluf had retreated to his properties in western Pennsylvania and wrote a "Dear Friends" letter to the whole family:

"Pat you are an affoul bad Girl, not to write me any before, you know I am out of work, and have been for some time, nearly all Echerson Co is out, and soon Swift and all their large Packing Co will be out, I never know how hard times is till when I got back to this town trying to borrow mony, I am glad Allen is working, be sjure to hang on to it, Pat I told you a Child is word a Berl of Gold. . . ."

He had a job though: "demonstrating and selling Pomosin, a New Product from Germany." He had also traded his car for an old Buick—"a Buirich Carre"—and was about to set out in it on a selling trip with his son Niels.

"Not working, do you know I am lost, and now all the Insurance People down here comes to see me, they all thinks I am full of mony or something, I say full of Balony, but now I will try this job first, I may land on the poor House but then I wont be the first, nor the last."

Two weeks later:

"Dear Elizabeth, Monday morning Niels, my Son and I started out selling Flavors and Speices, we made during the week 37 dollars, but we spent 34 dollars you know what I mean, Hotels and Meals, so I wouldent say it was so good. . . . The worst truble is this Bakers think I am going cracy, coming down selling Speices, this morning in Pittsburgh a Baker we called on there, said when he seing me, say what is this World comming to, now Oluf comes and wont to sell Speices, I felt so bad about it, so I said to Niels come on lett us go Home. . . ."

July 9, 1932:

"Dear Elizabeth, I got Home last Night late, and I sendt in my Resignation. That job was no good, by selling that Stuf I would have spoiled my Name amongst the Bakers. . . ."

They had not seen each other for three months.

"Yes I would have liked to see you now but I will later on, and then you and I will make up for all lost time, then I will be kissing you till you tell me, oh Oluf you are good will you do that? you better say yes, because I am almost sjure of it . . . tell me in your letters all the news, I like to hear it from you, oh all the Taxces and Bills I got to paid and have no Mony, but then I don't worrie, love to you and the Children from Oluf."

He was having trouble now meeting the mortgage payments on the houses he had bought, and he hoped to solve the problem by selling one. It was August, nearly five months since they had last seen each other. The long stretch of joblessness had started him reflecting philosophically about friendship.

August 11, 1932:

"Dear Elizabeth, Thanks very much for your letter I received today, yes I wich I was down near you, and we would go out for a ride, I am sjure it would make you cool, here it is wery neice Weather, and cool at Night, oh how I sleep when I am here at my Home, you know it is so quiet, compared with when I use to be in the Citys all noise, and so worm, I don't hear from anybody but you, how funy People are, only when they thinks they can get something out of a Person then they are, or I mean they let on to they are Freinds, but they soon change, you remember some days I received up to twenty letters, and now, not any, only you stick to me, you are a good Girl. . . .

"I begin to think I was going to sell a House this morning, but the Party diddent have any mony, now I have three Houses empty, nothing coming in, and Taxes to be paid, well it will come out OK, I hope so, I always tell People not to worrie, so I won't eather, now good Night with love to you and the Children from Oluf."

Well it will all come out OK, I hope so.

With the country reaching the modern equivalent of the Dark Ages, "Well it will all come out OK, I hope so" was a declaration of boundless optimism. It was a season of bread lines, soup kitchens,

hobo jungles, bandits riding the highways. Suicide was epidemic among men who felt their manhood lost because they could no longer support their families. Unemployment stood at 25 percent of the work force. There were 85,000 businesses bankrupt, 5,000 bank failures, 275,000 families evicted from their homes.

President Hoover's campaign slogan—"Prosperity is just around the corner"—had become a sardonic national joke. Even among people like Oluf who wanted to believe it, enthusiasm was muted down to, "Well it will all come out OK, I hope so."

October 6, 1932. It was now seven months since they had seen each other:

"Dear Elizabeth, Thanks very much for your letter I received yesterday, I see you were feeling a little blue that evening, yes I wich I could have been with you, I am sjure you would have feelt alright. Yes I will be down there for your Birthday unless something happening, there was a man here today he wonted to hire me, to call on Bakers in Pittsburgh, but it was all on Commission and no salary, so I said no. . . .

"I got a wery neice letter from the People today where Niels rents his House from, they asked me to paid Nielses rent from August so on til next Spring, but I am not even going to answer that letter, they said in the letter that you Mr. Oluf is the cause of Niels being in this World, and it was up to me to take care of him and his Familie, say I wonder who is to blame for I being here in this World, who ever it is, never helpt me, and who is to blame for you Elizabeth being here,—say that is what I call Balony, but that it what the Vorld is fuld of."

During their long separation their letters were creating an intimacy between them far deeper than they had known when they walked out together in Newark. There their relationship had been entirely correct and according to the canons of courtship. The most passionate moment, to which Oluf alluded now and then, occurred during a walk that took them near the neighborhood hospital, when they seem to have kissed.

"We are having such a neice Day," he wrote in the autumn of 1932, "just like Spring, I went out for a warlk this morning, do you remember when you and I went for a warlk, I mean to the Hospital. . . ."

Distance and loneliness encouraged hopes of a more passionate relationship when they met again, yet Oluf's most romantic compositions were constantly being interrupted by cries of terror.

In October:

"If I don't come to your Birthday this year, please don't worrie, because when I do come I will kiss and love you that much more, yes I will keep on till you put your Arms rown me and tell me I am good, can I love you to much? You better say no, tell Pat I will answer her letter when I get to feel a little better, what makes me sick is all this jobs I am to have, but never gets any, I was up to see my Dochtor to day, he tells me I am OK, in very good Health I know I am, if I only could get a job."

The election of Franklin Roosevelt in November did not raise his spirits.

November 11, 1932:

"Precident elesktion came out I think OK, it don't matter if it is Republican or Democrate in times like this. . . . Butter Prices are down where they were a year ago, and till they go back up rown 30 cents pr lbs, they never will hire me to demonstrate Margarine, now I am down and out again, and I don't like to keep on borrowing Moony from the Banks, because I got to paid it back sometimes sooner or later."

Desperate to pay his bankers, he went back to the bake ovens that month.

November 19, 1932:

"Dear Elizabeth. . . . I wont to come to you wery, wery bad, and I will, and when I do come you will be so glad with me, I know you will, but I borrowed doring the Summer over 1,000 Dollars from the Banks and was down and out again, then Metz came along, and told me about this job, and I went and got it, but oh how I dont like it, it is absolutely no good, to much work, I mean to long hours, we got to go to work tomorrow Sunday all day, and again Monday morning, and every morning at one A.M. til next day rown two or three Afternoon, but I must stand it for a while. . . ."

Two days later:

". . . this hours, it is day and night, work all the time, Yesterday we work all day till ten last evening then we started again at two this morning, now it is three Afternoon I just got home, now Elizabeth

don't worrie, get along the best you can, and always think and say, someday Oluf will come, and I will. . . ."

These lines were the closest to a promise of marriage he had written. She wrote back immediately urging him to look for an easier job more fitting for a man of his age and achievements.

November 25, 1932:

"No, Elizabeth I tried all over to get a job, I vill bet you I spendt over five Dollars on Stemps, sending letters to every one of this Bakers, who offered me jobs with big mony when I was traveling, but only one of them answered, no there was two, one in Newark and one in Boston, but they said they diddent have anything just now, the rest of them wouldent even spend a two cent Stamps on me, and they all were my Friends, well such is Life, no you musent think I would stay here in this dumpe one day ef I could get an other Job . . . now it is three a clock Afternoon, and we got to go to work at elleven this evening, isint it some Life, vell I hope soon vill change to something better . . . I will get to you some day, don't worrie, love to you all from Oluf."

Five days later he had good news.

"Yesterday I received a Box of Cigares from a wery good Baker in Philladelphia, so maby my Freinds begin to come rown again, I wrote him to day and Thankt him, and said ef he needed a man lett me know and I would come down there."

Ten days later:

"I got a letter from that Baker in Philadelphia to day, but it was the same story, he like very much to have me, but not now, vell there vill be something comming soon, I think so. . . .

"Say isent it funny doing a Persons Life all there comes up, one thing after an other, and then it is nothing, as long as we have our Health. . . ."

In the middle of December she wrote that she had sent him a Christmas present.

"You shouldn't send me any Precent, not in times like this," he replied. "I am sending a litle so you can by something for the Children for Christmas and I hope you vill all have a neice Christmas, and I wich I could be there with you, but I will someday, good Night with love to you all from Oluf."

Her gift arrived December 20.

"Dear Elizabeth, Thanks wery much for your letter and the Packets I received today. I wont open up for it til Christmas I never du with any Precent, My Wife used to open up for everything before the day and I always scoled her, say you are a sweet Girl now Elizabeth, the way you write me, and I like it, you vill see when I come down to you, we know each other, and we vont be afraid, now I never was of you, but you was a little of me, and you should be them days becouse you diddent know me, but now you do, and I can almost feel how sweet it vill be when I put my arms rown you. . . ."

He also had good news.

"To day a man came in our shop from Gumbert Co in New York, he said to me, vhat in the World are you doing here Oluf, I told hem, then he said, write to our Company and I think they vill heire you, so that is vhat I vill do, and I hope I vill get a job, but it vont be til in January, vell again I wishes you a Mery Christmas and Thanks for all your kindnes to me. . . ."

January 4, 1933:

"I got a letter from this People in New York to day, but the same Story, they vould like very much to have me, but the Depression is on, oh how I do wich it soon vill be better so I can get a job, but rown here it is getting worce insted of better. . . ."

Four days later his spirits were high and he was counting his blessings.

"This job here has been a great experience for me, you know vhat I mean, I use to be a Baker but it is eight years ago since I was working at it and a Fellow forgot all about working in that time, but now I am fearly good ad it again, I am loosing in waith now, I can feel it when I get dressed up on Sundays, but that is OK, because I was to fatt, don't you think? Elizabeth isent it funny all a Person goes tru during a Life time you have going tru lots, but I think I a litle more, because I am older, but again as long as we have our Health everything is OK, and we shouldent complain. . . ."

In mid-January another job prospect failed.

"That Baker never answered, and I spoce never will, it is funny how it goes."

The end of January:

"I did write Jelke Co, and hat an answeer, I did write Echerson Co, but it is the same Story, they sjure would like to have me, but the

Depression is on, it is affoul, I wont to come down to you, and you wont me to come and here I am more than 400 Miles away, and it is all from that Depression."

February 1, 1933:

"Business is getting worce insteadt of better. . . ."

February 9:

"That Baker in Baltimore never answered yet, it is funy, he is the one who offered me 125 Dollars per week ef I only whute come to hem, and it is not much over a Year ago, now he wont even spend a three cent Stamp on me, I mean telling me he cant use me, or something, the same day I wrote to hem, I wrote to one in Boston, he offered me 50 Dollars per week a Year ago, but I dont think he will spend a Stamp on me, well such is Life, I think I wrote over fifty Letters to differens Bakers about a job, but only two answered me telling how sorry they where they couldent use me. . . ."

The following week the gloom lifted at last. After so much despair, everything was turning out OK, after all. Life really was "funy" with its "cracy ups and downs." He was exuberant.

February 15, 1933:

"Dear Elizabeth, Can you imagien I received a letter to Day from Mr. Echerson in Jersey City telling me that Rice's Bakery at Baltimore wont to gett me at least for two weeks, and for ever if I am not to expensive, so I wrote them right now, I don't know who they are, but who ever they are, they must be OK, I mean becouse they wont me, so maby our dreams at last will come true, say it is funy, here I give up all this Bakers, and they send for me . . . now I hope it soon will be over with and then I will come to you, are you glad? Love to you all from Oluf."

Was she glad? She was delighted. She immediately wrote urging him not to sell himself too cheaply to Rice's Bakery. His reply to her was an epitaph for their entire generation.

"Dear Elizabeth, Thanks very much for your letter I received Yesterday, and Thanks very much for your Advice, but Elizabeth the War is over with, the good times is over with, them days we did seat a Price on ourself, but to day we just take what we can get and must be satisfact,—am I not right? So I diddent put any Price on, only told them what I am getting here, but what ever the wages are for a man like me down there I vould take. . . ."

Franklin Roosevelt was inaugurated March 4, 1933, but his sonorous cadences designed to revive the national spirit failed to stir Oluf. The great Baltimore opportunity seemed to be vanishing.

"Dear Elizabeth, Do you know Elizabeth I am feeling wery blue, I never heard from Rices Baking Co yet, and I begin to think it will go the same way as the others, now I have been seathing here all Day listening to Roosevelt being installed as our new Precident, well I do hope some of all this neice tings they told us over the Radio will come true, Elizabeth I am very Radicall, my idea would be to day ef I was to be the Precident, to jump on a Freight Train going to Washington, and say here I am ready to go to work, what they done there today will cost over 10 Million Dollars and we all know it would have helped many poor People out spending that mony giving us work, but perhaps I am funny the way I look at such tings. . . ."

Four days later:

"Yes, I got a letter from Rices Baking Co, saying *no*."

He had been trying to rent his houses, but without success. It was becoming harder to meet the payments on their mortgages. He was also having trouble paying the taxes. His letters were increasingly melancholy.

March 26, 1933:

"No, I dont do any thing, just seat rown or warlk up Town, and listening to People telling me how Lucky I am has lots of Mony, I always say, yes it is great, tomorrow I got to put in a new Hot Water Tank in a House, well there is always something. . . ."

On April 14 he confided that he was $1,000 in debt.

"I talk to the Caschier in our Bank to day, asking him to lett me have 1500 Dollars, he said, not now, but come in here middle of next month, I think then you can have it, ef I do I will come to you, ef I could have got it to day, I would have been down with you tomorrow night. . . ."

April 19, 1933:

"Dear Elizabeth, Thanks very much for your wery sweet letter I received to day, Thanks for telling me all the neice things, I do know now we can be free to each other, not afraid, when we see each other again, not like it was when I was down there, I know I was always looking at you when I was at your House, but you never seemed to

be interested in me, I know you beginn to be the day we went to the Hospital, am I right? . . . "

His next letter, written on April 24, was a hammer blow.

"Dear Elizabeth, Thanks for your letter I received to day, I am sorry, but Please dont write me any more.

"Yours truly

"Oluf"

She wrote back immediately. Had she said something that offended him?

April 30, 1933:

"Dear Elizabeth, Thanks for your letter I received the other day, no you have not done anything to me, but the Deprescion has, the City took everything I hat for Taxes, so I am down and out, that is why I don't want you to write me any more, I came to like you tru your letters, and I thought maybe some day we would come to know each other Personly, but not now, I wont be able to borrow any mony, any more, I am trying to gett anof so I can go to Danmark, and Perhaps stay there, so Please forget all about me, I am lost and going, ef I ever got back again, and you are not married, then ef I can help you I will, but please try to feind a man good anof for you, and forget all about you ever seing Oluf."

She wrote again and had no reply. Then again, and no reply. She sent a registered letter and the Post Office sent her his signed receipt for it, dated May 18.

On May 19 he wrote "Dear Elizabeth" for the last time:

"Thanks for your letters, yes I received them all, but as I told you vhat is the use to keep on writting, I was in hope someday to come to know you, by getting a job down there, but now I never can come down, I am like I told you before, lost. I tried to raice anof mony so I could go over Home, but so far I diddent, this Town is going down and out, so I am asking you to stop writting to me, becouse I am not interested in anything any more, love to you all from Oluf."

The war was over with, the good times were over with.

"Well it will all come out OK, I hope so" had become "I am lost and going and not interested in anything any more."

Oluf disappeared into the Depression. My mother's hopes for finding love and security vanished with him.

MAUREEN HOWARD
(1930–)

*Novelist Maureen Howard is also a playwright, scriptwriter, essayist,
and critic. The most recent and most ambitious of her six novels is*
Natural History *(1992); it takes place in Bridgeport, Connecticut,
where she grew up. She went to Smith College.*

Her vivid memoir, Facts of Life *(1980), won the National Book
Critics Circle Award in general nonfiction, and was nominated for an
American Book Award. How does a memoirist choose among the facts?
Howard said, "Make them into something worth giving. As I'd shape
fiction or cut you my prized delphiniums and lilies."*

*As a girl in Irish-Catholic Bridgeport, Howard took elocution
lessons that were originally intended for her brother, George. This is
from* Facts of Life.

■ ■ ■

from FACTS OF LIFE

George began to stutter: "B-b-bread, p-please," and "P-pass, the
b-b-butter." My brother was such a bright articulate boy any
dodo would have known that the sudden blubbering plosives were a
cry for attention. He must have been nine or ten years old. Though I
was eighteen months younger I knew the game he played. He would
keep it up—the b-bread, the b-butter and the p-p-potatoes—until
my mother's anxious solicitations drove my father to curse George
out: "Christ Almighty, can't you talk? What the hell is this?" He
would ask the question but my father never cared for an answer
other than his own: George was ruining dinner, making a fool of
himself. How many times had we heard that one of the supreme
skills in life was being able to speak out clearly, even eloquently, to
address the world grandly, as my father addressed the Kiwanis and
Rotary clubs, as the lawyers (those much-admired rich and clever
men) argued their cases down at the courthouse? And here was his
son blithering out of the b-blue. Today any half-wit child psycholo-
gist could tell us that a little boy with all A's and "Annoys others. A

great distraction!" written in the nun's precise hand on the back of his report card was b-bored out of his mind.

It was a crisis and though I hated every meal I was in awe of George's persistence. At the table he could keep the stutter going like a twitch, then wash it right out of his mouth when he played with Mark Gilday and Dick Ferucci.

"Speak slowly," my mother said, always in there trying. "Think of each word, George." But soon Jesus would be invoked again and the plates would dance at our places as my father struck a blow at weakness and irregularity. Since they didn't want to know all about us (Freud had not filtered down to our self-reliant American family), the burden was on my mother, as usual, to make things right. She found a Mrs. Holton: George was to go for speech lessons, though my mother let us know at once that this lady's abilities were not geared to anything so mundane as curing a boy's bumbling conversation.

In one morning she had discovered the finest woman in Bridgeport, too fine for us she implied somewhat crossly. Oh, her children were already ruined, she knew, by the coarseness of our neighborhood. A rough, dirty blanket covered the whole North End. There was no one with any more idea in his head than running up to the Rialto for a double feature. How she hoped that if Mrs. Holton could take George in hand ... He lasted two lessons, the only boy, made a sissy, waiting for one little girl to come out of her parlor and another one there to giggle at him when he was through. It was easier to abandon the stutter, so I was slipped into his place as an afterthought. Like his melton coat and school shoes passed down to me, I came by my brother's elocution lessons secondhand. My mother must have been pleased that at least one child of hers would be exposed to the art and manner of Mrs. Holton.

Today I can't read a poem out loud that my family doesn't ridicule me. They groan and titter. They intone a line after me with false resonance. No one ever, ever reads like that, they say, deep from the chest like a Barrymore. They claim it's not *me*. La-dee-dah they make my reading sound and I'll be damned if it is—for it's perfectly natural. It *is* me—the tone held up at the end of a line, the elisions and glides, the glottal softening, the hitch of caesura in my voice. Funny, of course, if you've heard nothing but the flat crackle of tele-

vision voices, thin as cheap beer, clinging to the microphone for dear life. Hurt and proud, I draw into my memories. A posture I hate at all other times seems justified: how can my daughter know, poor impoverished child with her crush on the golden movie idol of the moment—he of the starched mouth and droning masculinity? How can my common-sensical husband understand, a midwestern kid, the twang of his Saint Louis relatives in his ears? How can either of them hear the fine points of my elocution voice, trained weekly by Mrs. Holton?

It must have been the heyday of the Emerson School of Speech and Dramatic Art when Louise Holton was a student in the nineties. The photographs on her dining room sideboard were discreet: a stately brunet in the full-length portrait carried her head high with billowing pompadour, pearl choker on a long arched throat, pretty arms, a rose in hand. White muslin draped gracefully to the floor from the lacy exaggerated bosom of the day. Simplicity itself. The toe of one satin slipper indicated a positive stance. Nothing so transient as a smile on her face, the young lady gazed steadily ahead with an ethereal softness, capturing in her look some old idea of beauty. There was spirituality and competence at once in the gentle angle of the head. The world that this studio photo of young Mrs. Holton suggested was so far removed from mine that I never believed in it. It was dream stuff, like the drawings of beautiful ladies I found on the old sheet music in the seat of my grandmother's piano bench— "The Last Rose of Summer," "Come Down, Come Down My Evenin' Star." Another photograph featured a group of girls all costumed for a theatrical romp—Shakespeare I presumed even then—and my Mrs. Holton with arms akimbo, bold as you please in tights, had placed one foot jauntily up on a tree stump. They looked a deadly bunch, faking the hearty fun of it all, their performance captured in mud tones forever. Behind the bric-a-brac of silver plate there was one more half-hidden photo, not quite admitted to the everyday world, of a girl about my age with golden pipe curls and a wreath of roses on her head for some artistic event. This was the Holtons' dead daughter, Ruth, I'm sure of that, but God knows in the gentility of that dining room how I ever learned it outright. I was fascinated by the glint of her perfect teeth, the crisp ringlets of hair at

her temples . . . a child my age, dead. This sweet and satisfactory girl was infinitely more deserving of life than me—that's how I thought of her—and I stared at her photo hard and long the few times Mrs. Holton left the room.

That lifeless house where I presented myself each week after school—the whole somber feel and smell of it is with me still, the details more readily available than the arrangements of houses I have recently lived in . . . the hall with the hideous umbrella vase, art pottery of 1910, the brown scrub-brush mat to wipe my feet on, the toppledy coatrack that held its arms out invitingly and then slipped my coats and sweaters to the floor. A high table at the dining room window held waxy houseplants that seemed never to grow or bloom over the years. The scent of brown laundry soap rose from the freshly ironed cloth on the dining room table where we began my lesson. Everything in place and clean, no excess of matchbooks or rubble of dusty pennies from coat pockets, no tattered magazines, not even last night's *Post* folded out of the way. Nothing had happened here or ever would. Mrs. Holton's pupils came and went in a hush. *Mr.* Holton, on the early factory shift, came home from work, stole in the door and creaked up the back stairway. I encountered him once in the upper hall when I needed to go to the toilet so urgently that I finally asked permission to tiptoe up to the immaculate bathroom. There he stood, a lean Yankee the color of tallow soap. He wore his factory identification tag on the pocket of his blue workshirt and black lace-up boots. He did not speak.

Herbert Holton was a foreman at Jenkins Valve, an engineer in better days who had come down from Massachusetts to get work. Of course Louise Holton was not from *Bridgeport,* that, my mother pointed out, was easy to tell. Though she was loyal to our "Park City" my mother had some fix on Boston that we got a dose of now and then—the finesse, the delicacy of Bostonians made us all look like boors. Even the Boston Irish (she was so ignorant of the world) were better than the breed at home. So off I went to Mrs. Holton, who *was* Boston and culture, that I might acquire the clear rich speech and poise of a lady. Herbert came home. The stairs creaked. My teacher's voice rang through her modest house with the assurance of a grande dame, "Good afternoon, Herbert!" The brightness

of her greeting was always met with silence, and brighter still she turned back to our lesson.

A, E, I, O, U. We slid the vowels up, then down. We trilled them and shot them like spitballs at the walls, in unison, then on my own. I advanced to the more difficult roller-coaster effects, A, E, I, O, U—taking each vowel in death-defying swoops. Next, we addressed ourselves to those troublesome consonants, the D's and T's, spraying them lightly across the table, moving on to the plosives, those B's and P's George had picked to taunt us. All warmed up we let the vocal cords rest, closed our exercise books and went through the open arch to the living room. There we faced each other across the carpet—Mrs. Holton, a corseted full figure in her dark afternoon dress, her fluffy white hair pinned up in a modified pompadour, powdery white arms and neck, high color in her cheeks that even a child would not mistake for rouge. I was short for my age with plump legs encased in the brown lisle stockings prescribed for all pure Catholic girls. My usual school dress was a muted plaid to minimize my round tummy and each morning my mother finished me off with glossy fat braids. We swung our arms up and around. We bent from the middle (neither teacher nor student had a discernible waist) and lolled our heads round and round to loosen up before we began The Attitudes.

When I was first out of college, learning to hold my liquor and trying to enchant the world, I used to *do* The Attitudes at parties. Most anyone could sing old songs, but my skill in pantomime was acknowledged as special and antic, though my pick-up audiences, like my family, never believed in me. I like to think I am the only living person who can perform this lost art form. All the gestures of life boiled down, jelled to a routine and practiced first to the right side of Mrs. Holton's living room, then to the left: Calling (hand cupped to the mouth), Looking (hand over the eyes), Hearing, Greeting, Farewell, then into the deeper emotional material: Rejection, Fear, Love (both open and guarded variety), Laughter (head tossed, eyes dancing) and my favorite, Sorrow. Sorrow was posed with the head sagged, eyes covered with one drooping arm while the other was thrust back in limp Despair.

Week after week I mirrored the example of Louise Holton's perfect Attitudes. I could imagine her Calling Herbert to come down-

stairs after her pupils had departed, giving him a Farewell at the front door each morning as he went off to work with his black lunch pail, and naturally the most touching of all scenes, I envisioned her balanced in Sorrow over the photo of her dead daughter just my age. For what else could be intended but an elegant mime of life: I was to get my emotions fixed, to harness my awkward moments into ideal gestures and thus would my feelings be elevated to the ideal realm.

At home, to irritate us all, my father sat down to dinner in his undershirt, actually the top of his BVD's. My mother might say, "Put a shirt on, Bill," but could not pursue the matter. He was perverse and crude, a man who must have his way. I was humiliated by the scene between them: his childishness—demanding ketchup and ice water, finding fault with the butter fresh from the dairy that day, thrusting his freckled hairy chest out defiantly. Her painful submission to him brought a short uneasy peace. Then he was angrier than ever and provoked a fight with me or George for not helping our mother. Couldn't we see how dragged out she was, all afternoon cooking the pot roast, baking apple pie? How many families did we think were waited on hand and foot by a blessed martyr? How many of our friends, poor kids that they were in two-family houses down the street, were eating her homemade chocolate cake? You bet your life they're eating crap off Louie's shelf your mother wouldn't feed to the dog. And weren't we chauffeured to our lessons—clarinet, elocution and dance? For what? For us to sit at the table and be distressed—oh, it was too bad—by his undershirt? Once lathered up he could go on with great disdain about "educated" people.

George and I were miserable, choking down the chocolate cake or custard, whatever gift had been given us that day by our sainted mother—there was no easy Attitude to take. I had only the beginning of a notion when I was in grammar school of my father's delight in his own rhetoric. The next night he'd strike quite another pose—fully clothed, indeed, sporting a well-tailored suit from Fenn-Feinstein in New Haven—we'd all be taken through some intricate legal proposition that had come up at lunch in the Stratfield Hotel, or, the Latin and Greek roots of our common English words would be expounded and he would have a "sliver, darling—ah, that's not a sliver now" of our dessert. Charming and

urbane, he was the most interesting father in the world and we were his radiant family. We sat late at the table and played with our crumbs. My mother's demure laugh pleased me, though of course it was not Laughter or Joy in the nobler sense as I well knew. Our passions at home were too muddled to ever be cast in the classical mode.

The tension between my father and mother must often have come to a head at suppertime: the mortgage, the kids, the inner knowledge that they were both meant for better things. And the other nights—the alternate mood of our family meals was as sparkling as a good scene out of a Depression comedy.

"Oh, Bill!" our mother said, time and again. "Oh, Bill!" A perpetual girl, she was never dismayed for an instant by one of his wild stories. Her role of the innocent must be displayed like a talisman for good luck. The pact that my parents had drawn up between them had so many clauses—that he should bully her, captivate her, honor her: that she should suffer his folly and respect him: all his windy force against her steady will and self-effacement.

It was the psychiatrist's inevitable suggestion to me so many years later that my father was the dominant figure.

"Oh, no," I said.

"Your mother, then?"

"There is no answer to that question."

And I still cannot find my way through their intricate contract. My Looking and Listening at the dinner table were deeply troubling, yet they were easy exercises compared to the more heroic material I watched my parents enact—my father's raised fist of Anger or the white muslin folds and fading roses of what I once believed to be my mother's Unrequited Love.

The gliding vowels and The Attitudes were most probably an adaptation of the old Delsarte Method, techniques not so much for the stage as for the dead form of *tableau vivant* and the recitations expected of young ladies. The notion was farfetched, that I would ever nestle into the curve of a grand piano at some church social or stand in a drawing room flanked by potted palms, clear my throat, take the position of Welcome, left then right, balanced just slightly over the ball of the foot. In the phantom world evoked by Mrs.

Holton I did recite. There in her parlor I acted out the poems and monologues memorized during the week with fitting gestures, speaking from the diaphragm so that I might be heard in the last ghostly row of her imagined auditorium. I've lost track of all the sentimental verses that were once in my head, but some of the frisky pieces, thought appropriate for a girl my age, remain. One began: "I went to the dentist along with Aunt Nell," and reached its height of hilarity under the drill. Another featured "takeoffs" on a row of gullible hicks watching a cowboy movie. I was in great demand. I never attained the Brahmin ballroom for my stage but appeared often on the wood platform of Saint Patrick's School built one step up from the cement floor where big spiders and bubble-gum wrappers clogged the drains. I recited beautifully whenever Monsignor Lynch came to visit, when the diocesan supervisor came down from Hartford to inspect our classes (perfect classes, presumably, since no changes were ever deemed necessary). When the parents came once a year, dressed in Sunday clothes, I recited an elevating poem and did the darling piece about the dentist as an encore. Dick Ferucci gave them "Ave Maria" on his violin. Mary Morton, a giddy girl, fumbled over the piano keys: "The Barcarolle," "Country Gardens." A few flashy types, new in the neighborhood with the defense plants' hiring, tap-danced and did acrobatic splits. We all sang "To Jesus' heart all burning/With fervent love for men."

I recited at birthday parties and when company came at Christmas and Easter. "Cute" I must have been up to a certain age, insufferable. Then Mrs. Holton delved into her file cabinet and brought out yellowed sheets of paper—the great readings of English poetry and prose, all of our literature clipped and pasted up for the genteel recital. I was Puck, Richard II, Portia, Lear, Mr. Pickwick, the Ghost of Christmas Past, Sir Philip Sidney, Tennyson, Matthew Arnold and, as they say, many, many more. These selections were not memorized but read off the yellowed sheets, the lines preserved in the small blurred print of an ancient typewriter. My final elocutionary triumph came in the eighth grade. I was given a dramatic monologue which I was led to understand only an individual of great talent and sensitivity could deliver. By this time I knew that in some spooky way the work Mrs. Holton entrusted to me could only have been performed by Ruth, gone from us forever with her fresh

rose wreath and sickly smile. This last recitation was of the moment—the words of a British mother saying goodbye to her children as they were about to sail off to the safety of America during the war, while she stayed behind courageously, bombs soaring overhead. "Chin up, Gerald. That's Mummy's boy. It's going to be such fun, the tall buildings . . . and the Statue of Liberty will be there in the harbor with her torch of freedom to welcome you. Pam, my little one, what's this . . . not tears?" Farewell (to the right), Bravery (center), Sorrow (left).

I moved myself to choking sobs in rehearsal. The nuns were thrilled. I don't feel shame now but wonder, as though it were not me at all but some other self with a preadolescent idea of the tragic, a puppet girl babbling a text that must have been clipped out of a church newsletter or a women's magazine. A friend of mine, now a distinguished guardsman of our culture, was made to recite the Gettysburg Address when he was a boy before the entire city of Gloucester, standing out in a mist in front of the statue of the noble fisherman. Painful, funny, but his act was no more ludicrous than my version of the brave British mum waving her kids off: "It's only for a while, Pam. This frightful mess will soon be over. Write to me, darlings. No, Gerald, we must never say goodbye."

Departure was almost as good as death in this despairing wartorn world. A boy I loved moved out of town to an army base. I mooned about the house and ate . . . "Oh, my darling, be brave." I had pimples coming on and "difficult days" when I should not ride my bike or swim. Without warning there was a miraculous coming of age: I began to see the nonsense of my afternoons with Mrs. Holton and felt that I had been badly used. By this time I went freely into her neat refrigerator to get myself a glass of ice water. There at the kitchen table I saw two places laid for supper. The stage was set to unfold the steady disappointment of their lives: Louise and Herbert face each other over another silent meal.

I was humiliated by my past performances. I forced my mother to make excuses for me: it was understood that with Latin and algebra, field hockey in the afternoons at the convent school I now attended . . . There was a cool friendship of sorts that continued between the ladies, Christmas cards, infrequent phone calls. I was lectured on how lucky I was to have been "exposed" to Mrs. Holton.

I saw only the ladylike speech and scrim of empty gestures that was meant to separate me from the hard realities of life. Each adolescent Love and Fear was different. I threw the Delsarte Method out as trash: my responses to my father and the games he played with us each night were unpredictable and often graceless.

This should have been the end, but a few years later, when I went to public high school, I was involved in a cheap incident that shocked my parents (the particulars hidden, fortunately, in some obscure corner of my mind). In this crisis, as with George's stutter, my mother treated the disease of my rebellion as a surface wound. Mrs. Holton was resurrected. This last effort to save me lasted only a few weeks before I declared myself one of the damned. Not elocution this time, but etiquette—an orrisroot and almond-water finishing process lay in store for me in the silent parlor. Herbert was dead and Mrs. Holton lived on in her perfection. She had assembled on the clean cloth of the dining room table, books and pamphlets from the Emerson School. A lady always carries her head high. Her beauty is enhanced if the lips be slightly parted. She sits with care. She may cross her ankles but never the knees. But all was not superficial deportment: I was to beware of the double entendre and its lowly offspring, the smutty story. On these unforgivable occasions, thrown in with men of little breeding, et cetera . . . I was to turn my head decisively away or say with stern demeanor, "I do not understand."

I was in love with an Italian boy and we walked the North End at night, kissing between streetlights. His three buddies like a Mafia escort trailed half a block behind. He sang with a big band in the Ritz Ballroom at Pleasure Beach on Saturday nights but we knew my father would never in a million years let me go to a dance hall. We walked down back streets to a pizza parlor where we sat alone feeling each other under the table while his friends were posted guard in the booth behind.

Good-natured laughter is permitted in the home but is not tolerated on the street or in a public conveyance. I must subdue a gloomy mood before entering society. I must practice walking with a book balanced on my head and, above all, not afflict the world with any dismal account of my circumstances. "It is presumed," Mrs. Holton said, "that each one has trouble enough to bear without being burdened with the sorrows of others."

My boyfriend was diddling with me. He had a girl, a smoldery Italian beauty who took the secretarial course and it was presumed—each one has joy enough—that they would marry. I loved the smell of him and the strange beads of sweat that sat on the flat tip of his Sicilian nose and were brushed against my cheek when we embraced.

When I was in college Mrs. Holton died. Months before, she had called my mother and asked if I might come to visit during spring vacation. So on a chill bright day, the forsythia improving the small front yards of Bridgeport, I drove out to the Fanny Goodwin Home for elderly ladies. Her room had the familiar photos, clean linen doilies on the tables, plants and a hot plate. We drank Nescafé. I said that her elocution lessons had served me well. I was constantly asked to speak at college meetings and I announced the Glee Club from one end of New England to another, speaking from the diaphragm, sliding my vowels, spitting my D's and T's. She offered me one of two decorative plates as a keepsake. They were both Oriental in style and I felt that I stood in such a false position with her that I grabbed the worthless one, a turn-of-the-century Japanese thing, and left the deep-blue Canton china behind. Then she gave me a grocery carton filled with all the materials of her trade—the monologues, the typewritten selections from literature and the glossy cream-colored programs which memorialized those lofty evening recitals at the Emerson School. She walked down to the car with me past the old girls rocking in the sunshine on the porch and stood on the lawn, head high, lips slightly parted, and affecting me with nothing more troublesome than her Pride and Unguarded Love, she bid me a classic Farewell.

I've often wished that I had that piece about the Second World War, but it's gone. When I divorced, the box was left behind in New Jersey—in a leaky cellar that flooded in a hurricane. I said to hell with it and the family photographs, my Smith yearbook, early manuscripts washed away too: I was getting on with my life. Of least importance was that box of Mrs. Holton's. Good riddance to the bloated eloquence of perfectly enunciated poesy, the techniques of good behavior which had not implemented my salvation. I am not the lady I was meant to be.

When my husband, my ex-husband, came to pick up our daughter for the weekend visit he said: "I'm sorry about the mess in the cellar . . . all your papers."

"It's okay."

We stood in the doorway of my apartment with our little girl's overnight case between us while she shuffled through a shopping bag of her favorite toys. We weren't hardened to our circumstances. We dawdled and laughed a lot. He said he could not braid her hair. Finally they started on their way, but turned to look back up the flight of stairs. I stood above them on the landing, posturing, hand to heart. "Chin up. That's Mummy's darling." I laughed and struck the Attitude of Bravery. "It's going to be such fun. We must never say goodbye."

FREDERICK BUECHNER
(1926–)

Frederick Buechner is the author of twenty-seven books—thirteen novels and fourteen works of nonfiction. Born in New York, he attended Princeton University and Union Theological Seminary. He is an ordained Presbyterian minister and a full-time writer.

Buechner's most recent novel is Son of Laughter *(1992). His chief work consists of four novels published in the 1970s and brought together in 1979 as* The Book of Bebb. Lion Country, *the first in the Bebb tetralogy, was nominated for the National Book Award. In 1980, the unrelated novel* Godric *was nominated for the Pulitzer Prize.*

His memoirs include The Sacred Journey *(1982) and* Now and Then *(1983).*

■ ■ ■

from THE SACRED JOURNEY

How they do live on, those giants of our childhood, and how well they manage to take even death in their stride because although death can put an end to them right enough, it can never put an end to our relationship with them. Wherever or however else they may have come to life since, it is beyond a doubt that they live still in us. Memory is more than a looking back to a time that is no longer; it is a looking out into another kind of time altogether where everything that ever was continues not just to be, but to grow and change with the life that is in it still. The people we loved. The people who loved us. The people who, for good or ill, taught us things. Dead and gone though they may be, as we come to understand them in new ways, it is as though they come to understand us—and through them we come to understand ourselves—in new ways too. Who knows what "the communion of saints" means, but surely it means more than just that we are all of us haunted by ghosts because they are not ghosts, these people we once knew, not just echoes of voices that have years since ceased to speak, but saints in the sense that through them something of the power and richness

of life itself not only touched us once long ago, but continues to touch us. They have their own business to get on with now, I assume—"increasing in knowledge and love of Thee," says the Book of Common Prayer, and moving "from strength to strength," which sounds like business enough for anybody—and one imagines all of us on this shore fading for them as they journey ahead toward whatever new shore may await them; but it is as if they carry something of us on their way as we assuredly carry something of them on ours. That is perhaps why to think of them is a matter not only of remembering them as they used to be but of seeing and hearing them as in some sense they are now. If they had things to say to us then, they have things to say to us now too, nor are they by any means always things we expect or the same things.

It is the way I used to see her on late Saturday afternoons in winter that I remember my Grandmother Buechner best. She sits in her overstuffed chair with the lamp behind her unlit, though New York City is turning gray through the window. On the sill at her elbow, her squat little Philco is playing Wagner. She knows the libretto by heart as she also knows by heart how to crochet in the dusk with her silk and scissors lying on the great shelf of her bosom. Wotan is singing farewell to Brünnhilde—"*Leb' wohl, du kühnes, herrliches Kind! Du meines Herzens heiliger Stolz*"—while twelve stories down on Park Avenue, taxi horns echo the music's grieving. "Farewell, my brave and beautiful child, the life and light of my heart," sings Wotan as, ringed round with fire, Brünnhilde sinks into an enchanted sleep. *Leb' wohl.* Then Rosa the maid comes in with her *Essen ist fertig, Frau Büchner* to announce dinner, and my grandmother heaves her great weight out of her chair and with the aid of her stick and my arm makes her way to the dining room table of cold chicken, radishes, rye bread, and *lebkuchen* left over from Christmas. She talks of the *tanten*—how Tante Anna said of her, "Louise always tells me I'm naive, but what she means is I'm stupid," and of how Tante Anna phoned not long before to say that she had fallen and broken the bone in her eye. "The bone in her eye!" my grandmother says and laughs till out of her own eyes the tears roll down.

She talks of her father, Hermann Balthazar Scharmann, and of how walking back from luncheon at Lüchows, he would keep hurl-

ing his cane yards ahead on the pavement, pedestrians be damned, and then pick it up without breaking his stride to keep himself trim. "I'm too old," my grandmother says. "Somebody should shoot me," but of course we none of us dared. Instead we would bring her presents on her birthday, which Heaven help us if we forgot, and she would sit there in her chair by the window refusing to open them. "Whatever they are," she says, "I know I'm not going to like them."

She was the rich one of my two grandmothers, the holder of the purse strings. She could be an unholy terror, and when the terror was at its unholiest, Rosa would answer the doorbell with the single word *Grenma*, her hands in the air and her eyes rolled heavenward. My grandmother spoke her mind with terrible honesty, in German to Rosa and in English to the rest of us. But if her wrath burned hot, it also burned quick and was gone in a devastating flash. She never smoldered. And it was the same with her grief. Suddenly her voice would tremble, her eyes brim, over some ancient hurt, some remembered loss or failure. She never submerged her feelings but rode them like a great wave just the way, as a child, I often saw her ride the real waves too, swimming out to the barrels through the high Long Island surf as fat as Rinkitink but bobbing like a great cork, unsinkable, ocean-proof. Then back to the big shingled summer house by the canal, where ducks quacked for breadcrumbs and bees buzzed among the honeysuckle, and all through the house there were bowls of flowers—black-eyed Susans, wild roses, cattails—and cold crab in the ice box, cold beer, and lemonade in crockery pitchers, a mocha torte with ground almonds in it that took two days to make. My grandmother played croquet with her tennis-playing sons and golf-playing daughter, held her mallet one-handed and off to the side as she had learned to from the years when she needed that one hand free to gather up the long skirts of her girlhood. Her tow-headed grandchildren played hide-and-seek on the lawn as the dusk deepened and my grandfather poured out the evening martinis on the veranda.

He was sometimes mistaken for the British actor C. Aubrey Smith on his travels, my grandfather, and when people came up to ask for his autograph, he always obliged them but always signed his own name. There was a marble bust of Venus de Milo in the living room in New York, and I remember as a child being there alone with

him once as he sat in his chair across from my grandmother's with his glass in his hand. I felt his eye upon me, and shy of him, tongue-tied, not knowing what else to do, I wandered over to where the bust stood and, with no sense of what I was about, reached up and touched one of the cool, white breasts. I can hear his short, dry laugh still—as short and dry as his martini and wickeder. It was the future that I had touched without knowing it, but he knew it. The day would come. The curtain would rise. I was humiliated. His moustache was damp with gin. Not a word was spoken. It was a moment.

"Oh, it was so many years ago," my grandmother says, "and there were so many of you then, all four of my children alive still, and how little I dreamed then the terrible things that—" and suddenly she is dabbing at her eye, her voice in a tremble. "Never mind," she says. "Tears are an old Scharmann custom."

But of course she *had* dreamed them—the terrible things—maybe not the ones that actually happened when their time came, but others no less terrible and even more so for all I know. All her life she was a worrier, brooding like a hen over terrors to come almost as though to hatch them out into reality would be a kind of relief because there at least she could come to some sort of terms with them as in her dark dreams she could not. So when they did come—her husband and two of her sons falling like dominoes before their time, a fortune all but lost—she was ready for them in her way, found strength somewhere for surviving them. She would never have said that it was in God that she found it. If she spoke of God at all, it was always as *le bon Dieu* with an obscure little smile on her lips, a smile that was an only half satiric little curtsy in the direction of a belief which she herself did not hold but was perhaps not altogether willing to dismiss out of hand either any more than she would have dismissed it out of hand if a child had said he believed in fairies or the Man in the Moon. Who could tell, after all? But from her German forebears—free-thinkers and radicals who had come to this country during the troubles of 1848—the strongest faith she inherited was faith in hard work, in being careful with your money, in families staying together through thick and thin even unto the third and fourth generation of kaffee-klatsching cousins, in the strength that comes with facing even what is vastly stronger than yourself.

Sayings of her father, old Hermann Scharmann, came easily to her lips. "Never put on your bathing suit without going in the water," he said. He was a tyrant, a tycoon, a self-made man who through breweries and real estate was able to leave each of his many children a grand piano and more than money enough never to starve. As a child he had gone with his parents to California in the Gold Rush, his mother and a baby sister dying on the way to be buried by a river at Christmas time, and the rest of them barely able to pan enough gold to keep themselves alive before they finally limped back to Brooklyn where they had started from. My great-grandfather liked being thought of as a Forty-niner, even though he was only a child at the time, and when he had his father's memoirs of the trip privately printed many years later, it was his own picture, not his father's, that he had printed as the frontispiece. "Never put anything off because of the weather," he said, and from the look of his picture—those bulging eyes, those jowls, that fierce goatee—it is easier to imagine the weather's putting something off because of him.

Like her father, my grandmother had little patience with weakness, softness, sickness. Even gentleness made her uncomfortable, I think—tender-hearted people who from fear of giving pain, or just from fear of her, hung back from speaking their minds the way she spoke hers, let the Devil take the hindmost. Only once can I remember her having been gentle in her way, responding to gentleness gently. It was a day or two after the death of her eldest son, my father. We must have gone to her apartment for lunch, my mother, brother, and I, and Grandma and my mother had lingered over their coffee, talking to each other about the young man whose love they had fought each other for over the years. The dining room doors were open, and their voices drifted out with the smell of their coffee to where my brother and I were waiting for it to be time to go home to whatever home was just then. "With malice toward none," we heard my mother say. "With charity for all," and then the murmur of my grandmother's voice more terrible in its gentleness than it had ever been in its wrath, then the tinkle of a silver spoon against a china cup as those two old adversaries found it possible for perhaps the only time in their lives to weep together over a life that neither of them had had whatever it might have taken in the way of gentleness or strength to save.

But she came out of it in the end on the far side of tears, and my clearest memory of her is sitting dry-eyed by the same window, in the same chair, with that same small radio at her elbow, and one of the bedspreads that she was always crocheting out of linen thread spread out over her knees. It is Wagner again, only *Die Götterdämmerung* this time. It is the twilight of the gods. Valhalla is about to go up in flames. My grandmother sits there, the oldest living survivor. Like a rock at the edge of the sea, she bears the marks of the storm. Sharp edges have been pounded smooth. Parts have crumbled away altogether because though you can ignore the weather, you cannot alter it. But the rock still stands, bird-spattered and barnacled, a fixed point for the rest of us to steer clear of in one sense and to steer by in another, to get our bearings by. "Your father was gentle," she says. "The world is not gentle." It is less Siegfried suddenly than my father who lies there on his funeral pyre. "*Der Reinste war er . . . laut'rer als er liebte kein And'rer*," Brünnhilde sings with the burning torch in her hand. "He was the truest . . . no other loved so truly." But then, "*Trog keiner wie er!*" "None broke like him!" she cries—whoever it is lying there broken, broke, heart-broken, and heart-breaking as she touches his pyre with her torch. The little Philco's tubes rattle like teeth as the music flashes and swells and then dwindles to a single flute. The crochet hook is still.

My grandmother's jokes tended to have something medieval about them—heavy, wooden, with little art but made to do hard service. There was this preacher once, she says, preaching his sermon from his pulpit in his long black gown. It was such a hot day that he had put nothing on but the gown that morning and was as naked underneath as the day he was born. He got so wrought up over his sermon and was pounding and stomping around so hard up there that suddenly the platform gave way beneath him and he was pitched almost into the laps of his congregation with his black gown tossed up over his head. "May anyone who looks be struck blind!" he yelled out, and the whole congregation dutifully clapped their hands to their eyes with the exception of one old woman who let two fingers slip apart just enough for a chink to peer through. "I'll risk one eye," she said.

My grandmother was the old woman, of course. No doom she ever dreamed can have been as dark as the one that finally overtook

her, but with no faith to fall back on, other than such faith as she had in herself and such faith as she had left in what was left of her family, and with no God except *le bon Dieu,* whoever and whatever he was, if indeed he was anywhere at all, she never pretended that things were other than they were. She never armed herself against the world with bitterness or capitulated to it with despair. She looked at it bare, and she looked at it hard, and for a wonder she was never blinded. "Farewell," sings Wotan, "my brave and beautiful child."

As for me as a child, I was no braver than I was beautiful, nor, up to the age of ten, did I have anything out of the ordinary to be brave about. But at the same time, for a child—especially a bookish, rain-loving, inward-looking child—even the ordinary can at times require bravery enough. The hearth broom with the face of a malevolent dwarf. The servant's child, floating face down in the canal in front of the shingled house one morning—fished out and resuscitated, but appalling, shameful somehow, as it lay there puddling the weathered planks of the dock with the water that ran from its nose and mouth as the breath came rattling back. The circus horse, white as milk and brilliantly bridled, balking outside the great tent with a man beating it about the face and eyes with a stick. The green frog that some cousins and I tossed back and forth by one of its legs like a green toy until at last it broke like a toy and the slippery life came spilling out. The unexplored rooms on the third floor, and the new nurse who did not understand her instructions and thus did not know that it was all right for my brother and me to stay up an hour or so later to dye Easter eggs, but packed us off to bed at the usual time where we lay in the dark aghast at the sudden knowledge that much of the time we lived at the sufferance of strangers.

But if strangers and strange sights can shake the world of children, it takes the people they know and love best to pull it out from under them like a chair. Into the same Georgetown garden where Mrs. Taylor showed me the tough, white gristle of a soul, my other grandmother came one day. Naya was the name I had given her for reasons long since lost to history. She was as different from Grandma Buechner as a lamp to read by is different from the twilight of the gods. She was a superb solver of crossword puzzles

and a reader of French novels. She smoked cigarettes in white paper holders and watched the world go by. She played wistful tunes with one finger on a Steinway grand. She held me enraptured by tales of the past, evoking in dazzlingly spoken paragraphs a whole world of Dickensian freaks, relations and friends, like adopted cousin Nelly Dunbar, with her oiled ringlets and Armenian blood, who would filch pink soap from the family linen closet and peddle it on street corners; and Tante Elise Golay, who carried a watered silk reticule to restaurants so she would have something to empty the sugar bowl into when the meal was through; and Naya's step-grandfather, Amasa Barret, who was blind as a bat and told her—when as a child she asked him what the name *Amasa* meant—that what it meant was "a burden," and she could have bitten out her tongue. If Grandma Buechner was a rock with the rough seas of her life all but inundating her at times and yet immovable, impermeable, intractable to the end, then Naya was the old gray gull who rode it all out on the skin of the storm. The waves might rise like Everest above her or sink like the Valley of the Shadow beneath, but with her back to the wind and her wings tucked tight, Naya rarely ruffled so much as a feather. I see her knitting a scarf in a wicker peacock chair with the Blue Ridge mountains blue behind her, or under a beach umbrella in pleated white linen with her brave old Indian eyes on the far horizon, or, when she was well into her nineties, writing, after we had taken our first child to see her for the first time, "It was a noble deed to make the long journey down here, and the joy of seeing you two and your bewitching little fairy daughter more than compensates me for the ignominy of substituting an old crone in a dark little room for the Naya of legend."

In any case, of all the giants who held up my world, Naya was perhaps chief, and when I knew she was coming to Georgetown for a visit that day, I wanted to greet her properly. So what I did at the age of six was prepare her a feast. All I could find in the icebox that seemed suitable were some cold string beans that had seen better days with the butter on them long since gone to wax, and they were what I brought out to her in that fateful garden. I do not remember what she said then exactly, but it was an aside spoken to my parents or whatever grown-ups happened to be around to the effect that she

did not usually eat much at three o'clock in the afternoon or whatever it was, let alone the cold string beans of another age, but that she would see what she could do for propriety's sake. Whatever it was, she said it drily, wittily, the way she said everything, never dreaming for a moment that I would either hear or understand, but I did hear, and what I came to understand for the first time in my life, I suspect—why else should I remember it?—was that the people you love have two sides to them. One is the side they love you back with, and the other is the side that, even when they do not mean to, they can sting you with like a wasp. It was the first ominous scratching in the walls, the first telltale crack in the foundation of the one home which perhaps any child has when you come right down to it, and that is the people he loves.

There were other cracks, of course. My brother and I had misbehaved at lunch for days, and at last, for the sake of having a peaceful meal by herself for once, my mother dressed up in a coat of my father's and one of his hats and had word sent up to us that a little old man had come to eat that day. So we stayed upstairs, needless to say, too timid to think of lunching with a stranger, and I remember looking down through the bannister and seeing at the dining room table somebody who was both a little old man yet somehow also my mother; and again what had always seemed solid as a rock showed signs of cracking in two. Or the time my father was sick in bed for a day or two. That was all it took: my father sick, on whose health the foundations of the world were based; my father in bed when I knew that unless he stayed on his feet, the winds would die and the crops fail. Or, later on, my father coming in to say good-night and standing there at the foot of our beds with his hands on his hips and his face clammy and gray as he threw back his head and laughed in a way that made me know as surely as I knew anything that something had gone terribly wrong with his laughter. Something had gotten broken in it. Something in it was in danger of breaking him, breaking all of us. And the time he wanted the keys to the car, and my mother gave them to me and told me that he had had too much to drink and not to let him know where they were, no matter what, so that I lay in my bed with my pillow over my head and made no reply to his endless pleading because I could think of no reply that I could possibly make.

I no longer know what my father looked like, it has been so long since I saw him last, and have only photographs to remember his face by—a young man in a sailor's uniform, or sitting behind a desk in his first office, or lying in the sand in his swimming trunks and striped jersey top. But from somewhere deeper within myself than memory, and from what I have been able to find out over the years from people who knew him much longer and better than I, I can still summon up something of the feel of who he was. He was a gentle man, as my grandmother said, handsome and conscientious and kind. He was a strong swimmer who played water polo at college, and a good dancer, and could go nowhere, the family joke was, without running into at least six friends. He knew Zelda and Scott Fitzgerald from his Princeton days and knew waiters and barbers by their first names. People I doubt he would have remembered remember him still. As the oldest of four children, he was the one who shepherded the others through Central Park to school and from the start seems to have been given responsibilities beyond his years. Even in pictures of him as a small boy, he looks harried, seldom if ever smiling, as though he knew that as soon as the shutter snapped, it would all begin again—my grandmother saddling him with more, I suspect, than a small boy's share of her own dark burdens, his younger brothers and sister looking to him for some kind of strength, some kind of stability, which he must have had to dig deep into himself to find, having barely enough at that age, I can only imagine, to get by on himself. And then when he got married, and his two sons were born, and the crash of '29 came, there was a whole new set of things to be harried by as he moved from job to job and place to place, always bent on doing better by us, establishing us on some surer, more becoming ground.

He worked long hours and he worked hard at whatever minor executive job he happened to have at the time, but on weekends at least he found time to be a father. In an inlet full of jellyfish that stung, he taught me how to swim. He taught me how to ride a bike by running alongside with his hand on the handlebars till I started to get the hang of it, then taking his hand away and letting me roll along on my own till I wobbled finally into a hedge but knew how to do it from that day on. When at the age of nine or so I asked a pretty girl named Virginia with shampoo-smelling hair to go to the

movies with me (it was Eddie Cantor in *Roman Scandals*), he drove me to pick her up and explained on the way that she would probably keep us waiting a little because that was what pretty girls did, and he was right. When he came to say good-night, he would give my brother Jamie and me what he called a "hard kiss," which was all sandpapery whiskers and snorts and struggle. I remember sitting in the back seat of a car, with him and my mother up front, singing songs like "Me and My Shadow" and "That's My Weakness Now," remember eating dark Swiss chocolate and salty French bread with him on the long drives he took us on sometimes, remember one winter drive back over the Allegheny mountains from Pittsburgh when it was so cold that he gave the only blanket there was to us in the back seat and had to stuff newspaper under his coat to keep warm himself. I remember seeing the movie of *Green Pastures* with him—the great fish-fry in Heaven with De Lawd and his black angels—and driving down to the Quogue beach afterwards to see the moon rise like an angel over the incoming tide.

These were the bright times, the happy once-below-a-time times, but for a child even the bright times have, like the moon, their dark side too; and even below the time when time starts, the time to come can still cast a shadow. Any house where my father and mother were was home to me, but for that very reason, whenever they left—even for a day, even for an evening—it was home no longer but a house with walls as frail as paper and a roof as fragile as glass. My fear was that they would never come back.

I knew nothing more of death then than what I had learned of it from the slippery green frog, and nothing more of darkness than the night. I had never lost anything that I was not sure would be replaced if I really needed it by the people I loved, and I had never been hurt beyond the power of a word of comfort to heal. But whenever my father and mother left, taking home with them, I knew that hurt, loss, darkness, death could flatten that house in seconds. And to a degree that I had no way of knowing, and in ways that I could not possibly foresee, I was right.

VIVIAN GORNICK
(1935–)

Vivian Gornick, born in New York City, attended City College, and took her M.A. at New York University. For nine years she was a staff writer for the Village Voice.

She wrote In Search of Ali Mahmoud: An American Woman in Egypt *(1973),* The Romance of American Communism *(1977),* Essays in Feminism *(1979), and* Women in Science: Portraits from a World in Transition *(1990).*

Her striking memoir, Fierce Attachments *(1987), describes her ongoing vexed and deep relationship with her mother, and recalls her childhood in the Bronx in the 1940s. In this section, Nettie, a Ukrainian gentile, is her family's neighbor.*

■ ■ ■

from FIERCE ATTACHMENTS

A year after my mother told Mrs. Drucker she was a whore the Druckers moved out of the building and Nettie Levine moved into their vacated apartment. I have no memory of the Druckers moving out or of Nettie moving in, no truck or moving van coming to take away or deposit the furniture, dishes, or clothes of the one or of the other. People and all their belongings seemed to evaporate out of an apartment, and others simply took their place. How early I absorbed the circumstantial nature of most attachments. After all, what difference did it really make if we called the next-door neighbor Roseman or Drucker or Zimmerman? It mattered only that there was a next-door neighbor. Nettie, however, would make a difference.

I was running down the stairs after school, rushing to get out on the street, when we collided in the darkened hallway. The brown paper bags in her arms went flying in all directions. We each said "Oh!" and stepped back, I against the staircase railing, she against the paint-blistered wall. I bent, blushing, to help her retrieve the bags scattered across the landing and saw that she had bright red

hair piled high on her head in a pompadour and streaming down her back and over her shoulders. Her features were narrow and pointed (the eyes almond-shaped, the mouth and nose thin and sharp), and her shoulders were wide but she was slim. She reminded me of the pictures of Greta Garbo. My heart began to pound. I had never before seen a beautiful woman.

"Don't worry about the packages," she said to me. "Go out and play. The sun is shining. You mustn't waste it here in the dark. Go, go." Her English was accented, like the English of the other women in the building, but her voice was soft, almost musical, and her words took me by surprise. My mother had never urged me not to lose pleasure, even if it was only the pleasure of the sunny street. I ran down the staircase, excited. I knew she was the new neighbor. ("A *Ukrainishe* redhead married to a Jew," my mother had remarked dryly only two or three days before.)

Two evenings later, as we were finishing supper, the doorbell rang and I answered it. There she stood. "I . . . I . . ." She laughed, a broken, embarrassed laugh. "Your mother invited me." She looked different standing in the doorway, coarse and awkward, a peasant with a pretty face, not at all the gorgeous creature of the hallway. Immediately, I felt poised and generous. "Come in." I stepped courteously aside in the tiny foyer to let her pass into the kitchen.

"Sit down, sit down," my mother said in her rough-friendly voice, as distinguished from her rough I-really-mean-this voice. "Have a cup of coffee, a piece of pie." She pushed my brother. "Move over. Let Mrs. Levine sit down on the bench." A high-backed wooden bench ran the length of one side of the table; my brother and I each claimed a sprawling place on the bench as fast as we could.

"Perhaps you'd like a glass of schnapps?" My handsome, gentle father smiled, proud that his wife was being so civil to a Gentile.

"Oh no," demurred Nettie, "it would make me dizzy. And please"—she turned ardently toward my mother—"call me Nettie, not Mrs. Levine."

My mother flushed, pleased and confused. As always, when uncertain she beat a quick retreat into insinuation. "I haven't seen Mr. Levine, have I," she said. In her own ears this was a neutral question, in anyone else's it was a flat statement bordering on accusation.

"No, you haven't." Nettie smiled. "He isn't here. Right now he's somewhere on the Pacific Ocean."

"*Oy vay*, he's in the army," my mother announced, the color beginning to leave her cheeks. It was the middle of the war. My brother was sixteen, my father in his late forties. My mother had been left in peace. Her guilt was extravagant.

"No," said Nettie, looking confused herself. "He's in the Merchant Marine." I don't think she fully understood the distinction. Certainly my mother didn't. She turned an inquiring face toward my father. He shrugged and looked blank.

"That's a seaman, Ma," my brother said quickly. "He works as a sailor, but he's not in the navy. He works on ships for private companies."

"But I thought Mr. Levine was Jewish," my mother protested innocently.

My brother's face brightened nearly to purple, but Nettie only smiled proudly. "He is," she said.

My mother dared not say what she wanted to say: Impossible! What Jew would work voluntarily on a ship?

Everything about Nettie proved to be impossible. She was a Gentile married to a Jew like no Jew we had ever known. Alone most of the time and apparently free to live wherever she chose, she had chosen to live among working-class Jews who offered her neither goods nor charity. A woman whose sexy good looks brought her darting glances of envy and curiosity, she seemed to value inordinately the life of every respectable dowd. She praised my mother lavishly for her housewifely skills—her ability to make small wages go far, always have the house smelling nice and the children content to be at home—as though these skills were a treasure, some precious dowry that had been denied her, and symbolized a life from which she had been shut out. My mother—secretly as amazed as everyone else by Nettie's allure—would look thoughtfully at her when she tried (often vaguely, incoherently) to speak of the differences between them, and would say to her, "But you're a wife now. You'll learn these things. It's nothing. There's nothing to learn." Nettie's face would then flush painfully, and she'd shake her head. My mother didn't understand, and she couldn't explain.

Rick Levine returned to New York two months after Nettie had moved into the building. She was wildly proud of her tall, dark, bearded seaman—showing him off in the street to the teenagers she had made friends with, dragging him in to meet us, making him go to the grocery store with her—and she became visibly transformed. A kind of illumination settled on her skin. Her green almond eyes were speckled with light. A new grace touched her movements: the way she walked, moved her hands, smoothed back her hair. There was suddenly about her an aristocracy of physical being. Her beauty deepened. She was untouchable.

I saw the change in her, and was magnetized. I would wake up in the morning and wonder if I was going to run into her in the hall that day. If I didn't, I'd find an excuse to ring her bell. It wasn't that I wanted to see her with Rick: his was a sullen beauty, glum and lumpish, and there was nothing happening between them that interested me. It was *her* I wanted to see, only her. And I wanted to touch her. My hand was always threatening to shoot away from my body out toward her face, her arm, her side. I yearned toward her. She radiated a kind of promise I couldn't stay away from, I wanted . . . I wanted . . . I didn't know *what* I wanted.

But the elation was short-lived: hers and mine. One morning, a week after Rick's return, my mother ran into Nettie as they were both leaving the house. Nettie turned away from her.

"What's wrong?" my mother demanded. "Turn around. Let me see your face." Nettie turned toward her slowly. A tremendous blue-black splotch surrounded her half-closed right eye.

"Oh my God," my mother breathed reverently.

"He didn't mean it," Nettie pleaded. "It was a mistake. He wanted to go down to the bar to see his friends. I wouldn't let him go. It took a long time before he hit me."

After that she looked again as she had before he came home. Two weeks later Rick Levine was gone again, this time on a four-month cruise. He swore to his clinging wife that this would be his last trip. When he came home in April, he said, he would find a good job in the city and they would at long last settle down. She believed that he meant it this time, and finally she let him pull her arms from around his neck. Six weeks after he had sailed she discovered she was pregnant. Late in the third month of his absence she

received a telegram informing her that Rick had been shot to death during a quarrel in a bar in port somewhere on the Baltic Sea. His body was being shipped back to New York, and the insurance was in question.

Nettie became intertwined in the dailiness of our life so quickly it was hard later for me to remember what our days had been like before she lived next door. She'd slip in for coffee late in the morning, then again in the afternoon, and seemed to have supper with us three nights a week. Soon I felt free to walk into her house at any hour, and my brother was being consulted daily about the puzzling matter of Rick's insurance.

"It's a pity on her," my mother kept saying. "A widow. Pregnant, poor, abandoned."

Actually, her unexpected widowhood made Nettie safely pathetic and safely other. It was as though she had been trying, long before her husband died, to let my mother know that she was disenfranchised in a way Mama could never be, perched only temporarily on a landscape Mama was entrenched in, and when Rick obligingly got himself killed this deeper truth became apparent. My mother could now sustain Nettie's beauty without becoming unbalanced, and Nettie could help herself to Mama's respectability without being humbled. The compact was made without a word between them. We got beautiful Nettie in the kitchen every day, and Nettie got my mother's protection in the building. When Mrs. Zimmerman rang our bell to inquire snidely after the *shiksa* my mother cut her off sharply, telling her she was busy and had no time to talk nonsense. After that no one in the building gossiped about Nettie in front of any of us.

My mother's loyalty once engaged was unswerving. Loyalty, however, did not prevent her from judging Nettie; it only made her voice her reservations in a manner rather more indirect than the one to which she was accustomed. She would sit in the kitchen with her sister, my aunt Sarah, who lived four blocks away, discussing the men who had begun to appear, one after another, at Nettie's door in the weeks following Rick's death. These men were his shipmates, particularly the ones who had been on board with him on this last voyage, coming to offer condolences to the widow

of one of their own, and to talk over with her the matter of the seaman's life insurance, which evidently was being withheld from Nettie because of the way in which Rick had died. There was, my mother said archly, something *strange* about the way these men visited. Oh? My aunt raised an interested eyebrow. What exactly was strange? Well, my mother offered, some of them came only once, which was normal, but some of them came twice, three times, one day after another, and those who came two, three times had a look about them, she must surely be wrong about this, but they looked almost as though they thought they were getting away with something. And Nettie herself acted strangely with these men. Perhaps that was what was most troubling: the odd mannerisms Nettie seemed to adopt in the presence of the men. My mother and my aunt exchanged "glances."

"What do you mean?" I would ask loudly. "What's wrong with the way she acts? There's nothing wrong with the way she acts. Why are you talking like this?" They would become silent then, both of them, neither answering me nor talking again that day about Nettie, at least not while I was in the room.

One Saturday morning I walked into Nettie's house without knocking (her door was always closed but never locked). Her little kitchen table was propped against the wall beside the front door— her foyer was smaller than ours, you fell into the kitchen—and people seated at the table were quickly "caught" by anyone who entered without warning. That morning I saw a tall thin man with straw-colored hair sitting at the kitchen table. Opposite him sat Nettie, her head bent toward the cotton-print tablecloth I loved (we had shiny, boring oilcloth on our table). Her arm was stretched out, her hand lying quietly on the table. The man's hand, large and with great bony knuckles on it, covered hers. He was gazing at her bent head. I came flying through the door, a bundle of nine-year-old intrusive motion. She jumped in her seat, and her head came up swiftly. In her eyes was an expression I would see many times in the years ahead but was seeing that day for the first time, and although I had not the language to name it I had the sentience to feel jarred by it. She was calculating the impression this scene was making on me. . . .

<center>* * *</center>

It rained earlier in the day and now, at one in the afternoon, for a minute and a half, New York is washed clean. The streets glitter in the pale spring sunlight. Cars radiate dust-free happiness. Storefront windows sparkle mindlessly. Even people look made anew.

We're walking down Eighth Avenue into the Village. At the corner of Eighth and Greenwich is a White Tower hamburger joint, where a group of derelicts in permanent residence entertain visiting out-of-towners from Fourteenth Street, Chelsea, even the Bowery. This afternoon the party on the corner, often raucous, is definitely on the gloomy side, untouched by weather renewal. As we pass the restaurant doors, however, one gentleman detaches from the group, takes two or three uncertain steps, and bars our way. He stands, swaying, before us. He is black, somewhere between twenty-five and sixty. His face is cut and swollen, the eyelids three-quarters shut. His hair is a hundred filthy matted little pigtails, his pants are held up by a piece of rope, his shoes are two sizes too large, the feet inside them bare. So is his chest, visible beneath a grimy tweed coat that swings open whenever he moves. This creature confronts us, puts out his hand palm up, and speaks.

"Can you ladies let me have a thousand dollars for a martini?" he inquires.

My mother looks directly into his face. "I know we're in an inflation," she says, "but a thousand dollars for a martini?"

His mouth drops. It's the first time in God knows how long that a mark has acknowledged his existence. "You're beautiful," he burbles at her. "Beautiful."

"Look on him," she says to me in Yiddish. "Just look on him."

He turns his bleary eyelids in my direction. "Whad-she-say?" he demands. "Whad-she-say?"

"She said you're breaking her heart," I tell him.

"She-say-that?" His eyes nearly open. "She-say-that?"

I nod. He whirls at her. "Take me home and make love to me," he croons, and right there in the street, in the middle of the day, he begins to bay at the moon. "I need you," he howls at my mother and doubles over, his fist in his stomach. "I need you."

She nods at him. "I need too," she says dryly. "Fortunately or unfortunately, it is not you I need." And she propels me around the

now motionless derelict. Paralyzed by recognition, he will no longer bar our progress down the street.

We cross Abingdon Square and walk into Bleecker Street. The gentrified West Village closes around us, makes us not peaceful but quiet. We walk through block after block of antique stores, gourmet shops, boutiques, not speaking. But for how long can my mother and I not speak?

"So I'm reading the biography you gave me," she says. I look at her, puzzled, and then I remember. "Oh!" I smile in wide delight. "Are you enjoying it?"

"Listen," she begins. The smile drops off my face and my stomach contracts. That "listen" means she is about to trash the book I gave her to read. She is going to say, "What. What's here? What's here that I don't already know? I *lived* through it. I know it all. What can this writer tell me that I don't already know? Nothing. To *you* it's interesting, but to me? How can this be interesting to me?"

On and on she'll go, the way she does when she thinks she doesn't understand something and she's scared, and she's taking refuge in scorn and hypercriticality.

The book I gave her to read is a biography of Josephine Herbst, a thirties writer, a stubborn willful raging woman grabbing at politics and love and writing, in there punching until the last minute.

"Listen," my mother says now in the patronizing tone she thinks conciliatory. "Maybe this is interesting to you, but not to me. I lived through all this. I know it all. What can I learn from this? Nothing. To you it's interesting. Not to me."

Invariably, when she speaks so, my head fills with blood and before the sentences have stopped pouring from her mouth I am lashing out at her. "You're an ignoramus, you know nothing, only a know-nothing talks the way you do. The point of having lived through it, as you say, is only that the background is familiar, so the book is made richer, not that you could have written the book. People a thousand times more educated than you have read and learned from this book, but *you* can't learn from it?" On and on I would go, thoroughly ruining the afternoon for both of us.

However, in the past year an odd circumstance has begun to obtain. On occasion, my head fails to fill with blood. I become irritated but remain calm. Not falling into a rage, I do not make a holo-

caust of the afternoon. Today, it appears, one of those moments is upon us. I turn to my mother, throw my left arm around her still solid back, place my right hand on her upper arm, and say, "Ma, if this book is not interesting to you, that's fine. You can say that." She looks coyly at me, eyes large, head half-turned; *now* she's interested. "But don't say it has nothing to teach you. That there's nothing here. That's unworthy of you, and of the book, and of me. You demean us all when you say that." Listen to me. Such wisdom. And all of it gained ten minutes ago.

Silence. Long silence. We walk another block. Silence. She's looking off into that middle distance. I take my lead from her, matching my steps to hers. I do not speak, do not press her. Another silent block.

"That Josephine Herbst," my mother says. "She certainly carried on, didn't she?"

Relieved and happy, I hug her. "She didn't know what she was doing either, Ma, but yes, she carried on."

"I'm jealous," my mother blurts at me. "I'm jealous she lived her life, I didn't live mine."

RICHARD SELZER
(1928–)

*Richard Selzer's father, a general practitioner, wanted him to enter
medicine. His mother wanted him to be a writer. In 1984, Selzer
retired as a surgeon and a professor at Yale's School of Medicine to
devote himself to literature full time.*

He wrote a book of short stories, Rituals of Surgery *(1974), and
several extraordinary books of nonfiction, including* Mortal Lessons
(1977), Letters to a Young Doctor *(1982), and* Taking the World In
for Repairs *(1986), which includes both essays and short stories.*

His memoir Down from Troy: A Doctor Comes of Age *(1992)
describes with humor and love his boyhood in Troy, New York. His
most recent memoir is* Raising the Dead: A Doctor's Encounter with
His Own Mortality.

■ ■ ■

Spoils of Troy
from CONFESSIONS OF A KNIFE

A river casts its influence over those who dwell upon its banks.
From each river, there is given off a personal drift that is the
confusion of its numberless currents, the curves and recurves of
its long traipse, the strew of its bed. Even the overhanging trees,
the fish within it, the swallows and gulls above, the bridges and
boats, all conspire to form that special efflorescence that is the *air*
of the river. It is this air that is the influence of a river upon its
people.

Rivers such as the Snake and the Salmon, above which eagles
hang, and from which bears prong fish, such rivers let a clarity
that is reflected in the eyes of the men who live nearby. The Nile,
silted up and feculent, permeates its riverlands with a listlessness
that is the precursor of fatalism. And so it goes. For us who grew
up by the Hudson at Troy, there was the suspicion of ill to come.
Up in the hills, the hyenas were laughing. That sort of thing. Still,
it was by the banks of the green-eyed, many-turtled Hudson that I

learned of the resonance between a man and his river. Energy flows from one to the other and back again. In such a romance of electrons, the river-dweller becomes no other than the very tree that overhangs the bank of the stream, the weeds that tumble at its bottom, or the deep eels that lash its waters.

A man and a woman love themselves in each other; together, they become a home. A doctor gazes at his patient, and he sees himself; joined, they are one pilgrim in search of health. Just so do a man and his river become something else, a third, a confluence.

Not far from where I lived as a boy, a wooden footbridge arched halfway across the Hudson to Green Island, a dab of land midriver, inhabited only by a species of large rat. To walk across this footbridge was a very foretaste of Heaven. Had it something to do with death? So many children died in Troy in the nineteen-thirties. Tuberculosis, they said. But I suspect that monstrous irresistible footbridge.

There was so much death in the town. All those wreaths nailed to the lintels. You could not die without lilies exhaling their corruption up and down the street, the scent adhering to the skins of your neighbors like some blistering oil. And so much *handling* of corpses. To this day, it is the part of dying that I resent the most. This making free with the body, washing it, combing its hair, flipping it over to do the backside. Dragging it upstairs by its heels, perhaps, or kissing it. I do not share a tribal taste for matters funerary. Still, it ought not astonish that the survivors embrace and join not unwillingly in the rituals of death. What more tangible proof of one's own existence? He yet lives who bears the pall.

Sitting on the banks of the river, you grew used to departures, threatened and real. You watched so many pretty boats pass from view. It did not make it easier to bear.

Bobby Kinnicut was twelve when he drowned in the river. My brother Billy, Freddy Shires, Bobby, and I had sneaked off to go eel fishing. We did not see Bobby tumble. We heard only that single splash, as though a muskrat had jumped into the water. Bobby never once came up. Then we saw his empty shoe floating upside down, just beyond reach. We ran to follow it.

"I'll catch it," said Billy, "with my fishing line. Don't worry, Bobby," he called. "Here I come."

As though catching the shoe would somehow be the same as pulling Bobby out of the water; as though by some magic, once caught, the shoe would be found to contain a foot which would be attached to Bobby. And he would be saved.

"Dear God," I thought, "please let him catch it."

At the very least, the shoe was a fact that, no matter how dreadful, must be retrieved from the river, as we had retrieved so many twig boats.

Billy snagged the shoe and reeled it in. He carried it that way, swinging from a hook. Freddy and I had the eels. We ran home and rang the Kinnicuts' doorbell. Mrs. Kinnicut opened the door and sagged against it when she saw that shoe dangling from the line. It looked like a flag that had been hung upside down to announce defeat. Later, Mrs. Kinnicut told Mother that she had known the day before it happened. She had received the message in a dream, she said. Mother nodded, understanding completely. All of the women of Troy were witches then.

"How I hate that old brute," said Mother. "I wish it would dry up."

The thought made me gasp. I tried to picture the Hudson like an empty eye socket or a dry trough down into which you could *walk*, just the way you could walk anyplace. A dead gully without lit, without sprint. What an awful thing to say, I thought. Besides, Billy and I didn't really believe that Bobby was drowned in any "all gone" or "nevermore" sense. For us he had become a kind of river nymph, wearing fish at his nose, scratching the bottom for nickels and dimes.

It was the river (I am sure of it) that made the men of Troy fight in the streets, and the women feed the pigeons. At the end of our block, where King Street and Jacob Street came together, there was a sloping square at the center of which stood a stone horse-trough. Here, two neighborhood women came to feed the pigeons. Mrs. Shires and Mrs. Russell could have been sisters, each one grayish white, plump, cooing. And each with her fringed shawl. Only their styles were different. Mrs. Shires was a shy disburser, frigid almost. From arms straight-elbowed, straight-wristed, without the least flair, she would let fall her crumbs. Having run out of grain, she

would march away without a single backward glance at the frenzy she had raised. With Mrs. Russell, clearly, something else was going on. Her passionate scatterings were unbridled. Slowly at first, then faster and faster, she would cast about, hands teasing through the curtain of birds, until with a reckless pirouette, she would give up her last bit. "All gone!" she would cry, and hold up her empty hands. "See?" For a long time she would stand with the pigeons boiling about her, spattered by them, her upturned face vacant with ecstasy.

The men of Troy fought often and with the immense generosity that only the Irish bring to brawling. They held back from each other nothing of their arms, their backs, and their long bellies. Walk in Troy in the evening, and you come upon a place of special stillness. There is a ring of quiet men. Only grunts and the thud of unseen blows, the scrabbling of shoes on the cobblestones suggest the business within the ring. Nudge between the circled watchers, and you will see them. Punch. Duck. Punch. Duck. All at once, one of the two is knocked off balance. He begins to fall, but he knows that he must not go down without pulling the other after him. Now they are rolling in bloody confabulation upon the cobblestones. These men are not ashamed to show their devotion to each other's flesh. All at once, a sigh comes from the little crowd which had hitherto been silent. It is not a sigh of sorrow or satisfaction, but rather like a mark of punctuation, a semicolon. It means that a certain point has been reached. With a single punch or kick, one of the men has gained irreversible ascendancy over the other. When you hear that sigh, you can tell who is going to win.

An hour later, you pass the tavern. You look in and see the two men toasting each other with beer. Soon, they will once again wrap around each other. This time they will sing. Outside, a woman comes with a pail and a brush. She scours the place where the cobblestones are stained with blood; then, she swings her pail to the gutter. A pink twine of scrub water races for the river.

There came the day when it was my turn. I enjoyed no great-muscled youth, but was of that frail and pallid look that is often deceptive in that it may be coincident with true good health. Barry McKenna was bigger than I by half, and with a face so handsome it seemed to have been chipped out with a clever Irish axe. He had

curly lion-colored hair and green eyes. We were fourteen and in the eighth grade. The schoolyard had become a fascist pen of cement where no citizen was safe. For a long moment, we faced each other while the ring of classmates formed and clanged shut about us. There was no escape.

"I'm going to kill you," Barry said, and smiled with immense charm.

Then we closed, or rather, he bore down upon me. I raised my hands in a facsimile of boxing, holding them together lest my arms fly apart and I embrace my tragic destiny. His first punch hit me on the ear, stung, then scattered. The second punch landed on my shoulder. Minutes went by. Barry punched. He danced away. I swung. It was my obligation to do so. I missed. And so it went. At last I slipped, groped for him, and we were down. I no longer had to stand and face him. He sat astride, steadying me with his thighs and belling like a white stag. Just beyond one massy shoulder, something wild and gold hovered, then broke in the air. Straining, I listened for the sigh of the crowd. When it came, I welcomed it as a bedouin in the desert welcomes the flies that are the herald of an oasis. I had only to wait a little longer.

"Aw, let him go, Barry." It was a voice from the ring.

"Come on, let the faggot go."

Above me, Barry hesitated, weighing, I suppose, the pros and cons of the suggestion. But the words of that spectator had done what none of Barry's punches could. And from the ground, I drew my fist and threw it upward. It hit him in the Adam's apple. With the other fist, I hit him in the chest over the breastbone. Barry paused, as though listening to a sound far-off, barely audible. And raising one terrible fist above my face, he brought it down . . . to his own chest, pressing. Then he coughed, and blood ran from his mouth, dripping from his chin. Again he coughed, and I was splashed with his blood. Awkwardly, like a fat cow, he disengaged himself from my body and struggled to his feet.

Again and again he coughed, each time raising new and meatier gobs of blood. I thought of Miss Cleary's cranberry conserve with which she paid Father for her bee-venom treatments. For a long moment, Barry and I stared at each other. Then, pale and sweating, he backed away from where I lay like a small creature that has been

ripped and clenched, and dropped in midair. The ring of faces opened, and he was gone.

"You won," Billy said later. "You made him bleed."

"No," I said. "I didn't win."

The next week, they took Barry to the Pawling Sanatorium where my cousin Florence was a patient. First, we heard that they had collapsed his lung by injecting air into his chest.

"They're using 'pneumo' on him," said Billy. The next month they took out the upper six ribs on one side of his chest. He would have to stay in bed for a year. I tried to imagine what a chest looked like without six ribs. Something staved, dented.

"He's got a cavity," said Mother to Mrs. Fogarty.

"Ah, the poor boy. Which side?"

"Both is what I hear."

"Judas Priest! If it isn't the river, it's the chest. Is there no end to it?"

A cavity! I thought of a crater in the earth where a bomb had burst. At its base a shaggy pool where pale blind snails and cheesy beetles hopped. Creatures died in it and stank. I was certain I had done it to Barry with my fist, dislodged some essential plug that had been corking up that cavity. It was all my fault.

Near the end of the year that he was supposed to stay in bed, I saw Barry again. I had gone to visit my cousin Florence. The san was just inside the city limits, as far from the river as you could go and still be in Troy. To get to the san, you had to take the Albia bus all the way to the end of the line. From there the hospital van took the handful of visitors and the patients returning from weekend passes the rest of the way. The Pawling Sanatorium was a complex of gray-shingled buildings squatting atop the highest in a range of hills. There was a main hospital of two stories and a dozen or so "cottages" strung in a broken chain about it. There it sprawled like some loose-jointed dragon that each day demanded appeasement. Each day, one more beautiful youth. Between the river and the san lay Troy, spoiling.

The hospital van was an ancient green converted truck which was doubtless so contaminated it could have been fueled by its own germs. Billy said he could smell the fever in it.

"Don't touch anything on that bus," said Mother.

The ruts and potholes in this road just *had* to be bad for the patients, shaking loose whatever bacteria had been painstakingly herded inside rings of scar, and turning them out for yet more marauding. The driver of the van was a chronic "lunger." Now and then he would cough wetly and "raise" out the driver's window.

"He's not contagious," said Billy.

"I don't care whether he is or he isn't," said Mother. "You are not to sit near an open window on the same side of the bus."

Florence was in one of the "cottages" getting "arrested" for the second time. She greeted us with a smile.

"Guess what?" she said. "My sputum is negative."

I asked a nurse whether Barry McKenna was still there and where I could find him. He was in the main building, she said.

Barry's name was one of six on the swinging double doors. From outside the room, I could hear the ruckling of phlegm sliding to and fro in hollow bronchi. I cleared my throat and went in. It was horribly bright and sunny in that room, and every window was wide open. It had something to do with the beneficial effect of country air. Searching out Barry, I eliminated the five patients whose faces I could see. The sixth lay facing the wall, turned away from the door. A towel had been wrapped around his head like a cowl and tucked into the top of his hospital gown. I bent to peer within. What lay shrouded there was scarcely more than chin and cheekbone. But I knew him.

"Hello, Barry," I said.

His eyes, green as the river, were the only things that answered. They floated briefly up to take me in, then sank back to dead center, gazing at the wall. I made no further attempt to talk, merely stood there watching the boy who had seemed to me so big and now was smaller by half than I. As though I had wrestled with an angel all of whose mass and strength had left his body and entered mine. But the price for such a grace was that I must behold the angel as he lay dying, be marked forever by his vanishing. How dignified he looked! Like a Muslim dervish all lapped in his djellaba, who turns his face to the wall when he is ready to die.

I turned to leave. Upon the sheet, one tallow hand, the fingers each a string of polished bones. They hushed me dumb. Who could imagine that currents of warm air had ever coursed among those

fingers, streamed across those translucent webs? For that hand seemed to me always to have been dead, carved from some lifeless substance and buffed smooth. All the way down that hill, I listened to the old green van cough and rattle. And I tried not to breathe.

Barry died a week later. The principal announced it at assembly. It would be nice if you all went to the wake, he said.

About the wake, three things: The coffin was open. We didn't look at each other. Barry's sister did a lot of coughing.

That evening, I walked along the river to the footbridge. I mounted the gentle ramp to the place where it went level for the long crossing. The water—very high, very black. No boat could pass under. What was that smell, sick and fenny? I had an impulse to gather twigs and start a fire to drive away whatever horrid breath was there. But I did not. Instead, I stood gripping the wooden railing, and I listened to the river gargling and spitting at the under-beams of the bridge. It was then I felt a strange urgency from my tissues to mingle with these waters, be cleaned by this river to whom one told everything, but which said nothing in return. Yes. There would be this easy leaning out into the air, a soft closing around me, above. Bobby Kinnicut was there, scoured, permeable, his hair dressed with waterweeds, charmed by the river god, and charming, sliding his moon face just beneath the surface. . . .

With a haste that to someone watching from the bank would have seemed headlong, I turned and ran from that footbridge. But even now, years later, I will awaken to a tugging as of a fishing line emerging from the water. I tremble then, and I think of the river interdigitating with the town so that one could not say where the one left off and the other began, an anastomosis at the very quick of life.

CYNTHIA OZICK
(1928–)

Cynthia Ozick was born in New York City to immigrant parents, intellectuals from the Lithuanian Jewish tradition, who owned a drugstore in the Bronx. She attended New York University and earned her M.A. at Ohio State University.

Her published works include the novels Trust, The Cannibal Galaxy, *and* The Messiah of Stockholm, *and three story collections:* Bloodshed, The Pagan Rabbi and Other Stories, *and* Levitation: Five Fictions. *In 1973, the American Academy of Arts and Letters gave her its Academy Award in Literature. Some of her many essays appeared in* Art and Ardor *(1983) and* Metaphor and Memory *(1988).*

"A Drugstore in Winter," which appeared in the New York Times Book Review *as "Spells, Wishes, Goldfish, Old School Hurts," forms part of* Art and Ardor. *Her memoir demonstrates (as do most writings in this volume) her notion that "ego is not interesting."*

■ ■ ■

A Drugstore in Winter
from ART AND ARDOR

This is about reading; a drugstore in winter; the gold leaf on the dome of the Boston State House; also loss, panic, and dread.

First, the gold leaf. (This part is a little like a turn-of-the-century pulp tale, though only a little. The ending is a surprise, but there is no plot.) Thirty years ago I burrowed in the Boston Public Library one whole afternoon, to find out—not out of curiosity—how the State House got its gold roof. The answer, like the answer to most Bostonian questions, was Paul Revere. So I put Paul Revere's gold dome into an "article," and took it (though I was just as scared by recklessness then as I am now) to *The Boston Globe*, on Washington Street. The Features Editor had a bare severe head, a closed parenthesis mouth, and silver Dickensian spectacles. He made me wait, standing, at the side of his desk while he read; there was no bone in me

that did not rattle. Then he opened a drawer and handed me fifteen dollars. Ah, joy of Homer, joy of Milton! Grub Street bliss!

The very next Sunday, Paul Revere's gold dome saw print. Appetite for more led me to a top-floor chamber in Filene's department store: Window Dressing. But no one was in the least bit dressed—it was a dumbstruck nudist colony up there, a mob of naked frozen enigmatic manikins, tall enameled skinny ladies with bald breasts and skulls, and legs and wrists and necks that horribly unscrewed. Paul Revere's dome paled beside this gold mine! A sight—mute numb Walpurgisnacht—easily worth another fifteen dollars. I had a Master's degree (thesis topic: "Parable in the Later Novels of Henry James") and a job as an advertising copywriter (9 A.M. to 6 P.M. six days a week, forty dollars per week; if you were male and had no degree at all, sixty dollars). Filene's Sale Days— Crib Bolsters! Lulla-Buys! Jonnie-Mops! Maternity Skirts with Expanding Invisible Trick Waist! And a company show; gold watches to mark the retirement of elderly Irish salesladies; for me the chance to write song lyrics (to the tune of "On Top of Old Smoky") honoring our store. But "Mute Numb Walpurgisnacht in Secret Downtown Chamber" never reached the *Globe*. Melancholy and meaning business, the Advertising Director forbade it. Grub Street was bad form, and I had to promise never again to sink to another article. Thus ended my life in journalism.

Next: reading, and certain drugstore winter dusks. These come together. It is an eon before Filene's, years and years before the Later Novels of Henry James. I am scrunched on my knees at a round glass table near a plate glass door on which is inscribed, in gold leaf Paul Revere never put there, letters that must be read backward:

ꓬϽAMЯAHꟼ WƎIV ꓘЯAꟼ

There is an evening smell of late coffee from the fountain, and all the librarians are lined up in a row on the tall stools, sipping and chattering. They have just stepped in from the cold of the Traveling Library, and so have I. The Traveling Library is a big green truck that stops, once every two weeks, on the corner of Continental Avenue, just a little way in from Westchester Avenue, not far from a house that keeps a pig. Other houses fly pigeons from their roofs, other yards have chickens, and down on Mayflower there is even a

goat. This is Pelham Bay, the Bronx, in the middle of the Depression, all cattails and weeds, such a lovely place and tender hour! Even though my mother takes me on the subway far, far downtown to buy my winter coat in the frenzy of Klein's on Fourteenth Street, and even though I can recognize the heavy power of a quarter, I don't know it's the Depression. On the trolley on the way to Westchester Square I see the children who live in the boxcar strangely set down in an empty lot some distance from Spy Oak (where a Revolutionary traitor was hanged—served him right for siding with redcoats); the lucky boxcar children dangle their stick-legs from their train-house maw and wave; how I envy them! I envy the orphans of the Gould Foundation, who have their own private swings and seesaws. Sometimes I imagine I am an orphan, and my father is an impostor pretending to be my father.

My father writes in his prescription book: *#59330 Dr. O'Flaherty Pow .60/ #59331 Dr. Mulligan Gtt .65/ #59332 Dr. Thron Tab .90.* Ninety cents! A terrifically expensive medicine; someone is really sick. When I deliver a prescription around the corner or down the block, I am offered a nickel tip. I always refuse, out of conscience; I am, after all, the Park View Pharmacy's own daughter, and it wouldn't be seemly. My father grinds and mixes powders, weighs them out in tiny snowy heaps on an apothecary scale, folds them into delicate translucent papers or meticulously drops them into gelatin capsules.

In the big front window of the Park View Pharmacy there is a startling display—goldfish bowls, balanced one on the other in amazing pyramids. A German lady enters, one of my father's cronies—his cronies are both women and men. My quiet father's eyes are water-color blue, he wears his small skeptical quiet smile and receives the neighborhood's life-secrets. My father is discreet and inscrutable. The German lady pokes a punchboard with a pin, pushes up a bit of rolled paper, and cries out—she has just won a goldfish bowl, with two swimming goldfish in it! Mr. Jaffe, the salesman from McKesson & Robbins, arrives, trailing two mists: winter steaminess and the animal fog of his cigar, which melts into the

Mr. Matthew Bruccoli, another Bronx drugstore child, has written to say that he remembers with certainty that Mr. Jaffe did not smoke. In my memory the cigar is somehow there, so I leave it.

coffee smell, the tarpaper smell, the eerie honeyed tangled drugstore smell. Mr. Jaffe and my mother and father are intimates by now, but because it is the 1930s, so long ago, and the old manners still survive, they address one another gravely as Mr. Jaffe, Mrs. Ozick, Mr. Ozick. My mother calls my father Mr. O, even at home, as in a Victorian novel. In the street my father tips his hat to ladies. In the winter his hat is a regular fedora; in the summer it is a straw boater with a black ribbon and a jot of blue feather.

What am I doing at this round glass table, both listening and not listening to my mother and father tell Mr. Jaffe about their struggle with "Tessie," the lion-eyed landlady who has just raised, threefold, in the middle of that Depression I have never heard of, the Park View Pharmacy's devouring rent? My mother, not yet forty, wears bandages on her ankles, covering oozing varicose veins; back and forth she strides, dashes, runs, climbing cellar stairs or ladders; she unpacks cartons, she toils behind drug counters and fountain counters. Like my father, she is on her feet until one in the morning, the Park View's closing hour. My mother and father are in trouble, and I don't know it. I am too happy. I feel the secret center of eternity, nothing will ever alter, no one will ever die. Through the window, past the lit goldfish, the gray oval sky deepens over our neighborhood wood, where all the dirt paths lead down to seagull-specked water. I am familiar with every frog-haunted monument: Pelham Bay Park is thronged with WPA art—statuary, fountains, immense rococo staircases cascading down a hillside, Bacchus-faced stelae— stone Roman glories afterward mysteriously razed by an avenging Robert Moses. One year—how distant it seems now, as if even the climate is past returning—the bay froze so hard that whole families, mine among them, crossed back and forth to City Island, strangers saluting and calling out in the ecstasy of the bright trudge over such a sudden wilderness of ice.

In the Park View Pharmacy, in the winter dusk, the heart in my body is revolving like the goldfish fleet-finned in their clear bowls. The librarians are still warming up over their coffee. They do not recognize me, though only half an hour ago I was scrabbling in the mud around the two heavy boxes from the Traveling Library— oafish crates tossed with a thump to the ground. One box contains magazines—*Boy's Life, The American Girl, Popular Mechanix*. But

the other, the other! The other transforms me. It is tumbled with storybooks, with clandestine intimations and transfigurations. In school I am a luckless goosegirl, friendless and forlorn. In P.S. 71 I carry, weighty as a cloak, the ineradicable knowledge of my scandal—I am cross-eyed, dumb, an imbecile at arithmetic; in P.S. 71 I am publicly shamed in Assembly because I am caught not singing Christmas carols; in P.S. 71 I am repeatedly accused of deicide. But in the Park View Pharmacy, in the winter dusk, branches blackening in the park across the road, I am driving in rapture through the Violet Fairy Book and the Yellow Fairy Book, insubstantial chariots snatched from the box in the mud. I have never been *inside* the Traveling Library; only grownups are allowed. The boxes are for the children. No more than two books may be borrowed, so I have picked the fattest ones, to last. All the same, the Violet and the Yellow are melting away. Their pages dwindle. I sit at the round glass table, dreaming, dreaming. Mr. Jaffe is murmuring advice. He tells a joke about Wrong-Way Corrigan. The librarians are buttoning up their coats. A princess, captive of an ogre, receives a letter from her swain and hides it in her bosom. I can visualize her bosom exactly—she clutches it against her chest. It is a tall and shapely vase, with a hand-painted flower on it, like the vase on the second-hand piano at home.

I am incognito. No one knows who I truly am. The teachers in P.S. 71 don't know. Rabbi Meskin, my *cheder* teacher, doesn't know. Tessie the lion-eyed landlady doesn't know. Even Hymie the fountain clerk can't know—though he understands other things better than anyone: how to tighten roller skates with a skatekey, for instance, and how to ride a horse. On Friday afternoons, when the new issue is out, Hymie and my brother fight hard over who gets to see *Life* magazine first. My brother is older than I am, and doesn't like me; he builds radios in his bedroom, he is already W2LOM, and operates his transmitter (*da-di-da-dit, da-da-di-da*) so penetratingly on Sunday mornings that Mrs. Eva Brady, across the way, complains. Mrs. Eva Brady has a subscription to *The Writer;* I fill a closet with her old copies. How to Find a Plot. Narrative and Character, the Writer's Tools. Because my brother has his ham license, I say, "I have a license too." "What kind of license?" my brother asks, falling into the trap. "Poetic license," I reply; my brother hates me, but anyhow his birthday pre-

sents are transporting: one year *Alice in Wonderland, Pinocchio* the next, then *Tom Sawyer.* I go after Mark Twain, and find *Joan of Arc* and my first satire, *Christian Science.* My mother surprises me with *Pollyanna,* the admiration of her Lower East Side childhood, along with *The Lady of the Lake.* Mrs. Eva Brady's daughter Jeannie has outgrown her Nancy Drews and Judy Boltons, so on rainy afternoons I cross the street and borrow them, trying not to march away with too many—the child of immigrants, I worry that the Bradys, true and virtuous Americans, will judge me greedy or careless. I wrap the Nancy Drews in paper covers to protect them. Old Mrs. Brady, Jeannie's grandmother, invites me back for more. I am so timid I can hardly speak a word, but I love her dark parlor; I love its black book-cases. Old Mrs. Brady sees me off, embracing books under an umbrella; perhaps she divines who I truly am. My brother doesn't care. My father doesn't notice. I think my mother knows. My mother reads the *Saturday Evening Post* and the *Woman's Home Companion;* sometimes the *Ladies' Home Journal,* but never *Good Housekeeping.* I read all my mother's magazines. My father reads *Drug Topics* and *Der Tog,* the Yiddish daily. In Louie Davidowitz's house (waiting our turn for the rabbi's lesson, he teaches me chess in *cheder*) there is a piece of furniture I am in awe of: a shining circular table that is also a revolving bookshelf holding a complete set of Charles Dickens. I borrow *Oliver Twist.* My cousins turn up with *Gulliver's Travels, Just So Stories, Don Quixote,* Oscar Wilde's *Fairy Tales,* uncannily different from the usual kind. Blindfolded, I reach into a Thanksgiving grabbag and pull out *Mrs. Leicester's School,* Mary Lamb's desolate stories of rejected children. Books spill out of rumor, exchange, miracle. In the Park View Pharmacy's lending library I discover, among the nurse romances, a browning, brittle miracle: *Jane Eyre.* Uncle Morris comes to visit (*his* drugstore is on the other side of the Bronx) and leaves behind, just like that, a three-volume Shakespeare. Peggy and Betty Provan, Scottish sisters around the corner, lend me their *Swiss Family Robinson.* Norma Foti, a whole year older, transmits a rumor about Louisa May Alcott; afterward I read *Little Women* a thousand times. Ten thousand! I am no longer incognito, not even to myself. I am Jo in her "vortex"; not Jo exactly, but some Jo-of-the-future. I am under an enchantment: who I truly am must be deferred, waited for and waited for. My father, silently filling cap-

sules, is grieving over his mother in Moscow. I write letters in Yiddish to my Moscow grandmother, whom I will never know. I will never know my Russian aunts, uncles, cousins. In Moscow there is suffering, deprivation, poverty. My mother, threadbare, goes without a new winter coat so that packages can be sent to Moscow. Her fiery justice-eyes are semaphores I cannot decipher.

Some day, when I am free of P.S. 71, I will write stories: meanwhile, in winter dusk, in the Park View, in the secret bliss of the Violet Fairy Book, I both see and do not see how these grains of life will stay forever, papa and mama will live forever, Hymie will always turn my skatekey.

Hymie, after Italy, after the Battle of the Bulge, comes back from the war with a present: *From Here to Eternity.* Then he dies, young. Mama reads *Pride and Prejudice* and every single word of Willa Cather. Papa reads, in Yiddish, all of Sholem Aleichem and Peretz. He reads Malamud's *The Assistant* when I ask him to.

Papa and mama, in Staten Island, are under the ground. Some other family sits transfixed in the sun parlor where I read *Jane Eyre* and *Little Women* and, long afterward, *Middlemarch.* The Park View Pharmacy is dismantled, turned into a Hallmark card shop. It doesn't matter! I close my eyes, or else only stare, and everything is in its place again, and everyone.

A writer is dreamed and transfigured into being by spells, wishes, goldfish, silhouettes of trees, boxes of fairy tales dropped in the mud, uncles' and cousins' books, tablets and capsules and powders, papa's Moscow ache, his drugstore jacket with his special fountain pen in the pocket, his beautiful Hebrew paragraphs, his Talmudist's rationalism, his Russian-Gymnasium Latin and German, mama's furnace-heart, her masses of memoirs, her paintings of autumn walks down to the sunny water, her braveries, her reveries, her old, old school hurts.

A writer is buffeted into being by school hurts—Orwell, Forster, Mann!—but after a while other ambushes begin: sorrows, deaths, disappointments, subtle diseases, delays, guilts, the spite of the private haters of the poetry side of life, the snubs of the glamorous, the bitterness of those for whom resentment is a daily gruel, and so on and so on; and then one day you find yourself leaning here, writing at that selfsame round glass table salvaged from the Park View

Pharmacy—writing this, an impossibility, a summary of how you came to be where you are now, and where, God knows, is that? Your hair is whitening, you are a well of tears, what you meant to do (beauty and justice) you have not done, papa and mama are under the earth, you live in panic and dread, the future shrinks and darkens, stories are only vapor, your inmost craving is for nothing but an old scarred pen, and what, God knows, is that?

HAMLIN GARLAND
(1860–1940)

Hamlin Garland grew up on a farm in Wisconsin. He attended Cedar Valley Seminary in Iowa, and worked as a carpenter, schoolteacher, and clerk. Later he reviewed books for Boston newspapers, and lived almost twenty years in New York.

He wrote over forty books, among them his classic story collection, Main-Travelled Roads. A Son of the Middle Border *(1917) is a memoir. When its companion volume,* A Daughter of the Middle Border *(1921), won the Pulitzer Prize for biography in 1922, the committee told Garland privately that the prize was actually for* A Son of the Middle Border.

By Middle Border, Garland meant the recently settled farmlands of his childhood: southwestern Wisconsin in the 1860s, northern Iowa in the 1870s, and Dakota Territory in the 1880s. These scenes take place in the 1870s in Iowa near the Minnesota border.

■ ■ ■

from A SON OF THE MIDDLE BORDER

Spring came to us that year with such sudden beauty, such sweet significance after our long and depressing winter, that it seemed a release from prison, and when at the close of a warm day in March we heard, pulsing down through the golden haze of sunset, the mellow *boom, boom, boom* of the prairie cock our hearts quickened, for this, we were told, was the certain sign of spring.

Day by day the call of this gay herald of spring was taken up by others until at last the whole horizon was ringing with a sunrise symphony of exultant song. "*Boom, boom, boom!*" called the roosters; "*cutta, cutta, wha-whoop-squaw, squawk!*" answered the hens as they fluttered and danced on the ridges—and mingled with their jocund hymn we heard at last the slender, wistful piping of the prairie lark.

With the coming of spring my duties as a teamster returned. My father put me in charge of a harrow, and with old Doll and

Queen—quiet and faithful span—I drove upon the field which I had plowed the previous October, there to plod to and fro behind my drag, while in the sky above my head and around me on the mellowing soil the life of the season thickèned.

Aided by my team I was able to study at close range the prairie roosters as they assembled for their parade. They had regular "stamping grounds" on certain ridges, where the soil was beaten smooth by the pressure of their restless feet. I often passed within a few yards of them. I can see them now, the cocks leaping and strutting, with trailing wings and down-thrust heads, displaying their bulbous orange-colored neck ornaments while the hens flutter and squawk in silly delight. All the charm and mystery of that prairie world comes back to me, and I ache with an illogical desire to recover it and hold it, and preserve it in some form for my children.—It seems an injustice that they should miss it, and yet it is probable that they are getting an equal joy of life, an equal exaltation from the opening flowers of the single lilac bush in our city back-yard or from an occasional visit to the lake in Central Park.

Dragging is even more wearisome than plowing, in some respects, for you have no handles to assist you and your heels sinking deep into the soft loam bring such unwonted strain upon the tendons of your legs that you can scarcely limp home to supper, and it seems that you cannot possibly go on another day,—but you do—at least I did.

There was something relentless as the weather in the way my soldier father ruled his sons, and yet he was neither hard-hearted nor unsympathetic. The fact is easily explained. His own boyhood had been task-filled and he saw nothing unnatural in the regular employment of his children. Having had little play-time himself, he considered that we were having a very comfortable boyhood. Furthermore the country was new and labor scarce. Every hand and foot must count under such conditions.

There are certain ameliorations to child-labor on a farm. Air and sunshine and food are plentiful. I never lacked for meat or clothing, and mingled with my records of toil are exquisite memories of the joy I took in following the changes in the landscape, in the notes of birds, and in the play of small animals on the sunny soil.

There were no pigeons on the prairie but enormous flocks of ducks came sweeping northward, alighting at sunset to feed in the fields of stubble. They came in countless myriads and often when they settled to earth they covered acres of meadow like some prodigious cataract from the sky. When alarmed they rose with a sound like the rumbling of thunder.

At times the lines of their cloud-like flocks were so unending that those in the front rank were lost in the northern sky, while those in the rear were but dim bands beneath the southern sun.—I tried many times to shoot some of them, but never succeeded, so wary were they. Brant and geese in formal flocks followed and to watch these noble birds pushing their arrowy lines straight into the north always gave me special joy. On fine days they flew high—so high they were but faint lines against the shining clouds.

I learned to imitate their cries, and often caused the leaders to turn, to waver in their course as I uttered my resounding call.

The sand-hill crane came last of all, loitering north in lonely easeful flight. Often of a warm day, I heard his sovereign cry falling from the azure dome, so high, so far his form could not be seen, so close to the sun that my eyes could not detect his solitary, majestic circling sweep. He came after the geese. He was the herald of summer. His brazen, reverberating call will forever remain associated in my mind with mellow, pulsating earth, springing grass and cloudless glorious May-time skies.

As my team moved to and fro over the field, ground sparrows rose in countless thousands, flinging themselves against the sky like grains of wheat from out a sower's hand, and their chatter fell upon me like the voices of fairy sprites, invisible and multitudinous. Long swift narrow flocks of a bird we called "the prairie-pigeon" swooped over the swells on sounding wing, winding so close to the ground, they seemed at times like slender air-borne serpents,—and always the brown lark whistled as if to cheer my lonely task.

Back and forth across the wide field I drove, while the sun crawled slowly up the sky. It was tedious work and I was always hungry by nine, and famished at ten. Thereafter the sun appeared to stand still. My chest caved in and my knees trembled with weakness, but when at last the white flag fluttering from a chamber window summoned to the mid-day meal, I started with strength miracu-

lously renewed and called, "*Dinner!*" to the hired hand. Unhitching my team, with eager haste I climbed upon old Queen, and rode at ease toward the barn.

Oh, it was good to enter the kitchen, odorous with fresh biscuit and hot coffee! We all ate like dragons, devouring potatoes and salt pork without end, till mother mildly remarked, "Boys, boys! Don't 'founder' yourselves!"

From such a meal I withdrew torpid as a gorged snake, but luckily I had half an hour in which to get my courage back,—and besides, there was always the stirring power of father's clarion call. His energy appeared superhuman to me. I was in awe of him. He kept track of everything, seemed hardly to sleep and never complained of weariness. Long before the nooning was up, (or so it seemed to me) he began to shout: "Time's up, boys. Grab a root!"

And so, lame, stiff and sore, with the sinews of my legs shortened, so that my knees were bent like an old man's, I hobbled away to the barn and took charge of my team. Once in the field, I felt better. A subtle change, a mellower charm came over the afternoon earth. The ground was warmer, the sky more genial, the wind more amiable, and before I had finished my second "round" my joints were moderately pliable and my sinews relaxed.

Nevertheless the temptation to sit on the corner of the harrow and dream the moments away was very great, and sometimes as I laid my tired body down on the tawny, sunlit grass at the edge of the field, and gazed up at the beautiful clouds sailing by, I wished for leisure to explore their purple valleys.—The wind whispered in the tall weeds, and sighed in the hazel bushes. The dried blades touching one another in the passing winds, spoke to me, and the gophers, glad of escape from their dark, underground prisons, chirped a cheery greeting. Such respites were strangely sweet.

So day by day, as I walked my monotonous round upon the ever mellowing soil, the prairie spring unrolled its beauties before me. I saw the last goose pass on to the north, and watched the green grass creeping up the sunny slopes. I answered the splendid challenge of the loitering crane, and studied the ground sparrow building her grassy nest. The prairie hens began to seek seclusion in the swales, and the pocket gopher, busily mining the sod, threw up his purple-brown mounds of cool fresh earth. Larks, blue-birds and king-birds

followed the robins, and at last the full tide of May covered the world with luscious green.

Harriet and Frank returned to school but I was too valuable to be spared. . . .

The snows fell deep in February and when at last the warm March winds began to blow, lakes developed with magical swiftness in the fields, and streams filled every swale, transforming the landscape into something unexpected and enchanting. At night these waters froze, bringing fields of ice almost to our door. We forgot all our other interests in the joy of the games which we played thereon at every respite from school, or from the wood-pile, for splitting fire-wood was our first spring task.

From time to time as the weather permitted, father had been cutting and hauling maple and hickory logs from the forests of the Cedar River, and these logs must now be made into stove-wood and piled for summer use. Even before the school term ended we began to take a hand at this work, after four o'clock and on Saturdays. While the hired man and father ran the cross-cut saw, whose pleasant song had much of the seed-time suggestion which vibrated in the *caw-caw* of the hens as they burrowed in the dust of the chipyard, I split the easy blocks and my brother helped to pile the finished product.

The place where the wood-pile lay was slightly higher than the barnyard and was the first dry ground to appear in the almost universal slush and mud. Delightful memories are associated with this sunny spot and with a pond which appeared as if by some conjury, on the very field where I had husked the down-row so painfully in November. From the wood-pile I was often permitted to go skating and Burton was my constant companion in these excursions. However, my joy in his companionship was not unmixed with bitterness, for I deeply envied him the skates which he wore. They were trimmed with brass and their runners came up over his toes in beautiful curves and ended in brass acorns which transfigured their wearer. To own a pair of such skates seemed to me the summit of all earthly glory.

My own wooden "contraptions" went on with straps and I could not make the runners stay in the middle of my soles where they

belonged, hence my ankles not only tipped in awkwardly but the stiff outer edges of my boot counters dug holes in my skin so that my outing was a kind of torture after all. Nevertheless, I persisted and, while Burton circled and swooped like a hawk, I sprawled with flapping arms in a mist of ignoble rage. That I learned to skate fairly well even under these disadvantages argues a high degree of enthusiasm.

Father was always willing to release us from labor at times when the ice was fine, and at night we were free to explore the whole country round about, finding new places for our games. Sometimes the girls joined us, and we built fires on the edges of the swales and played "gool" and a kind of "shinny" till hunger drove us home.

We held to this sport to the last—till the ice with prodigious booming and cracking fell away in the swales and broke through the icy drifts (which lay like dams along the fences) and vanished, leaving the corn-rows littered with huge blocks of ice. Often we came in from the pond, wet to the middle, our boots completely soaked with water. They often grew hard as iron during the night, and we experienced the greatest trouble in getting them on again. Greasing them with hot tallow was a regular morning job.

Then came the fanning mill. The seed grain had to be fanned up, and that was a dark and dusty "trick" which we did not like anything near as well as we did skating or even piling wood. The hired man turned the mill, I dipped the wheat into the hopper, Franklin held sacks and father scooped the grain in. I don't suppose we gave up many hours to this work, but it seems to me that we spent weeks at it. Probably we took spells at the mill in the midst of the work on the chip pile.

Meanwhile, above our heads the wild ducks again pursued their northward flight, and the far honking of the geese fell to our ears from the solemn deeps of the windless night. On the first dry warm ridges the prairie cocks began to boom, and then at last came the day when father's imperious voice rang high in familiar command. "Out with the drags, boys! We start seeding tomorrow."

Again we went forth on the land, this time to wrestle with the tough, unrotted sod of the new breaking, while all around us the larks and plover called and the gray badgers stared with disapproving bitterness from their ravaged hills.

Maledictions on that tough northwest forty! How many times I harrowed and cross-harrowed it I cannot say, but I well remember the maddening persistency with which the masses of hazel roots clogged the teeth of the drag, making it necessary for me to raise the corner of it—a million times a day! This had to be done while the team was in motion, and you can see I did not lack for exercise. It was necessary also to "lap-half" and this requirement made careful driving needful for father could not be fooled. He saw every "balk."

As the ground dried off the dust arose from under the teeth of the harrow and flew so thickly that my face was not only coated with it but tears of rebellious rage stained my cheeks with comic lines. At such times it seemed unprofitable to be the twelve-year-old son of a western farmer.

One day, just as the early sown wheat was beginning to throw a tinge of green over the brown earth, a tremendous wind arose from the southwest and blew with such devastating fury that the soil, caught up from the field, formed a cloud, hundreds of feet high,—a cloud which darkened the sky, turning noon into dusk and sending us all to shelter. All the forenoon this blizzard of loam raged, filling the house with dust, almost smothering the cattle in the stable. Work was impossible, even for the men. The growing grain, its roots exposed to the air, withered and died. Many of the smaller plants were carried bodily away.

As the day wore on father fell into dumb, despairing rage. His rigid face and smoldering eyes, his grim lips, terrified us all. It seemed to him (as to us), that the entire farm was about to take flight and the bitterest part of the tragic circumstance lay in the reflection that our loss (which was much greater than any of our neighbors) was due to the extra care with which we had pulverized the ground.

"If only I hadn't gone over it that last time," I heard him groan in reference to the "smooch" with which I had crushed all the lumps making every acre friable as a garden. "Look at Woodring's!"

Sure enough. The cloud was thinner over on Woodring's side of the line fence. His rough clods were hardly touched. My father's bitter revolt, his impotent fury appalled me, for it seemed to me (as to him), that nature was, at the moment, an enemy. More than seventy acres of this land had to be resown.

Most authors in writing of "the merry merry farmer" leave out experiences like this—they omit the mud and the dust and the grime, they forget the army worm, the flies, the heat, as well as the smells and drudgery of the barns. Milking the cows is spoken of in the traditional fashion as a lovely pastoral recreation, when as a matter of fact it is a tedious job. We all hated it. We saw no poetry in it. We hated it in summer when the mosquitoes bit and the cows slashed us with their tails, and we hated it still more in the winter time when they stood in crowded malodorous stalls.

In summer when the flies were particularly savage we had a way of jamming our heads into the cows' flanks to prevent them from kicking into the pail, and sometimes we tied their tails to their legs so that they could not lash our ears. Humboldt Bunn tied a heifer's tail to his boot straps once—and regretted it almost instantly.—No, no, it won't do to talk to me of "the sweet breath of kine." I know them too well—and calves are not "the lovely, fawn-like creatures" they are supposed to be. To the boy who is teaching them to drink out of a pail they are nasty brutes—quite unlike fawns. They have a way of filling their nostrils with milk and blowing it all over their nurse. They are greedy, noisy, ill-smelling and stupid. They look well when running with their mothers in the pasture, but as soon as they are weaned they lose all their charm—for me.

Attendance on swine was less humiliating for the reason that we could keep them at arm's length, but we didn't enjoy that. We liked teaming and pitching hay and harvesting and making fence, and we did not greatly resent plowing or husking corn but we did hate the smell, the filth of the cow-yard. Even hostling had its "outs," especially in spring when the horses were shedding their hair. I never fully enjoyed the taste of equine dandruff, and the eternal smell of manure irked me, especially at the table.

Clearing out from behind the animals was one of our never ending jobs, and hauling the compost out on the fields was one of the tasks which, as my father grimly said, "We always put off till it rains so hard we can't work out doors." This was no joke to us, for not only did we work out doors, we worked while standing ankle deep in the slime of the yard, getting full benefit of the drizzle. Our new land did not need the fertilizer, but we were forced to haul it away or move the barn. Some folks moved the barn. But then my father was an idealist.

Life was not all currying or muck-raking for Burt or for me. Herding the cows came in to relieve the monotony of farm-work. Wide tracts of unbroken sod still lay open to the north and west, and these were the common grazing grounds for the community. Every farmer kept from twenty-five to a hundred head of cattle and half as many colts, and no sooner did the green begin to show on the fire-blackened sod in April than the winter-worn beasts left the straw-piles under whose lee they had fed during the cold months, and crawled out to nip the first tender spears of grass in the sheltered swales. They were still "free commoners" in the eyes of the law.

The colts were a fuzzy, ungraceful lot at this season. Even the best of them had big bellies and carried dirty and tangled manes, but as the grazing improved, as the warmth and plenty of May filled their veins with new blood, they sloughed off their mangy coats and lifted their wide-blown nostrils to the western wind in exultant return to freedom. Many of them had never felt the weight of a man's hand and even those that had wintered in and around the barn-yard soon lost all trace of domesticity. It was not unusual to find that the wildest and wariest of all the leaders bore a collar mark or some other ineffaceable badge of previous servitude.

They were for the most part Morgan grades or "Canuck," with a strain of broncho to give them fire. It was curious, it was glorious to see how deeply-buried instincts broke out in these halterless herds. In a few days, after many trials of speed and power the bands of all the region united into one drove, and a leader, the swiftest and most tireless of them all, appeared from the ranks and led them at will.

Often without apparent cause, merely for the joy of it, they left their feeding grounds to wheel and charge and race for hours over the swells, across the creeks and through the hazel thickets. Sometimes their movements arose from the stinging of gadflies, sometimes from a battle between two jealous leaders, sometimes from the passing of a wolf—often from no cause at all other than that of abounding vitality.

In much the same fashion, but less rapidly, the cattle went forth upon the plain and as each herd not only contained the growing steers, but the family cows, it became the duty of one boy from each farm to mount a horse at five o'clock every afternoon and "hunt the cattle," a task seldom shirked. My brother and I took turn and turn

about at this delightful task, and soon learned to ride like Comanches. In fact we lived in the saddle, when freed from duty in the field. Burton often met us on the feeding grounds, and at such times the prairie seemed an excellent place for boys. As we galloped along together it was easy to imagine ourselves Wild Bill and Buckskin Joe in pursuit of Indians or buffalo.

We became, by force of unconscious observation, deeply learned in the language and the psychology of kine as well as colts. We watched the big bull-necked stags as they challenged one another, pawing the dust or kneeling to tear the sod with their horns. We possessed perfect understanding of their battle signs. Their boastful, defiant cries were as intelligible to us as those of men. Every note, every motion had a perfectly definite meaning. The foolish, inquisitive young heifers, the staid self-absorbed dowagers wearing their bells with dignity, the frisky two-year-olds and the lithe-bodied wide-horned truculent three-year-olds all came in for interpretation.

Sometimes a lone steer ranging the sod came suddenly upon a trace of blood. Like a hound he paused, snuffling the earth. Then with wide mouth and outthrust, curling tongue, uttered voice. Wild as the tiger's food-sick cry, his warning roar burst forth, ending in a strange, upward explosive whine. Instantly every head in the herd was lifted, even the old cows heavy with milk stood as if suddenly renewing their youth, alert and watchful.

Again it came, that prehistoric bawling cry, and with one mind the herd began to center, rushing with menacing swiftness, like warriors answering their chieftain's call for aid. With awkward lope or jolting trot, snorting with fury they hastened to the rescue, only to meet in blind bewildered mass, swirling to and fro in search of an imaginary cause of some ancestral danger.

At such moments we were glad of our swift ponies. From our saddles we could study these outbreaks of atavistic rage with serene enjoyment.

In herding the cattle we came to know all the open country round about and found it very beautiful. On the uplands a short, light-green, hair-like grass grew, intermixed with various resinous weeds, while in the lowland feeding grounds luxuriant patches of blue-joint, wild oats, and other tall forage plants waved in the wind.

Along the streams and in the "sloos" cat-tails and tiger-lilies nodded above thick mats of wide-bladed marsh grass.—Almost without realizing it, I came to know the character of every weed, every flower, every living thing big enough to be seen from the back of a horse.

Nothing could be more generous, more joyous, than these natural meadows in summer. The flash and ripple and glimmer of the tall sunflowers, the myriad voices of gleeful bobolinks, the chirp and gurgle of red-winged blackbirds swaying on the willows, the meadow-larks piping from grassy bogs, the peep of the prairie chick and the wailing call of plover on the flowery green slopes of the uplands made it all an ecstatic world to me. It was a wide world with a big, big sky which gave alluring hint of the still more glorious unknown wilderness beyond.

Sometimes of a Sunday afternoon, Harriet and I wandered away to the meadows along Dry Run, gathering bouquets of pinks, sweet-williams, tiger-lilies and lady-slippers, thus attaining a vague perception of another and sweeter side of life. The sun flamed across the splendid serial waves of the grasses and the perfumes of a hundred spicy plants rose in the shimmering mid-day air. At such times the mere joy of living filled our young hearts with wordless satisfaction.

Nor were the upland ridges less interesting, for huge antlers lying bleached and bare in countless numbers on the slopes told of the herds of elk and bison that had once fed in these splendid savannahs, living and dying in the days when the tall Sioux were the only hunters.

The gray hermit, the badger, still clung to his deep den on the rocky unplowed ridges, and on sunny April days the mother fox lay out with her young, on southward-sloping swells. Often we met the prairie wolf or startled him from his sleep in hazel copse, finding in him the spirit of the wilderness. To us it seemed that just over the next long swell toward the sunset the shaggy brown bulls still fed in myriads, and in our hearts was a longing to ride away into the "sunset regions" of our song.

All the boys I knew talked of Colorado, never of New England. We dreamed of the plains, of the Black Hills, discussing cattle raising and mining and hunting. "We'll have our rifles ready, boys, ha,

ha, ha-ha!" was still our favorite chorus, "Newbrasky" and Wyoming our far-off wonderlands, Buffalo Bill our hero.

David, my hunter uncle who lived near us, still retained his long old-fashioned, muzzle-loading rifle, and one day offered it to me, but as I could not hold it at arm's length, I sorrowfully returned it. We owned a shotgun, however, and this I used with all the confidence of a man. I was able to kill a few ducks with it and I also hunted gophers during May when the sprouting corn was in most danger. Later I became quite expert in catching chickens on the wing.

On a long ridge to the north and west, the soil, too wet and cold to cultivate easily, remained unplowed for several years and scattered over these clay lands stood small groves of popple trees which we called "tow-heads." They were usually only two or three hundred feet in diameter, but they stood out like islands in the waving seas of grasses. Against these dark-green masses, breakers of blue-joint radiantly rolled.—To the east some four miles ran the Little Cedar River, and plum trees and crabapples and haws bloomed along its banks. In June immense crops of strawberries offered from many meadows. Their delicious odor rose to us as we rode our way, tempting us to dismount and gather and eat.

Over these uplands, through these thickets of hazel brush, and around these coverts of popple, Burton and I careered, hunting the cows, chasing rabbits, killing rattlesnakes, watching the battles of bulls, racing the half-wild colts and pursuing the prowling wolves. It was an alluring life, and Harriet, who rode with us occasionally, seemed to enjoy it quite as much as any boy. She could ride almost as well as Burton, and we were all expert horse-tamers.

We all rode like cavalrymen,—that is to say, while holding the reins in our left hands we guided our horses by the pressure of the strap across the neck, rather than by pulling at the bit. Our ponies were never allowed to trot. We taught them a peculiar gait which we called "the lope," which was an easy canter in front and a trot behind (a very good gait for long distances), and we drilled them to keep this pace steadily and to fall at command into a swift walk without any jolting intervening trot.—We learned to ride like circus performers standing on our saddles, and practised other of the

tricks we had seen, and through it all my mother remained unalarmed. To her a boy on a horse was as natural as a babe in the cradle. The chances we took of getting killed were so numerous that she could not afford to worry.

Burton continued to be my almost inseparable companion at school and whenever we could get together, and while to others he seemed only a shy, dull boy, to me he was something more. His strength and skill were remarkable and his self-command amazing. Although a lad of instant, white-hot, dangerous temper, he suddenly, at fifteen years of age, took himself in hand in a fashion miraculous to me. He decided (I never knew just why or how)— that he would never again use an obscene or profane word. He kept his vow. I knew him for over thirty years and I never heard him raise his voice in anger or utter a word a woman would have shrunk from,—and yet he became one of the most fearless and indomitable mountaineers I ever knew.

This change in him profoundly influenced me and though I said nothing about it, I resolved to do as well. I never quite succeeded, although I discouraged as well as I could the stories which some of the men and boys were so fond of telling, but alas! when the old cow kicked over my pail of milk, I fell from grace and told her just what I thought of her in phrases that Burton would have repressed. Still, I manfully tried to follow his good trail.

Cornplanting, which followed wheat-seeding, was done by hand, for a year or two, and this was a joyous task.—We "changed works" with neighbor Button, and in return Cyrus and Eva came to help us. Harriet and Eva and I worked side by side, "dropping" the corn, while Cyrus and the hired man followed with the hoes to cover it. Little Frank skittered about, planting with desultory action such pumpkin seeds as he did not eat. The presence of our young friends gave the job something of the nature of a party and we were sorry when it was over.

After the planting a fortnight of less strenuous labor came on, a period which had almost the character of a holiday. The wheat needed no cultivation and the corn was not high enough to plow. This was a time for building fence and fixing up things generally. This, too, was the season of the circus. Each year one came along

from the east, trailing clouds of glorified dust and filling our minds with the color of romance.

From the time the "advance man" flung his highly colored posters over the fence till the coming of the glorious day we thought of little else. It was India and Arabia and the jungle to us. History and the magic and pomp of chivalry mingled in the parade of the morning, and the crowds, the clanging band, the haughty and alien beauty of the women, the gold embroidered housings, the stark majesty of the acrobats subdued us into silent worship.

I here pay tribute to the men who brought these marvels to my eyes. To rob me of my memories of the circus would leave me as poor as those to whom life was a drab and hopeless round of toil. It was our brief season of imaginative life. In one day—in a part of one day—we gained a thousand new conceptions of the world and of human nature. It was an embodiment of all that was skillful and beautiful in manly action. It was a compendium of biologic research but more important still, it brought to our ears the latest band pieces and taught us the most popular songs. It furnished us with jokes. It relieved our dullness. It gave us something to talk about.

We always went home wearied with excitement, and dusty and fretful—but content. We had seen it. We had grasped as much of it as anybody and could remember it as well as the best. Next day as we resumed work in the field the memory of its splendors went with us like a golden cloud.

Most of the duties of the farmer's life require the lapse of years to seem beautiful in my eyes, but haying was a season of well-defined charm. In Iowa, summer was at its most exuberant stage of vitality during the last days of June, and it was not strange that the faculties of even the toiling hay-maker, dulled and deadened with never ending drudgery, caught something of the superabundant glow and throb of nature's life.

As I write I am back in that marvellous time.—The cornfield, dark-green and sweetly cool, is beginning to ripple in the wind with multitudinous stir of shining, swirling leaf. Waves of dusk and green and gold, circle across the ripening barley, and long leaves upthrust, at intervals, like spears. The trees are in heaviest foliage, insect life is

at its height, and the shimmering air is filled with buzzing, dancing forms, and the clover is gay with the sheen of innumerable gauzy wings.

The west wind comes to me laden with ecstatic voices. The bobolinks sail and tinkle in the sensuous hush, now sinking, now rising, their exquisite notes filling the air as with the sound of fairy bells. The king-bird, alert, aggressive, cries out sharply as he launches from the top of a poplar tree upon some buzzing insect, and the plover makes the prairie sad with his wailing call. Vast purple-and-white clouds move like stately ships before the breeze, dark with rain, which they drop momentarily in trailing garments upon the earth, and so pass in majesty amidst a roll of thunder.

The grasshoppers move in clouds with snap and buzz, and out of the luxurious stagnant marshes comes the ever-thickening chorus of the toads, while above them the kildees and the snipe shuttle to and fro in sounding flight. The blackbirds on the cat-tails sway and swing, uttering through lifted throats their liquid gurgle, mad with delight of the sun and the season—and over all, and laving all, moves the slow wind, heavy with the breath of the far-off blooms of other lands, a wind which covers the sunset plain with a golden entrancing haze.

At such times it seemed to me that we had reached the "sunset region" of our song, and that we were indeed "lords of the soil."

I am not so sure that haying brought to our mothers anything like this rapture, for the men added to our crew made the duties of the kitchens just that much heavier. I doubt if the women—any of them—got out into the fields or meadows long enough to enjoy the birds and the breezes. Even on Sunday as they rode away to church, they were too tired and too worried to re-act to the beauties of the landscape.

I now began to dimly perceive that my mother was not well. Although large and seemingly strong, her increasing weight made her long days of housework a torture. She grew very tired and her sweet face was often knotted with physical pain.

She still made most of our garments as well as her own. She tailored father's shirts and underclothing, sewed carpet rags, pieced quilts and made butter for market,—and yet, in the midst of it all, found time to put covers on our baseball, and to do up all our burns

and bruises. Being a farmer's wife in those days, meant laboring outside any regulation of the hours of toil. I recall hearing one of the tired housewives say, "Seems like I never get a day off, not even on Sunday," a protest which my mother thoroughly understood and sympathized with, notwithstanding its seeming inhospitality.

FRANK CONROY
(1936–)

Frank Conroy was born in New York and attended Haverford College. His memoir Stop-time *appeared in 1967; it seemed to fly from his typewriter directly into the literary canon. In 1985, he brought out the story collection* Midair, *and in 1993, the novel* Body & Soul.

He has worked as a journalist and as a jazz pianist. From 1981 to 1987 he was director of the literary programs at the National Endowment for the Arts. Now he directs the University of Iowa Writers' Workshop.

Stop-time *recalls his boyhood in the late 1940s. He grew up under makeshift conditions, mostly in Florida and New York. Here he is in Florida.*

■ ■ ■

from STOP-TIME

Is it the mindlessness of childhood that opens up the world? Today nothing happens in a gas station. I'm eager to leave, to get where I'm going, and the station, like some huge paper cutout, or a Hollywood set, is simply a façade. But at thirteen, sitting with my back against the wall, it was a marvelous place to be. The delicious smell of gasoline, the cars coming and going, the free air hose, the half-heard voices buzzing in the background—these things hung musically in the air, filling me with a sense of well-being. In ten minutes my psyche would be topped up like the tanks of the automobiles.

Downtown the streets were crowded with shoppers. I cut in and out between the slow-moving cars, enjoying my superior mobility. At a red light I took hold of the tailgate of a chicken truck and let it pull me a couple of blocks. Peeling off at the foot of Los Olas Boulevard, I coasted up to the bike rack in front of the Sunset Theater.

It cost nine cents to get in. I bought my ticket, paused in the lobby to select a Powerhouse candy bar, and climbed to the balcony.

The theater was almost empty and no one objected when I draped my legs over the seat in front. On the screen was a western, with Randolph Scott as the sheriff. I recognized a cheap process called Trucolor and hissed spontaneously, smiling foolishly at the empty darkness around me afterwards. Except for the gunfights the film was dull and I amused myself finding anachronisms.

The feature was better, an English movie with Ann Todd as a neurotic pianist and James Mason as her teacher. I was sorry when the house lights came on.

Outside, blinking against the sun, I left my bike in the rack and wandered down the street. Something was happening in front of the dime store. I could see a crowd of kids gathered at the doors and a policeman attempting to keep order. I slipped inside behind his back. The place was a madhouse, jammed with hundreds of shrieking children, all pressing toward one of the aisles where some kind of demonstration was going on.

"What's happening?" I asked a kid as I elbowed past.

"It's Ramos and Ricardo," he shouted. "The twins from California."

I pushed my way to the front rank and looked up at the raised platform.

There, under a spotlight, two Oriental gentlemen in natty blue suits were doing some amazing things with yo-yos. Tiny, neat men, no bigger than children, they stared abstractedly off into space while yo-yos flew from their hands, zooming in every direction as if under their own power, leaping out from small fists in arcs, circles, and straight lines. I stared open-mouthed as a yo-yo was thrown down and *stayed down*, spinning at the end of its string a fraction of an inch above the floor.

"Walking the Dog," said the twin, and lowered his yo-yo to the floor. It skipped along beside him for a yard or so and mysteriously returned to his palm.

"The Pendulum," said the other twin, and threw down a yo-yo. "Sleeping," he said, pointing to the toy as it spun at the end of its string. He gathered the line like so much loose spaghetti, making a kind of cat's cradle with his fingers, and gently rocked the spinning yo-yo back and forth through the center. "Watch end of trick closely," he said smiling, and suddenly dropped everything. Instead

of the tangled mess we'd all expected the yo-yo wound up safely in his palm.

"Loop-the-Loop." He threw a yo-yo straight ahead. When it returned he didn't catch it, but executed a subtle flick of his wrist and sent it back out again. Five, ten, twenty times. "Two Hands Loop-the-Loop," he said, adding another, alternating so that as one flew away from his right hand the other flew in toward his left.

"Pickpocket," said the other twin, raising the flap of his jacket. He threw the yo-yo between his legs, wrapping the string around his thigh. As he looked out over the crowd the yo-yo dropped, perfectly placed, in his trouser pocket. Laughing, the kids applauded.

I spent the whole afternoon in one spot, watching them, not even moving when they took breaks for fear I'd lose my place. When it was over I spent my last money on a yo-yo, a set of extra strings, and a pamphlet explaining all the tricks, starting from the easiest and working up to the hardest.

Walking back to the bike I was so absorbed a mail truck almost ran me down. I did my first successful trick standing by the rack, a simple but rather spectacular exercise called Around the World. Smiling, I put the yo-yo in my pocket and pulled out the bike. I knew I was going to be good at it.

The common yo-yo is crudely made, with a thick shank between two widely spaced wooden disks. The string is knotted or stapled to the shank. With such an instrument nothing can be done except the simple up-down movement. My yo-yo, on the other hand, was a perfectly balanced construction of hard wood, slightly weighted, flat, with only a sixteenth of an inch between the halves. The string was not attached to the shank, but looped over it in such a way as to allow the wooden part to spin freely on its own axis. The gyroscopic effect thus created kept the yo-yo stable in all attitudes.

I started at the beginning of the book and quickly mastered the novice, intermediate, and advanced stages, practicing all day every day in the woods across the street from my house. Hour after hour of practice, never moving to the next trick until the one at hand was mastered.

The string was tied to my middle finger, just behind the nail. As I threw—with your palm up, make a fist; throw down your hand,

fingers unfolding, as if you were casting grain—a short bit of string would tighten across the sensitive pad of flesh at the tip of my finger. That was the critical area. After a number of weeks I could interpret the condition of the string, the presence of any imperfections on the shank, but most importantly the exact amount of spin or inertial energy left in the yo-yo at any given moment—all from that bit of string on my fingertip. As the throwing motion became more and more natural I found I could make the yo-yo "sleep" for an astonishing length of time—fourteen or fifteen seconds—and still have enough spin left to bring it back to my hand. Gradually the basic moves became reflexes. Sleeping, twirling, swinging, and precise aim. Without thinking, without even looking, I could run through trick after trick involving various combinations of the elemental skills, switching from one to the other in a smooth continuous flow. On particularly good days I would hum a tune under my breath and do it all in time to the music.

Flicking the yo-yo expressed something. The sudden, potentially comic extension of one's arm to twice its length. The precise neatness of it, intrinsically soothing, as if relieving an inner tension too slight to be noticeable, the way a man might hitch up his pants simply to enact a reassuring gesture. It felt good. The comfortable weight in one's hand, the smooth, rapid descent down the string, ending with a barely audible snap as the yo-yo hung balanced, spinning, pregnant with force and the slave of one's fingertip. That it was vaguely masturbatory seems inescapable. I doubt that half the pubescent boys in America could have been captured by any other means, as, in the heat of the fad, half of them were. A single Loop-the-Loop might represent, in some mysterious way, the act of masturbation, but to break down the entire repertoire into the three stages of throw, trick, and return representing erection, climax, and detumescence seems immoderate.

The greatest pleasure in yo-yoing was an abstract pleasure—watching the dramatization of simple physical laws, and realizing they would never fail if a trick was done correctly. The geometric purity of it! The string wasn't just a string, it was a tool in the enactment of theorems. It was a line, an idea. And the top was an entirely different sort of idea, a gyroscope, capable of storing energy and of interacting with the line. I remember the first time I did a particu-

larly lovely trick, one in which the sleeping yo-yo is swung from right to left while the string is interrupted by an extended index finger. Momentum carries the yo-yo in a circular path around the finger, but instead of completing the arc the yo-yo falls on the taut string between the performer's hands, where it continues to spin in an upright position. My pleasure at that moment was as much from the beauty of the experiment as from pride. Snapping apart my hands I sent the yo-yo into the air above my head, bouncing it off nothing, back into my palm.

I practiced the yo-yo because it pleased me to do so, without the slightest application of will power. It wasn't ambition that drove me, but the nature of yo-yoing. The yo-yo represented my first organized attempt to control the outside world. It fascinated me because I could see my progress in clearly defined stages, and because the intimacy of it, the almost spooky closeness I began to feel with the instrument in my hand, seemed to ensure that nothing irrelevant would interfere. I was, in the language of jazz, "up tight" with my yo-yo, and finally free, in one small area at least, of the paralyzing sloppiness of life in general.

The first significant problem arose in the attempt to do fifty consecutive Loop-the-Loops. After ten or fifteen the yo-yo invariably started to lean and the throws became less clean, resulting in loss of control. I almost skipped the whole thing because fifty seemed excessive. Ten made the point. But there it was, written out in the book. To qualify as an expert you had to do fifty, so fifty I would do.

It took me two days, and I wouldn't have spent a moment more. All those Loop-the-Loops were hard on the strings. Time after time the shank cut them and the yo-yo went sailing off into the air. It was irritating, not only because of the expense (strings were a nickel each, and fabricating your own was unsatisfactory), but because a random element had been introduced. About the only unforeseeable disaster in yo-yoing was to have your string break, and here was a trick designed to do exactly that. Twenty-five would have been enough. If you could do twenty-five clean Loop-the-Loops you could do fifty or a hundred. I supposed they were simply trying to sell strings and went back to the more interesting tricks.

The witty nonsense of Eating Spaghetti, the surprise of The

Twirl, the complex neatness of Cannonball, Backwards round the World, or Halfway round the World—I could do them all, without false starts or sloppy endings. I could do every trick in the book. Perfectly.

The day was marked on the kitchen calendar (God Gave Us Bluebell Natural Bottled Gas). I got on my bike and rode into town. Pedaling along the highway I worked out with the yo-yo to break in a new string. The twins were appearing at the dime store.

I could hear the crowd before I turned the corner. Kids were coming on bikes and on foot from every corner of town, rushing down the streets like madmen. Three or four policemen were busy keeping the street clear directly in front of the store, and in a small open space around the doors some of the more adept kids were running through their tricks, showing off to the general audience or stopping to compare notes with their peers. Standing at the edge with my yo-yo safe in my pocket, it didn't take me long to see I had them all covered. A boy in a sailor hat could do some of the harder tricks, but he missed too often to be a serious threat. I went inside.

As Ramos and Ricardo performed I watched their hands carefully, noticing little differences in style and technique. Ricardo was a shade classier, I thought, although Ramos held an edge in the showy two-handed stuff. When they were through we went outside for the contest.

"Everybody in the alley!" Ramos shouted, his head bobbing an inch or two above the others. "Contest starting now in the alley!" A hundred excited children followed the twins into an alley beside the dime store and lined up against the wall.

"Attention all kids!" Ramos yelled, facing us from the middle of the street like a drill sergeant. "To qualify for contest you got to Rock the Cradle. You got to rock yo-yo in cradle four time. Four time! Okay? Three time no good. Okay. Everybody happy?" There were murmurs of disappointment and some of the kids stepped out of line. The rest of us closed ranks. Yo-yos flicked nervously as we waited. "Winner receive grand prize. Special Black Beauty Prize Yo-Yo with Diamonds," said Ramos, gesturing to his brother who smiled and held up the prize, turning it in the air so we could see the four stones set on each side. ("The crowd gasped . . ." I want to

write. Of course they didn't. They didn't make a sound, but the impact of the diamond yo-yo was obvious.) We'd never seen anything like it. One imagined how the stones would gleam as it revolved, and how much prettier the tricks would be. The ultimate yo-yo! The only one in town! Who knew what feats were possible with such an instrument? All around me a fierce, nervous resolve was settling into the contestants, suddenly skittish as racehorses.

"Ricardo will show trick with Grand Prize Yo-Yo. Rock the Cradle four time!"

With a perfect, fluid movement Ricardo threw down the yo-yo, gathered the string and leisurely rocked the cradle.

"One!" cried Ramos.

"Two!" the kids joined in.

"Three!" It was really beautiful. He did it so slowly you would have thought he had all the time in the world. I counted seconds under my breath to see how long he made it sleep.

"Four!" said the crowd.

"Thirteen," I said to myself as the yo-yo snapped back into his hand. Thirteen seconds. Excellent time for that particular trick.

"Attention all kids!" Ramos announced. "Contest start now at head of line."

The first boy did a sloppy job of gathering his string but managed to rock the cradle quickly four times.

"Okay." Ramos tapped him on the shoulder and moved to the next boy, who fumbled. "Out." Ricardo followed, doing an occasional Loop-the-Loop with the diamond yo-yo. "Out ... out ... okay," said Ramos as he worked down the line.

There was something about the man's inexorable advance that unnerved me. His decisions were fast, and there was no appeal. To my surprise I felt my palms begin to sweat. Closer and closer he came, his voice growing louder, and then suddenly he was standing in front of me. Amazed, I stared at him. It was as if he'd appeared out of thin air.

"What happen boy, you swarrow bubble gum?"

The laughter jolted me out of it. Blushing, I threw down my yo-yo and executed a slow Rock the Cradle, counting the four passes and hesitating a moment at the end so as not to appear rushed.

"Okay." He tapped my shoulder. "Good."

I wiped my hands on my blue jeans and watched him move down the line. "Out . . . out . . . out." He had a large mole on the back of his neck.

Seven boys qualified. Coming back, Ramos called out, "Next trick Backward Round the World! Okay? Go!"

The first two boys missed, but the third was the kid in the sailor hat. Glancing quickly to see that no one was behind him, he hunched up his shoulder, threw, and just barely made the catch. There was some loose string in his hand, but not enough to disqualify him.

Number four missed, as did number five, and it was my turn. I stepped forward, threw the yo-yo almost straight up over my head, and as it began to fall pulled very gently to add some speed. It zipped neatly behind my legs and there was nothing more to do. My head turned to one side, I stood absolutely still and watched the yo-yo come in over my shoulder and slap into my hand. I added a Loop-the-Loop just to show the tightness of the string.

"Did you see that?" I heard someone say.

Number seven missed, so it was between myself and the boy in the sailor hat. His hair was bleached by the sun and combed up over his forehead in a pompadour, held from behind by the white hat. He was a year or two older than me. Blinking his blue eyes nervously, he adjusted the tension of his string.

"Next trick Cannonball! Cannonball! You go first this time," Ramos said to me.

Kids had gathered in a circle around us, those in front quiet and attentive, those in back jumping up and down to get a view. "Move back for room," Ricardo said, pushing them back. "More room, please."

I stepped into the center and paused, looking down at the ground. It was a difficult trick. The yo-yo had to land exactly on the string and there was a chance I'd miss the first time. I knew I wouldn't miss twice. "Can I have one practice?"

Ramos and Ricardo consulted in their mother tongue, and then Ramos held up his hands. "Attention all kids! Each boy have one practice before trick."

The crowd was silent, watching me. I took a deep breath and threw, following the fall of the yo-yo with my eyes, turning slightly, matador-fashion, as it passed me. My finger caught the string, the

yo-yo came up and over, and missed. Without pausing I threw again. "Second time," I yelled, so there would be no misunderstanding. The circle had been too big. This time I made it small, sacrificing beauty for security. The yo-yo fell where it belonged and spun for a moment. (A moment I don't rush, my arms widespread, my eyes locked on the spinning toy. The Trick! There it is, brief and magic, right before your eyes! My hands are frozen in the middle of a deaf-and-dumb sentence, holding the whole airy, tenuous statement aloft for everyone to see.) With a quick snap I broke up the trick and made my catch.

Ramos nodded. "Okay. Very good. Now next boy."

Sailor-hat stepped forward, wiping his nose with the back of his hand. He threw once to clear the string.

"One practice," said Ramos.

He nodded.

"C'mon Bobby," someone said. "You can do it."

Bobby threw the yo-yo out to the side, made his move, and missed. "Damn," he whispered. (He said "dahyum.") The second time he got halfway through the trick before his yo-yo ran out of gas and fell impotently off the string. He picked it up and walked away, winding slowly.

Ramos came over and held my hand in the air. "The winner!" he yelled. "Grand prize Black Beauty Diamond Yo-Yo will now be awarded."

Ricardo stood in front of me. "Take off old yo-yo." I loosened the knot and slipped it off. "Put out hand." I held out my hand and he looped the new string on my finger, just behind the nail, where the mark was. "You like Black Beauty," he said, smiling as he stepped back. "Diamond make pretty colors in the sun."

"Thank you," I said.

"Very good with yo-yo. Later we have contest for whole town. Winner go to Miami for State Championship. Maybe you win. Okay?"

"Okay." I nodded. "Thank you."

A few kids came up to look at Black Beauty. I threw it once or twice to get the feel. It seemed a bit heavier than my old one. Ramos and Ricardo were surrounded as the kids called out their favorite tricks.

"Do Pickpocket! Pickpocket!"

"Do the Double Cannonball!"

"Ramos! Ramos! Do the Turkish Army!"

Smiling, waving their hands to ward off the barrage of requests, the twins worked their way through the crowd toward the mouth of the alley. I watched them moving away and was immediately struck by a wave of fierce and irrational panic. "Wait," I yelled, pushing through after them. "Wait!"

I caught them on the street.

"No more today," Ricardo said, and then paused when he saw it was me. "Okay. The champ. What's wrong? Yo-yo no good?"

"No. It's fine."

"Good. You take care of it."

"I wanted to ask when the contest is. The one where you get to go to Miami."

"Later. After school begins." They began to move away. "We have to go home now."

"Just one more thing," I said, walking after them. "What is the hardest trick you know?"

Ricardo laughed. "Hardest trick killing flies in air."

"No, no. I mean a real trick."

They stopped and looked at me. "There is a very hard trick," Ricardo said. "I don't do it, but Ramos does. Because you won the contest he will show you. But only once, so watch carefully."

We stepped into the lobby of the Sunset Theater. Ramos cleared his string. "Watch," he said, and threw. The trick started out like a Cannonball, and then unexpectedly folded up, opened again, and as I watched breathlessly the entire complex web spun around in the air, propelled by Ramos' two hands making slow circles like a swimmer. The end was like the end of a Cannonball.

"That's beautiful," I said, genuinely awed. "What's it called?"

"The Universe."

"The Universe," I repeated.

"Because it goes around and around," said Ramos, "like the planets."

MALCOLM X (MALCOLM LITTLE)
(1925–1965)

One of eight children, Malcolm Little was born in Omaha, Nebraska. White supremacists killed his father. Later the children went to foster homes.

He was a distinguished student, but abandoned school, discouraged, and turned to drugs and crime. Imprisoned at twenty-one, he studied Elijah Muhammad's Black Muslim teachings in the prison library. In 1952, after his release, he adopted the name Malcolm X and joined the Nation of Islam; he worked as a minister and was a powerful spokesman for Elijah Muhammad.

Twelve years later, Malcolm X broke with the organization and formed his own Muslim group. He visited Mecca, deepened his spirituality, enlarged his views, and founded the Organization of Afro-American Unity. In 1965, he was assassinated while speaking at a Harlem ballroom.

Writer Alex Haley worked with him on The Autobiography of Malcolm X. *It came out the year he died. Since his death, nine volumes of his speeches have been published.*

■ ■ ■

from THE AUTOBIOGRAPHY OF MALCOLM X

I came into a classroom with my hat on. I did it deliberately. The teacher, who was white, ordered me to keep the hat on, and to walk around and around the room until he told me to stop. "That way," he said, "everyone can see you. Meanwhile, we'll go on with class for those who are here to learn something."

I was still walking around when he got up from his desk and turned to the blackboard to write something on it. Everyone in the classroom was looking when, at this moment, I passed behind his desk, snatched up a thumbtack and deposited it in his chair. When he turned to sit back down, I was far from the scene of the crime, circling around the rear of the room. Then he hit the tack, and I

heard him holler and caught a glimpse of him spraddling up as I disappeared through the door.

With my deportment record, I wasn't really shocked when the decision came that I had been expelled.

I guess I must have had some vague idea that if I didn't have to go to school, I'd be allowed to stay on with the Gohannas' and wander around town, or maybe get a job if I wanted one for pocket money. But I got rocked on my heels when a state man whom I hadn't seen before came and got me at the Gohannas' and took me down to court.

They told me I was going to go to a reform school. I was still thirteen years old.

But first I was going to the detention home. It was in Mason, Michigan, about twelve miles from Lansing. The detention home was where all the "bad" boys and girls from Ingham County were held, on their way to reform school—waiting for their hearings.

The white state man was a Mr. Maynard Allen. He was nicer to me than most of the state Welfare people had been. He even had consoling words for the Gohannas' and Mrs. Adcock and Big Boy; all of them were crying. But I wasn't. With the few clothes I owned stuffed into a box, we rode in his car to Mason. He talked as he drove along, saying that my school marks showed that if I would just straighten up, I could make something of myself. He said that reform school had the wrong reputation; he talked about what the word "reform" meant—to change and become better. He said the school was really a place where boys like me could have time to see their mistakes and start a new life and become somebody everyone would be proud of. And he told me that the lady in charge of the detention home, a Mrs. Swerlin, and her husband were very good people.

They were good people. Mrs. Swerlin was bigger than her husband, I remember, a big, buxom, robust, laughing woman, and Mr. Swerlin was thin, with black hair, and a black mustache and a red face, quiet and polite, even to me.

They liked me right away, too. Mrs. Swerlin showed me to my room, my own room—the first in my life. It was in one of those huge dormitory-like buildings where kids in detention were kept in

those days—and still are in most places. I discovered next, with surprise, that I was allowed to eat with the Swerlins. It was the first time I'd eaten with white people—at least with grown white people—since the Seventh Day Adventist country meetings. It wasn't my own exclusive privilege, of course. Except for the very troublesome boys and girls at the detention home, who were kept locked up—those who had run away and been caught and brought back, or something like that—all of us ate with the Swerlins sitting at the head of the long tables.

They had a white cook-helper, I recall—Lucille Lathrop. (It amazes me how these names come back, from a time I haven't thought about for more than twenty years.) Lucille treated me well, too. Her husband's name was Duane Lathrop. He worked somewhere else, but he stayed there at the detention home on the weekends with Lucille.

I noticed again how white people smelled different from us, and how their food tasted different, not seasoned like Negro cooking. I began to sweep and mop and dust around in the Swerlins' house, as I had done with Big Boy at the Gohannas'.

They all liked my attitude, and it was out of their liking for me that I soon became accepted by them—as a mascot, I know now. They would talk about anything and everything with me standing right there hearing them, the same way people would talk freely in front of a pet canary. They would even talk about me, or about "niggers," as though I wasn't there, as if I wouldn't understand what the word meant. A hundred times a day, they used the word "nigger." I suppose that in their own minds, they meant no harm; in fact they probably meant well. It was the same with the cook, Lucille, and her husband, Duane. I remember one day when Mr. Swerlin, as nice as he was, came in from Lansing, where he had been through the Negro section, and said to Mrs. Swerlin right in front of me, "I just can't see how those niggers can be so happy and be so poor." He talked about how they lived in shacks, but had those big, shining cars out front.

And Mrs. Swerlin said, me standing right there, "Niggers are just that way. . . ." That scene always stayed with me.

It was the same with the other white people, most of them local politicians, when they would come visiting the Swerlins. One of

their favorite parlor topics was "niggers." One of them was the judge who was in charge of me in Lansing. He was a close friend of the Swerlins. He would ask about me when he came, and they would call me in, and he would look me up and down, his expression approving, like he was examining a fine colt, or a pedigreed pup. I knew they must have told him how I acted and how I worked.

What I am trying to say is that it just never dawned upon them that I could understand, that I wasn't a pet, but a human being. They didn't give me credit for having the same sensitivity, intellect, and understanding that they would have been ready and willing to recognize in a white boy in my position. But it has historically been the case with white people, in their regard for black people, that even though we might be *with* them, we weren't considered *of* them. Even though they appeared to have opened the door, it was still closed. Thus they never did really see *me*.

This is the sort of kindly condescension which I try to clarify today, to these integration-hungry Negroes, about their "liberal" white friends, these so-called "good white people"—most of them anyway. I don't care how nice one is to you; the thing you must always remember is that almost never does he really see you as he sees himself, as he sees his own kind. He may stand with you through thin, but not thick; when the chips are down, you'll find that as fixed in him as his bone structure is his sometimes subconscious conviction that he's better than anybody black.

But I was no more than vaguely aware of anything like that in my detention-home years. I did my little chores around the house, and everything was fine. And each weekend, they didn't mind my catching a ride over to Lansing for the afternoon or evening. If I wasn't old enough, I sure was big enough by then, and nobody ever questioned my hanging out, even at night, in the streets of the Negro section.

I was growing up to be even bigger than Wilfred and Philbert, who had begun to meet girls at the school dances, and other places, and introduced me to a few. But the ones who seemed to like me, I didn't go for—and vice versa. I couldn't dance a lick, anyway, and I couldn't see squandering my few dimes on girls. So mostly I pleasured myself these Saturday nights by gawking around the Negro bars and restaurants. The jukeboxes were wailing Erskine Hawkins'

"Tuxedo Junction," Slim and Slam's "Flatfoot Floogie," things like that. Sometimes, big bands from New York, out touring the one-night stands in the sticks, would play for big dances in Lansing. Everybody with legs would come out to see any performer who bore the magic name "New York." Which is how I first heard Lucky Thompson and Milt Jackson, both of whom I later got to know well in Harlem.

Many youngsters from the detention home, when their dates came up, went off to the reform school. But when mine came up—two or three times—it was always ignored. I saw new youngsters arrive and leave. I was glad and grateful. I knew it was Mrs. Swerlin's doing. I didn't want to leave.

She finally told me one day that I was going to be entered in Mason Junior High School. It was the only school in town. No ward of the detention home had ever gone to school there, at least while still a ward. So I entered their seventh grade. The only other Negroes there were some of the Lyons children, younger than I was, in the lower grades. The Lyons and I, as it happened, were the town's only Negroes. They were, as Negroes, very much respected. Mr. Lyons was a smart, hardworking man, and Mrs. Lyons was a very good woman. She and my mother, I had heard my mother say, were two of the four West Indians in that whole section of Michigan.

Some of the white kids at school, I found, were even friendlier than some of those in Lansing had been. Though some, including the teachers, called me "nigger," it was easy to see that they didn't mean any more harm by it than the Swerlins. As the "nigger" of my class, I was in fact extremely popular—I suppose partly because I was kind of a novelty. I was in demand, I had top priority. But I also benefited from the special prestige of having the seal of approval from that Very Important Woman about the town of Mason, Mrs. Swerlin. Nobody in Mason would have dreamed of getting on the wrong side of her. It became hard for me to get through a school day without someone after me to join this or head up that—the debating society, the Junior High basketball team, or some other extracurricular activity. I never turned them down.

And I hadn't been in the school long when Mrs. Swerlin, knowing I could use spending money of my own, got me a job after school washing the dishes in a local restaurant. My boss there was

the father of a white classmate whom I spent a lot of time with. His family lived over the restaurant. It was fine working there. Every Friday night when I got paid, I'd feel at least ten feet tall. I forget how much I made, but it seemed like a lot. It was the first time I'd ever had any money to speak of, all my own, in my whole life. As soon as I could afford it, I bought a green suit and some shoes, and at school I'd buy treats for the others in my class—at least as much as any of them did for me.

English and history were the subjects I liked most. My English teacher, I recall—a Mr. Ostrowski—was always giving advice about how to become something in life. The one thing I didn't like about history class was that the teacher, Mr. Williams, was a great one for "nigger" jokes. One day during my first week at school, I walked into the room and he started singing to the class, as a joke, "'Way down yonder in the cotton field, some folks say that a nigger won't steal." Very funny. I liked history, but I never thereafter had much liking for Mr. Williams. Later, I remember, we came to the text-book section on Negro history. It was exactly one paragraph long. Mr. Williams laughed through it practically in a single breath, reading aloud how the Negroes had been slaves and then were freed, and how they were usually lazy and dumb and shiftless. He added, I remember, an anthropological footnote of his own, telling us between laughs how Negroes' feet were "so big that when they walk, they don't leave tracks, they leave a hole in the ground."

I'm sorry to say that the subject I most disliked was mathematics. I have thought about it. I think the reason was that mathematics leaves no room for argument. If you made a mistake, that was all there was to it.

Basketball was a big thing in my life, though. I was on the team; we traveled to neighboring towns such as Howell and Charlotte, and wherever I showed my face, the audiences in the gymnasiums "niggered" and "cooned" me to death. Or called me "Rastus." It didn't bother my teammates or my coach at all, and to tell the truth, it bothered me only vaguely. Mine was the same psychology that makes Negroes even today, though it bothers them down inside, keep letting the white man tell them how much "progress" they are making. They've heard it so much they've almost gotten brain-washed into believing it—or at least accepting it.

After the basketball games, there would usually be a school dance. Whenever our team walked into another school's gym for the dance, with me among them, I could feel the freeze. It would start to ease as they saw that I didn't try to mix, but stuck close to someone on our team, or kept to myself. I think I developed ways to do it without making it obvious. Even at our own school, I could sense it almost as a physical barrier, that despite all the beaming and smiling, the mascot wasn't supposed to dance with any of the white girls.

It was some kind of psychic message—not just from them, but also from within myself. I am proud to be able to say that much for myself, at least. I would just stand around and smile and talk and drink punch and eat sandwiches, and then I would make some excuse and get away early.

They were typical small-town school dances. Sometimes a little white band from Lansing would be brought in to play. But most often, the music was a phonograph set up on a table, with the volume turned up high, and the records scratchy, blaring things like Glenn Miller's "Moonlight Serenade"—his band was riding high then—or the Ink Spots, who were also very popular, singing "If I Didn't Care."

I used to spend a lot of time thinking about a peculiar thing. Many of these Mason white boys, like the ones at the Lansing school—especially if they knew me well, and if we hung out a lot together—would get me off in a corner somewhere and push me to proposition certain white girls, sometimes their own sisters. They would tell me that they'd already had the girls themselves—including their sisters—or that they were trying to and couldn't. Later on, I came to understand what was going on: If they could get the girls into the position of having broken the terrible taboo by slipping off with me somewhere, they would have that hammer over the girls' heads, to make them give in to them.

It seemed that the white boys felt that I, being a Negro, just naturally knew more about "romance," or sex, than they did—that I instinctively knew more about what to do and say with their own girls. I never did tell anybody that I really went for some of the white girls, and some of them went for me, too. They let me know in many ways. But anytime we found ourselves in any close conver-

sations or potentially intimate situations, always there would come up between us some kind of a wall. The girls I really wanted to have were a couple of Negro girls whom Wilfred or Philbert had introduced me to in Lansing. But with those girls, somehow, I lacked the nerve.

From what I heard and saw on the Saturday nights I spent hanging around in the Negro district I knew that race-mixing went on in Lansing. But strangely enough, this didn't have any kind of effect on me. Every Negro in Lansing, I guess, knew how white men would drive along certain streets in the black neighborhoods and pick up Negro streetwalkers who patrolled the area. And, on the other hand, there was a bridge that separated the Negro and Polish neighborhoods, where white women would drive or walk across and pick up Negro men, who would hang around in certain places close to the bridge, waiting for them. Lansing's white women, even in those days, were famous for chasing Negro men. I didn't yet appreciate how most whites accord to the Negro this reputation for prodigious sexual prowess. There in Lansing, I never heard of any trouble about this mixing, from either side. I imagine that everyone simply took it for granted, as I did.

Anyway, from my experience as a little boy at the Lansing school, I had become fairly adept at avoiding the white-girl issue—at least for a couple of years yet.

Then, in the second semester of the seventh grade, I was elected class president. It surprised me even more than other people. But I can see now why the class might have done it. My grades were among the highest in the school. I was unique in my class, like a pink poodle. And I was proud; I'm not going to say I wasn't. In fact, by then, I didn't really have much feeling about being a Negro, because I was trying so hard, in every way I could, to be white. Which is why I am spending much of my life today telling the American black man that he's wasting his time straining to "integrate." I know from personal experience. I tried hard enough.

"Malcolm, we're just so *proud* of you!" Mrs. Swerlin exclaimed when she heard about my election. It was all over the restaurant where I worked. Even the state man, Maynard Allen, who still dropped by to see me once in a while, had a word of praise. He said he never saw anybody prove better exactly what "reform" meant. I

really liked him—except for one thing: he now and then would drop something that hinted my mother had let us down somehow.

Fairly often, I would go and visit the Lyons, and they acted as happy as though I was one of their own children. And it was the same warm feeling when I went into Lansing to visit my brothers and sisters, and the Gohannas'.

I remember one thing that marred this time for me: the movie "Gone with the Wind." When it played in Mason, I was the only Negro in the theater, and when Butterfly McQueen went into her act, I felt like crawling under the rug.

Every Saturday, just about, I would go into Lansing. I was going on fourteen, now. Wilfred and Hilda still lived out by themselves at the old family home. Hilda kept the house very clean. It was easier than my mother's plight, with eight of us always under foot or running around. Wilfred worked wherever he could, and he still read every book he could get his hands on. Philbert was getting a reputation as one of the better amateur fighters in this part of the state; everyone really expected that he was going to become a professional.

Reginald and I, after my fighting fiasco, had finally gotten back on good terms. It made me feel great to visit him and Wesley over at Mrs. Williams'. I'd offhandedly give them each a couple of dollars to just stick in their pockets, to have something to spend. And little Yvonne and Robert were doing okay, too, over at the home of the West Indian lady, Mrs. McGuire. I'd give them about a quarter apiece; it made me feel good to see how they were coming along.

None of us talked much about our mother. And we never mentioned our father. I guess none of us knew what to say. We didn't want anybody else to mention our mother either, I think. From time to time, though, we would all go over to Kalamazoo to visit her. Most often we older ones went singly, for it was something you didn't want to have to experience with anyone else present, even your brother or sister.

During this period, the visit to my mother that I most remember was toward the end of that seventh-grade year, when our father's grown daughter by his first marriage, Ella, came from Boston to visit us. Wilfred and Hilda had exchanged some letters with Ella, and I, at Hilda's suggestion, had written to her from the Swerlins'.

We all were excited and happy when her letter told us that she was coming to Lansing.

I think the major impact of Ella's arrival, at least upon me, was that she was the first really proud black woman I had ever seen in my life. She was plainly proud of her very dark skin. This was unheard of among Negroes in those days, especially in Lansing.

I hadn't been sure just what day she would come. And then one afternoon I got home from school and there she was. She hugged me, stood me away, looked me up and down. A commanding woman, maybe even bigger than Mrs. Swerlin, Ella wasn't just black, but like our father, she was jet black. The way she sat, moved, talked, did everything, bespoke somebody who did and got exactly what she wanted. This was the woman my father had boasted of so often for having brought so many of their family out of Georgia to Boston. She owned some property, he would say, and she was "in society." She had come North with nothing, and she had worked and saved and had invested in property that she built up in value, and then she started sending money to Georgia for another sister, brother, cousin, niece or nephew to come north to Boston. All that I had heard was reflected in Ella's appearance and bearing. I had never been so impressed with anybody. She was in her second marriage; her first husband had been a doctor.

Ella asked all kinds of questions about how I was doing; she had already heard from Wilfred and Hilda about my election as class president. She asked especially about my grades, and I ran and got my report cards. I was then one of the three highest in the class. Ella praised me. I asked her about her brother, Earl, and her sister, Mary. She had the exciting news that Earl was a singer with a band in Boston. He was singing under the name of Jimmy Carleton. Mary was also doing well.

Ella told me about other relatives from that branch of the family. A number of them I'd never heard of; she had helped them up from Georgia. They, in their turn, had helped up others. "We Littles have to stick together," Ella said. It thrilled me to hear her say that, and even more, the way she said it. I had become a mascot; our branch of the family was split to pieces; I had just about forgotten about being a Little in any family sense. She said that different members of the family were working in good jobs, and

some even had small businesses going. Most of them were home-owners.

When Ella suggested that all of us Littles in Lansing accompany her on a visit to our mother, we all were grateful. We all felt that if anyone could do anything that could help our mother, that might help her get well and come back, it would be Ella. Anyway, all of us, for the first time together, went with Ella to Kalamazoo.

Our mother was smiling when they brought her out. She was extremely surprised when she saw Ella. They made a striking contrast, the thin near-white woman and the big black one hugging each other. I don't remember much about the rest of the visit, except that there was a lot of talking, and Ella had everything in hand, and we left with all of us feeling better than we ever had about the circumstances. I know that for the first time, I felt as though I had visited with someone who had some kind of physical illness that had just lingered on.

A few days later, after visiting the homes where each of us were staying, Ella left Lansing and returned to Boston. But before leaving, she told me to write to her regularly. And she had suggested that I might like to spend my summer holiday visiting her in Boston. I jumped at that chance.

That summer of 1940, in Lansing, I caught the Greyhound bus for Boston with my cardboard suitcase, and wearing my green suit. If someone had hung a sign, "HICK," around my neck, I couldn't have looked much more obvious. They didn't have the turnpikes then; the bus stopped at what seemed every corner and cowpatch. From my seat in—you guessed it—the back of the bus, I gawked out of the window at white man's America rolling past for what seemed a month, but must have been only a day and a half.

When we finally arrived, Ella met me at the terminal and took me home. The house was on Waumbeck Street in the Sugar Hill section of Roxbury, the Harlem of Boston. I met Ella's second husband, Frank, who was now a soldier; and her brother Earl, the singer who called himself Jimmy Carleton; and Mary, who was very different from her older sister. It's funny how I seemed to think of Mary as Ella's sister, instead of her being, just as Ella is, my own half-sister. It's probably because Ella and I always were much closer as basic

types; we're dominant people, and Mary has always been mild and quiet, almost shy.

Ella was busily involved in dozens of things. She belonged to I don't know how many different clubs; she was a leading light of local so-called "black society." I saw and met a hundred black people there whose big-city talk and ways left my mouth hanging open.

I couldn't have feigned indifference if I had tried to. People talked casually about Chicago, Detroit, New York. I didn't know the world contained as many Negroes as I saw thronging downtown Roxbury at night, especially on Saturdays. Neon lights, nightclubs, poolhalls, bars, the cars they drove! Restaurants made the streets smell—rich, greasy, down-home black cooking! Jukeboxes blared Erskine Hawkins, Duke Ellington, Cootie Williams, dozens of others. If somebody had told me then that some day I'd know them all personally, I'd have found it hard to believe. The biggest bands, like these, played at the Roseland State Ballroom, on Boston's Massachusetts Avenue—one night for Negroes, the next night for whites.

I saw for the first time occasional white-black couples strolling around arm in arm. And on Sundays, when Ella, Mary, or somebody took me to church, I saw churches for black people such as I had never seen. They were many times finer than the white church I had attended back in Mason, Michigan. There, the white people just sat and worshiped with words; but the Boston Negroes, like all other Negroes I had ever seen at church, threw their souls and bodies wholly into worship.

Two or three times, I wrote letters to Wilfred intended for everybody back in Lansing. I said I'd try to describe it when I got back.

But I found I couldn't.

My restlessness with Mason—and for the first time in my life a restlessness with being around white people—began as soon as I got back home and entered eighth grade.

I continued to think constantly about all that I had seen in Boston, and about the way I had felt there. I know now that it was the sense of being a real part of a mass of my own kind, for the first time.

The white people—classmates, the Swerlins, the people at the restaurant where I worked—noticed the change. They said, "You're

acting so strange. You don't seem like yourself, Malcolm. What's the matter?"

I kept close to the top of the class, though. The topmost scholastic standing, I remember, kept shifting between me, a girl named Audrey Slaugh, and a boy named Jimmy Cotton.

It went on that way, as I became increasingly restless and disturbed through the first semester. And then one day, just about when those of us who had passed were about to move up to 8-A, from which we would enter high school the next year, something happened which was to become the first major turning point of my life.

Somehow, I happened to be alone in the classroom with Mr. Ostrowski, my English teacher. He was a tall, rather reddish white man and he had a thick mustache. I had gotten some of my best marks under him, and he had always made me feel that he liked me. He was, as I have mentioned, a natural-born "advisor," about what you ought to read, to do, or think—about any and everything. We used to make unkind jokes about him: why was he teaching in Mason instead of somewhere else, getting for himself some of the "success in life" that he kept telling us how to get?

I know that he probably meant well in what he happened to advise me that day. I doubt that he meant any harm. It was just in his nature as an American white man. I was one of his top students, one of the school's top students—but all he could see for me was the kind of future "in your place" that almost all white people see for black people.

He told me, "Malcolm, you ought to be thinking about a career. Have you been giving it thought?"

The truth is, I hadn't. I never have figured out why I told him, "Well, yes, sir, I've been thinking I'd like to be a lawyer." Lansing certainly had no Negro lawyers—or doctors either—in those days, to hold up an image I might have aspired to. All I really knew for certain was that a lawyer didn't wash dishes, as I was doing.

Mr. Ostrowski looked surprised, I remember, and leaned back in his chair and clasped his hands behind his head. He kind of half-smiled and said, "Malcolm, one of life's first needs is for us to be realistic. Don't misunderstand me, now. We all here like you, you know that. But you've got to be realistic about being a nigger. A

lawyer—that's no realistic goal for a nigger. You need to think about something you *can* be. You're good with your hands—making things. Everybody admires your carpentry shop work. Why don't you plan on carpentry? People like you as a person—you'd get all kinds of work."

The more I thought afterwards about what he said, the more uneasy it made me. It just kept treading around in my mind.

What made it really begin to disturb me was Mr. Ostrowski's advice to others in my class—all of them white. Most of them had told him they were planning to become farmers, like their parents—to one day take over their family farms. But those who wanted to strike out on their own, to try something new, he had encouraged. Some, mostly girls, wanted to be teachers. A few wanted other professions, such as one boy who wanted to become a county agent; another, a veterinarian; and one girl wanted to be a nurse. They all reported that Mr. Ostrowski had encouraged whatever they had wanted. Yet nearly none of them had earned marks equal to mine.

It was a surprising thing that I had never thought of it that way before, but I realized that whatever I wasn't, I *was* smarter than nearly all of those white kids. But apparently I was still not intelligent enough, in their eyes, to become whatever *I* wanted to be.

It was then that I began to change—inside.

I drew away from white people. I came to class, and I answered when called upon. It became a physical strain simply to sit in Mr. Ostrowski's class.

Where "nigger" had slipped off my back before, wherever I heard it now, I stopped and looked at whoever said it. And they looked surprised that I did.

I quit hearing so much "nigger" and "What's wrong?"—which was the way I wanted it. Nobody, including the teachers, could decide what had come over me. I knew I was being discussed.

In a few more weeks, it was that way, too, at the restaurant where I worked washing dishes, and at the Swerlins'.

One day soon after, Mrs. Swerlin called me into the living room, and there was the state man, Maynard Allen. I knew from their faces that something was about to happen. She told me that none of them

could understand why—after I had done so well in school, and on my job, and living with them, and after everyone in Mason had come to like me—I had lately begun to make them all feel that I wasn't happy there anymore.

She said she felt there was no need for me to stay at the detention home any longer, and that arrangements had been made for me to go and live with the Lyons family, who liked me so much.

She stood up and put out her hand. "I guess I've asked you a hundred times, Malcolm—do you want to tell me what's wrong?"

I shook her hand, and said, "Nothing, Mrs. Swerlin." Then I went and got my things, and came back down. At the living room door I saw her wiping her eyes. I felt very bad. I thanked her and went out in front to Mr. Allen, who took me over to the Lyons'.

Mr. and Mrs. Lyons, and their children, during the two months I lived with them—while finishing eighth grade—also tried to get me to tell them what was wrong. But somehow I couldn't tell them, either.

I went every Saturday to see my brothers and sisters in Lansing, and almost every other day I wrote to Ella in Boston. Not saying why, I told Ella that I wanted to come there and live.

I don't know how she did it, but she arranged for official custody of me to be transferred from Michigan to Massachusetts, and the very week I finished the eighth grade, I again boarded the Greyhound bus for Boston.

I've thought about that time a lot since then. No physical move in my life has been more pivotal or profound in its repercussions.

If I had stayed on in Michigan, I would probably have married one of those Negro girls I knew and liked in Lansing. I might have become one of those state capitol building shoeshine boys, or a Lansing Country Club waiter, or gotten one of the other menial jobs which, in those days, among Lansing Negroes, would have been considered "successful"—or even become a carpenter.

Whatever I have done since then, I have driven myself to become a success at it. I've often thought that if Mr. Ostrowski had encouraged me to become a lawyer, I would today probably be among some city's professional black bourgeoisie, sipping cocktails and palming myself off as a community spokesman for and leader

of the suffering black masses, while my primary concern would be to grab a few more crumbs from the groaning board of the two-faced whites with whom they're begging to "integrate."

All praise is due to Allah that I went to Boston when I did. If I hadn't, I'd probably still be a brainwashed black Christian.

HARRY MIDDLETON
(1949–1993)

*Because his father was a U.S. Army colonel, Harry Middleton was
born in Frankfurt, Germany. He attended high school in Virginia and
college in Louisiana; he earned an M.A. in American history at
Louisiana State University.*

A journalist and writer, Middleton was a columnist for Southern
Living. *His books, all nonfiction, ran to trout fishing:* On the Spine of
Time *(1991);* The Bright Country *(1993);* Rivers of Memory *(1993).*

The Earth Is Enough: Growing Up in a World of Trout and Old
Men *(1989) is Middleton's memoir. As a boy of fourteen, he went to
live at his grandfather's farm in the Ozark Mountains of Arkansas. He
got to know three contented, dignified, and rebellious old men: his
grandfather Emerson, his great-uncle Albert, and their Sioux friend
Elias Wonder, a World War I veteran.*

■ ■ ■

from THE EARTH IS ENOUGH

Late spring had spread across the mountains before I found the
courage to ask them one morning at the breakfast table. I spoke
up just as they were piling their dishes in the sink, getting ready to
head for the creek for an hour's fishing before the sun topped the
hills—the sign for them to exchange fly rods for hoes and wheelbar-
rows.

"Could you show me?" I said weakly, my voice struggling to
break the bonds of a whisper.

"Show you what, son?" Emerson asked, pulling the wide, flat
brim of his Montana hat down over his eyes. The hat was the dull
silver color of a trout's belly.

"You know, teach me—" I stopped short because I was shaking
badly and I wanted to sound serious and mature, someone worthy
of instruction.

Certain that something of consequence was at hand, Albert took
off his hat, sat back down, and poured himself another cup of cof-

fee. His hands trembled slightly, sending tiny waves of coffee over the lip of the cup onto the tablecloth. Albert looked at Emerson, his face a mixture of confusion and incredulity. Emerson returned a similar look, only his face was more distorted, as though he had just bitten into a sour grape.

"Teach you what, exactly?" said Emerson in a low voice, the same voice he fell into whenever he felt a catastrophe was at hand.

"Fly fishing," I said.

Silence, for a long moment. Canyon deep and cave perfect. It was as if all of us had stopped breathing at the same instant.

Emerson took off the big Montana hat and scratched his head thoughtfully. His bright eyes fixed on me.

"Teach you fly fishing!" he roared, a thundering sound that caused Albert to fling what was left of his coffee straight up in the air. "Why—why, that's criminal. Tell him, Albert, for chrissakes. That's criminal. Why, I'd get a lighter sentence lacing your root beer with paregoric. Teach you fly fishing, for chrissakes. Better you should ask me how to pick up eighty-year-old women. Fly fishing!"

He sat back in his chair and the red drained slowly from his face. He and Albert were old washed-up mountain farmers, he told me. That and no more. Not teachers or scholars, and certainly not your typical old pipe-smoking, rocking-chair patriarchs, dispensing homespun wisdom to their kin, boring them with memories of the "good old days, which weren't all that damn good," and old folkways that were as suspect as they might be virtuous.

Albert nodded. "Yeah, we're a couple of old farts who want to see the younger generations screw up all on their own, with no help from us. Though we probably could steer them to disaster a good deal faster."

Emerson embraced a more serious tone. "We have nothing of lasting worth to teach you, son. That's what it comes down to," he said earnestly. And he told me coldly that he and Albert were of the belief that an old man, and especially a relative, should never teach a child how to fish—unless, that is, the old man had something against the child and was out to get even.

Then Emerson leaned forward in his chair, so that his face was but inches from mine and I saw that there were endless flecks of blue in his gray eyes and that the lines that spread like dried-up

creek beds in his face were cut more deeply than I had realized. "Why, to anchor you with what paltry knowledge the two of us have of fly fishing would make as much sense as a second-rate con man trying to teach his kid the ropes, the same crap that put the old man in the slammer in the first place." He sighed deeply, as if searching for the next turn of his argument.

Pools of sunlight began to fill the kitchen. Albert looked nervously out the back door toward the creek.

"I'm fumbling about for the words," Emerson mused out loud. "We barely know anything about angling ourselves. That's it, that's what I'm struggling for. Why, we'd just saddle you with a cartload of bad habits. Trout fishing is worse than alcohol or women."

"Well, maybe alcohol," Albert said, smiling.

"It's a ruinous thing, an addiction more destructive than Albert's habitual need for I.B.C. root beer. Fly rodding will consume your life. You'll transform, become absolutely piscine. Look at Albert . . . " Emerson pointed his long, bony index finger at Albert, who dropped the smile and took on the grim aspect of a man about to be hanged. ". . . that salmonid smile, the cold, indifferent eyes, the constant pucker of the lips."

"The indomitable spirit," said Albert, coming to his own rescue.

"And he's only been at it sixty years," concluded Emerson. "Imagine what kind of pisciform monster a lifetime with a fly rod might create! The thought is frightening, son. Frightening. The rod and reel. Don't ask me to damn my grandson to a life as a maladjusted piscator." And he took a long pause, then added, "Anyway, your father did not send you here so that you might immerse yourself in fly fishing or quail, or mountain streams, or wild turkey, all of which are frivolous to him and to most of the civilized world. Save yourself some grief."

As he talked, I was thinking. About trout. About how the morning was getting late and how we should have been on the creek an hour ago. From my chair I could look beyond Emerson, out the back door. Sunlight cut into the forest in great shafts like faults through stone. Albert, too, had his back to the sunlight and he became a shimmering silhouette with a pompadour of ungainly hair.

"Have you really thought this through?" Emerson asked, his words thick as though coated with molasses. "Again I say, look at

us." This time the bony finger went to Albert and then into his own chest. Albert squirmed in his chair, a man unable to keep a tight grip on neutrality. "Look at the way we live. Take a good, long look. These are the rewards of the outdoor life, son, sad and paltry as they are. Take up the fly rod and the shotgun, and before you know it, you're an outcast, a social leper, rejected by your family, despised by your neighbors, mistrusted by your community. Unaware that your soul is quite safe, in the best of company, your church will pity you, pray mightily for your redemption from hideous sin. The final question is, should any man turn his back on ambition, profit, security, and a parking place in the city, just to pursue a fish!"

Albert jumped up, shook his fist at the ceiling. "And look at Elias Wonder. Yeah, take a gander at that buzzard. Forty years ago he was happy, generous, charitable, tall, dark, and handsome. Then he took up the fly rod. Now consider him. Uglier than a fresh road kill. Evil-eyed, cantankerous, sullen, mean. An antisocial misfit that causes a groundswell of spleen wherever he goes. Consider him well. Should a man abandon success just to pursue a fish?" Then he bolted for the door, yelling, "Yes, but only if it's trout!"

Emerson's face was turned away from me, but I could hear him chuckling under his breath. When he spoke again, it was only to say: "Amen. That's the spiel, son."

I smiled at them both. Soon we were all on the hard-dirt path leading down to Starlight Creek and we were all laughing, sinners together.

We fished only a little while, because there were fields to tend. I thought I understood it now: even if the old men had no interest in being my angling mentors, they would not try to stop me from following my own interests, no matter how foolhardy, whether it be trout fishing or nuclear physics. If they had never actually invited me to go with them to the creek each day to fish, neither had they seemed to mind my company, the hours I spent watching them. Perhaps it was their way of testing my devotion to the trout of Starlight Creek, the depth and veracity of my new convictions.

"Better get things cleaned up," Emerson told me after a dinner of venison steaks, fresh-baked bread, potatoes, tomatoes, field peas, and iced tea. "See to the feathered ladies out in the coop. Tuck them in cozy. Get your mind off trout, if you can. I know they've got you.

I can see it. Every fraternity of sufferers knows its brothers. Trout hook men; men don't hook trout. Better try and throw the hook while you can. By the time you're a grown man there probably won't be a pure trout healthy enough to fiddle with."

Albert yelled from the big room, where he was stretched out on the couch, "How's that for wise, soothing, elderly counsel, son? Words of succor from the ancient and learned. It must be humbling to eat at the same table with Emerson, the Exalted Sage of the Ozarks, and St. Albert. Ah, yes, a path lighted by guidance from the dim past, exhortations from the doomed! Now, if you two boys will excuse me, I'm off on a moonlit walk with Mr. Hemingway, who wishes to persuade me that when it comes to sports afield, it's quantity that counts rather than quality or experience. Forward, then, good brother Emerson. A double amen to your orations."

And I heard the front door close and Albert's harmonica playing "Little Walter," deep and mournful.

At breakfast the next morning Albert said brusquely, "I suggest we dismiss all piscatorial conversations this morning and get down to the creek. You know how the trout pout when they miss a day of humiliating us."

Emerson looked at him hard. "Onward it is, then," he said. "Son, you clean up the dishes, fetch the eggs."

Albert was up and walking toward the back door when he turned and winked and I knew my incipient conspiracy had enlisted its first confederate. On that morning I had determined to baptize myself completely in the life of Starlight Creek. . . .

On a May morning shrouded in darkening clouds and a constant drizzle, Albert stole into my room, came almost on tiptoe, silently, as though he were a man on the run. "How much money you got?" he whispered. Down the hall, Emerson lay naked on his bed reading Loren Eiseley. He was naked because he had gotten into a patch of poison ivy while trying to outsmart an old hermit gobbler down in the oak sloughs by Woollum's place. As always happened, the turkey got the best of things, leading the old man right into the tangle of poison ivy, and Emerson got the itch, which he deserved, he said, for fooling around with wild turkeys. Albert scrubbed him down with so much calamine lotion that Emerson

took on the aspect of a body freshly laid out at the mortician's, just waiting for something eternal to wear.

"Well, how much?" prodded Albert.

"About fifteen dollars," I said. That included all my wages at $1.50 a week, plus what was left of the $25 my father had given me.

"Okay, that's plenty," said Albert, his voice registering a hint of excitement and intrigue. "Get it and meet me by the truck. We're going to town."

Albert said nothing as we drove. He had this sly grin on his face, the same grin he wore each time he outfoxed Emerson or got the best of the good Reverend Conrad Biddle of the Mount Hebron First Primitive Methodist Church, or each time Elias Wonder threatened to die and didn't. Between us on the seat was a thin piece of quilt, folded in half, rolled up and tied loosely at each end with a length of torn sheet.

In town, he parked across from Bates's, then gingerly carried the parcel into the dimly lit store. Mr. Bates looked startled, as if he'd never seen Albert in town on a weekday.

"What's up?" he asked with some urgency. "How's Emerson? Everything all right with you old fellas?"

"Emerson's down with the itch," said Albert. "Just as cranky as ever, more temperamental than a two-legged dog." As he spoke, Albert set the package on the counter, untied and unrolled it. It was the old Orvis cane rod and some nameless worn, dull gray-steel reel already packed with line. In the store's diluted light, the old rod took on the color of soft sunlight, pure, comb-fresh honey. A thing of beauty.

Albert coughed slightly, cleared his throat to get Bates's full attention. "You know, Bates, a man can use only so many rods. Really, any more than one is a wasteful luxury, seems to me. Any more would be too many dependents for a man of my years, so I'd like to sell this one. It's been a good rod, devoted, trustworthy, more dependable than most things a man hooks up with in life. I'd like to get what I gave for it, if possible. That would be five dollars. You think I could display it here in the store?"

Bates's face took on a suspicious and confused look. "Albert, you haven't sold a rod or reel or shotgun since this place has been here. Why now? Look, if it's credit you need . . ."

"No, no, Bates, thank you anyway. I'm still solvent. The simple life keeps a man away from many things, including debt. No, I just got a special urge for five dollars. Now, can I leave the rod with you?"

"Certainly," said Bates. "I'll put it in the front window with a large white tag on it. Bet it sells in less than a week's time."

"Good," Albert said, smiling. "That's good. Many thanks to you, Bates. I appreciate it." And the two men shook hands.

Throughout the entire transaction, Albert had not turned to me, looked at me, acknowledged me in any way. Now, he simply walked out the door. But I knew my part. My hands were already deep in my jeans pocket, fishing out one-dollar bills.

"Wait, Mr. Bates," I cried. "I'll take it." My hand trembling, I slid the money, five crumpled dollar bills, onto the counter.

"Take what?" asked Mr. Bates, now genuinely perplexed.

"Why, the rod and reel there, the one for five dollars," I said, my eyes locked firmly on the little rod, the worn-out reel. Sunlight coming in through the wide doorway flashed off the rod's polished ferrules.

I laid another dollar bill on the counter, and said confidently, "And I'd like four dry flies, sir. Two No. 16 Adams and two No. 18 Quill Gordons."

Bates looked out the door in Albert's direction and then down at me, then out the door again. He scurried down the aisle to the long glass case where he kept the trout flies, along with the watches, pocketknives, cigarette lighters, and cheap costume jewelry. He put the flies into a brown paper bag, took the money and, leaning down close to my face, said, "Boy, you just spent six dollars on fishing. That's six dollars down the rathole, boy. There ain't a fish in this whole county worth no six dollars," he sneered.

"Yes, sir," I replied politely, and reached out reverently for the rod.

I found Albert at the café, nursing a bowl of soup and a glass of iced tea. He sat in the back corner, his pale skin standing out like a slice of moon on a stormy night.

"What'd you buy, son?" he asked, crushing a handful of crackers into his soup, stirring them in until they got soggy and drowned, white pulp floating in a stream of bright red tomatoes, string beans and corn, and a dash of Elias Wonder's stump juice.

"Why, the rod," I said proudly.

"What rod?" asked Albert, a seemingly genuine pall of ignorance spreading over his face.

"Why, the rod you just left at Bates's store to be sold," I said, as a tight ball of bewilderment knotted in my stomach.

"Couldn't have been me, son," Albert said flatly. "I've struggled to encumber my modest life with few canons, but I must admit to warming up to a few principles, one of which is that a man never willingly parts with a fly rod, especially if it has been a loyal rod, steadfast and reliable, any more than he should part with a faithful dog or a truck that always kicks over, even in harsh weather." He paused for a moment to wipe a glop of cracker from the corner of his mouth. "Let's have a look at this rod of yours."

I handed him the rod that Mr. Bates had wrapped for me and he unwrapped it with great care, as though the contents were as fragile as porcelain. He fitted the pieces of the slender cane rod together and gave it a shake. "Could have trout in it, son," he said. And I saw how he held the old rod, how he looked at it, his eyes all but glowing, his mind, I knew, conjuring up every trout the rod had taken. "Sure, it might have trout in it. I guess it really depends as much on the angler as the rod. How much did you give for it, anyway?" he asked as he rolled the rod back up in its cotton cocoon.

"Five dollars," I said incredulously. "Exactly what you told Mr. Bates to sell it for."

Albert kept working on the soup and tea, then whispered darkly as he looked about the empty café, "Leave me out of this, son. You want your poor old uncle locked up for contributing to the moral collapse of a child? I didn't give you the rod. Such an act would be worse than a drunk spiking his baby's milk just to give it a taste of its future. No, this is trouble you purchased of your own free will, with no help from me or Emerson or anyone else. And it is trouble you've latched on to. Just ask Donna when she comes around for the dishes. She'll tell you straight that you've gone and hitched a ride on the Devil's tail."

But Miss Donna said no such thing, although she did tell me in a chiding voice that any man who eats at the table with his hat on is "sure nuff eating' with the Devil."

"You sure about that?" said Albert with an amused grin.

"Albert, you know I don't kid around when it comes to Satan," Miss Donna snapped as she gathered up Albert's dirty dishes.

"True," confessed Albert. "But you know how we mountain people are. We're not choosy about our company, don't care about the condition of their soul or the length of their tail."

Miss Donna winced. Albert chuckled. I just sat there thinking about that Orvis rod, how it had shone so in Bates's store.

After Miss Donna had strutted away in a huff, Albert asked me again, "What did you give for that rod?"

"Just what I told you. Five dollars."

"Kinda pricey, don't you think. I mean, for such a beat-up old rod. Thing might not have five dollars' worth of fly fishing left in it. Perhaps you should have talked Bates down to four dollars. Shit, maybe three." But he was smiling as he put seventy-five cents on the table and got up to leave. . . .

I never really knew how long it had been going on. Perhaps thirty years. Maybe more. By the time of my arrival among the old men, the meetings between them and the good Reverend Biddle had long since settled into an uncomplicated ritual. Biddle knew that Albert and Emerson and Elias Wonder were well anchored beyond whatever he might tell them, say to them, either as friend or reverend. That didn't matter, however, because he liked them, perhaps even admired them a little. Likewise, the old men liked the Reverend Biddle and often felt bad that they couldn't bring themselves to believe in the God that he believed in so totally and unconditionally. Sometimes, I thought that perhaps they envied him, as well.

The Reverend Biddle came to the house the last Sunday of every month. These Sundays were always looked forward to, for they involved a good meal, wine, hours of heady conversation. Biddle took it as his personal mission to save the old men from hell. He had determined years before that they should be led, willingly or not, into the magnanimous arms of righteousness.

Biddle had tired, mouselike eyes, a rounded, fleshy chin, sunken cheeks, and a few tufts of silky gray hair on his melon-shaped head. He was given to moping about a great deal, and from his perpetually slumped shoulders one got the impression that he hauled the sins of the world, or at least his part of it, the congregation of the

Mount Hebron First Primitive Methodist Church, 106 threatened souls, on his aching back. His followers worshipped him. They worshipped him because they not only suspected that he was in direct contact with God, they knew it. They knew it because Biddle had performed a miracle. The old ones never forgot the night it happened; the young ones grew up on their haunting stories of God's intervention through the Reverend Biddle's holy hands.

It happened on a Sunday morning in September 1945. While on his way to the church to prepare for the day's services, the Reverend Biddle saw an enormous dark hump in the road, curled up in the morning's fog and lacy shadows. He pulled his car off the road, got out to find Lloyd Haysberry's two-year-old milk cow laid out stiff as a frozen cat across the highway, just across from Haysberry's place. As for what followed, Haysberry saw the whole thing and it left him mute for two days until he finally blurted out the incredible story at the café, yelling at the top of his weak, hacking voice that quivered like a plucked guitar string every time he spoke.

The first time through, no one in the café could make out a syllable of what Haysberry was trying to say. It all came out as coughs or hiccups, incoherent rambling. It wasn't until Big Joe came out of the kitchen and poured a pitcher of iced tea over him that Haysberry settled down, sat on a nearby chair, and while crushing his brown fedora in his nervous hands told how the Reverend Biddle had raised his milk cow from the dead.

"She'd been there on the road nearly all night," whispered Haysberry, looking cautiously around the room, as if he half expected Satan to be among the gathering crowd. "I thought I'd heard a truck out on the road after midnight, and later thought maybe it had hit her good and kilt her dead. Guess she got through the hole I never fixed along the roadside fence. Anyways, I walked out to the highway and put my hand on her. Stone dead, I tell ya. Colder than January ice. No warmth in her at all. I bent down and put my head to her chest. Nothing. Quieter than a potato cellar. There was frost on her eyes and mouth. I started cursing up a storm, I did, and finally went to get the truck and a length of rope to drag her off the highway. Thought maybe I could still salvage the meat.

"When I came back out the house with the rope, the Reverend Biddle was standing over her. I saw him touch her frozen head,

kinda kick her gentle like. He said some words over her I couldn't make out and, I tell ya, that cow began to move. As cold as it was, I broke out in a bad sweat. That cow moved its legs and I dropped to my knees right there on the porch. My cow got to her feet slow like, like maybe some other force was helping her, some other hand was on her. Then the Reverend Biddle—and this here's the eerie part— he don't think nothin' of it. Just shrugs his shoulders, gets back into his car and drives off. I spent nearly the whole of that day on my knees, tears filling my eyes, and I couldn't speak. There must be some kinda law that goes with divine miracles involving raising the dead that whoever witnesses the miracle loses his speech for two days. But, friends, I tell ya this: it was the hand of our Lord workin' through the reverend."

And everybody gasped with reverence. This was something, something indeed, that God would show up in Mount Hebron, work a miracle in their midst. No one doubted Haysberry's story. He was a good man, a good Christian, and no one had ever caught him in a lie before. Why not, said the townspeople. Stranger things had happened. God seemed to have a special gift for manifesting himself in the most peculiar ways. Wasn't there the Shroud of Turin, and the healing waters of Lourdes. It seemed like every time you picked up the newspaper, God had shown up in someone's Christmas lights, carved his image in a beanfield, cast his shadow across some adobe hut in Wolfe's Hole, Arizona, or been sighted mowing a lawn in France. So why not Mount Hebron's Holy Cow.

The faster Haysberry's story spread throughout the country, the more credible it became. News of the miracle on Mount Hebron highway swept over the countryside like some unstoppable virus. It touched everyone, refueled their broken faith, offered hope to the hopeless, promised salvation to the damned, health to the sickly, healing to the incurable. If the Reverend Biddle had the divine power to restore life to a lousy milk cow, said everyone, just think what he could do with their ravaged bodies and souls. And all with a painless touch of his hand.

"Touch me," pleaded Reilly Larson, as he stopped the Reverend Biddle in the street and lifted up his artificial leg to receive Biddle's magic touch. Biddle screamed and ran to his car. The more the good reverend denied his divine powers, the more his congregation

flocked about him, yearning for his healing touch, the miracles in his fingertips.

As Biddle's reputation as a humble saint grew, so did the fame of Haysberry's milk cow. For as long as she lived, people traveled to her stall on the Haysberry farm to ogle her, pray to her, touch her, wonder why God had chosen to raise her from the dead. After all, she wasn't even a decent milk cow. Falling into fits of divine epilepsy, some worshippers cut off pieces of her hide for luck. Others flopped about Haysberry's barnyard speaking to her in tongues and were surprised to find that she responded. Her stall became a shrine, a place where people left flowers, simple gifts, photographs of dead relatives. The old cow took the adulation for as long as she could, then died. Haysberry toyed with the idea of having her stuffed, keeping her on as a paid attraction, twenty-five cents a look. But winter was coming on and so he ate her instead.

Biddle's resurrection of Haysberry's milk cow hounded him for the rest of his life. No one believed for one minute that he had nothing whatsoever to do with either the cow's life or death, and in the end he gave in and touched anyone who asked, just so they would go away and leave him alone. For years, no matter where he went he seemed to stumble on people who would throw themselves in his path, crying hysterically to be touched by his ineffable hand, the hand that had put the life back into Haysberry's milk cow. And Biddle would touch them quickly, wincing all the while. The whole matter reached its apex the Sunday Mrs. Priddy, from across Blackberry Run, showed up in the first pew loosely disguised in a freshly tanned cowhide. "Moo," she cried mournfully. Biddle stepped down from behind the lectern and touched her gently between her floppy ears, one brown and one white, because Mrs. Priddy had liver cancer and her luck had run out.

It never seemed to matter that no one the Reverend Biddle touched ever got better, recovered, reported a cure. No one really cared. No one seemed the worse for it—no one, that is, except Biddle, who boiled his hands in lye water three times a day and who had stopped sleeping at night. He dreamed of dead cows littering the highway.

One of Biddle's few escapes from his great burden of divine

power was getting into his two-tone green Pontiac once a month and driving as fast as hell out to Trail's End, because Emerson and Albert thought the good reverend was kind and thoughtful rather than aloof and divine. While they thought he was a good man, they didn't believe he had the power to raise dead cows, especially Haysberry's old cow, which they knew for a fact had a habit of napping out on the highway. The asphalt held the heat and she liked that.

Still, walking about with the perceived power of immortality in his fingertips was a grave responsibility, one that the Reverend Biddle learned to shoulder with dignity and humility, even when the religious pilgrims who sought him out were less than satisfied.

"Ouch!" bellowed Garland Nobben. Nobben had sunk to his knees in front of the Reverend Biddle as he ate at the café. Nobben rubbed his forehead and climbed to his feet. "I asked you to save me, Pastor, not kill me, for God's sake!"

"Have you faith, brother Nobben?" mumbled Biddle, biting deeply into a bacon, lettuce, and tomato sandwich.

"Naturally," said Nobben reverently.

Biddle wiped a dab of mayonnaise from his lips. "Then go forth, read your Bible, lead a good, clean, and righteous life, and you will be saved, dear sir. I assure you."

After one such encounter, Biddle hopped in the Pontiac and drove like a madman out to the farm, showed up like a peddler wracked and bent from his load of pots and pans, a man of God seeking temporary refuge from his cargo of redemption, his flock of unquestioning believers. As the door opened, he almost fell into Emerson's arms. Slowly, he made his way to the big room, shed his stern black coat and collar, sank into the rocking chair and leaned his head back, his moist, tender eyes red with exhaustion, salvation's endless turmoil. He sat like this, like a reptile on a warm stone, for perhaps half an hour, letting all the tension in him dissipate, siphon out of his muscles like poison. Suddenly, he straightened up in the rocking chair, moistened his lips, began to speak.

"Wait!" Albert yelled, throwing his arms up in irritation. "For chrissakes, Biddle. All these years and you still can't keep the routine straight, can you? First the wine, then the sermon and so on."

Biddle laid his head back against the chair and whispered, "Yes, Albert. First the wine."

Albert made fruit and wild berry wines in the old copper still in the barn. There was always a big clay jug cooling in the waters of Starlight Creek. The jug sat on the bottom of the creek, secured by a rope tied around its neck at one end and a nearby gum tree at the other.

I fetched the jug, pulled it up out of the cool creek water, and we all gathered in the big room and the men drank the wine from large water glasses while eating a good meal. The old men always tried to have something special for the reverend. Perhaps some fried quail and lima beans and cornbread, or a stuffed wild turkey with rice and gravy and fresh biscuits, or maybe just a good plate of beans and bacon, with fresh bread, butter, and plenty of cool wine.

And at last, Biddle took off his hat, revealing the perfectly round bald spot on the crown of his flushed head, a spot that gleamed, everybody said, just like a halo. Just another sign, boasted the proud members of the Mount Hebron First Primitive Methodist Church, that Conrad Biddle was no ordinary man. He had truly been touched by the hand of God.

The Reverend Biddle was neat, efficient, a man of telling ecclesiastical aplomb, who was against evil and for good, though he often, said Emerson, got the two confused. The old men felt sorry for him and worried about his fragile health. After all, should he die, who would be around to touch him and bring him back to life?

Biddle, in turn, worried about the old men. He even worried about Elias Wonder, even though he believed Wonder was moonstruck, crack-brained as he had ever seen, and therefore beyond whatever good his prayers might do for him. Biddle was greatly troubled about the old men because if he failed to save their tortured, misguided souls, they would spend eternity in the bowels of hell. It bothered him even more deeply that Albert and Emerson were so calmly resigned to doing just that—dying.

Biddle cleared his throat, couched his words in a cloak of deadly gravity. "But don't you know what waits beyond the grave for the unforgiven," he implored them, a drop of wine on his bottom lip.

"Rot," answered Albert cheerfully, as though he were the only child in a classroom who knew the answer to a difficult question. "Followed by ripeness."

REYNOLDS PRICE
(1933–)

Reynolds Price grew up in North Carolina and, except for three years at Oxford as a Rhodes Scholar, has lived all his life within sixty miles of his birthplace. He is James B. Duke Professor of English at Duke University.

Price has written ten novels. In 1962, his first novel, A Long and Happy Life, *won the William Faulkner Foundation Award and the Sir Walter Raleigh Award. In 1986,* Kate Vaiden *received the National Book Critics Circle Award in fiction. He has written poetry, too, and five plays.*

His most recent memoir, A Whole New Life *(1994), takes up his battle with spinal cancer.*

This story about his uncle appears in his 1989 memoir, Clear Pictures. *His uncle Macon Thornton is a tobacco farmer in Macon, North Carolina. His name, Mac, for Macon, is pronounced "Make." Delbert is his tenant farmer, and Spencer the farmer's son. Ida is young Reynolds's beloved aunt, with whom he spends his summers. Emma is the widowed sister with whom Mac Thornton, a bachelor, lives.*

■ ■ ■

from CLEAR PICTURES

In my hearing Mac never delivered so much as a line of agrarian thought or primitive poetry; but the way his lively face would halt, then go serene for maybe ten seconds said more than any bucolic of Vergil's or any hundred seminars at the State Ag. and Normal; and even a town-boy, bookish as I, could watch it and wonder how many people found that much peace in a lifetime's work.

Even to a half-bored watchful child, Mac's days plainly said that something could speak, through dirt and leaves and human sweat, and give a sane man this much return. I knew that money was partly involved, though I was still too young to care much for money. I couldn't speak for Delbert or Spencer, but I knew from far back that Macon Thornton was not in this for anything as solemn

and joyless as money. I've already said that Mac never flaunted wealth nor was he a skinflint. For all their faults, none of my grown kin were in love with money. Though again, I was born in the pit of the Great Depression, I never heard within my family a whole conversation on the subject of money. There'd be little snatches of worry about a bill, little dry quick laughs at the specter of loss; but money was neither their goal nor theme.

I also knew what I couldn't have said, that Mac lived as pure a life of contemplation as any cloistered monk. I never saw him engaged in harder work than saddling a horse or stepping off the dimensions of a field, but that's not to say he was lazy. He kept the standard farmer's day, sunup to past dark and then early sleep. On an average day he'd visit two farms, overseeing and guiding, encouraging and curbing. To one he'd haul a load of fertilizer; to another, lime and chicken-feed and maybe a case of Carnation milk for the bottle-fed baby that seemed to be failing. He'd listen and watch, laugh and console. It was all the business he'd made for himself but also a steady brand of meditation.

The only visits that gave him obvious worry were the ones to Uncle Will Egerton's widow, who was prone to wildness and was also named Emma. Even in youth and in a tolerant village, she'd been known as *mean*. Ida told me that one freezing morning a black man knocked on Uncle Will's door with a message. Mrs. Egerton had just come from the well with a five-gallon bucket of water. When she saw the man standing there, she suddenly dashed all the water in his face (her explanation was "He looked like a fool just standing there grinning"). By the time I was riding with Mac, she was well into a clearly deranged old age. She wouldn't live with the Thorntons, or maybe they couldn't have stood her; so Mac had the duty of finding decent white families in the country to give her room and board and the necessary curbing.

I recall a particular day in the late forties when Mac and Joe came to get me, and we headed out for the Snipes place where Mrs. Egerton had been staying with apparent satisfaction. A straw had finally broken the Snipeses' back; and they'd sent a postcard for Mac to come get her—the previous Sunday in church, she'd noticed that her dress was wrong-side-out; and when most heads were bowed in prayer, she'd simply stood up, stripped off the dress and put it on

the right way. When we got there, Mrs. Egerton was waiting on the porch with her Gladstone bag—tall for her age, with wild white hair from under her black hat, dying gardenias pinned to the brim. I can't recall where we took her next. But as always she and I rode in the bed of the pickup on straight chairs; and she ate from her inexhaustible bag of dried Smyrna figs, "Good for your bowels, boy; here eat you one."

On the way back to Ida's in late afternoon, Joe would stop us downtown for the mail and a drink; mine was always Nu-Grape that left a purple arc on your upper lip. Mac and I would stay in the store, by the checker game, and drink ours slowly beneath the fan—Mac watched but never played. Once Joe got his drink, he'd go outside where black men sat on the window ledge with cold drinks and cakes (no signs were posted, no word was said; but everybody knew blacks sat outside).

So I'd have Mac alone for the first time today, and that was my chance for a swift operation. I'd beckon him down and whisper fast. I'd seen an ad for a microscope in one of my funny books, $2.98; it would help me in school.

Mac would nod "Yes, yes" but make no move. So I'd be left to wonder if he heard or had just said no. In fact through the years, my least request, if it sounded "educational," was sure to be met. Mac seemed to read nothing but the Raleigh paper and maybe a few farm publications; and I seem to recall him telling stories of a year or so at Trinity College down in Durham, later Duke University. So his own education was hardly extensive, but he firmly backed my interest in school. His last word to me as I left each summer was "Be smart, Ren. Any damned fool can fail. Look at me, dumb as dirt. You be some count, hear?"

And there in the store, among six or eight white men watching a game, he'd palm me a wadded five-dollar bill with one long hushing finger to his lips, "Don't tell Emma, hear?"

At the end of my visit the summer I was ten, Mac came by to see me on my last afternoon. The pickup stopped out front in the road, Ida called me and I ran out to find Mac alone at the wheel. He said "Let me show you a pretty sight." I was more than ready, but he made me run back for Ida's permission. Then we turned and headed

for the fields by the Baptist Church, the ones more or less face-to-face with his house. More tall tobacco, all he had to show; I could hardly act thrilled. Still I climbed out with him and walked down a row till we came to the end by the curing barns, the scene of catfish fries and Brunswick stews in hundred-gallon iron pots. From there Mac faced the road and said "Can you see Mrs. Nowell?" He always referred to his sister Emma by her married name, and it was time for Emma's late afternoon pause on the front porch.

Short as I was, I told him I couldn't see anything but green.

Mac said "Which one of these rows you like the best?"

He'd tried to teach me to judge tobacco, so I eyed it slowly and finally said "This one." The row stretched in a clear line right on to the dirt road, a hundred yards.

Mac said "Then it's yours. In late September you watch the mail."

I barely understood.

Then he led the way out and drove me back. We exchanged the usual farewell—his admonitions to "be some damned *count*," my thanks for good times and the microscope. Then we'd part for long months, no hug or handshake. I've said his eyes were blacker than any brave's; he'd set them on you and watch you go for as long as you took. But you could wave your arm off, he'd never look back and wave again. That was the limit his mind allowed.

I almost forgot the row of tobacco. Then in early October I biked home for lunch and found a letter addressed in Mac's hand, which was always more like printing than script. Mother was curious and stood close in as I opened the envelope. It held one sheet of lined tablet-paper with a penciled note, "Dear Ren, Here is what your tobacco brought. Be smart. Love, Mac." The note was folded around a fifty-dollar bill. I'd never seen one before—neither had Mother—with its picture of Ulysses Grant, looking as sour as if he hadn't won the War. Our household finances were nearer stability than they'd ever been; but fifty dollars was still a serious sum in 1943, the equivalent of maybe five hundred now. First we were speechless; then we must have danced. I know we were both so elated that I took the letter and the bill back to school and, with my teacher's permission, showed it to the thunderstruck class (those were days when you didn't fear an after-school mugging).

I've long since forgot my purchases. I was already an obsessive collector of totemic objects—palpable things, mostly hand-size, that hummed for me with mysterious energy: a statuette of Superman, my own copy of a favorite library book (*Tales from Shakespeare* by Charles and Mary Lamb), a set of flint arrowheads from a mail-order company in Montana, the stamps I collected, the model airplanes I made, a bronze coin of the Emperor Hadrian. I sent Mac more than one short letter, notifying him of major acquisitions, explaining their relevance to my education and thanking him again. His replies came promptly on penny postcards, seldom more than two sentences—he was glad to hear my news, he hoped to see me soon, be smart.

It didn't occur to me for some years that he was always secretive about his gifts. Whenever he gave me the ritual "Don't tell Emma," I'd nod and comply—accustomed, like any child, to family conspiracies. He'd told me to tell Ida and Elizabeth (he always said "your mammy"), so I rushed to tell and then was sorry. A child that young has too few secrets; I should have kept mine. I also never wondered why Emma might have minded. In her good months Miss Emma seemed as generous as Mac, with her time and intelligence. Like any busy child I filed such questions as insoluble adult mysteries and went downtown to open my first checking account at the First National Bank. The manager was a friend of Will's and came to the teller's window to thank me—"Reynolds, I bet you're our youngest depositor. Welcome to the family." And with Mac's continued help, I never looked back in my life as a junior financier.

From then on, Mac cut an even larger figure in my mind. He was not just the cousin who gave me outings from Ida's house and exposed me to the useful mysteries of farming, tenant-owner relations, the horrific skills of hog killing and butchering, saddling and riding a horse and the deep satisfactions of generosity. He was the only friend, except my parents, who confirmed his love for me with tangible gifts on any occasion but Christmas and my birthday. He was the one reliable financial benefactor of my childhood. Various aunts and cousins would strike unexpectedly with birthday checks or the odd dollar-bill; but Mac not only endowed me each fall, and in the most enjoyable way (secretly), he also responded to every

interim hint. And since he never asked for thanks or bargained for any return from me, the dignified silence of his giving taught me volumes about the difficulties and duties of receiving. Simone Weil states the dilemma precisely, "Our friends owe us what we think they will give us. We must forgive them this debt."

Once Mac began his harvest gift—and as long as his tobacco thrived—he knew I expected the money and that I might even hope for occasional increases. And I knew that he knew that I knew. Will and Elizabeth's only concern in the matter was that I thank Mac appropriately and that I write him from time to time. Neither of them, in their own childhood, had faced so early a training in gratitude, so I was on my own to steer a true course. By the time of the second year's harvest, I'd begun to see at least some of the ways in which generosity can be, not a burden but a real enhancement of mutual care. Mac seemed all the grander, less old and secret, much funnier and all the more trustworthy as a friend. In his eyes I hope I seemed to get smarter, though Mother had warned me not to show off or to correct my elders unless they were doing something actively dangerous.

RICHARD WRIGHT
(1908–1960)

Born on a cotton plantation near Natchez, Mississippi, the son of a sharecropper and a teacher, Richard Wright ended his formal schooling at sixteen.

At seventeen, Wright moved to Memphis, where, using forged notes to borrow books, he read most of everything the public library contained. When he was nineteen he migrated to Chicago, where he wrote poems; ten years later, he moved to New York. Switching to prose, he wrote his first four books. The novel Native Son *(1940) and the autobiography* Black Boy *(1945) made him prominent. He was the first black novelist to write about life and rage in the northern cities.*

Following an invitation from the government of France, he moved to Paris, where he and his family could live without fear of prejudice; there he stayed. He published eleven books during his short life. Native Son *and* The Outsider *(1953) remain his best-known novels.*

Wright's memoir Black Boy *consists of a series of dramatic encounters with the closed society in the white South of the time.* American Hunger, *the complete text of the original second section of* Black Boy, *did not see publication until seventeen years after Wright died. "My environment," Wright said of his boyhood world, "contained nothing more alien than writing." This selection from* Black Boy *describes Wright's literary adolescence.*

■ ■ ■

from BLACK BOY

The eighth grade days flowed in their hungry path and I grew more conscious of myself; I sat in classes, bored, wondering, dreaming. One long dry afternoon I took out my composition book and told myself that I would write a story; it was sheer idleness that led me to it. What would the story be about? It resolved itself into a plot about a villain who wanted a widow's home and I called it *The*

Voodoo of Hell's Half-Acre. It was crudely atmospheric, emotional, intuitively psychological, and stemmed from pure feeling. I finished it in three days and then wondered what to do with it.

The local Negro newspaper! That's it . . . I sailed into the office and shoved my ragged composition book under the nose of the man who called himself the editor.

"What is that?" he asked.

"A story," I said.

"A news story?"

"No, fiction."

"All right. I'll read it," he said.

He pushed my composition book back on his desk and looked at me curiously, sucking at his pipe.

"But I want you to read it *now*," I said.

He blinked. I had no idea how newspapers were run. I thought that one took a story to an editor and he sat down then and there and read it and said yes or no.

"I'll read this and let you know about it tomorrow," he said.

I was disappointed; I had taken time to write it and he seemed distant and uninterested.

"Give me the story," I said, reaching for it.

He turned from me, took up the book and read ten pages or more.

"Won't you come in tomorrow?" he asked. "I'll have it finished then."

I honestly relented.

"All right," I said. "I'll stop in tomorrow."

I left with the conviction that he would not read it. Now, where else could I take it after he had turned it down? The next afternoon, en route to my job, I stepped into the newspaper office.

"Where's my story?" I asked.

"It's in galleys," he said.

"What's that?" I asked; I did not know what galleys were.

"It's set up in type," he said. "We're publishing it."

"How much money will I get?" I asked, excited.

"We can't pay for manuscript," he said.

"But you sell your papers for money," I said with logic.

"Yes, but we're young in business," he explained.

"But you're asking me to *give* you my story, but you don't *give* your papers away," I said.

He laughed.

"Look, you're just starting. This story will put your name before our readers. Now, that's something," he said.

"But if the story is good enough to sell to your readers, then you ought to give me some of the money you get from it," I insisted.

He laughed again and I sensed that I was amusing him.

"I'm going to offer you something more valuable than money," he said. "I'll give you a chance to learn to write."

I was pleased, but I still thought he was taking advantage of me.

"When will you publish my story?"

"I'm dividing it into three installments," he said.

"The first installment appears this week. But the main thing is this: Will you get news for me on a space rate basis?"

"I work mornings and evenings for three dollars a week," I said.

"Oh," he said. "Then you better keep that. But what are you doing this summer?"

"Nothing."

"Then come to see me before you take another job," he said. "And write some more stories."

A few days later my classmates came to me with baffled eyes, holding copies of the *Southern Register* in their hands.

"Did you really write that story?" they asked me.

"Yes."

"Why?"

"Because I wanted to."

"Where did you get it from?"

"I made it up."

"You didn't. You copied it out of a book."

"If I had, no one would publish it."

"But what are they publishing it for?"

"So people can read it."

"Who told you to do that?"

"Nobody."

"Then why did you do it?"

"Because I wanted to," I said again.

They were convinced that I had not told them the truth. We

had never had any instruction in literary matters at school; the literature of the nation or the Negro had never been mentioned. My schoolmates could not understand why anyone would want to write a story; and, above all, they could not understand why I had called it *The Voodoo of Hell's Half-Acre*. The mood out of which a story was written was the most alien thing conceivable to them. They looked at me with new eyes, and a distance, a suspiciousness came between us. If I had thought anything in writing the story, I had thought that perhaps it would make me more acceptable to them, and now it was cutting me off from them more completely than ever.

At home the effects were no less disturbing. Granny came into my room early one morning and sat on the edge of my bed.

"Richard, what is this you're putting in the papers?" she asked.

"A story," I said.

"About what?"

"It's just a story, granny."

"But they tell me it's been in three times."

"It's the same story. It's in three parts."

"But what is it about?" she insisted.

I hedged, fearful of getting into a religious argument.

"It's just a story I made up," I said.

"Then it's a lie," she said.

"Oh, Christ," I said.

"You must get out of this house if you take the name of the Lord in vain," she said.

"Granny, please . . . I'm sorry," I pleaded. "But it's hard to tell you about the story. You see, granny, everybody knows that the story isn't true, but . . ."

"Then why write it?" she asked.

"Because people might want to read it."

"That's the Devil's work," she said and left.

My mother also was worried.

"Son, you ought to be more serious," she said. "You're growing up now and you won't be able to get jobs if you let people think that you're weak-minded. Suppose the superintendent of schools would ask you to teach here in Jackson, and he found out that you had been writing stories?"

I could not answer her.

"I'll be all right, mama," I said.

Uncle Tom, though surprised, was highly critical and contemptuous. The story had no point, he said. And whoever heard of a story by the title of *The Voodoo of Hell's Half-Acre*? Aunt Addie said that it was a sin for anyone to use the word "hell" and that what was wrong with me was that I had nobody to guide me. She blamed the whole thing upon my upbringing.

In the end I was so angry that I refused to talk about the story. From no quarter, with the exception of the Negro newspaper editor, had there come a single encouraging word. It was rumored that the principal wanted to know why I had used the word "hell." I felt that I had committed a crime. Had I been conscious of the full extent to which I was pushing against the current of my environment, I would have been frightened altogether out of my attempts at writing. But my reactions were limited to the attitude of the people about me, and I did not speculate or generalize.

I dreamed of going north and writing books, novels. The North symbolized to me all that I had not felt and seen; it had no relation whatever to what actually existed. Yet, by imagining a place where everything was possible, I kept hope alive in me. But where had I got this notion of doing something in the future, of going away from home and accomplishing something that would be recognized by others? I had, of course, read my Horatio Alger stories, my pulp stories, and I knew my Get-Rich-Quick Wallingford series from cover to cover, though I had sense enough not to hope to get rich; even to my naïve imagination that possibility was too remote. I knew that I lived in a country in which the aspirations of black people were limited, marked-off. Yet I felt that I had to go somewhere and do something to redeem my being alive.

I was building up in me a dream which the entire educational system of the South had been rigged to stifle. I was feeling the very thing that the state of Mississippi had spent millions of dollars to make sure that I would never feel; I was becoming aware of the thing that the Jim Crow laws had been drafted and passed to keep out of my consciousness; I was acting on impulses that southern senators in the nation's capital had striven to keep out of Negro life;

I was beginning to dream the dreams that the state had said were wrong, that the schools had said were taboo.

Had I been articulate about my ultimate aspirations, no doubt someone would have told me what I was bargaining for; but nobody seemed to know, and least of all did I. My classmates felt that I was doing something that was vaguely wrong, but they did not know how to express it. As the outside world grew more meaningful, I became more concerned, tense; and my classmates and my teachers would say: "Why do you ask so many questions?" Or: "Keep quiet."

I was in my fifteenth year; in terms of schooling I was far behind the average youth of the nation, but I did not know that. In me was shaping a yearning for a kind of consciousness, a mode of being that the way of life about me had said could not be, must not be, and upon which the penalty of death had been placed. Somewhere in the dead of the southern night my life had switched onto the wrong track and, without my knowing it, the locomotive of my heart was rushing down a dangerously steep slope, heading for a collision, heedless of the warning red lights that blinked all about me, the sirens and the bells and the screams that filled the air. . . .

One morning I arrived early at work and went into the bank lobby where the Negro porter was mopping. I stood at a counter and picked up the Memphis *Commercial Appeal* and began my free reading of the press. I came finally to the editorial page and saw an article dealing with one H. L. Mencken. I knew by hearsay that he was the editor of the *American Mercury,* but aside from that I knew nothing about him. The article was a furious denunciation of Mencken, concluding with one, hot, short sentence: Mencken is a fool.

I wondered what on earth this Mencken had done to call down upon him the scorn of the South. The only people I had ever heard denounced in the South were Negroes, and this man was not a Negro. Then what ideas did Mencken hold that made a newspaper like the *Commercial Appeal* castigate him publicly? Undoubtedly he must be advocating ideas that the South did not like. Were there, then, people other than Negroes who criticized the South? I knew that during the Civil War the South had hated northern whites, but I had not encountered such hate during my life. Knowing no more

of Mencken than I did at that moment, I felt a vague sympathy for him. Had not the South, which had assigned me the role of a non-man, cast at him its hardest words?

Now, how could I find out about this Mencken? There was a huge library near the riverfront, but I knew that Negroes were not allowed to patronize its shelves any more than they were the parks and playgrounds of the city. I had gone into the library several times to get books for the white men on the job. Which of them would now help me to get books? And how could I read them without causing concern to the white men with whom I worked? I had so far been successful in hiding my thoughts and feelings from them, but I knew that I would create hostility if I went about this business of reading in a clumsy way.

I weighed the personalities of the men on the job. There was Don, a Jew; but I distrusted him. His position was not much better than mine and I knew that he was uneasy and insecure; he had always treated me in an offhand, bantering way that barely concealed his contempt. I was afraid to ask him to help me to get books; his frantic desire to demonstrate a racial solidarity with the whites against Negroes might make him betray me.

Then how about the boss? No, he was a Baptist and I had the suspicion that he would not be quite able to comprehend why a black boy would want to read Mencken. There were other white men on the job whose attitudes showed clearly that they were Kluxers or sympathizers, and they were out of the question.

There remained only one man whose attitude did not fit into an anti-Negro category, for I had heard the white men refer to him as a "Pope lover." He was an Irish Catholic and was hated by the white Southerners. I knew that he read books, because I had got him volumes from the library several times. Since he, too, was an object of hatred, I felt that he might refuse me but would hardly betray me. I hesitated, weighing and balancing the imponderable realities.

One morning I paused before the Catholic fellow's desk.

"I want to ask you a favor," I whispered to him.

"What is it?"

"I want to read. I can't get books from the library. I wonder if you'd let me use your card?"

He looked at me suspiciously.

"My card is full most of the time," he said.

"I see," I said and waited, posing my question silently.

"You're not trying to get me into trouble, are you, boy?" he asked, staring at me.

"Oh, no, sir."

"What book do you want?"

"A book by H. L. Mencken."

"Which one?"

"I don't know. Has he written more than one?"

"He has written several."

"I didn't know that."

"What makes you want to read Mencken?"

"Oh, I just saw his name in the newspaper," I said.

"It's good of you to want to read," he said. "But you ought to read the right things."

I said nothing. Would he want to supervise my reading?

"Let me think," he said. "I'll figure out something."

I turned from him and he called me back. He stared at me quizzically.

"Richard, don't mention this to the other white men," he said.

"I understand," I said. "I won't say a word."

A few days later he called me to him.

"I've got a card in my wife's name," he said. "Here's mine."

"Thank you, sir."

"Do you think you can manage it?"

"I'll manage fine," I said.

"If they suspect you, you'll get in trouble," he said.

"I'll write the same kind of notes to the library that you wrote when you sent me for books," I told him. "I'll sign your name."

He laughed.

"Go ahead. Let me see what you get," he said.

That afternoon I addressed myself to forging a note. Now, what were the names of books written by H. L. Mencken? I did not know any of them. I finally wrote what I thought would be a foolproof note: *Dear Madam: Will you please let this nigger boy*—I used the word "nigger" to make the librarian feel that I could not possibly be the author of the note—*have some books by H. L. Mencken?* I forged the white man's name.

I entered the library as I had always done when on errands for whites, but I felt that I would somehow slip up and betray myself. I doffed my hat, stood a respectful distance from the desk, looked as unbookish as possible, and waited for the white patrons to be taken care of. When the desk was clear of people, I still waited. The white librarian looked at me.

"What do you want, boy?"

As though I did not possess the power of speech, I stepped forward and simply handed her the forged note, not parting my lips.

"What books by Mencken does he want?" she asked.

"I don't know, ma'am," I said, avoiding her eyes.

"Who gave you this card?"

"Mr. Falk," I said.

"Where is he?"

"He's at work, at the M——— Optical Company," I said. "I've been in here for him before."

"I remember," the woman said. "But he never wrote notes like this."

Oh, God, she's suspicious. Perhaps she would not let me have the books? If she had turned her back at that moment, I would have ducked out the door and never gone back. Then I thought of a bold idea.

"You can call him up, ma'am," I said, my heart pounding.

"You're not using these books, are you?" she asked pointedly.

"Oh, no, ma'am. I can't read."

"I don't know what he wants by Mencken," she said under her breath.

I knew now that I had won; she was thinking of other things and the race question had gone out of her mind. She went to the shelves. Once or twice she looked over her shoulder at me, as though she was still doubtful. Finally she came forward with two books in her hand.

"I'm sending him two books," she said. "But tell Mr. Falk to come in next time, or send me the names of the books he wants. I don't know what he wants to read."

I said nothing. She stamped the card and handed me the books. Not daring to glance at them, I went out of the library, fearing that

the woman would call me back for further questioning. A block away from the library I opened one of the books and read a title: *A Book of Prefaces*. I was nearing my nineteenth birthday and I did not know how to pronounce the word "preface." I thumbed the pages and saw strange words and strange names. I shook my head, disappointed. I looked at the other book; it was called *Prejudices*. I knew what that word meant; I had heard it all my life. And right off I was on guard against Mencken's books. Why would a man want to call a book *Prejudices*? The word was so stained with all my memories of racial hate that I could not conceive of anybody using it for a title. Perhaps I had made a mistake about Mencken? A man who had prejudices must be wrong.

When I showed the books to Mr. Falk, he looked at me and frowned.

"That librarian might telephone you," I warned him.

"That's all right," he said. "But when you're through reading those books, I want you to tell me what you get out of them."

That night in my rented room, while letting the hot water run over my can of pork and beans in the sink, I opened *A Book of Prefaces* and began to read. I was jarred and shocked by the style, the clear, clean, sweeping sentences. Why did he write like that? And how did one write like that? I pictured the man as a raging demon, slashing with his pen, consumed with hate, denouncing everything American, extolling everything European or German, laughing at the weaknesses of people, mocking God, authority. What was this? I stood up, trying to realize what reality lay behind the meaning of the words . . . Yes, this man was fighting, fighting with words. He was using words as a weapon, using them as one would use a club. Could words be weapons? Well, yes, for here they were. Then, maybe, perhaps, I could use them as a weapon? No. It frightened me. I read on and what amazed me was not what he said, but how on earth anybody had the courage to say it.

Occasionally I glanced up to reassure myself that I was alone in the room. Who were these men about whom Mencken was talking so passionately? Who was Anatole France? Joseph Conrad? Sinclair Lewis, Sherwood Anderson, Dostoevski, George Moore, Gustave Flaubert, Maupassant, Tolstoy, Frank Harris, Mark Twain, Thomas

Hardy, Arnold Bennett, Stephen Crane, Zola, Norris, Gorky, Bergson, Ibsen, Balzac, Bernard Shaw, Dumas, Poe, Thomas Mann, O. Henry, Dreiser, H. G. Wells, Gogol, T. S. Eliot, Gide, Baudelaire, Edgar Lee Masters, Stendhal, Turgenev, Huneker, Nietzsche, and scores of others? Were these men real? Did they exist or had they existed? And how did one pronounce their names?

I ran across many words whose meanings I did not know, and I either looked them up in a dictionary or, before I had a chance to do that, encountered the word in a context that made its meaning clear. But what strange world was this? I concluded the book with the conviction that I had somehow overlooked something terribly important in life. I had once tried to write, had once reveled in feeling, had let my crude imagination roam, but the impulse to dream had been slowly beaten out of me by experience. Now it surged up again and I hungered for books, new ways of looking and seeing. It was not a matter of believing or disbelieving what I read, but of feeling something new, of being affected by something that made the look of the world different.

As dawn broke I ate my pork and beans, feeling dopey, sleepy. I went to work, but the mood of the book would not die; it lingered, coloring everything I saw, heard, did. I now felt that I knew what the white men were feeling. Merely because I had read a book that had spoken of how they lived and thought, I identified myself with that book. I felt vaguely guilty. Would I, filled with bookish notions, act in a manner that would make the whites dislike me?

I forged more notes and my trips to the library became frequent. Reading grew into a passion. My first serious novel was Sinclair Lewis's *Main Street*. It made me see my boss, Mr. Gerald, and identify him as an American type. I would smile when I saw him lugging his golf bags into the office. I had always felt a vast distance separating me from the boss, and now I felt closer to him, though still distant. I felt now that I knew him, that I could feel the very limits of his narrow life. And this had happened because I had read a novel about a mythical man called George F. Babbitt.

The plots and stories in the novels did not interest me so much as the point of view revealed. I gave myself over to each novel without reserve, without trying to criticize it; it was enough for me to see and feel something different. And for me, everything was some-

thing different. Reading was like a drug, a dope. The novels created moods in which I lived for days. But I could not conquer my sense of guilt, my feeling that the white men around me knew that I was changing, that I had begun to regard them differently.

Whenever I brought a book to the job, I wrapped it in newspaper—a habit that was to persist for years in other cities and under other circumstances. But some of the white men pried into my packages when I was absent and they questioned me.

"Boy, what are you reading those books for?"

"Oh, I don't know, sir."

"That's deep stuff you're reading, boy."

"I'm just killing time, sir."

"You'll addle your brains if you don't watch out."

I read Dreiser's *Jennie Gerhardt* and *Sister Carrie* and they revived in me a vivid sense of my mother's suffering; I was overwhelmed. I grew silent, wondering about the life around me. It would have been impossible for me to have told anyone what I derived from these novels, for it was nothing less than a sense of life itself. All my life had shaped me for the realism, the naturalism of the modern novel, and I could not read enough of them.

Steeped in new moods and ideas, I bought a ream of paper and tried to write; but nothing would come, or what did come was flat beyond telling. I discovered that more than desire and feeling were necessary to write and I dropped the idea. Yet I still wondered how it was possible to know people sufficiently to write about them? Could I ever learn about life and people? To me, with my vast ignorance, my Jim Crow station in life, it seemed a task impossible of achievement. I now knew what being a Negro meant. I could endure the hunger. I had learned to live with hate. But to feel that there were feelings denied me, that the very breath of life itself was beyond my reach, that more than anything else hurt, wounded me. I had a new hunger.

In buoying me up, reading also cast me down, made me see what was possible, what I had missed. My tension returned, new, terrible, bitter, surging, almost too great to be contained. I no longer *felt* that the world about me was hostile, killing; I *knew* it. A million times I asked myself what I could do to save myself, and there were no answers. I seemed forever condemned, ringed by walls.

I did not discuss my reading with Mr. Falk, who had lent me his

library card; it would have meant talking about myself and that would have been too painful. I smiled each day, fighting desperately to maintain my old behavior, to keep my disposition seemingly sunny. But some of the white men discerned that I had begun to brood.

"Wake up there, boy!" Mr. Olin said one day.

"Sir!" I answered for the lack of a better word.

"You act like you've stolen something," he said.

I laughed in the way I knew he expected me to laugh, but I resolved to be more conscious of myself, to watch my every act, to guard and hide the new knowledge that was dawning within me.

If I went north, would it be possible for me to build a new life then? But how could a man build a life upon vague, unformed yearnings? I wanted to write and I did not even know the English language. I bought English grammars and found them dull. I felt that I was getting a better sense of the language from novels than from grammars. I read hard, discarding a writer as soon as I felt that I had grasped his point of view. At night the printed page stood before my eyes in sleep.

Mrs. Moss, my landlady, asked me one Sunday morning:

"Son, what is this you keep on reading?"

"Oh, nothing. Just novels."

"What you get out of 'em?"

"I'm just killing time," I said.

"I hope you know your own mind," she said in a tone which implied that she doubted if I had a mind.

I knew of no Negroes who read the books I liked and I wondered if any Negroes ever thought of them. I knew that there were Negro doctors, lawyers, newspapermen, but I never saw any of them. When I read a Negro newspaper I never caught the faintest echo of my preoccupation in its pages. I felt trapped and occasionally, for a few days, I would stop reading. But a vague hunger would come over me for books, books that opened up new avenues of feeling and seeing, and again I would forge another note to the white librarian. Again I would read and wonder as only the naïve and unlettered can read and wonder, feeling that I carried a secret, criminal burden about with me each day.

That winter my mother and brother came and we set up house-

keeping, buying furniture on the installment plan, being cheated and yet knowing no way to avoid it. I began to eat warm food and to my surprise found that regular meals enabled me to read faster. I may have lived through many illnesses and survived them, never suspecting that I was ill. My brother obtained a job and we began to save toward the trip north, plotting our time, setting tentative dates for departure. I told none of the white men on the job that I was planning to go north; I knew that the moment they felt I was thinking of the North they would change toward me. It would have made them feel that I did not like the life I was living, and because my life was completely conditioned by what they said or did, it would have been tantamount to challenging them.

I could calculate my chances for life in the South as a Negro fairly clearly now.

I could fight the southern whites by organizing with other Negroes, as my grandfather had done. But I knew that I could never win that way; there were many whites and there were but few blacks. They were strong and we were weak. Outright black rebellion could never win. If I fought openly I would die and I did not want to die. News of lynchings were frequent.

I could submit and live the life of a genial slave, but that was impossible. All of my life had shaped me to live by my own feelings and thoughts. I could make up to Bess and marry her and inherit the house. But that, too, would be the life of a slave; if I did that, I would crush to death something within me, and I would hate myself as much as I knew the whites already hated those who had submitted. Neither could I ever willingly present myself to be kicked, as Shorty had done. I would rather have died than do that.

I could drain off my restlessness by fighting with Shorty and Harrison. I had seen many Negroes solve the problem of being black by transferring their hatred of themselves to others with a black skin and fighting them. I would have to be cold to do that, and I was not cold and I could never be.

I could, of course, forget what I had read, thrust the whites out of my mind, forget them; and find release from anxiety and longing in sex and alcohol. But the memory of how my father had conducted himself made that course repugnant. If I did not want others to violate my life, how could I voluntarily violate it myself?

I had no hope whatever of being a professional man. Not only had I been so conditioned that I did not desire it, but the fulfillment of such an ambition was beyond my capabilities. Well-to-do Negroes lived in a world that was almost as alien to me as the world inhabited by whites.

What, then, was there? I held my life in my mind, in my consciousness each day, feeling at times that I would stumble and drop it, spill it forever. My reading had created a vast sense of distance between me and the world in which I lived and tried to make a living, and that sense of distance was increasing each day. My days and nights were one long, quiet, continuously contained dream of terror, tension, and anxiety. I wondered how long I could bear it.

TOBIAS WOLFF
(1945–)

*Tobias Wolff grew up with his mother and stepfather in Concrete,
Washington, in the Cascade Mountains.*

*Wolff took his B.A. from Oxford University and his M.A. from
Stanford University. He has taught at Stanford, at Arizona State
University, and, since 1980, at Syracuse University.*

Wolff has written three collections of outstanding short stories: In
the Garden of North American Martyrs *(1981),* The Barracks Thief
(1984), winner of the PEN/Faulkner Award, and Back in the World
*(1985). He won O. Henry short story prizes in 1980, 1981, and 1985.
Wolff has written two memoirs.* In Pharaoh's Army: Memories of the
Lost War *was a finalist for the National Book Award in 1994.*

This is a section from the memoir This Boy's Life. *Geoffrey is
Tobias's brother, eight years older and an honors scholar at Princeton
University. Arthur is Arthur Gayle, Tobias's former best friend at
school.*

*After an interview, the Hill School accepted him. The other schools
turned him down.*

■ ■ ■

from THIS BOY'S LIFE

Iknew something had happened, but I didn't know what. My
mother wouldn't tell me. She was afraid I would make things
worse if I knew, stir Dwight up all over again. The fact was, she had
no money and no place to go. Alone, she might have bolted anyway.
With me to take care of she thought she couldn't.

When I told her I'd spoken to Geoffrey, her eyes filled with tears.
This was unusual for her. We were sitting at the kitchen table, where
we liked to talk when we were alone in the house. Geoffrey had
recently been sending my mother letters, too, but they hadn't spo-
ken since we left Utah. She wanted to know what he sounded like,
how he was, and all manner of things I had not thought to ask him.
My mother grew somber, as she often did when we talked about

Geoffrey. She was afraid she'd done the wrong thing in letting him go with my father, afraid he held it against her, that and the divorce, and taking up with Roy.

I mentioned Geoffrey's idea about Choate, about the possibility of my getting a scholarship there or maybe at some other school. I was afraid of her reaction. I thought she would be hurt by my wish to go, but she liked the idea. "He actually thinks you have a chance?" she said.

"He said they'll be eating out of my hand, quote unquote."

"I don't know why he thinks that."

"My grades are good," I said.

"That's true. Your grades are good. What other schools did he mention?"

"St. Paul's."

"He's got big plans for you."

"Deerfield."

She laughed. "They'll recognize your name, anyway. I think your father was the only boy they ever expelled." Then she said, "Don't get your hopes too high."

"Geoffrey said he'd talk to Dad about it. He said maybe Dad would have some ideas."

"I'm sure he will," she said.

Geoffrey sent the names and addresses of the schools he had first mentioned, and also three others—Hill, Andover, and Exeter. I went to the library at school and looked them up in Vance Packard's *The Status Seekers*. This book explained how the upper class perpetuates itself. Its motive was supposedly democratic, to attack snobbery and subvert the upper class by giving away its secrets. But I didn't read it as social criticism. To seek status seemed the most natural thing in the world to me. Everyone did it. The people who bought the book were certainly doing it. They consulted it with the same purpose I had, not to deplore the class problem but to solve it by changing classes.

Whatever he meant it to be, Packard's book was the perfect guide for social climbers. He listed the places you should live and the colleges you should go to and the clubs you should join and the faith you should confess. He named the tailors and stores you

should patronize, and described with filigree exactitude the ways you could betray your origins. Wearing a blue serge suit to a yacht-club party. Saying davenport for sofa, ill for sick, wealthy for rich. Painting the walls of your house in bright colors. Mixing ginger ale with whiskey. Being too good a dancer. He showed boxes within boxes, circles within circles. Of course you would go to an Ivy League school, but that by itself wouldn't do the trick. "The point is not Harvard, but which Harvard? By Harvard one means Porcellian, Fly, or AD." And he said that the key to which Harvard one attended, or which Yale, or which Princeton, and therefore which life one led thereafter, was one's prep school. "Harvard or Yale or Princeton is not enough. It is the really exclusive prep school that counts. . . ."

Packard said there were over three thousand private schools in America. Only a very few satisfied his standard of exclusivity. He specified them in a brief list almost exactly the same as Geoffrey's. I understood, pondering these names in the library of Concrete High, that the brilliant life they promised depended on leaving most people out, to loud walls and bad tailors. I did not want to be left out. Now that I had felt the possibility of this life, any other life would be an oppression.

Packard made a point of saying that these schools were just about impossible for outsiders to get into. But he did mention that they gave scholarships, and that many of the scholarships went to "descendants of once-prosperous alumni who had come into difficult times." That made me feel as if the people at Deerfield were just sitting around waiting to hear from me.

I wrote off for application forms. The schools responded quickly, with cover letters in whose stiff courtesy I managed to hear panting enthusiasm. I did get a friendly note from John Boyden, the headmaster of Deerfield and the son of the man who had thrown my father out. He said that the school was already swamped with applications that year, and recommended that I apply to some other schools. His list was familiar. In a handwritten postscript he added that he remembered my father, and wished me all the best. I fixed on this cordial nod as a signal of favor.

When the forms were all in, I sat down to fill them out and ran into a wall. I could see from the questions they asked that to get into

one of these schools, let alone win a scholarship, I had to be at least the boy I'd described to my brother and probably something more. Geoffrey was willing to take me at my word; the schools were not. Each of the applications required supporting letters. They wanted letters from teachers, coaches, counselors, and, if possible, their own alumni. They asked for an account of my Community Service, and left a space of disheartening length for the answer. Likewise Athletic Achievements, likewise Foreign Travel, and Languages. I understood that these claims were to be confirmed in the letters of recommendation. They wanted my grades sent by Concrete High on its official transcript form. Finally, they required that I take a prep-school version of the Scholastic Aptitude Test, to be administered in January at the Lakeside School in Seattle.

I was stumped. Whenever I looked at the forms I felt despair. Their whiteness seemed hostile and vast, Saharan. I had nothing to get me across. During the day I composed high-flown circumlocutions, but at night, when it came to writing them down, I balked at their silliness. The forms stayed clean. When my mother pressed me to send them off, I transferred them to my locker at school and told her everything was taken care of. I did not trouble my teachers for praise they could not give me, or bother to have my collection of C's sent out. I was giving up—*being realistic,* as people liked to say, meaning the same thing. Being realistic made me feel bitter. It was a new feeling, and one I didn't like, but I saw no way out.

My father called. He called on a night when both Dwight and Pearl were out of the house, and that was a lucky thing, because my mother took the call and everything about her immediately changed. She became girlish. I realized who it was and stood beside her, straining to hear words in the rumble of my father's voice. He did most of the talking. My mother smiled and shook her head. Now and then she laughed skeptically and said, "We'll have to see," and "I don't know about that." Finally she said, "He's right here," and handed the receiver over to me.

"Hi, Chum," he said, and I could feel him there. His bearish bulk, his tobacco smell.

I said hello.

"Your brother tells me you're thinking of Choate," he said. "Personally, I think you'd be happier at Deerfield."

"Well, I just applied," I said. "Maybe I won't get in."

"Oh, you'll get in all right, boy like you." He recited back to me the things I had told Geoffrey.

"I don't know. They get a lot of applications."

"You'll get in," he said sternly. "The question is, which school to choose. I'm simply suggesting that Deerfield may be on a more congenial scale than Choate. Let's face it, you're used to being a big fish in a small pond—you might get lost at Choate. But it's your choice to make. If you want to go to Choate, for Christ's sake go to Choate! It's a fine school. A damn fine school."

"Yes sir."

He asked me where else I'd applied and I went through the list. He gave his approval, then added, "Mind you, Andover's something of a factory. I'm not sure I'd send a boy of mine there, but we can talk about that when the time comes. Now here's the plan."

The plan was that I should come down to La Jolla as soon as school was over. Then Geoffrey would fly out from Princeton after graduation and the three of us would spend the whole summer together. Geoffrey would work on his novel while I started preparing for classes at Deerfield. When we wanted a break we could go for a swim at Wind and Sea Beach, which was just down the street from the apartment. And later, when she saw how well everything was going, my mother would join us. We would be a family again. "I've made some mistakes," he told me. "We all have. But that's behind us. Right, Tober?"

"Right."

"You damn betcha. We're starting from scratch. And look, no more of this Jack business. You can't go off to Deerfield with a name like Jack. Understand?"

I said I understood.

"Good boy." He asked if it was true that my stepfather had hit me. When I said yes, he said, "The next time he does it, kill him." Then he asked to speak to my mother again.

After she hung up I told her what he'd said to me.

"Sounds real nice," she said. "Don't bank on it."

"He said you would come too."

"Hah! That's what he thinks. I'd have to be crazy to do that." Then she said, "Let's see what happens."

My mother drove me down to Seattle for the tests. I took the verbal section in the morning and immediately began to enjoy myself. I recognized, behind the easy-seeming questions on vocabulary and reading comprehension, a competitive intelligence out to tempt me with answers that were not correct. The tricks had a smugness about them that provoked me. I wanted to confound these sharpies, show them I wasn't as dumb as they thought I was. When the monitor called the tests in I felt suddenly alone, as if someone had walked out on me in the middle of a good argument.

The other boys who were taking the test gathered in the hallway to compare answers. They all seemed to know each other. I did not approach them, but I watched them closely. They wore rumpled sport coats and baggy flannel pants. White socks showing above brown loafers. I was the only boy there in a suit, a salt-and-pepper suit I'd gotten for eighth-grade graduation, now too small for me. And I was the only boy there with a "Princeton" haircut. The others had long hair roughly parted and left hanging down across their foreheads, almost to their eyes. Now and then they tossed their heads to throw the loose hair back. The effect would have been careless on just one of them, but it was uniform, an effect of style, and I took note of it. I also took note of the way they talked to each other, their predatory, reflexive sarcasm. It interested me, excited me; at certain moments I had to make an effort not to laugh. As they spoke they smiled ironically, and rocked on their heels, and tossed their heads like nickering horses.

After lunch I walked around the campus. The regular students had not yet returned from their Christmas vacation, and the quiet was profound. I found a bench overlooking the lake. The surface was misty and gray. Until they rang the bell for the math test I sat with crossed legs and made believe I belonged here, that these handsome old buildings, webbed with vines of actual ivy to which a few brown leaves still clung, were my home.

Arthur hated shop, which was a required course for boys at Concrete High. After making his eighth or ninth cedar box he

revolted. He was able to negotiate his way out by agreeing to work in the school office during that period. I thought he would help me, but he refused angrily. His anger made no sense to me. I did not understand that he wanted out, too. I backed off and didn't ask again.

But a few days later he came up to me in the cafeteria, dropped a manila folder on the table, and walked away without a word. I got up and took the folder to the bathroom and locked myself in a stall. It was all there, everything I had asked for. Fifty sheets of school stationery, several blank transcript forms, and a stack of official envelopes. I slipped them into the folder again and went back to the cafeteria.

Over the next couple of nights I filled out the transcripts and the application forms. Now the application forms came easy; I could afford to be terse and modest in my self-descriptions, knowing how detailed my recommenders were going to be. When these were done I began writing the letters of support. I wrote out rough copies in longhand, then typed up the final versions on official stationery, using different machines in the typing lab at school. I wrote the first drafts deliberately, with much crossing out and penciling in, but with none of the hesitance I'd felt before. Now the words came as easily as if someone were breathing them into my ear. I felt full of things that had to be said, full of stifled truth. That was what I thought I was writing—the truth. It was truth known only to me, but I believed in it more than I believed in the facts arrayed against it. I believed that in some sense not factually verifiable I was a straight-A student. In the same way, I believed that I was an Eagle Scout, and a powerful swimmer, and a boy of integrity. These were ideas about myself that I had held on to for dear life. Now I gave them voice.

I made no claims that seemed false to me. I did not say that I was a star quarterback or even a varsity football player, because even though I went out for football every year I never quickened to the lumpen spirit of the sport. The same was true of basketball. I couldn't feature myself sinking a last-second clincher from the key, as Elgin Baylor did for Seattle that year in the NCAA playoffs against San Francisco. Ditto school politics; the unending compulsion to test one's own popularity was baffling to me.

These were not ideas I had of myself, and I did not propose to urge them on anyone else.

I declined to say I was a football star, but I did invent a swimming team for Concrete High. The coach wrote a fine letter for me, and so did my teachers and the principal. They didn't gush. They wrote plainly about a gifted, upright boy who had already in his own quiet way exhausted the resources of his school and community. They had done what they could for him. Now they hoped that others would carry on the good work.

I wrote without heat or hyperbole, in the words my teachers would have used if they had known me as I knew myself. These were their letters. And on the boy who lived in their letters, the splendid phantom who carried all my hopes, it seemed to me I saw, at last, my own face. . . .

I had done well on the tests I'd taken in Seattle. But not long after my scores came in I got a rejection letter from Andover. Then St. Paul's turned me down. Then Exeter. The letters were polite, professed regret for the news they bore, and wished me well. I never heard back from Choate at all.

The rejections disappointed me, but I hadn't really counted on these schools anyway. I was counting on Deerfield. When I got their letter I went off by myself. I sat by the river and read it. I read it many times, first because I was too numb to take it all in, then to find some word or tone that would cancel out everything else the letter said, or at least give me hope for an appeal. But they knew what they were doing, the people who wrote these letters. They knew how to close the door so that no seam showed, no light glimmered at the edges. I understood that the game was over.

A week or so later the school secretary summoned me out of class to take a telephone call in the office. She said it sounded long distance. I thought it might be my brother, or even my father, but the caller turned out to be a Hill School alumnus who lived in Seattle. His name was Mr. Howard. He told me the school was "interested" in my application, and had asked him to meet with me and have a talk. Just an informal chat, he said. He said he'd always wanted to see our part of the state, and this would give him a good excuse. We arranged to meet outside Concrete High after classes let out the next day. Mr. Howard said he'd be driving a blue Thunderbird. He didn't say anything about wanting to meet my teachers, thank God.

"Whatever you do, just don't try to impress him," my mother said when I told her about the call. "Just be yourself."

When Mr. Howard asked me where we might go to talk, I suggested the Concrete drugstore. I knew there would be kids from school there. I wanted them to see me pull up in the Thunderbird and get out with this man, who was just old enough to be my father, and different from other men you might see in the Concrete drugstore. Without affecting boyishness, Mr. Howard still had the boy in him. He bounced a little as he walked. His narrow face was lively, foxlike. He looked around with a certain expectancy, as if he were ready to be interested in what he saw, and when he was interested he allowed himself to show it. He wore a suit and tie. The men who taught at the high school also wore suits and ties, but less easily. They were always pulling at their cuffs and running their fingers between their collars and their necks. To watch them was to suffocate. Mr. Howard wore his suit and tie as if he didn't know he had them on.

We sat at a booth in the back. Mr. Howard bought us milkshakes, and while we drank them he asked me about Concrete High. I told him I enjoyed my classes, especially the more demanding ones, but that I was feeling a little restless lately. It was hard to explain.

"Oh, come on," he said. "It's easy to explain. You're bored."

I shrugged. I wasn't going to speak badly of the teachers who had written so well of me.

"You wouldn't be bored at Hill," Mr. Howard said. "I can promise you that. But you might find it difficult in other ways." He told me about his own time there in the years just before World War II. He had grown up in Seattle, where he'd done well in school. He expected that he would fall easily into life at Hill, but he hadn't. The academic work was much harder. He missed his family and hated the snowy Pennsylvania winters. And the boys at Hill were different from his friends back home, more reserved, more concerned with money and social position. He had found the school a cold place. Then, in his last year, something changed. The members of his class grew close in ways that he had never thought possible, until they were more like brothers than friends. It came, he said, from the simple fact of shar-

ing the same life for a period of years. It made them a family. That was how he thought of the school now—as his second family.

But he'd had a rough time getting to that point, and some of the boys never got to it at all. They lived unhappily at the edge of things. These same boys might have done well if they'd stayed at home. A prep school was a world unto itself, and not the right world for everyone.

If any of this was supposed to put me off, it didn't. Of course the boys were concerned with money and social position. Of course a prep school wasn't for everyone—otherwise, what would be the point?

But I put on a thoughtful expression and said that I was aware of these problems. My father and my brother had given me similar warnings, I explained, and I was willing to endure whatever was necessary to get a good education.

Mr. Howard seemed amused by this answer, and asked me on what experience my father and brother had based their warnings. I told him that they had both gone to prep schools.

"Is that right? Where?"

"Deerfield and Choate."

"I see." He looked at me with a different quality of interest than before, as I had hoped he would. Though Mr. Howard was not a snob, I could see he was worried that I might not fit in at his school.

"My brother's at Princeton now," I added.

He asked me about my father. When I told him that my father was an aeronautical engineer, Mr. Howard perked up. It turned out he had been a pilot during the war, and was familiar with a plane my father had helped design—the P-51 Mustang. He hadn't flown it himself but he knew men who had. This led him to memories of his time in uniform, the pilots he had served with and the nutty things they used to do. "We were just a bunch of kids," he said. He spoke to me as if I were not a kid myself but someone who could understand him, someone of his world, family even. His hands were folded on the tabletop, his head bent slightly. I leaned forward to hear him better. We were really getting along. And then Huff showed up.

Huff had a peculiar voice, high and nasal. I had my back to the door but I heard him come in and settle into the booth behind ours with another boy, whose voice I did not recognize. The two of them

were discussing a fight they'd seen the previous weekend. A guy from Concrete had broken a guy from Sedro Woolley's nose.

Mr. Howard stopped talking. He leaned back, blinking a little as if he had dozed off. He did not speak, nor did I. I didn't want Huff to know I was there. Huff had certain rituals of greeting that I was anxious to avoid, and if he sensed he was embarrassing me he would never let me get away. He would sink my ship but good. So I kept my head down and my mouth shut while Huff and the other boy talked about the fight, and about the girl the two boys had been fighting over. They talked about another girl. Then they talked about eating pussy. Huff took the floor on this subject, and showed no sign of giving it up. He went on at length. I heard boys hold forth like this all the time, and I did it myself, but now I thought I'd better show some horror. I frowned and shook my head, and stared down at the tabletop.

"Shall we go?" Mr. Howard asked.

I did not want to break cover but I had no choice. I got up and walked past Huff's booth, Mr. Howard behind me. Though I kept my face averted I was sure that Huff would see me, and as I moved toward the door I was waiting to hear him shout, "Hey! Dicklick!" The shout never came.

Mr. Howard drove around Concrete for a while before taking me back to school. He was curious about the cement plant, and disappointed that I could tell him nothing about what went on inside it. He was quiet for a time. Then he said, "You should know that a boys' school can be a pretty rough-and-tumble place."

I said that I could take care of myself.

"I don't mean physically rough," Mr. Howard said. "Boys talk about all kinds of things. Even at a school like Hill you don't hear a whole lot of boys sitting around at night talking about Shakespeare. They're going to talk about other things. Sex, whatever. And they're going to take the gloves off."

I said nothing.

"You can't expect everyone to be, you know, an Eagle Scout."

"I don't," I said.

"I'm just saying that life in a boys' school can come as a bit of a shock to someone who's led a sheltered life." I began to make an answer, but Mr. Howard said, "Let me just say one more thing.

You're obviously doing a great job here. With your grades and so on you should be able to get into an excellent college later on. I'm not sure that a prep school is exactly the right move for you. You might end up doing yourself more harm than good. It's something to consider."

I told Mr. Howard that I had not led a sheltered life, and that I was determined to get myself a better education than the one I was getting now. In trying to keep my voice from breaking I ended up sounding angry.

"Don't misunderstand me," Mr. Howard said. "You're a fine boy and I'll be happy to give you a good report." He said these words quickly, as if reciting them. Then he added, "You have a strong case. But you should know what you're getting into." He said he would write to the school the next day, then we'd just have to wait and see. From what he understood, I was one of many boys being considered for the few remaining places.

"I assume you've got applications in at other schools," he said.

"Just Choate. But I'd rather go to Hill. Hill is my first choice."

We were parked in front of the school. Mr. Howard took a business card from his wallet and told me to call him if I had any questions. He advised me not to worry, said whatever happened would surely be for the best. Then he said good-bye and drove away. I watched the Thunderbird all the way down the hill to the main road, watched it as a man might watch a woman he'd just met leave his life, taking with her some hope of change that she had made him feel. The Thunderbird turned south at the main road and disappeared behind some trees.

DON ASHER
(1926–)

Don Asher is a novelist and jazz pianist. Born in Massachusetts,
educated at Cornell University, Asher has played both the East and
West coasts, including a long stint at San Francisco's The hungry i.
He also worked for a year as a research chemist.

His most recent novel is Blood Summer. *He and pianist Hampton*
Hawes together wrote Hawes's biography, Raise Up Off Me.

"Shoot the Piano Player" is a short version of his 1992 musical
memoir, Notes from a Battered Grand. Harper's *magazine first*
published it, subtitled "Tales of an Ivory Tickler."

■ ■ ■

Shoot the Piano Player

At sixteen I was embarking on a course that would admit me to
the preeminent cabarets and ballrooms of Boston and San
Francisco—a piano bench my passkey—entering via the back doors
of assorted waterfront dives, backstreet saloons, and turnpike toilets.
Tiny's Carousel, on Route 9 between Worcester and Boston, embod-
ied the middle reaches of the final category. A sign over the bar said,
"Our waitresses are ladies of unimpeachable moral character," and
the band, a quartet, featured a Negro on tenor sax who played rings
around everyone in town. I later learned that I acquired the job (fol-
lowing an undistinguished audition) and held on to it by grace of
Tiny's having come up before my uncle, a fairly well-known
Worcester County judge, on an extortion charge. My uncle had given
him a small fine and probation, and Tiny was the soul of deference
and congeniality throughout my tenure at his club. "A fine upstand-
ing man, your uncle the judge," he'd say at the slightest provocation.
Tiny hired only strippers six feet tall and over. Glamazons, he called
them. I believe the coinage originated with Billy Rose at his
Diamond Horseshoe. Tiny's six-footers had names like Belle
Adonna, Beryl Bang! (exclamation point hers), Eve Cherry, and
Ginger Rhale. They rarely brought in music, simply asking for "some

slow blues" or "any jump tune, medium tempo, 'bout like this"—snapping a thumb and middle finger in a brisk ellipse—or "'Satin Doll,' medium-slow, couple choruses, stop time on the bridge; when I'm down to the bra and G-string, double time and out."

Tiny, according to my uncle the judge, was a man "of humble origins and acquired manners." Short and chunky, with a comical rocking motion to his walk, he intoned in a soft, husky voice expressions of civility such as "Happy to be making your acquaintance," on being introduced to a new customer, and "Try the veal parmigiana, it'll enliven the palate." His introductions of the acts were equally florid: "Now for your postprandial pleasure, the pulchritudinous Ginger Rhale . . ." The second night of Ginger's engagement Tiny changed her billing to "Silverella." A lissome ebony-skinned beauty ("I grew up on a boulevard of broken lights," I overheard her tell a man at the bar), she emerged from behind a red velvet curtain in glittering silver headdress and swirling layers of diaphanous mauve and scarlet, tracing a sinuous course between the tables under a pale blue spot to a Fats Waller medley of "Ain't Misbehavin'" and "Keepin' Out of Mischief Now." Gutbucket tenor and boiling drums propelled the medley through a progression of crescendos, spurring Silverella to impassioned maneuvers—now prancing like a thoroughbred mare, now swinging her head to the floor, legs taut as a stork's, and straightening abruptly with a rapid-fire shimmy of shoulders and switching of hips—all the while loosening strategically placed strings, allowing raiment to spin tempestuously from her body in incarnadine streamers. Thundering tom-toms, mingling with the crowd's raucous exhortations, built to a frenzied pitch, rolling into the climax—the blue spot winking out on a vision that stormed the blood: Silverella, throat arched and arms akimbo, revealed in all her extravagant glory but for a phosphorescent coat of silver paint, collarbone to toes (and this fifteen years before *Goldfinger!*), shining diabolically in the black light. A hollering, foot-stomping ovation followed her regal exit through the swirling red curtain. She colored my dreams, Silverella, the most erotic fantasies I've ever known, and she departed before I could muster the courage to speak a word to her.

Beryl Bang! was equally statuesque but more accessible. She had

recently graduated from Pembroke, was funny and imaginative, and told me she had perfected her supple feline strut by conjuring a metamorphic image of herself as a Persian cat strolling along the top of a fence on a moonlit night. Her legs went on forever ("Do they go all the way up?" inquired a leering businessman as she sauntered past his table; "All the way to heaven, dearie," came her over-the-shoulder retort), and her raven hair fell like a lace shawl about her shoulders. Toward the end of her engagement I plucked raw courage out of the air:

"How about a bite of supper after the last show, Miss Bang!?"

She wore three-inch spikes; I was five feet six, and her green gaze, which seemed to descend on me from the eaves, was not unkindly. "Honey, look at me and look at you and tell me what we're gonna do together."

Strippers, I was learning, appropriate for their art the best, bluest, gutsiest tunes of the day, and that year and a half at Tiny's was probably the happiest time I've ever known. Home at two in the morning and up at seven for school; trying to nap in the late afternoons but too keyed up in anticipation of nightfall, the lights, the funky, vibrant club and long-legged glamazons, and the music that sent the blood leaping and bucking in my veins.

As it must to all nightclubs, the IRS came to Tiny's Carousel—dispassionate agents armed with padlocks—and I gravitated back to Worcester, a solo spot at Vincent's in the Shrewsbury Street Italian section. This was a shiny and opulent cabaret, incongruously situated among the neighborhood groceries, laundries, and pizzerias, and frequented by members of the thriving Worcester-Boston-Providence axis of La Cosa Nostra. I never learned who Vincent was. The manager, whom I'll call Guido, owned two cocker spaniels, and every night at closing time he'd set out twin yellow bowls of food on either side of the leather-padded door, beneath the zebra-striped awning. Inside was a black marble fireplace and lots of mirrors on the crimson walls; from different angles they glittered and flashed with light thrown from the banquettes' silver and glassware. The bar was separate, a small horseshoe affair called The Paddock, with black glass-top tables and framed photographs of racetracks and horses. In an alcove between the supper room, where I worked,

and the bar was a combination coatcheck stand and cigarette counter operated by a pretty, faded woman attired in mesh stockings, satin corselet, and pillbox hat. This was Guido's sister, and I would soon become overly familiar with a phrase that she invariably appended to her offhand remarks: "It's fairly common knowledge, but for the love of God don't quote me."

At that time you could distinguish the mob-patronized clubs by the preponderance of good-looking women who appeared to be unattached—it took an immoderately courageous or naïve outsider to find out—and middle-aged men in conservative suits. The younger men dressed more elegantly but still along reserved lines—dark suits of shiny material and monogrammed white shirts and light-colored silk ties, the sole note of ostentation residing in the cufflinks and tiepins that gleamed opulently in the restrained bar lights. The mobsters enjoyed contemporary music and the kindred arts—singing, dancing, comedy. They liked to conduct their business and relax in sleek and animated surroundings and could grow misty-eyed listening to a pretty girl singing a sentimental tune.

I backed singer Amy Avallone and played solo segments around her. She was a full-bodied, sloe-eyed woman with olive skin and a marauding walk. ("Honey, I only walk down wide corridors 'cause I bruise kinda easy," I heard her say to an aging mafioso.) She came in that first night wearing a luxurious fur coat, a monogrammed leather folder under one arm and a blue silk gown over the other; she dropped the folder on the piano. "Let's run over my charts before the place fills up."

I glanced through the arrangements; they were elaborate and overwritten, dense with notes. My reading skill at the time was rudimentary, and to speak frankly, the notation looked about as decipherable as a spattering of bird droppings across a barn wall.

"I know most of the tunes; why don't we just fake them?"

"I paid good loot for these charts. You can read, can't you?"

"Let's save ourselves trouble. Just write out the order with keys and number of choruses."

She leaned her elbows disconsolately on the piano and for a moment seemed to be studying her reflection in the polished wood;

then she muttered something under her breath that sounded like a resigned "What a pity." When I got to know her better I realized the phrase had been "Shit city."

She opened each of her three nightly sets with "Once in Love with Amy" and closed with some sprightly, maudlin jumper like "Aren't You Glad You're You?" (*Ev'ry time you're near a rose / Aren't you glad you've got a nose?*). The mafiosi ate it up. Part of my job was to boost her to a sitting position on the baby grand à la Helen Morgan, in one of her strapless sheaths (she wore a different one for every set and a week would elapse before I noticed a repeat). A rich and heady perfume came off her throat and shoulders like mist off a still pond, and I'd retreat from these exquisite exertions reeling.

Between her sets I played ballads and show tunes of the day, trying to impress with a lot of gloss and technical display—cross-handed embellishments, two melodies rendered simultaneously (Watch *this*, Alec Templeton), and rhythmic variations on sturdy warhorses like "Alexander's Ragtime Band"—what musicians call flagwavers. I thought it wouldn't hurt to get on the right side of these guys. (Guido's sister had told me he'd tried a pair of strolling fiddlers when the place first opened, "but the clientele wasn't all that crazy about the horsehair shafts poking into their lobster Newburg. They lasted three nights and no one's heard of them since. It's fairly common knowledge, but for the love of God don't quote me.") What sometimes drifted across my mind as I served up my flagwavers to the blankly pretty women and blunt-featured men was an account I'd read in *National Geographic* of primitive Indian tribesmen in the remote upper reaches of the Amazon displaying "extraordinary emotional responses" to a recording of Beethoven's Violin Concerto.

Guido took me aside one night. Unlike his conservatively dressed clientele, he wore a brown shirt and yellow tie with his pin-stripe suit. Complaints had come his way: people were having trouble recognizing the melody, and a highly esteemed party at a reserved table had remarked that the piano player couldn't seem to keep a steady beat—sadly mistaking my embroideries for rhythmic instability.

"I like you, you're a nice boy," Guido said. "Amy wishes you'd use her music, but she's happier than she was with the last guy. Now,

you want to make an old businessman happy? My friends are simple good-time Charlies, they don't like a lot of adornment. Knock off the fancy flourishes, cut down the DiMaggios [arpeggios]. Leave us hear the melody, *capisc*?" And he drove a short playful right to my midriff and slapped my cheek in a friendly but brisk manner.

Later that night an old and battered mafioso approached the piano while I was playing a medley from *Oklahoma*. His face was deeply seamed, and coarse tufts of gray hair sprouted from the backs of his thick hands. They lowered onto mine, at first merely covering them, then gently pressing them into the dead keys as if he were reluctantly squashing a pair of harmless but repulsive insects; "The Surrey with the Fringe on Top" went flatter than a doormat.

"Play 'Ciao, Ciao, Bambina.' It's for my wife." His voice was a hoarse whisper. "Play it every ten minutes until I tell you to stop." He raised off my hands, which involuntarily retained their crushed-bug position, and dropped a five-dollar bill on the piano; it fluttered like an autumn leaf, brushing the keyboard, coming to rest in my lap. To my considerable relief I knew the tune, thanks to my apprenticeship at the Italian-American Social Club two years earlier—and found myself smiling in recollection, thinking "Eat, Eat, Babe Ruth," which had been an Armenian bass player's designation for "Ciao, Ciao, Bambina."

Guido wandered in from the bar, grimacing painfully and banging the heel of his palm against his ear like a long-distance swimmer emerging from a heavy surf. "What's with the same song, you're sounding like a broken record." I told him of the unusual request and pointed out the party who had made it. Guido took a look and said, "Keep playing it."

Now that I was reactivating my Italian repertoire and playing unadorned melody, a steady stream of drinks began arriving at the piano. I was drinking an occasional beer at the time but was not yet into the heavy stuff. I tried to cut off the flow; if a drink was pressed on me or arrived unsolicited I let it stand on the piano until it went flat. Guido noticed this aberration and spoke to me during a break.

"It's not a friendly attitude."

I told him if I accepted every drink offered me I'd be finished by the time I was thirty. (A piano-bar player I knew in Provincetown handled this problem by announcing at the start of the evening, "As

I'm allergic to both booze and flowers, thunderous applause and the clatter of silver dollars will do nicely. Thanks a million.")

Guido gave a sad little smile and laid a parental hand on my shoulder. "Always order the drink. The bartender will send up colored water. Order an Old Fashioned, we'll load it with fruit, you'll have yourself a nutritious snack, *capisc'*?"—followed by the right to the midsection and the friendly slap across the face.

I soon began to retch at the sight of maraschino cherries and orange slices. A stranger dropped into the club late one night, an out-of-town boy by the looks of him—charcoal suit, checked shirt, white scarf—and seeing three untouched Old Fashioneds lined up in front of me, said, "You seem to be overloaded here." He hefted one and took a generous slug; a contemplative expression came over his face. "I see Guido's still pouring the same old swill." The next night I asked the bartender to substitute gin rickeys *sans* gin and very light on the lime juice. He had never been overly friendly toward me and greeted my request with mute contempt. I think I can safely interpose a blanket judgment here: bartenders are not enamored of musicians. They begrudge us our short hours— roughly half theirs—and our frequent (union-sanctioned) intermissions. A businessman at Tiny's Carousel once tried to buy the band champagne cocktails. The bartender told him, "Pouring champagne for this crew is like feeding a pig strawberries," and his accompanying smile failed to conceal the underlying rancor.

After a month backing Amy Avallone I helped her on with her coat one Saturday night as she was leaving. It was either mink or a class muskrat and gave off a fragrance like a moon-splashed field of jasmine. I opened the door for her and blurted, "How about going somewhere for coffee?" She glanced at me in a sidelong, questioning way, smiling and frowning at the same time; a low chuckle rose in her throat. "You tired of living?" I watched her swing voluptuously across the street on spike heels, her breath pluming in the chill morning, and slide into the front seat of a black Chrysler. A man in a dark, shiny suit sat behind the wheel, smoking. At my feet Guido's cocker spaniels were scarfing noisily from the twin yellow bowls. The club door opened, and the elderly mafioso who had flattened my hands on the keyboard a week earlier came out. He breathed deeply of the crisp air, buttoning his overcoat.

"Guido tells me your name is Asher," he said in his soft hoarse voice.

"That's right."

"Your father's the judge?"

"Uncle."

He nodded sagely and gazed down at the busy spaniels; an almost angelic smile crept over the bulbous, weathered face as he stooped laboriously to fondle one of the golden heads. "I see you dogs're dining out again tonight," he whispered.

Guys and Dolls and *Call Me Madam* opened on Broadway, and eighty blocks north Bird and Dizzy were generating lightning bolts in the night sky over Harlem. I had moved to Boston and was studying with a virtuoso black jazz pianist at the Berklee College of Music ("You'll have to pick up your final credits," he told me, "in the University of the Streets of New York"), supporting myself by working with Rudy Yellin's Society Orchestra. At wedding receptions, when the newlyweds posed with bright grins, their entwined hands gripping the engraved silver knife, we played the year's hit tune, "If I Knew You Were Coming I'd've Baked a Cake."

On a busy Saturday night Rudy would have a dozen or more combos working in the Boston area's hotels, country clubs, lodges, catering halls, and private homes. From a reservoir or "stable" of musicians he was able to put together units of any size and specification to fit a hostess' needs. This pool consisted mainly of middle-aged professionals, family men moderate in habit and mien, who could both read and fake. (Only in the music business is the word "fake" nonpejorative. People are always asking musicians if they read or play by ear; most do both, but this reply for some reason creates consternation, as if an airline captain were to claim to be both pilot and navigator. A Boston colleague of mine responds to all such queries, "I read pretty good but not without moving my lips.") Rudy's stableboys, as they jocularly or plaintively referred to themselves, gave Rudy first call on all nights in return for a guaranteed annual income. They were steady and dependable (some had daytime occupations), maintained a repertoire of current pop and show tunes, and stuck close to the melody on their choruses. The younger jazz and club-date musicians scorned them as "mickey-

mouse" or "ricky-tick" players, but a good many could have acquitted themselves creditably in a Harlem jam session, and their families ate regularly.

There is less real music to the society-band business than people think; or, putting it another way, the music itself is frequently a minor ingredient. The success of an organization like Rudy's depends to a great extent on contacts with banquet and catering managers, club social directors, society leaders, columnists, and other community *machers;* this entails constant wining, dining, or alternative forms of cajolery. Competition is keen and bandleaders will often vie for engagements by outfitting their musicians in exotic costumes to fit an ethnic or thematic occasion. It's the old sell-the-sizzle-not-the-steak concept. Theme parties are the bane of the professional musician's existence, reducing him, in the space of one night, to the level of the meat-market clerk in phosphorescent green vest and paper bow tie on St. Patrick's Day. With Rudy I found myself working classy hotel rooms and country clubs, attired in striped blazer, Hawaiian shirt (lei optional), serape, Gay Nineties brocaded vest (with straw boater and sleeve garters), balloon-sleeved Greek tunic, coolie shift and hat (endless choruses of "Slow Boat to China"), bowler derby, yarmulke, and accessories coincident to Halloween, Valentine's Day, Thanksgiving, St. Patrick's Day, Christmas, and the Fourth of July. It is the closest the professional musician comes to prostitution, other than playing the parlor upright in a reconstructed New Orleans whorehouse.

With the help of the more experienced stableboys, I soon picked up tricks of the trade: carrying a gooseneck lamp and extension cord on reading jobs (most music-stand lights won't accommodate to pianos) and a pocket chess set or paperback book for killing time during long-winded after-dinner speeches; requesting ice water (heavy on the ice) from bartenders during breaks, drinking off the water, and replenishing the glass from my coat-concealed half pint for a tasty Southern Comfort on the rocks. From a Filipino busboy, of all people, I learned how to bring a piano's flat notes up to pitch by strategically wedging folded cocktail napkins between the strings. I'd lift a cigarette-scorched piano lid and find a note from the previ-

ous pianist: "This box is a dirty dog. D and E above high C stick and a couple bass notes don't work at all. If there's a peculiar smell you can't place I pissed in it closing night."

Complaints to management were usually futile. Catering managers and non-jazz club owners didn't want to hear about defective instruments. The piano was invariably "tuned just last week," or "Out of eighty-eight notes you got eighty-three in working condition; I wish I could count on that kind of percentage in my end of the business," or "I'm sick of spending money on the goddamn thing, next time bring your own" (which a generation of pianists would be doing in the Seventies, trundling electric keyboards and fifty-pound speakers down hotel corridors like latter-day Willy Lomans). Keyboards sprinkled with missing notes can take the heart out of you; consider a gardener trying to work with the center teeth missing from his rake. At an after-hours club in Somerville I watched a black pianist dexterously hopscotching a string of non-playing notes using an aggressive stride technique. He called it his Jack-be-nimble style, developed over the years for dealing with "these rotten tomatoes," and thought of his hands as leaping the candlesticks of dead notes. I expressed my sympathy and admiration for his resourcefulness. "There're times you got to come on like Alexander the Great," he told me. "You can't let the suckers beat you down."

The Brigantine Club in Revere Beach was notorious for its rinky-dink atrocity of a baby grand. Ivories were discolored and chipped or missing altogether; the felts looked like they had been chewed by crazed rodents; the strings were coated with a whitish substance that could only be salt (on balmy nights did invisible sea mists waft through the open windows?); and the casing was studded with drink rings and cigarette burns. Early in the evening of my first Brigantine gig I punctured my thumb on one of the ragged ivories and began spotting the keys like a gored bullfighter dripping on the sand. I signaled the leader-saxophonist who was playing the lead on "The Night Has a Thousand Eyes"; he wandered over, blowing as he walked; gazed at the keyboard, eyes bulging slightly, and wandered back to center stage, still blowing. (Musicians aren't easily disconcerted; they've undergone too many bizarre experiences, witnessed too much craziness on the stand and out front. I once saw a woman

at a drunken Gay Nineties brawl pour a schooner of beer into the bell of the tuba player's horn. He gazed at her mournfully and kept on blowing—it sounded like frogs in a bathtub.) Between tunes a waitress handed me a bar rag, then quickly backed off. "You contagious?" she asked from a respectful distance. Naturally, I requested an explanation. "TB," she said demurely. I said I knew I was thin, but not *that* thin. "Well, this movie I saw . . ." I knew the one she meant and instantly understood: Cornel Wilde as Frédéric Chopin coughing gobbets of red onto the gleaming ivories.

During the break I bandaged my thumb and began wedging cocktail napkins between the salt-encrusted strings. An intelligent-looking bystander asked what I was doing. I explained, and he introduced himself: Dr. So-and-so, a gynecologist from Swampscott. In my inquisitive, small-town way I asked him what gynecologists always get asked by frustrated lechers: Don't you get nervous examining all those beautiful chicks? His answer was eloquent and instructive (and possibly rehearsed): "My work is like that of the piano repairman who can only afford a modest instrument in his own home. When he hires out to a rich man to work on a magnificent concert grand, he does the best job he can and does not covet it. He understands it is beyond his reach."

I had occasion to return to the Brigantine two months later. Praying that the monstrosity had been replaced, I came fortified with Band-Aids and a liberal stash of Southern Comfort. Black Beauty stood in the window just as I'd left her, massive, bullying, unassailable. Disheartened, I lifted the top and found, Scotch-taped to the underside, a wry and piquant dissertation by a previous tenant: "This vintage instrument has a storied history. It was fashioned for Czar Alexander I of Russia in the fierce winter of 1857–58 by the craftsman Melinkov of Smolensk. Only small pedigreed animals from the czar's private preserve had access to its innards during the long nocturnal hours, and even after a century's lapse their musty fragrance and distinctive nibblings are still detectable. You'll notice the instrument's unusual sonority. Careful examination of the casing reveals the czar's personal crest, an ingenious design of interlocking circles predating this century's famed Ballantine rings and overlaid with a series of vertical grooves, each, by striking coincidence, approximately the size of an Old Gold."

Bandleaders will sometimes join forces and attempt to shame or coerce managers and proprietors into repairing a derelict. But it is a losing cause: many are beyond salvage and will hold a tuning only so long before reverting to their former primordial state. As Rudy's first-call trombonist said to the Brigantine's owner, "Here's what you should do with this aberration: tune it, clean it thoroughly, refurbish the felts and hammers, polish the casing. Then hire a handyman to chop it up for firewood. And you know what you'd have?" The owner shook his head. "A bad fire."

Paradoxically, I encountered the rottenest tomato of them all at a sumptuous lawn party on a Wellesley estate. "Chinatown" was the motif. Paper lanterns strung in the poplar trees and silvered vessels of barbecued pork, chow mein, et al. warming over burners on red-clothed tables; a pagoda-roofed bar at one end of the wide lawn. We dressed accordingly: coolie hats and loose-fitting pastel cotton garments, intended, I gathered, to simulate the garb of rice-gathering peasants. Indian summer weather had prevailed for the past two weeks—blue and gold days and velvet nights—but on this night autumn fell like a clanging gate: a brisk fifty-five degrees and a good wind blowing. A half dozen electric heaters had been propped in the crooks of the tall trees.

We got out of our tux coats, balled them up, laid them in the drum cases and donned our coolie shifts. The garments came in one size only, fitting the small guys like little girls' dresses and making our beanpole bass player look like a night heron out of water. I played a trial run on the blond Baldwin spinet and—never mind my ears—didn't believe my eyes. The keys went down and stayed down like the plug had been pulled on a player piano in mid-tune. With a sinking heart I took off the front and set it on the grass. The hammers I had struck were cocked back against the strings as if glued there, yet the tripping mechanisms and felts all appeared in good condition. I called over trumpeter-leader Tommy Tedesco, who was alternately blowing into his hands and blasting fat notes on his horn, trying to warm it. I pointed mutely to the depressed keys (*Look, man, no hands*). Tommy lowered his horn, chewed on a corner of his lip, and went off to find the hostess. Less than a minute later a skinny, alert-looking kid of about twelve approached. The

guests were beginning to arrive, strolling through the mansion's rear portal onto the illuminated emerald lawn.

"I'm William. Mom says you have a problem."

"Watch." I struck a full chord: ten more hammers shot back and stuck fast like flies on molasses.

"Huh." The kid stuck his head inside and poked around. "What are these metal things?"

"No idea."

"But you're the piano player."

"Right. Not a mechanic." It was almost farcical; in what other profession are you so regularly sabotaged by the tools of your trade? Four hours of egg-foo-yung tunes on this abomination and I'd be a shattered man, licking my lips and blinking vacantly into the night shadows.

"I wonder if its being out overnight had something to do with it."

"The piano was out*side* all night?" I looked down at the grass; already the evening dew was dampening my shoes.

"The guys who set up the tables and decorations moved it out yesterday afternoon. But we had a canvas over it."

"That wouldn't have helped. The damp came from underneath and swelled the wood. It's hopeless."

William's face suddenly brightened. "Tell you what. I'll stand here and free 'em for you." By way of illustration he grabbed two handfuls of hammers and pulled them away from the strings. "See, now you're back in starting position."

"You're going to do that after every chord?"

"Well, I'll let you play for a few bars and accumulate a backlog."

We were looking brightly, kind of crazily, at each other. I was beginning to learn about the kids of the affluent: they were different, possessed of a special awareness and guile that had nothing to do with the streets. I'd already met ten-year-olds who were masterful con artists.

"Tell you what you can do for me first. Bring me a stiff Southern Comfort on the rocks."

"We don't stock it."

"Gin then."

"One double Beefeater over comin' up."

We got under way, a motley crew of frigid coolies contriving

chop-suey medleys—"China Boy," "Chinatown, My Chinatown," "Slow Boat to China," "Japanese Sandman" (nobody would know)—out of range of the overhead heaters, shoes soaking in the damp grass. I'd play a bar or two, then lay out while William grabbed fistfuls of hammers and pulled them back in my face, announcing cheerfully each time, and driving me mad, "There you go, Mr. A., back to starting position." Two or three times an hour he took off to fetch me a fresh gin from the bar. Tommy observed this traffic with growing unease, doubtless pondering his obligatory report to Rudy tomorrow, with someone else in the band finking if, out of friendship, he glossed over any indecorous exhibition on my part. But I'd worked under Tommy a dozen times and he knew by now that if I were going to get bombed, it would be a quiet, unostentatious, professional job.

"Now you know how Lewis and Clark must've felt," William said, depositing another gin and grasping a clutch of hammers.

With the cold stiffening the horn players' fingers and a piano chord infrequently punched in to no more advantage than a flung cowpie, every tune was starting to sound like "Donkey Serenade."

The shivering guests were beginning to desert the flagstone dance area, drifting back into the house, when Rudy put in his promised appearance. He sawed off a few bars on fiddle, wandered over to the piano, appraised the hammer situation (taking cursory note of the backed-up gin glasses), muttered, "Jesus Christ on a crutch," and left.

On my sixth gin, watching Tommy tuck his hands under his belt beneath the little-girl dress for warmth, I thought, Another year of Rudy, coolie hats, and assorted monkey suits, of moisture-sodden, rotten-tomato pianos, and I'd be reduced to a shadow of a man, devoid of talent, invention, and testicles. Might as well sew up ducks' rectums in a meat market, or trade off with that waiter carrying a tray of fresh foo yung to the warming table; at least he wasn't whoring, merely putting in his hours. He was doing his own thing (to cop a vacuous expression from a future decade) honestly, with purpose, invulnerable to shifting winds of fashion, ludicrous accouterment, and the whims of parvenu hostesses and ambitious bandleaders . . .

"There you go, back to starting position."

And just after midnight, as William freed the hammers for perhaps the two hundredth time, I gave it up: sat with my hands in my lap, stuporous, gazing at the slender, shadowy pinnacles of trees tossing in a high cold wind as the band . . . played . . . on . . .

"What's the matter, Mr. A.?"

"Out of gas, William. Beat. Cold and tired. Don't care anymore."

"That's okay, we all grow old sooner or later."

At one bell (a grandfather clock pealing faintly behind the diamond-paned windows) Tommy and company wrapped it up for the two diehard couples left on the flagstones with a final chorus of "Slow Boat to China"—the fifth time around for that serviceable ditty—and we shucked our coolie apparel and packed up. William helped the drummer with his cases and waved us off, standing amid the littered, sauce-stained tables under the Japanese lanterns: "So long, you guys, see you all later at that big tuning fork in the sky . . . "

It would be sooner than William realized. The big fork sounded its knell for me before another month had elapsed. Rudy's secretary phoned in mid-October to give me my week's engagements. The last date was for Saturday night: Clearview Golf and Country Club, tux, eight to twelve. "And wear bathing trunks under the tux," she added. I was sure I had heard incorrectly and asked for confirmation. She confirmed. I said, "Where are we playing, in the swimming pool? A fish pond? Is the club supplying aqualungs?" She testily repeated the information and hung up.

I spent an uneasy week speculating on those bathing trunks. The fateful night arrived. "Gladiators and Charioteers" was the theme of the party, sponsored by the Junior League. Plaster statuary and colonnades amid the ferns; purple grapes cascading from six-foot papier-mâché urns; helmets and wreaths garlanding the heads of the tuxedoed and gowned revelers.

At the first intermission Tommy Tedesco told us to bring our instruments—"Not you," he smiled wanly at me; "Drummer, take two sticks, woodblock, and cowbell"—and we followed him to the downstairs locker room. Averting his gaze from us, frowning in concentration, Tommy undid the twine on the large clothing-store boxes, and the enigma was resolved: crepe togas. There was a moment of funereal silence.

"Over the tuxes?" a tremulous voice piped.

"Under. The tuxes come off," Tommy said, removing his coat and his suspenders.

"You're pulling our legs."

"Let's *go*," Tommy scowled, unclipping his tie and unzipping his pants.

"What happens if we don't?" the second trumpet said, appropriating my question.

In his canary-yellow bathing trunks Tommy looked at him incredulously. "Wha' d'you mean? You *have* to."

These were family men, with kids in nursery schools and colleges. I was the least encumbered, but we were only seven pieces, three rhythm; without piano the band would go down in flames, and Rudy would do his damnedest to ensure that I never played another octave on a rotten tomato in the sovereign domain of the bean and the cod.

"Next week it's high heels and garter belts," someone murmured resignedly, and the mass disrobing commenced, soup and fish shedding like black chrysalises.

Musicians do not often see one another with their clothes off, nor should they. Never would you be likely to encounter a more goose-stippled, pale-fleshed, bandy-legged motley of bodies; never in a hundred years would you associate that locker room with the playing fields of Eton. The varicolored paper togas reached, contingent on the musician's height, from mid-shin to mid-thigh. "Single file behind me, piano last," Tommy said. "We go in with 'Never on Sunday,' three flats."

Upstairs, past the trophy cases and into the banquet room we wound, a Greco-Roman version of the Chinese dragon snaking among the tables with a clatter and tinkle and bray of horns. An excursion down Nightmare Alley to gargoyle smiles and decadent applause; all that was missing were the geek, the carny's spiel, the barking of trained seals. The piano player in armed-forces parade bands is supplied a glockenspiel or helps carry the bass drum; that night at the Clearview Golf and Country I brought up the dragon's rear, banging a cowbell with a drum stick. The nadir of a burgeoning career. Like Fitzgerald's boat, beating on, borne back ceaselessly into the past.

I jumped ship the following morning (a knife between my teeth

for severing the life-line)—leaving word with Rudy's secretary. Goodbye forever, old fellows and seals.

The last news I had of Rudy and his stable before I headed for San Francisco was in a *Boston Globe* account of a dinner-dance at the Copley Plaza Hotel. The society-page item concluded: "The scintillating music was provided by Rudy Yellin's Orchestra. Enlivening the festivities were the antics of a member of the band attired in a colorful checkered vest who periodically got down on all fours and howled like a dog. The lovely flowers were courtesy of Baldoni-Heggins."

WRIGHT MORRIS
(1910–)

The plains of Nebraska figure largely in Wright Morris's books. "The characteristics of this region have conditioned what I see, what I look for, and what I find in the world to write about." Of his characters, he says, "I'm a spokesman for people who don't want to be spoken for and who don't particularly want to read about themselves."

Morris was born in Central City, Nebraska. He has written over forty works of fiction and nonfiction. In 1957, The Field of Vision *won the National Book Award in fiction. In 1979, the Western Literature Association gave Morris its Distinguished Achievement Award. In 1981,* Plains Song *won the American Book Award for fiction, and the* Los Angeles Times *gave Morris its Robert Kirsch Award for a body of work.*

Morris has written three memoirs: Solo: An American Dreamer in Europe, 1933–34 *(1983);* The Cloak of Light: Writing My Life *(1985); and* Will's Boy: A Memoir *(1981).*

Will's Boy *covers the first nineteen years of Morris's life. This part occurs between 1925 and 1930, when he worked with his uncle on a hardscrabble farm in Texas.*

■ ■ ■

from WILL'S BOY

I found a postcard from my uncle in Texas. He was pleased to learn that I had left a school that taught nothing but lies and falsehoods, but he was not accustomed to paying his hired hands in advance. If I was to work for him, he urged me to arrive as soon as possible, or it would be too late. The spring plowing had started. His wife, Agnes, was now taking my place on the tractor.

I found I was short the bus fare to Texas by three dollars. The PO clerk loaned me a dollar, and I pawned the silver-plated initial buckle on my belt that I had given my father the previous Christmas but borrowed to wear to California. After all, we had the same initial. When he wore it, it was always concealed by his vest.

At the Y, where I owed a week's rent, I left an IOU on the dresser, giving my address as Hereford, Texas. I then went down the fire escape to the second floor, where the last flight of stairs was suspended above the dark alley. I did not weigh enough, even with my suitcase, to lower the stairs to the ground. When I lowered and dropped my bag I was puzzled by the silence of its fall. I then let myself hang, my legs dangling, and let go, falling silently into a mound of fresh garbage. It stuck to my hands and clothes as I groped in it for my bag. I could smell it, all right, but I couldn't see it until I got into the light at the end of the alley. Smears of grease and gravy, salad greens, chunks of Jell-O, clung to my pants. I took a streetcar to Echo Lake Park, where I sat on the boat pier, my feet in the water, while I cleaned my socks and shoes.

The bus to Hereford, Texas, which proved to be near Amarillo, went through Phoenix and Globe, in Arizona, which were places I had missed on the trip west. The bus went through without stopping, but the drivers changed. I dozed off during the day, but I was usually awake most of the night. In a country with so much to see, it helped to see just a small piece of it under streetlights.

Without the high false fronts on the stores in Hereford I might have gone right through it and not seen it. The sunset burned like a fire in the second-floor windows of the general store. All around it, in every direction, the panhandle was as boundless and bare as the sea. Having seen the sea, I could say that. It even had the sort of dip and swell that the sea has. The man in the general store knew my Uncle Dwight, but there was no way to get in touch with him. His farm was about eight miles southeast, which was a long way to walk carrying a suitcase. But if I left the suitcase with him, I could walk it. He led me into the street, which was almost dark, but the sky was so full of light I blinked to look at it. He pointed out to me the trail I should follow, and the wire poles along it looked no higher than fence posts. The road was little more than smoothed-over grass, and once it got dark it would be hard to see it. What I had to look for, once it got dark, were the lights of his house and his tractor. He kept it going day and night. If I didn't see it, I would hear the cough of the engine. The light for me to keep my eye on, of course, was the one that stayed in one place. That was the house. If I walked at a good smart clip I could do it in about two hours.

After two days and two nights on the bus it felt good to walk. At one point, where I was on a rise, I could see the lights of Amarillo, like a cluster of stars. I could hear the tractor coughing before I saw it, and it sounded like a plug was missing. Some time later, when it made a turn, the lights came toward me like a locomotive. The last thing I saw was the feeble lampglow at a window of the house. I had never asked myself what he might have as a farm. A farm to me was a big old house, with some barns, and perhaps some trees along one side as a windbreak. What I saw slowly emerging in the milky darkness was a building no larger than my Uncle Harry's cobshed, set up on concrete blocks. A line of wash, like ghosts, hung to one side, where a machine of some sort was covered with a tarpaulin. Fifty or sixty yards away from the house were two sheds, and still further away was the peaked roof of a privy. The white spots in the yard were Leghorn chickens. Way, way off to the south, where the sky was darkest, the dim lights of the tractor flickered, and it made me so mournful and lonely I wanted to cry. If I had not come so far and was not so tired, I would have turned back. An eerie mauve and crimson afterglow filled the western horizon, like the earth was burning. Until I was right there in the yard, beside the sagging line of wash, the dog under the house neither saw nor heard me. When he came at me barking, he scared me out of my wits. I probably let out a yell. At the door to the house, up three steps from the yard, a woman appeared with a clothes basket. She called off the dog, then said, "You're Wright?" I said that I was. "I'm Agnes," she said. "Dwight's on the tractor."

With the light behind her I could not see her face.

"Where's your bag?"

I explained that I had left it in Hereford, since I had to walk.

"Dwight's not going to like that," she said. "It means he's got to go fetch it." When I said nothing, she added, "I suppose you're hungry," and beckoned me to come in.

In the morning I saw nothing but the food on my plate, the slit of light at the window. It was on the horizon, but it might have been attached to the blind. Dawn. Sunrise would not come for another hour. The wind blowing under the house puffed dust between the floorboards, like smoke. There was never any talk. My Uncle would slip off his coveralls, like a flight suit, and eat in his

two suits of underwear: one of fine, snug-fitting wool, flecked with gray, like a pigeon; the other of heavy, nubby cotton flannel with the elbows patched with quilting, the fly-seat yawning. The outer suit would come off in the spring, but the inner suit was part of my Uncle. I once saw him plucked like a chicken, standing in a small wash basin of water while Agnes wiped him off with a damp towel. Dust. He was dusted rather than washed.

Sometime before dawn, the wind rising, I was awakened by the cough of the tractor approaching the house. It went on coughing while I pulled on the clothes Agnes brought me—itchy underwear and socks, two heavy flannel shirts, coveralls still stiff from drying on the wash line, cold as ice.

Agnes had explained to me the night before that I would take over the tractor when Dwight brought it in in the morning, the engine never stopping because it was so hard to start. While I gulped hot biscuits and eggs fried in pork fat I could hear my uncle cursing. What was the trouble? It was just his way of keeping warm, talking to himself. When he came into the house dust caked his face, like the men I had seen in grain elevators. He did not look pleased when he saw me sitting there eating his food. He wore a cap with ear muffs, coveralls like mine, the legs tucked into three-buckle galoshes. I wouldn't know until Sunday what he really looked like, when I would first see him without his cap on—not because it was the Lord's day of rest, but my uncle's day off. His forehead, ears and neck were white as flour, the rest of his face was dark as an Indian's. Where had I seen him before? He could have been the brother of William S. Hart. He had the same steely, watery-blue eyes and thin-lipped mouth. When he smiled I could see the dirt caked at the roots of his teeth.

He didn't say who he was, or ask who I was, but came to the table and opened up a biscuit, smeared it in the pork fat, then put it in his mouth. I understood right then that you didn't talk to him while he was trying to eat. My uncle was a lean wiry man who just naturally stood with his legs flexed, as if he meant to hop. When he burned himself with a swallow of hot coffee he made a face just like I would, with his eyes creased, then he let out a stream of curses. I

Cause for Wonder, 1963.

followed him out in the yard, where the crack of dawn was right there on the horizon like a knife slit, then we carried between us a milk can full of kerosene to the John Deere tractor. It took both of us to lift it as high as the fuel tank, and pouring it into the funnel I got my gloves and hands soaked. He shouted at me, above the cough of the motor, if I knew how to steer a tractor? I nodded that I did. He rode along behind me, seated on one of the gang plows, letting his hand trail in the loam turned up by the plow blade. His section of land was about 1,800 acres, and I could see only a portion of it at one time. With the tractor running day and night it would take a month or more to get it plowed. On the west side, headed south, the wind in my face was so cold it made my eyes blur. Headed north, the dust raised by the plows blew over my head like a cloud of smoke. But when he saw I could manage the tractor on the turns he got off the plows and walked back toward the house, his arms raised from his sides as if he carried two pails. In that great empty expanse, the sun just rising, he looked like a bug and hardly seemed to move. When the light in the house turned off I missed it.

I'd been plowing half the morning before I noticed how the big jackrabbits moved just enough to stay clear of the plows. They would wait until the last second, then hop just enough to be clear of the blades. The whole section of land I was on had never before been turned by a plow. Only cattle had grazed it, most of them the white-faced Herefords that stood along the fence to watch me pass. I didn't know at that point that I was turning topsoil that had been centuries in the making. My uncle knew it, and it was why he had gambled on planting grain where it seldom rained. If it would grow grass, he argued, it would also grow wheat. Just five years before he had leased 1,200 acres, and he and Agnes, working alone, had harvested a crop worth more than $30,000. It hadn't rained a winter since then, but he was sure that it would.

In the sky around me, maybe twenty miles away, I could see cloud masses forming and drifting. I could even see mauve sheets of rain falling somewhere. A few days of steady rain was all that was needed, then months of hot sun. I thought I would die of hunger before I saw Agnes, followed by the dog, between the plowed land and the house. She brought me my lunch in a syrup pail, with a jar

of black coffee. I'd never cared much for coffee, but I got to like it fine. The dog would stay with me, watching me eat, then he would trail in the fresh furrows left by the plows. When a rabbit moved, he tried to head it off and keep it running in the plowed section. He ran like the wind, so low to the ground that a plowed furrow would send him tumbling. It was hard to see the grass-colored rabbits when he chased them, just the crazy zigzagging patterns made by the dog, like he was chasing flies. He was a sort of spitz, mixed with collie, his fur a mat of burrs picked up from the grass. His big stunt was to run straight at the Herefords if he found them all lined up like a wall at the fence. He would go right for them like a streak, and at the last split second they would break and panic, going off with their tails up, bellowing. We both loved it. I would stop the tractor and give him some attention. He was Agnes' dog. For one reason or another he didn't like Dwight. I think it was because Dwight would often shoot toward him when the two of them did a little hunting. It was Dwight who gave him the name of Jesus, because of the way a dead-looking rabbit would spring to life when he saw him.

*Two hours before dawn we had left the dark house to shoot at what I thought might be cattle rustlers. In the windless pause before my Uncle ran forward hooting like an Indian, I prepared myself to shoot it out with Billy the Kid. When Dwight ran forward, hooting, I shot into the air over his head. I heard a great flapping of wings, but very little honking. I think I managed to fire two or three times. Still dark, we came back to the house where Agnes had coffee perking and a fire going. When the sky was light we went out to see if we had bagged any birds. Just shooting blind into the rising flock we had bagged nine. So we had fresh gamy meat for two weeks and lead shot on my plate in the evening, some of which I kept and used over in a bee-bee gun.**

The John Deere tractor, until I got used to it, sounded like a plug was missing and it was about to stop running. It ran on the cheapest fuel, however, and once you got it started it was hard to stop. To start it up, you had to give the flywheel a spin, which scared the hell out of me because of the way it backfired. The first time it

**Cause for Wonder.*

died on me I couldn't get it restarted, and Dwight knew it right away when the coughing stopped. He could hear that the way he could hear a rise or fall in the wind. He had got out of bed at about seven in the morning and walked the half mile or so to where I was stalled. That gave me plenty of time to watch him coming, his arms high from his sides like a winded chicken. He was so mad he hardly troubled to curse me, and grabbed the flywheel like he meant to tear it off. He didn't catch it just right, and the loud backfire lifted him off his feet. That made him even madder, and less smart about it, and when he grabbed the wheel it spun him like a top and thumped him hard against one of the wheels. That hurt him so bad, and he was so ashamed, tears came to his eyes. If he had had a club big enough, or an axe, I think he would have chopped the John Deere to pieces. The reason he hated his father the way he did, as Winona had said, was that they were so much alike. They were both hard-driving, ambitious men who were accustomed to putting the harness on others as well as themselves. It almost killed him to have the tractor, right before my eyes, make a fool of him. It frightened me like the devil just to watch him, but when it was over I liked him better, and he was friendlier with me. By the time we got it started we were both so worn out we just got on it and rode it back to the house, where he went back to bed, and I sat in the sun where it warmed the wall. It made a difference between us, not such a big one that my job got to be any softer, but I had become a hired hand and he didn't have to watch me to know I was working.

As a rule I rode the tractor all day, and he rode it at night. He slept until early afternoon, then he did what needed doing around the place. Agnes raised chickens for the eggs we lived on, and the one she stewed or fried on Sunday. By afternoon the sun would heat up the house, but the way the wind blew around and beneath it, it would soon cool off in the evening. After supper we would sit around the range in the kitchen, with the oven door open. Agnes always had her mending to do, or washing, or the baking of bread she did on Mondays, and she was not a person who liked to talk while she worked. Nor had I ever before lived with a woman who didn't seem to like me. Not that she *dis*liked me, but at most she felt neutral. In the house she liked me to keep in my place. The year he made a lot of money Dwight had bought a big console radio in

Kansas City that required a lot of batteries to run it. He got tired of trying to keep the batteries charged, so all it did was sit there with her sewing on it. In the space on the floor beneath there were two big cartons of Haldemann-Julius Little Blue Books. They sold for five cents each, and my uncle had bought two or three hundred of them. He was a great reader, over the winter, and read the books that he liked several times. Most of the books exposed religious hypocrisy and fakery. There were also books on geology, history and travel, so I didn't lack for something to read. I often carried one of these books in my pocket and read it when I stopped for lunch. What surprised me was how much my uncle loved to talk. On the day I had off we might sit up till almost midnight doing nothing but talking. A lot of what I said got him to laughing so hard his sides ached, and he could hardly stop. He loved to hear me talk about Pacific Union College, and the stuff they believed. I liked the way his eyes watered when he laughed, and the way they twinkled when he looked at me. The good talk we often had was no reason, however, I shouldn't be on the tractor at dawn the next morning.

That morning I heard the dawn crack like a whip. A little later I could peer out and see the wind where there was neither dust, lines of wash, nor even grass to blow. The yard was like a table, with a dull, flat gloss where the shoes buffed it toward the privy. Scoured by the wind, the cracks had been picked clean by the chickens. Out there, as nowhere else, I could see the wind. The five minutes in the morning I lay in a stupor listening to Agnes build the fire, I would face the window, the dawn like a slit at the base of a door. In the kitchen Agnes would put fresh cobs on the banked fire. Was it the sparks in the chimney, the crackle in the stove? The cats would hear it, five or six of them. With the first draw of the fire they would start from the grain sheds toward the house, a distance of about one hundred yards. Was that so far? It can be if you crawl. In the dawn light I would see only the white cats, or those that were spotted, moving toward the house like primitive or crippled reptiles. How explain it? The invisible thrust of the wind. The hard peltless yard gave them no hold. Even the chickens, a witless bird, had learned never to leave the shelter of the house at the risk of blowing away, like paper bags. A strip of chicken wire, like a net, had been stretched to the windward of the yard to catch them. They would stick like rags, or wads of cotton, till my Aunt would go out and pick them off. The cats and hens were quick to learn that the wind

would prevail. My Aunt Agnes knew, but she preferred not to admit it. The last to learn was my Uncle Dwight.

The way Agnes looked after my Uncle Dwight helped me to see why it was she seemed so neutral toward me. Dwight was hers. She liked him so much she didn't want to share him with anybody. The way he could talk pleased her, but the pleasure he showed when I talked made her frown and turn to her mending. She was not a pretty woman, her skin darkened by the weather, her hands like those of a man and chapped at the wrists, but I knew that she was a woman my uncle could take pride in. He had found her in Kansas, put her in a buggy and driven southwest till they came to the Pecos River in New Mexico. There he homesteaded a claim and raised sheep. Why didn't they have children? She would have liked kids of her own better than she liked me. Dwight was so independent in all of his thinking, he might not have wanted to share Agnes with them. He talked to her the way he did to me, but he considered me a better listener. I would come back at him. And he liked that. He said a lot of things just to rile me. I had also read some books that he hadn't, and that both pleased and shamed him. Sometimes he would put his hands to his face and just think about it for a moment, in silence.

My Uncle Dwight had not had, as he said, much schooling, preferring to educate himself by reading, but he talked in the assured manner of a man who could give a sermon. Words came to him easily, and quickly. His accent was like none I had heard, as if he had lived with strange people. I would hear nothing like it until I heard ballad singers on records. When he listened to me, his head tilted as if for a portrait, I felt in his gaze his admiration for his own kind. Was that what I was? Were we both pieces chipped from the same block? It pleased me to think that we might be, because I felt for him a secret admiration. He was strong. His mind was sharp as the glint of his eye. If the great men I had heard of were gathered together around a stalled tractor on the Texas panhandle, my uncle would prove to be the equal or the superior to most of them. They would listen in silence and admiration as he cursed.

Cause for Wonder.

MAXINE HONG KINGSTON
(1940–)

Born in Stockton, California, Maxine Hong Kingston was the oldest child of educated Chinese-immigrant parents; they owned a laundry.

Kingston attended the University of California in Berkeley. She taught English at high schools in California and Hawaii. In 1976, her first book, The Woman Warrior: Memoirs of a Girlhood Among Ghosts, *won the National Book Critics Circle Award for general nonfiction.* China Men *(1980) received the American Book Award for general nonfiction. Kingston considers the two companion works "one big book." Her novel* Tripmaster Monkey: His Fake Book *appeared in 1988.*

In this comic selection from Part Four of The Woman Warrior, *Brave Orchid, Kingston's mother, has persuaded her older sister Moon Orchid to leave China and come to California in order to confront the husband who left her in China thirty years earlier.*

■ ■ ■

from THE WOMAN WARRIOR

"Wait until morning, Aunt," said Moon Orchid's daughter. "Let her get some sleep."

"Yes, I do need rest after travelling all the way from China," she said. "I'm here. You've done it and brought me here." Moon Orchid meant that they should be satisfied with what they had already accomplished. Indeed, she stretched happily and appeared quite satisfied to be sitting in that kitchen at that moment. "I want to go to sleep early because of jet lag," she said, but Brave Orchid, who had never been on an airplane, did not let her.

"What are we going to do about your husband?" Brave Orchid asked quickly. That ought to wake her up.

"I don't know. Do we have to do something?"

"He does not know you're here."

Moon Orchid did not say anything. For thirty years she had been receiving money from him from America. But she had never told him that she wanted to come to the United States. She waited

for him to suggest it, but he never did. Nor did she tell him that her sister had been working for years to transport her here. First Brave Orchid had found a Chinese-American husband for her daughter. Then the daughter had come and had been able to sign the papers to bring Moon Orchid over.

"We have to tell him you've arrived," said Brave Orchid.

Moon Orchid's eyes got big like a child's. "I shouldn't be here," she said.

"Nonsense. I want you here, and your daughter wants you here."

"But that's all."

"Your husband is going to have to see you. We'll make him recognize you. Ha. Won't it be fun to see his face? You'll go to his house. And when his second wife answers the door, you say, 'I want to speak to my husband,' and you name his personal name. 'Tell him I'll be sitting in the family room.' Walk past her as if she were a servant. She'll scold him when he comes home from work, and it'll serve him right. You yell at him too."

"I'm scared," said Moon Orchid. "I want to go back to Hong Kong."

"You can't. It's too late. You've sold your apartment. See here. We know his address. He's living in Los Angeles with his second wife, and they have three children. Claim your rights. Those are *your* children. He's got two sons. *You* have two sons. You take them away from her. You become their mother."

"Do you really think I can be a mother of sons? Don't you think they'll be loyal to her, since she gave birth to them?"

"The children will go to their true mother—you," said Brave Orchid. "That's the way it is with mothers and children."

"Do you think he'll get angry at me because I came without telling him?"

"He deserves your getting angry with him. For abandoning you and for abandoning your daughter."

"He didn't abandon me. He's given me so much money. I've had all the food and clothes and servants I've ever wanted. And he's supported our daughter too, even though she's only a girl. He sent her to college. I can't bother him. I mustn't bother him."

"How can you let him get away with this? Bother him. He deserves to be bothered. How dare he marry somebody else when he

has you? How can you sit there so calmly? He would've let you stay in China forever. *I* had to send for your daughter, and *I* had to send for you. Urge her," she turned to her niece. "Urge her to go look for him."

"I think you should go look for my father," she said. "I'd like to meet him. I'd like to see what my father looks like."

"What does it matter what he's like?" said her mother. "You're a grown woman with a husband and children of your own. You don't need a father—or a mother either. You're only curious."

"In this country," said Brave Orchid, "many people make their daughters their heirs. If you don't go see him, he'll give everything to the second wife's children."

"But he gives us everything anyway. What more do I have to ask for? If I see him face to face, what is there to say?"

"I can think of hundreds of things," said Brave Orchid. "Oh, how I'd love to be in your place. I could tell him so many things. What scenes I could make. You're so wishy-washy."

"Yes, I am."

"You have to ask him why he didn't come home. Why he turned into a barbarian. Make him feel bad about leaving his mother and father. Scare him. Walk right into his house with your suitcases and boxes. Move right into the bedroom. Throw her stuff out of the drawers and put yours in. Say, 'I am the first wife, and she is our servant.'"

"Oh, no, I can't do that. I can't do that at all. That's terrible."

"Of course you can. I'll teach you. 'I am the first wife, and she is our servant.' And you teach the little boys to call you Mother."

"I don't think I'd be very good with little boys. Little American boys. Our brother is the only boy I've known. Aren't they very rough and unfeeling?"

"Yes, but they're yours. Another thing I'd do if I were you, I'd get a job and help him out. Show him I could make his life easier; how I didn't need his money."

"He has a great deal of money, doesn't he?"

"Yes, he can do some job the barbarians value greatly."

"Could I find a job like that? I've never had a job."

"You could be a maid in a hotel," Brave Orchid advised. "A lot of immigrants start that way nowadays. And the maids get to bring home all the leftover soap and the clothes people leave behind."

"I would clean up after people, then?"

Brave Orchid looked at this delicate sister. She was such a little old lady. She had long fingers and thin, soft hands. And she had a high-class city accent from living in Hong Kong. Not a trace of village accent remained; she had been away from the village for that long. But Brave Orchid would not relent; her dainty sister would just have to toughen up. "Immigrants also work in the canneries, where it's so noisy it doesn't matter if they speak Chinese or what. The easiest way to find a job, though, is to work in Chinatown. You get twenty-five cents an hour and all your meals if you're working in a restaurant."

If she were in her sister's place, Brave Orchid would have been on the phone immediately, demanding one of those Chinatown jobs. She would make the boss agree that she start work as soon as he opened his doors the next morning. Immigrants nowadays were bandits, beating up store owners and stealing from them rather than working. It must've been the Communists who taught them those habits.

Moon Orchid rubbed her forehead. The kitchen light shined warmly on the gold and jade rings that gave her hands complete-ness. One of the rings was a wedding ring. Brave Orchid, who had been married for almost fifty years, did not wear any rings. They got in the way of all the work. She did not want the gold to wash away in the dishwater and the laundry water and the field water. She looked at her younger sister whose very wrinkles were fine. "Forget about a job," she said, which was very lenient of her. "You won't have to work. You just go to your husband's house and demand your rights as First Wife. When you see him, you can say, 'Do you remember me?'"

"What if he doesn't?"

"Then start telling him details about your life together in China. Act like a fortuneteller. He'll be so impressed."

"Do you think he'll be glad to see me?"

"He better be glad to see you."

As midnight came, twenty-two hours after she left Hong Kong, Moon Orchid began to tell her sister that she really was going to face her husband. "He won't like me," she said.

"Maybe you should dye your hair black, so he won't think you're old. Or I have a wig you can borrow. On the other hand, he should see how you've suffered. Yes, let him see how he's made your hair turn white. . . ."

The summer days passed while they talked about going to find Moon Orchid's husband. . . . She spent the evening observing the children. She liked to figure them out. She described them aloud. "Now they're studying again. They read so much. Is it because they have enormous quantities to learn, and they're trying not to be savages? He is picking up his pencil and tapping it on the desk. Then he opens his book to page 168. His eyes begin to read. His eyes go back and forth. They go from left to right, from left to right." This makes her laugh. "How wondrous—eyes reading back and forth. Now he's writing his thoughts down. What's *that* thought?" she asked, pointing.

She followed her nieces and nephews about. She bent over them. "Now she is taking a machine off the shelf. She attaches two metal spiders to it. She plugs in the cord. She cracks an egg against the rim and pours the yolk and white out of the shell into the bowl. She presses a button, and the spiders spin the eggs. What are you making?"

"Aunt, please take your finger out of the batter."

"She says, 'Aunt, please take your finger out of the batter,'" Moon Orchid repeated as she turned to follow another niece walking through the kitchen. "Now what's this one doing? Why, she's sewing a dress. She's going to try it on." Moon Orchid would walk right into the children's rooms while they were dressing. "Now she must be looking over her costumes to see which one to wear." Moon Orchid pulled out a dress. "This is nice," she suggested. "Look at all the colors."

"No, Aunt. That's the kind of dress for a party. I'm going to school now."

"Oh, she's going to school now. She's choosing a plain blue dress. She's picking up her comb and brush and shoes, and she's going to lock herself up in the bathroom. They dress in bathrooms here." She pressed her ear against the door. "She's brushing her teeth. Now she's coming out of the bathroom. She's wearing the blue dress and a white sweater. She's combed her hair and washed her face. She looks in the refrigerator and is arranging things between slices of bread. She's putting an orange and cookies in a bag. Today she's taking her green book and her blue book. And tablets and pencils. Do you take a dictionary?" Moon Orchid asked.

"No," said the child, rolling her eyeballs up and exhaling loudly. "We have dictionaries at school," she added before going out the door.

"They have dictionaries at school," said Moon Orchid, thinking this over. "She knows 'dictionary.'" Moon Orchid stood at the window peeping. "Now she's shutting the gate. She strides along like an Englishman."

The child married to a husband who did not speak Chinese translated for him, "Now she's saying that I'm taking a machine off the shelf and that I'm attaching two metal spiders to it. And she's saying the spiders are spinning with legs intertwined and beating the eggs electrically. Now she says I'm hunting for something in the refrigerator and—ha!—I've found it. I'm taking out butter—'cow oil.' 'They eat a lot of cow oil,' she's saying."

"She's driving me nuts!" the children told each other in English.

At the laundry Moon Orchid hovered so close that there was barely room between her and the hot presses. "Now the index fingers of both hands press the buttons, and—kalump—the press comes down. But one finger on a button will release it—sssssss—the steam lets loose. Sssst—the water squirts." She could describe it so well, you would think she could do it. She wasn't as hard to take at the laundry as at home, though. She could not endure the heat, and after a while she had to go out on the sidewalk and sit on her apple crate. When they were younger the children used to sit out there too during their breaks. They played house and store and library, their orange and apple crates in a row. Passers-by and customers gave them money. But now they were older, they stayed inside or went for walks. They were ashamed of sitting on the sidewalk, people mistaking them for beggars. "Dance for me," the ghosts would say before handing them a nickel. "Sing a Chinese song." And before they got old enough to know better, they'd dance and they'd sing. Moon Orchid sat out there by herself.

Whenever Brave Orchid thought of it, which was everyday, she said, "Are you ready to go see your husband and claim what is yours?"

"Not today, but soon," Moon Orchid would reply.

But one day in the middle of summer, Moon Orchid's daughter said, "I have to return to my family. I promised my husband and

children I'd only be gone a few weeks. I should return this week." Moon Orchid's daughter lived in Los Angeles.

"Good!" Brave Orchid exclaimed. "We'll all go to Los Angeles. You return to your husband, and your mother returns to hers. We only have to make one trip."

"You ought to leave the poor man alone," said Brave Orchid's husband. "Leave him out of women's business."

"When your father lived in China," Brave Orchid told the children, "he refused to eat pastries because he didn't want to eat the dirt the women kneaded from between their fingers."

"But I'm happy here with you and all your children," Moon Orchid said. "I want to see how this girl's sewing turns out. I want to see your son come back from Vietnam. I want to see if this one gets good grades. There's so much to do."

"We're leaving on Friday," said Brave Orchid. "I'm going to escort you, and you will arrive safely."

On Friday Brave Orchid put on her dress-up clothes, which she wore only a few times during the year. Moon Orchid wore the same kind of clothes she wore every day and was dressed up. Brave Orchid told her oldest son he had to drive. He drove, and the two old ladies and the niece sat in the back seat.

They set out at gray dawn, driving between the grape trees, which hunched like dwarfs in the fields. Gnomes in serrated outfits that blew in the morning wind came out of the earth, came up in rows and columns. Everybody was only half awake. "A long time ago," began Brave Orchid, "the emperors had four wives, one at each point of the compass, and they lived in four palaces. The Empress of the West would connive for power, but the Empress of the East was good and kind and full of light. You are the Empress of the East, and the Empress of the West has imprisoned the Earth's Emperor in the Western Palace. And you, the good Empress of the East, come out of the dawn to invade her land and free the Emperor. You must break the strong spell she has cast on him that has lost him the East."

Brave Orchid gave her sister last-minute advice for five hundred miles. All her possessions had been packed into the trunk.

"Shall we go into your house together," asked Brave Orchid, "or do you want to go by yourself?"

"You've got to come with me. I don't know what I would say."

"I think it would be dramatic for you to go by yourself. He opens the door. And there you are—alive and standing on the porch with all your luggage. 'Remember me?' you say. Call him by his own name. He'll faint with shock. Maybe he'll say, 'No. Go away.' But you march right in. You push him aside and go in. Then you sit down in the most important chair, and you take off your shoes because you belong."

"Don't you think he'll welcome me?"

"She certainly wasn't very imaginative," thought Brave Orchid.

"It's against the law to have two wives in this country," said Moon Orchid. "I read that in the newspaper."

"But it's probably against the law in Singapore too. Yet our brother has two, and his sons have two each. The law doesn't matter."

"I'm scared. Oh, let's turn back. I don't want to see him. Suppose he throws me out? Oh, he will. He'll throw me out. And he'll have a right to throw me out, coming here, disturbing him, not waiting for him to invite me. Don't leave me by myself. You can talk louder than I can."

"Yes, coming with you would be exciting. I can charge through the door and say, 'Where is your wife?' And he'll answer, 'Why, she's right here.' And I'll say, 'This isn't your wife. Where is Moon Orchid? I've come to see her. I'm her first sister, and I've come to see that she is being well taken care of.' Then I accuse him of murderous things; I'd have him arrested—and you pop up to his rescue. Or I can take a look at his wife, and I say, 'Moon Orchid, how young you've gotten.' And he'll say, 'This isn't Moon Orchid.' And you come in and say, 'No. I am.' If nobody's home, we'll climb in a window. When they get back we'll be at home; you the hostess, and I your guest. You'll be serving me cookies and coffee. And when he comes in I'll say, 'Well, I see your husband is home. Thank you so much for the visit.' And you say, 'Come again anytime.' Don't make violence. Be routine."

Sometimes Moon Orchid got into the mood. "Maybe I could be folding towels when he comes in. He'll think I'm so clever. I'll get to them before his wife does." But the further they came down the great central valley—green fields changing to fields of cotton on dry, brown stalks, first a stray bush here and there, then thick—the

more Moon Orchid wanted to turn back. "No. I can't go through with this." She tapped her nephew on the shoulder. "Please turn back. Oh, you must turn the car around. I should be returning to China. I shouldn't be here at all. Let's go back. Do you understand me?"

"Don't go back," Brave Orchid ordered her son. "Keep going. She can't back out now."

"What do you want me to do? Make up your minds," said the son, who was getting impatient.

"Keep going," said Brave Orchid. "She's come this far, and we can't waste all this driving. Besides, we have to take your cousin back to her own house in Los Angeles. We have to drive to Los Angeles anyway."

"Can I go inside and meet my grandchildren?"

"Yes," said her daughter.

"We'll see them after you straighten out things with your husband," said Brave Orchid.

"What if he hits me?"

"I'll hit *him*. I'll protect you. I'll hit him back. The two of us will knock him down and make him listen." Brave Orchid chuckled as if she were looking forward to a fight. But when she saw how terrified Moon Orchid was, she said, "It won't come to a fight. You mustn't start imagining things. We'll simply walk up to the door. If he answers, you'll say, 'I have decided to come live with you in the Beautiful Nation.' If *she* answers the door, you'll say, 'You must be Little Wife. I am Big Wife.' Why, you could even be generous. 'I'd like to see our husband, please,' you say. I brought my wig," said Brave Orchid. "Why don't you disguise yourself as a beautiful lady? I brought lipstick and powder too. And at some dramatic point, you pull off the wig and say, 'I am Moon Orchid.'"

"That is a terrible thing to do. I'd be so scared. I am so scared."

"I want to be dropped off at my house first," said the niece. "I told my family I'd be home to make lunch."

"All right," said Brave Orchid, who had tried to talk her niece into confronting her father five years ago, but all she had done was write him a letter telling him she was in Los Angeles. He could visit her, or she could visit him if he wanted to see her, she had suggested. But he had not wanted to see her.

When the car stopped in front of her daughter's house, Moon Orchid asked, "May I get out to meet my grandchildren?"

"I told you no," said Brave Orchid. "If you do that you'll stay here, and it'll take us weeks to get up our courage again. Let's save your grandchildren as a reward. You take care of this other business, and you can play with your grandchildren without worry. Besides, you have some children to meet."

"Grandchildren are more wonderful than children."

After they left the niece's suburb, the son drove them to the address his mother had given him, which turned out to be a sky-scraper in downtown Los Angeles.

"Don't park in front," said his mother. "Find a side street. We've got to take him by surprise. We mustn't let him spot us ahead of time. We have to catch the first look on his face."

"Yes, I think I would like to see the look on his face."

Brave Orchid's son drove up and down the side streets until he found a parking space that could not be seen from the office building.

"You have to compose yourself," said Brave Orchid to her sister. "You must be calm as you walk in. Oh, this is most dramatic—in broad daylight and in the middle of the city. We'll sit here for a while and look at his building."

"Does he own that whole building?"

"I don't know. Maybe so."

"Oh, I can't move. My knees are shaking so much I won't be able to walk. He must have servants and workers in there, and they'll stare at me. I can't bear it."

Brave Orchid felt a tiredness drag her down. She had to baby everyone. The traffic was rushing, Los Angeles noon-hot, and she suddenly felt carsick. No trees. No birds. Only city. "It must be the long drive," she thought. They had not eaten lunch, and the sitting had tired her out. Movement would strengthen her; she needed movement. "I want you to stay here with your aunt while I scout that building," she instructed her son. "When I come back, we'll work out a plan." She walked around the block. Indeed, she felt that her feet stepping on the earth, even when the earth was covered with concrete, gained strength from it. She breathed health from the air, though it was full of gasoline fumes. The bottom floor of the building housed several stores. She looked at the clothes and jewelry

on display, picking out some for Moon Orchid to have when she came into her rightful place.

Brave Orchid rushed along beside her reflection in the glass. She used to be young and fast; she was still fast and felt young. It was mirrors, not aches and pains, that turned a person old, everywhere white hairs and wrinkles. Young people felt pain.

The building was a fine one; the lobby was chrome and glass, with ashtray stands and plastic couches arranged in semicircles. She waited for the elevator to fill before she got in, not wanting to operate a new machine by herself. Once on the sixth floor she searched alertly for the number in her address book.

How clean his building was. The rest rooms were locked, and there were square overhead lights. No windows, though. She did not like the quiet corridors with carpets but no windows. They felt like tunnels. He must be very wealthy. Good. It would serve a rich man right to be humbled. She found the door with his number on it; there was also American lettering on the glass. Apparently this was his business office. She hadn't thought of the possibility of catching him at his job. Good thing she had decided to scout. If they had arrived at his house, they would not have found him. Then they would have had to deal with *her*. And she would have phoned him, spoiled the surprise, and gotten him on her side. Brave Orchid knew how the little wives maneuvered; her father had had two little wives.

She entered the office, glad that it was a public place and she needn't knock. A roomful of men and women looked up from their magazines. She could tell by their eagerness for change that this was a waiting room. Behind a sliding glass partition sat a young woman in a modern nurse's uniform, not a white one, but a light blue pantsuit with white trim. She sat before an elegant telephone and an electric typewriter. The wallpaper in her cubicle was like aluminum foil, a metallic background for a tall black frame around white paint with dashes of red. The wall of the waiting room was covered with burlap, and there were plants in wooden tubs. It was an expensive waiting room. Brave Orchid approved. The patients looked well dressed, not sickly and poor.

"Hello. May I help you?" said the receptionist, parting the glass. Brave Orchid hesitated, and the receptionist took this to mean that

she could not speak English. "Just a moment," she said, and went into an inner room. She brought back another woman, who wore a similar uniform except that it was pink trimmed in white. This woman's hair was gathered up into a bunch of curls at the back of her head; some of the curls were fake. She wore round glasses and false eyelashes, which gave her an American look. "Have you an appointment?" she asked in poor Chinese; she spoke less like a Chinese than Brave Orchid's children. "My husband, the doctor, usually does not take drop-in patients," she said. "We're booked up for about a month." Brave Orchid stared at her pink-painted finger-nails gesticulating, and thought she probably would not have given out so much information if she weren't so clumsy with language.

"I have the flu," Brave Orchid said.

"Perhaps we can give you the name of another doctor," said this woman, who was her sister-in-law. "This doctor is a brain surgeon and doesn't work with flu." Actually she said, "This doctor cuts brains," a child making up the words as she went along. She wore pink lipstick and had blue eyelids like the ghosts.

Brave Orchid, who had been a surgeon too, thought that her brother-in-law must be a clever man. She herself could not practice openly in the United States because the training here was so different and because she could never learn English. He was smart enough to learn ghost ways. She would have to be clever to outwit him. She needed to retreat and plan some more. "Oh, well, I'll go to another doctor, then," she said, and left.

She needed a new plan to get her sister and brother-in-law together. This nurse-wife was so young, and the office was so rich with wood, paintings, and fancy telephones, that Brave Orchid knew it wasn't because he couldn't get the fare together that he hadn't sent for his old wife. He had abandoned her for this modern, heartless girl. Brave Orchid wondered if the girl knew that her husband had a Chinese wife. Perhaps she should ask her.

But no, she mustn't spoil the surprise by giving any hints. She had to get away before he came out into the corridor, perhaps to go to one of the locked rest rooms. As she walked back to her sister, she noted corners and passageways, broom closets, other offices— ambush spots. Her sister could crouch behind a drinking fountain and wait for him to get thirsty. Waylay him.

"I met his second wife," she said, opening the car door.

"What's she like?" asked Moon Orchid. "Is she pretty?"

"She's very pretty and very young; just a girl. She's his nurse. He's a doctor like me. What a terrible, faithless man. You'll have to scold him for years, but first you need to sit up straight. Use my powder. Be as pretty as you can. Otherwise you won't be able to compete. You do have one advantage, however. Notice he has her be his worker. She is like a servant, so you have room to be the wife. She works at the office; you work at the house. That's almost as good as having two houses. On the other hand, a man's real partner is the hardest worker. You couldn't learn nursing, could you? No, I guess not. It's almost as difficult as doing laundry. What a petty man he turned out to be, giving up responsibility for a pretty face." Brave Orchid reached for the door handle. "Are you ready?"

"For what?"

"To go up there, of course. We're at his office, and I think we ought to be very direct. There aren't any trees to hide you, no grass to soften your steps. So, you walk right into his office. You make an announcement to the patients and the fancy nurses. You say, 'I am the doctor's wife. I'm going to see my husband.' Then you step to the inner door and enter. Don't knock on any doors. Don't listen if the minor wife talks to you. You walk past her without changing pace. When you see him, you say, 'Surprise!' You say, 'Who is that woman out there? She claims to be your wife.' That will give him a chance to deny her on the spot."

"Oh, I'm so scared. I can't move. I can't do that in front of all those people—like a stage show. I won't be able to talk." And sure enough, her voice was fading into a whisper. She was shivering and small in the corner of the seat.

"So. A new plan, then," said Brave Orchid, looking at her son, who had his forehead on the steering wheel. "You," she said. "I want you to go up to his office and tell your uncle that there has been an accident out in the street. A woman's leg has been broken, and she's crying in pain. He'll have to come. You bring him to the car."

"Mother."

"Mm," mused Brave Orchid. "Maybe we ought to put your aunt in

the middle of the street, and she can lie down with her leg bent under her." But Moon Orchid kept shaking her head in trembling no's.

"Why don't you push her down in the intersection and pour ketchup on her? I'll run over her a little bit," said her son.

"Stop being silly," she said. "You Americans don't take life seriously."

"Mother, this is ridiculous. This whole thing is ridiculous."

"Go. Do what I tell you," she said.

"I think your schemes will be useless, Mother."

"What do you know about Chinese business?" she said. "Do as I say."

"Don't let him bring the nurse," said Moon Orchid.

"Don't you want to see what she looks like?" asked Brave Orchid. "Then you'll know what he's giving up for you."

"No. No. She's none of my business. She's unimportant."

"Speak in English," Brave Orchid told her son. "Then he'll feel he has to come with you."

She pushed her son out of the car. "I don't want to do this," he said.

"You'll ruin your aunt's life if you don't. You can't understand business begun in China. Just do what I say. Go."

Slamming the car door behind him, he left.

Moon Orchid was groaning now and holding her stomach. "Straighten up," said Brave Orchid. "He'll be here any moment." But this only made Moon Orchid groan louder, and tears seeped out between her closed eyelids.

"You want a husband, don't you?" said Brave Orchid. "If you don't claim him now, you'll never have a husband. Stop crying," she ordered. "Do you want him to see you with your eyes and nose swollen when that young so-called wife wears lipstick and nail polish like a movie star?"

Moon Orchid managed to sit upright, but she seemed stiff and frozen.

"You're just tired from the ride. Put some blood into your cheeks," Brave Orchid said, and pinched her sister's withered face. She held her sister's elbow and slapped the inside of her arm. If she had had time, she would have hit until the black and red dots

broke out on the skin; that was the tiredness coming out. As she hit, she kept an eye on the rearview mirror. She saw her son come running, his uncle after him with a black bag in his hand. "Faster. Faster," her son was saying. He opened the car door. "Here she is," he said to his uncle. "I'll see you later." And he ran on down the street.

The two old ladies saw a man, authoritative in his dark western suit, start to fill the front of the car. He had black hair and no wrinkles. He looked and smelled like an American. Suddenly the two women remembered that in China families married young boys to older girls, who baby-sat their husbands their whole lives. Either that or, in this ghost country, a man could somehow keep his youth.

"Where's the accident?" he said in Chinese. "What is this? You don't have a broken leg."

Neither woman spoke. Brave Orchid held her words back. She would not let herself interfere with this meeting after long absence.

"What is it?" he asked. "What's wrong?" These women had such awful faces. "What is it, Grandmothers?"

"Grandmother?" Brave Orchid shouted. "This is your wife. I am your sister-in-law."

Moon Orchid started to whimper. Her husband looked at her. And recognized her. "You," he said. "What are you doing here?"

But all she did was open and shut her mouth without any words coming out.

"Why are you here?" he asked, eyes wide. Moon Orchid covered her face with one hand and motioned no with the other.

Brave Orchid could not keep silent. Obviously he was not glad to see his wife. "I sent for her," she burst out. "I got her name on the Red Cross list, and I sent her the plane ticket. I wrote her every day and gave her the heart to come. I told her how welcome she would be, how her family would welcome her, how her husband would welcome her. I did what you, the husband, had time to do in these last thirty years."

He looked directly at Moon Orchid the way the savages looked, looking for lies. "What do you want?" he asked. She shrank from his stare; it silenced her crying.

"You weren't supposed to come here," he said, the front seat a barrier against the two women over whom a spell of old age had

been cast. "It's a mistake for you to be here. You can't belong. You don't have the hardness for this country. I have a new life."

"What about me?" whispered Moon Orchid.

"Good," thought Brave Orchid. "Well said. Said with no guile."

"I have a new wife," said the man.

"She's only your second wife," said Brave Orchid. "This is your real wife."

"In this country a man may have just one wife."

"So you'll get rid of that creature in your office?" asked Brave Orchid.

He looked at Moon Orchid. Again the rude American eyes. "You go live with your daughter. I'll mail you the money I've always sent you. I could get arrested if the Americans knew about you. I'm living like an American." He talked like a child born here.

"How could you ruin her old age?" said Brave Orchid.

"She has had food. She has had servants. Her daughter went to college. There wasn't anything she thought of that she couldn't buy. I have been a good husband."

"You made her live like a widow."

"That's not true. Obviously the villagers haven't stoned her. She's not wearing mourning. The family didn't send her away to work. Look at her. She'd never fit into an American household. I have important American guests who come inside my house to eat." He turned to Moon Orchid, "You can't talk to them. You can barely talk to me."

Moon Orchid was so ashamed, she held her hands over her face. She wished she could also hide her dappled hands. Her husband looked like one of the ghosts passing the car windows, and she must look like a ghost from China. They had indeed entered the land of ghosts, and they had become ghosts.

"Do you want her to go back to China then?" Brave Orchid was asking.

"I wouldn't wish that on anyone. She may stay, but I do not want her in my house. She has to live with you or with her daughter, and I don't want either of you coming here anymore."

Suddenly his nurse was tapping on the glass. So quickly that they might have missed it, he gestured to the old women, holding a finger to his mouth for just a moment: he had never told his

American wife that he had a wife in China, and they mustn't tell her either.

"What's happening?" she asked. "Do you need help? The appointments are piling up."

"No. No," he said. "This woman fainted in the street. I'll be up soon."

They spoke to each other in English.

The two old women did not call out to the young woman. Soon she left. "I'm leaving too now," said the husband.

"Why didn't you write to tell her once and for all you weren't coming back and you weren't sending for her?" Brave Orchid asked.

"I don't know," he said. "It's as if I had turned into a different person. The new life around me was so complete; it pulled me away. You became people in a book I had read a long time ago."

"The least you can do," said Brave Orchid, "is invite us to lunch. Aren't you inviting us to lunch? Don't you owe us a lunch? At a good restaurant?" She would not let him off easily.

So he bought them lunch, and when Brave Orchid's son came back to the car, he had to wait for them.

Moon Orchid was driven back to her daughter's house, but though she lived in Los Angeles, she never saw her husband again. "Oh, well," said Brave Orchid. "We're all under the same sky and walk the same earth; we're alive together during the same moment." Brave Orchid and her son drove back north, Brave Orchid sitting in the back seat the whole way.

JAMES BALDWIN
(1924–1987)

As a teenager, James Baldwin preached the gospel in Harlem. After high school, he relocated to Greenwich Village to write, and published articles in The Nation *and* Commentary.

In 1948, he moved to Paris, keeping his U.S. citizenship. "I could see where I came from very clearly, and I could see that I carried myself, which is my home, with me." In 1953, he published the celebrated novel Go Tell It on the Mountain, *and two years later, the nonfiction volume* Notes of a Native Son.

He was a member of the American Academy and Institute of Arts and Letters and a commander of the Legion of Honor. When he died, he was working on a biography of Martin Luther King, Jr.

■ ■ ■

from NOTES OF A NATIVE SON

On the 29th of July, in 1943, my father died. On the same day, a few hours later, his last child was born. Over a month before this, while all our energies were concentrated in waiting for these events, there had been, in Detroit, one of the bloodiest race riots of the century. A few hours after my father's funeral, while he lay in state in the undertaker's chapel, a race riot broke out in Harlem. On the morning of the 3rd of August, we drove my father to the graveyard through a wilderness of smashed plate glass.

The day of my father's funeral had also been my nineteenth birthday. As we drove him to the graveyard, the spoils of injustice, anarchy, discontent, and hatred were all around us. It seemed to me that God himself had devised, to mark my father's end, the most sustained and brutally dissonant of codas. And it seemed to me, too, that the violence which rose all about us as my father left the world had been devised as a corrective for the pride of his eldest son. I had declined to believe in that apocalypse which had been central to my father's vision; very well, life seemed to be saying, here is something that will certainly pass for an apocalypse until the real thing comes

along. I had inclined to be contemptuous of my father for the conditions of his life, for the conditions of our lives. When his life had ended I began to wonder about that life and also, in a new way, to be apprehensive about my own.

I had not known my father very well. We had got on badly, partly because we shared, in our different fashions, the vice of stubborn pride. When he was dead I realized that I had hardly ever spoken to him. When he had been dead a long time I began to wish I had. It seems to be typical of life in America, where opportunities, real and fancied, are thicker than anywhere else on the globe, that the second generation has no time to talk to the first. No one, including my father, seems to have known exactly how old he was, but his mother had been born during slavery. He was of the first generation of free men. He, along with thousands of other Negroes, came North after 1919 and I was part of that generation which had never seen the landscape of what Negroes sometimes call the Old Country.

He had been born in New Orleans and had been a quite young man there during the time that Louis Armstrong, a boy, was running errands for the dives and honky-tonks of what was always presented to me as one of the most wicked of cities—to this day, whenever I think of New Orleans, I also helplessly think of Sodom and Gomorrah. My father never mentioned Louis Armstrong, except to forbid us to play his records; but there was a picture of him on our wall for a long time. One of my father's strong-willed female relatives had placed it there and forbade my father to take it down. He never did, but he eventually maneuvered her out of the house and when, some years later, she was in trouble and near death, he refused to do anything to help her.

He was, I think, very handsome. I gather this from photographs and from my own memories of him, dressed in his Sunday best and on his way to preach a sermon somewhere, when I was little. Handsome, proud, and ingrown, "like a toe-nail," somebody said. But he looked to me, as I grew older, like pictures I had seen of African tribal chieftains: he really should have been naked, with war-paint on and barbaric mementos, standing among spears. He could be chilling in the pulpit and indescribably cruel in his personal life and he was certainly the most bitter man I have ever met;

yet it must be said that there was something else in him, buried in him, which lent him his tremendous power and, even, a rather crushing charm. It had something to do with his blackness, I think—he was very black—with his blackness and his beauty, and with the fact that he knew that he was black but did not know that he was beautiful. He claimed to be proud of his blackness but it had also been the cause of much humiliation and it had fixed bleak boundaries to his life. He was not a young man when we were growing up and he had already suffered many kinds of ruin; in his outrageously demanding and protective way he loved his children, who were black like him and menaced, like him; and all these things sometimes showed in his face when he tried, never to my knowledge with any success, to establish contact with any of us. When he took one of his children on his knee to play, the child always became fretful and began to cry; when he tried to help one of us with our homework the absolutely unabating tension which emanated from him caused our minds and our tongues to become paralyzed, so that he, scarcely knowing why, flew into a rage and the child, not knowing why, was punished. If it ever entered his head to bring a surprise home for his children, it was, almost unfailingly, the wrong surprise and even the big watermelons he often brought home on his back in the summertime led to the most appalling scenes. I do not remember, in all those years, that one of his children was ever glad to see him come home. From what I was able to gather of his early life, it seemed that this inability to establish contact with other people had always marked him and had been one of the things which had driven him out of New Orleans. There was something in him, therefore, groping and tentative, which was never expressed and which was buried with him. One saw it most clearly when he was facing new people and hoping to impress them. But he never did, not for long. We went from church to smaller and more improbable church, he found himself in less and less demand as a minister, and by the time he died none of his friends had come to see him for a long time. He had lived and died in an intolerable bitterness of spirit and it frightened me, as we drove him to the graveyard through those unquiet, ruined streets, to see how powerful and overflowing this bitterness could be and to realize that this bitterness now was mine.

When he died I had been away from home for a little over a year. In that year I had had time to become aware of the meaning of all my father's bitter warnings, had discovered the secret of his proudly pursed lips and rigid carriage: I had discovered the weight of white people in the world. I saw that this had been for my ancestors and now would be for me an awful thing to live with and that the bitterness which had helped to kill my father could also kill me.

He had been ill a long time—in the mind, as we now realized, reliving instances of his fantastic intransigence in the new light of his affliction and endeavoring to feel a sorrow for him which never, quite, came true. We had not known that he was being eaten up by paranoia, and the discovery that his cruelty, to our bodies and our minds, had been one of the symptoms of his illness was not, then, enough to enable us to forgive him. The younger children felt, quite simply, relief that he would not be coming home anymore. My mother's observation that it was he, after all, who had kept them alive all these years meant nothing because the problems of keeping children alive are not real for children. The older children felt, with my father gone, that they could invite their friends to the house without fear that their friends would be insulted or, as had sometimes happened with me, being told that their friends were in league with the devil and intended to rob our family of everything we owned. (I didn't fail to wonder, and it made me hate him, what on earth we owned that anybody else would want.)

His illness was beyond all hope of healing before anyone realized that he was ill. He had always been so strange and had lived, like a prophet, in such unimaginably close communion with the Lord that his long silences which were punctuated by moans and hallelujahs and snatches of old songs while he sat at the living-room window never seemed odd to us. It was not until he refused to eat because, he said, his family was trying to poison him that my mother was forced to accept as a fact what had, until then, been only an unwilling suspicion. When he was committed, it was discovered that he had tuberculosis and, as it turned out, the disease of his mind allowed the disease of his body to destroy him. For the doctors could not force him to eat, either, and, though he was fed intravenously, it was clear from the beginning that there was no hope for him.

In my mind's eye I could see him, sitting at the window, locked up in his terrors; hating and fearing every living soul including his children who had betrayed him, too, by reaching towards the world which had despised him. There were nine of us. I began to wonder what it could have felt like for such a man to have had nine children whom he could barely feed. He used to make little jokes about our poverty, which never, of course, seemed very funny to us; they could not have seemed very funny to him, either, or else our all too feeble response to them would never have caused such rages. He spent great energy and achieved, to our chagrin, no small amount of success in keeping us away from the people who surrounded us, people who had all-night rent parties to which we listened when we should have been sleeping, people who cursed and drank and flashed razor blades on Lenox Avenue. He could not understand why, if they had so much energy to spare, they could not use it to make their lives better. He treated almost everybody on our block with a most uncharitable asperity and neither they, nor, of course, their children were slow to reciprocate.

The only white people who came to our house were welfare workers and bill collectors. It was almost always my mother who dealt with them, for my father's temper, which was at the mercy of his pride, was never to be trusted. It was clear that he felt their very presence in his home to be a violation: this was conveyed by his carriage, almost ludicrously stiff, and by his voice, harsh and vindictively polite. When I was around nine or ten I wrote a play which was directed by a young, white schoolteacher, a woman, who then took an interest in me, and gave me books to read and, in order to corroborate my theatrical bent, decided to take me to see what she somewhat tactlessly referred to as "real" plays. Theatergoing was forbidden in our house, but, with the really cruel intuitiveness of a child, I suspected that the color of this woman's skin would carry the day for me. When, at school, she suggested taking me to the theater, I did not, as I might have done if she had been a Negro, find a way of discouraging her, but agreed that she should pick me up at my house one evening. I then, very cleverly, left all the rest to my mother, who suggested to my father, as I knew she would, that it would not be very nice to let such a kind woman make the trip for nothing. Also, since it was a schoolteacher, I imagine that my

mother countered the idea of sin with the idea of "education," which word, even with my father, carried a kind of bitter weight.

Before the teacher came my father took me aside to ask *why* she was coming, what *interest* she could possibly have in our house, in a boy like me. I said I didn't know but I, too, suggested that it had something to do with education. And I understood that my father was waiting for me to say something—I didn't quite know what; perhaps that I wanted his protection against this teacher and her "education." I said none of these things and the teacher came and we went out. It was clear, during the brief interview in our living room, that my father was agreeing very much against his will and that he would have refused permission if he had dared. The fact that he did not dare caused me to despise him: I had no way of knowing that he was facing in that living room a wholly unprecedented and frightening situation.

Later, when my father had been laid off from his job, this woman became very important to us. She was really a very sweet and generous woman and went to a great deal of trouble to be of help to us, particularly during one awful winter. My mother called her by the highest name she knew. She said she was a "christian." My father could scarcely disagree but during the four or five years of our relatively close association he never trusted her and was always trying to surprise in her open, Midwestern face the genuine, cunningly hidden, and hideous motivation. In later years, particularly when it began to be clear that this "education" of mine was going to lead me to perdition, he became more explicit and warned me that my white friends in high school were not really my friends and that I would see, when I was older, how white people would do anything to keep a Negro down. Some of them could be nice, he admitted, but none of them were to be trusted and most of them were not even nice. The best thing was to have as little to do with them as possible. I did not feel this way and I was certain, in my innocence, that I never would.

But the year which preceded my father's death had made a great change in my life. I had been living in New Jersey, working in defense plants, working and living among southerners, white and black. I knew about the south, of course, and about how southerners treated Negroes and how they expected them to behave, but it

had never entered my mind that anyone would look at me and expect *me* to behave that way. I learned in New Jersey that to be a Negro meant, precisely, that one was never looked at but was simply at the mercy of the reflexes the color of one's skin caused in other people. I acted in New Jersey as I had always acted, that is as though I thought a great deal of myself—I had to *act* that way—with results that were, simply, unbelievable. I had scarcely arrived before I had earned the enmity, which was extraordinarily ingenious, of all my superiors and nearly all my co-workers. In the beginning, to make matters worse, I simply did not know what was happening. I did not know what I had done, and I shortly began to wonder what *anyone* could possibly do, to bring about such unanimous, active, and unbearably vocal hostility. I knew about jim-crow but I had never experienced it. I went to the same self-service restaurant three times and stood with all the Princeton boys before the counter, waiting for a hamburger and coffee; it was always an extraordinarily long time before anything was set before me; but it was not until the fourth visit that I learned that, in fact, nothing had ever been set before me: I had simply picked something up. Negroes were not served there, I was told, and they had been waiting for me to realize that I was always the only Negro present. Once I was told this, I determined to go there all the time. But now they were ready for me and, though some dreadful scenes were subsequently enacted in that restaurant, I never ate there again.

It was the same story all over New Jersey, in bars, bowling alleys, diners, places to live. I was always being forced to leave, silently, or with mutual imprecations. I very shortly became notorious and children giggled behind me when I passed and their elders whispered or shouted—they really believed that I was mad. And it did begin to work on my mind, of course; I began to be afraid to go anywhere and to compensate for this I went places to which I really should not have gone and where, God knows, I had no desire to be. My reputation in town naturally enhanced my reputation at work and my working day became one long series of acrobatics designed to keep me out of trouble. I cannot say that these acrobatics succeeded. It began to seem that the machinery of the organization I worked for was turning over, day and night, with but one aim: to eject me. I was fired once, and contrived, with the aid of a friend

from New York, to get back on the payroll; was fired again, and bounced back again. It took a while to fire me for the third time, but the third time took. There were no loopholes anywhere. There was not even any way of getting back inside the gates.

That year in New Jersey lives in my mind as though it were the year during which, having an unsuspected predilection for it, I first contracted some dread, chronic disease, the unfailing symptom of which is a kind of blind fever, a pounding in the skull and fire in the bowels. Once this disease is contracted, one can never be really care-free again, for the fever, without an instant's warning, can recur at any moment. It can wreck more important things than race relations. There is not a Negro alive who does not have this rage in his blood—one has the choice, merely, of living with it consciously or surrendering to it. As for me, this fever has recurred in me, and does, and will until the day I die.

My last night in New Jersey, a white friend from New York took me to the nearest big town, Trenton, to go to the movies and have a few drinks. As it turned out, he also saved me from, at the very least, a violent whipping. Almost every detail of that night stands out very clearly in my memory. I even remember the name of the movie we saw because its title impressed me as being so patly ironical. It was a movie about the German occupation of France, starring Maureen O'Hara and Charles Laughton and called *This Land Is Mine*. I remember the name of the diner we walked into when the movie ended: it was the "American Diner." When we walked in the counter-man asked what we wanted and I remember answering with the casual sharpness which had become my habit: "We want a hamburger and a cup of coffee, what do you think we want?" I do not know why, after a year of such rebuffs, I so completely failed to anticipate his answer, which was, of course, "We don't serve Negroes here." This reply failed to discompose me, at least for the moment. I made some sardonic comment about the name of the diner and we walked out into the streets.

This was the time of what was called the "brown-out," when the lights in all American cities were very dim. When we re-entered the streets something happened to me which had the force of an optical illusion, or a nightmare. The streets were very crowded and I was facing north. People were moving in every direction but it seemed

to me, in that instant, that all of the people I could see, and many more than that, were moving toward me, against me, and that everyone was white. I remember how their faces gleamed. And I felt, like a physical sensation, a *click* at the nape of my neck as though some interior string connecting my head to my body had been cut. I began to walk. I heard my friend call after me, but I ignored him. Heaven only knows what was going on in his mind, but he had the good sense not to touch me—I don't know what would have happened if he had—and to keep me in sight. I don't know what was going on in my mind, either; I certainly had no conscious plan. I wanted to do something to crush these white faces, which were crushing me. I walked for perhaps a block or two until I came to an enormous, glittering, and fashionable restaurant in which I knew not even the intercession of the Virgin would cause me to be served. I pushed through the doors and took the first vacant seat I saw, at a table for two, and waited.

I do not know how long I waited and I rather wonder, until today, what I could possibly have looked like. Whatever I looked like, I frightened the waitress who shortly appeared, and the moment she appeared all of my fury flowed towards her. I hated her for her white face, and for her great, astounded, frightened eyes. I felt that if she found a black man so frightening I would make her fright worth-while.

She did not ask me what I wanted, but repeated, as though she had learned it somewhere, "We don't serve Negroes here." She did not say it with the blunt, derisive hostility to which I had grown so accustomed, but, rather, with a note of apology in her voice, and fear. This made me colder and more murderous than ever. I felt I had to do something with my hands. I wanted her to come close enough for me to get her neck between my hands.

So I pretended not to have understood her, hoping to draw her closer. And she did step a very short step closer, with her pencil poised incongruously over her pad, and repeated the formula: ". . . don't serve Negroes here."

Somehow, with the repetition of that phrase, which was already ringing in my head like a thousand bells of a nightmare, I realized that she would never come any closer and that I would have to strike from a distance. There was nothing on the table but an ordi-

nary water-mug half full of water, and I picked this up and hurled it with all my strength at her. She ducked and it missed her and shattered against the mirror behind the bar. And, with that sound, my frozen blood abruptly thawed, I returned from wherever I had been, I *saw*, for the first time, the restaurant, the people with their mouths open, already, as it seemed to me, rising as one man, and I realized what I had done, and where I was, and I was frightened. I rose and began running for the door. A round, potbellied man grabbed me by the nape of the neck just as I reached the doors and began to beat me about the face. I kicked him and got loose and ran into the streets. My friend whispered, "*Run!*" and I ran.

My friend stayed outside the restaurant long enough to misdirect my pursuers and the police, who arrived, he told me, at once. I do not know what I said to him when he came to my room that night. I could not have said much. I felt, in the oddest, most awful way, that I had somehow betrayed him. I lived it over and over and over again, the way one relives an automobile accident after it has happened and one finds oneself alone and safe. I could not get over two facts, both equally difficult for the imagination to grasp, and one was that I could have been murdered. But the other was that I had been ready to commit murder. I saw nothing very clearly but I did see this: that my life, my *real* life, was in danger, and not from anything other people might do but from the hatred I carried in my own heart.

I had returned home around the second week in June—in great haste because it seemed that my father's death and my mother's confinement were both but a matter of hours. In the case of my mother, it soon became clear that she had simply made a miscalculation. This had always been her tendency and I don't believe that a single one of us arrived in the world, or has since arrived anywhere else, on time. But none of us dawdled so intolerably about the business of being born as did my baby sister. We sometimes amused ourselves, during those endless, stifling weeks, by picturing the baby sitting within in the safe, warm dark, bitterly regretting the necessity of becoming a part of our chaos and stubbornly putting it off as long as possible. I understood her perfectly and congratulated her on showing such good sense so soon. Death, however, sat as purposefully at my father's bedside as life stirred within my mother's

womb and it was harder to understand why he so lingered in that long shadow. It seemed that he had bent, and for a long time, too, all of his energies towards dying. Now death was ready for him but my father held back.

All of Harlem, indeed, seemed to be infected by waiting. I had never before known it to be so violently still. Racial tensions throughout this country were exacerbated during the early years of the war, partly because the labor market brought together hundreds of thousands of ill-prepared people and partly because Negro soldiers, regardless of where they were born, received their military training in the south. What happened in defense plants and army camps had repercussions, naturally, in every Negro ghetto. The situation in Harlem had grown bad enough for clergymen, policemen, educators, politicians, and social workers to assert in one breath that there was no "crime wave" and to offer, in the very next breath, suggestions as to how to combat it. These suggestions always seemed to involve playgrounds, despite the fact that racial skirmishes were occurring in the playgrounds, too. Playground or not, crime wave or not, the Harlem police force had been augmented in March, and the unrest grew—perhaps, in fact, partly as a result of the ghetto's instinctive hatred of policemen. Perhaps the most revealing news item, out of the steady parade of reports of muggings, stabbings, shootings, assaults, gang wars, and accusations of police brutality is the item concerning six Negro girls who set upon a white girl in the subway because, as they all too accurately put it, she was stepping on their toes. Indeed she was, all over the nation.

I had never before been so aware of policemen, on foot, on horseback, on corners, everywhere, always two by two. Nor had I ever been so aware of small knots of people. They were on stoops and on corners and in doorways, and what was striking about them, I think, was that they did not seem to be talking. Never, when I passed these groups, did the usual sound of a curse or a laugh ring out and neither did there seem to be any hum of gossip. There was certainly, on the other hand, occurring between them communication extraordinarily intense. Another thing that was striking was the unexpected diversity of the people who made up these groups. Usually, for example, one would see a group of sharpies standing on the street corner, jiving the passing chicks; or a group of older men,

usually, for some reason, in the vicinity of a barber shop, discussing baseball scores, or the numbers or making rather chilling observations about women they had known. Women, in a general way, tended to be seen less often together—unless they were church women, or very young girls, or prostitutes met together for an unprofessional instant. But that summer I saw the strangest combinations: large, respectable, churchly matrons standing on the stoops or the corners with their hair tied up, together with a girl in sleazy satin whose face bore the marks of gin and the razor, or heavy-set, abrupt, no-nonsense older men, in company with the most disreputable and fanatical "race" men, or these same "race" men with the sharpies, or these sharpies with the churchly women. Seventh Day Adventists and Methodists and Spiritualists seemed to be hobnobbing with Holyrollers and they were all, alike, entangled with the most flagrant disbelievers; something heavy in their stance seemed to indicate that they had all, incredibly, seen a common vision, and on each face there seemed to be the same strange, bitter shadow.

The churchly women and the matter-of-fact, no-nonsense men had children in the Army. The sleazy girls they talked to had lovers there, the sharpies and the "race" men had friends and brothers there. It would have demanded an unquestioning patriotism, happily as uncommon in this country as it is undesirable, for these people not to have been disturbed by the bitter letters they received, by the newspaper stories they read, not to have been enraged by the posters, then to be found all over New York, which described the Japanese as "yellow-bellied Japs." It was only the "race" men, to be sure, who spoke ceaselessly of being revenged—how this vengeance was to be exacted was not clear—for the indignities and dangers suffered by Negro boys in uniform; but everybody felt a directionless, hopeless bitterness, as well as that panic which can scarcely be suppressed when one knows that a human being one loves is beyond one's reach, and in danger. This helplessness and this gnawing uneasiness does something, at length, to even the toughest mind. Perhaps the best way to sum all this up is to say that the people I knew felt, mainly, a peculiar kind of relief when they knew that their boys were being shipped out of the south, to do battle overseas. It was, perhaps, like feeling that the most dangerous part of a dangerous journey had been passed and that now, even if death

should come, it would come with honor and without the complicity of their countrymen. Such a death would be, in short, a fact with which one could hope to live.

It was on the 28th of July, which I believe was a Wednesday, that I visited my father for the first time during his illness and for the last time in his life. The moment I saw him I knew why I had put off this visit so long. I had told my mother that I did not want to see him because I hated him. But this was not true. It was only that I *had* hated him and I wanted to hold on to this hatred. I did not want to look on him as a ruin: it was not a ruin I had hated. I imagine that one of the reasons people cling to their hates so stubbornly is because they sense, once hate is gone, that they will be forced to deal with pain.

We traveled out to him, his older sister and myself, to what seemed to be the very end of a very Long Island. It was hot and dusty and we wrangled, my aunt and I, all the way out, over the fact that I had recently begun to smoke and, as she said, to give myself airs. But I knew that she wrangled with me because she could not bear to face the fact of her brother's dying. Neither could I endure the reality of her despair, her unstated bafflement as to what had happened to her brother's life, and her own. So we wrangled and I smoked and from time to time she fell into a heavy reverie. Covertly, I watched her face, which was the face of an old woman; it had fallen in, the eyes were sunken and lightless; soon she would be dying, too.

In my childhood—it had not been so long ago—I had thought her beautiful. She had been quick-witted and quick-moving and very generous with all the children and each of her visits had been an event. At one time one of my brothers and myself had thought of running away to live with her. Now she could no longer produce out of her handbag some unexpected and yet familiar delight. She made me feel pity and revulsion and fear. It was awful to realize that she no longer caused me to feel affection. The closer we came to the hospital the more querulous she became and at the same time, naturally, grew more dependent on me. Between pity and guilt and fear I began to feel that there was another me trapped in my skull like a jack-in-the-box who might escape my control at any moment and fill the air with screaming.

She began to cry the moment we entered the room and she saw him lying there, all shriveled and still, like a little black monkey. The

great, gleaming apparatus which fed him and would have compelled him to be still even if he had been able to move brought to mind, not beneficence, but torture; the tubes entering his arm made me think of pictures I had seen when a child, of Gulliver, tied down by the pygmies on that island. My aunt wept and wept, there was a whistling sound in my father's throat; nothing was said; he could not speak. I wanted to take his hand, to say something. But I do not know what I could have said, even if he could have heard me. He was not really in that room with us, he had at last really embarked on his journey; and though my aunt told me that he said he was going to meet Jesus, I did not hear anything except that whistling in his throat. The doctor came back and we left, into that unbearable train again, and home. In the morning came the telegram saying that he was dead. Then the house was suddenly full of relatives, friends, hysteria, and confusion and I quickly left my mother and the children to the care of those impressive women, who, in Negro communities at least, automatically appear at times of bereavement armed with lotions, proverbs, and patience, and an ability to cook. I went downtown. By the time I returned, later the same day, my mother had been carried to the hospital and the baby had been born.

For my father's funeral I had nothing black to wear and this posed a nagging problem all day long. It was one of those problems, simple, or impossible of solution, to which the mind insanely clings in order to avoid the mind's real trouble. I spent most of that day at the downtown apartment of a girl I knew, celebrating my birthday with whiskey and wondering what to wear that night. When planning a birthday celebration one naturally does not expect that it will be up against competition from a funeral and this girl had anticipated taking me out that night, for a big dinner and a night club afterwards. Sometime during the course of that long day we decided that we would go out anyway, when my father's funeral service was over. I imagine *I* decided it, since, as the funeral hour approached, it became clearer and clearer to me that I would not know what to do with myself when it was over. The girl, stifling her very lively concern as to the possible effects of the whiskey on one of my father's chief mourners, concentrated on being conciliatory and practically

helpful. She found a black shirt for me somewhere and ironed it and, dressed in the darkest pants and jacket I owned, and slightly drunk, I made my way to my father's funeral.

The chapel was full, but not packed, and very quiet. There were, mainly, my father's relatives, and his children, and here and there I saw faces I had not seen since childhood, the faces of my father's onetime friends. They were very dark and solemn now, seeming somehow to suggest that they had known all along that something like this would happen. Chief among the mourners was my aunt, who had quarreled with my father all his life; by which I do not mean to suggest that her mourning was insincere or that she had not loved him. I suppose that she was one of the few people in the world who had, and their incessant quarreling proved precisely the strength of the tie that bound them. The only other person in the world, as far as I knew, whose relationship to my father rivaled my aunt's in depth was my mother, who was not there.

It seemed to me, of course, that it was a very long funeral. But it was, if anything, a rather shorter funeral than most, nor, since there were no overwhelming, uncontrollable expressions of grief, could it be called—if I dare to use the word—successful. The minister who preached my father's funeral sermon was one of the few my father had still been seeing as he neared his end. He presented to us in his sermon a man whom none of us had ever seen—a man thoughtful, patient, and forbearing, a Christian inspiration to all who knew him, and a model for his children. And no doubt the children, in their disturbed and guilty state, were almost ready to believe this; he had been remote enough to be anything and, anyway, the shock of the incontrovertible, that it was really our father lying up there in that casket, prepared the mind for anything. His sister moaned and this grief-stricken moaning was taken as corroboration. The other faces held a dark, non-committal thoughtfulness. This was not the man they had known, but they had scarcely expected to be confronted with *him;* this was, in a sense deeper than questions of fact, the man they had not known, and the man they had not known may have been the real one. The real man, whoever he had been, had suffered and now he was dead: this was all that was sure and all that mattered now. Every man in the chapel hoped that when his hour came he, too, would be eulogized, which is to say forgiven, and that all of his

lapses, greeds, errors, and strayings from the truth would be invested with coherence and looked upon with charity. This was perhaps the last thing human beings could give each other and it was what they demanded, after all, of the Lord. Only the Lord saw the midnight tears, only He was present when one of His children, moaning and wringing hands, paced up and down the room. When one slapped one's child in anger the recoil in the heart reverberated through heaven and became part of the pain of the universe. And when the children were hungry and sullen and distrustful and one watched them, daily, growing wilder, and further away, and running headlong into danger, it was the Lord who knew what the charged heart endured as the strap was laid to the backside; the Lord alone who knew what one *would* have said if one had had, like the Lord, the gift of the living word. It was the Lord who knew of the impossibility every parent in that room faced: how to prepare the child for the day when the child would be despised and how to *create* in the child—by what means?—a stronger antidote to this poison than one had found for oneself. The avenues, side streets, bars, billiard halls, hospitals, police stations, and even the playgrounds of Harlem—not to mention the houses of correction, the jails, and the morgue—testified to the potency of the poison while remaining silent as to the efficacy of whatever antidote, irresistibly raising the question of whether or not such an antidote existed; raising, which was worse, the question of whether or not an antidote was desirable; perhaps poison should be fought with poison. With these several schisms in the mind and with more terrors in the heart than could be named, it was better not to judge the man who had gone down under an impossible burden. It was better to remember: *Thou knowest this man's fall; but thou knowest not his wrassling.*

While the preacher talked and I watched the children—years of changing their diapers, scrubbing them, slapping them, taking them to school, and scolding them had had the perhaps inevitable result of making me love them, though I am not sure I knew this then— my mind was busily breaking out with a rash of disconnected impressions. Snatches of popular songs, indecent jokes, bits of books I had read, movie sequences, faces, voices, political issues—I thought I was going mad; all these impressions suspended, as it were, in the solution of the faint nausea produced in me by the heat

and liquor. For a moment I had the impression that my alcoholic breath, inefficiently disguised with chewing gum, filled the entire chapel. Then someone began singing one of my father's favorite songs and, abruptly, I was with him, sitting on his knee, in the hot, enormous, crowded church which was the first church we attended. It was the Abyssinia Baptist Church on 138th Street. We had not gone there long. With this image, a host of others came. I had forgotten, in the rage of my growing up, how proud my father had been of me when I was little. Apparently, I had had a voice and my father had liked to show me off before the members of the church. I had forgotten what he had looked like when he was pleased but now I remembered that he had always been grinning with pleasure when my solos ended. I even remembered certain expressions on his face when he teased my mother—had he loved her? I would never know. And when had it all begun to change? For now it seemed that he had not always been cruel. I remembered being taken for a haircut and scraping my knee on the footrest of the barber's chair and I remembered my father's face as he soothed my crying and applied the stinging iodine. Then I remembered our fights, fights which had been of the worst possible kind because my technique had been silence.

I remembered the one time in all our life together when we had really spoken to each other.

It was on a Sunday and it must have been shortly before I left home. We were walking, just the two of us, in our usual silence, to or from church. I was in high school and had been doing a lot of writing and I was, at about this time, the editor of the high school magazine. But I had also been a Young Minister and had been preaching from the pulpit. Lately, I had been taking fewer engagements and preached as rarely as possible. It was said in the church, quite truthfully, that I was "cooling off."

My father asked me abruptly, "You'd rather write than preach, wouldn't you?"

I was astonished at his question—because it was a real question. I answered, "Yes."

That was all we said. It was awful to remember that that was all we had *ever* said.

The casket now was opened and the mourners were being led up

the aisle to look for the last time on the deceased. The assumption was that the family was too overcome with grief to be allowed to make this journey alone and I watched while my aunt was led to the casket and, muffled in black, and shaking, led back to her seat. I disapproved of forcing the children to look on their dead father, considering that the shock of his death, or, more truthfully, the shock of death as a reality, was already a little more than a child could bear, but my judgment in this matter had been overruled and there they were, bewildered and frightened and very small, being led, one by one, to the casket. But there is also something very gallant about children at such moments. It has something to do with their silence and gravity and with the fact that one cannot help them. Their legs, somehow, seem *exposed*, so that it is at once incredible and terribly clear that their legs are all they have to hold them up.

I had not wanted to go to the casket myself and I certainly had not wished to be led there, but there was no way of avoiding either of these forms. One of the deacons led me up and I looked on my father's face. I cannot say that it looked like him at all. His blackness had been equivocated by powder and there was no suggestion in that casket of what his power had or could have been. He was simply an old man dead, and it was hard to believe that he had ever given anyone either joy or pain. Yet, his life filled that room. Further up the avenue his wife was holding his newborn child. Life and death so close together, and love and hatred, and right and wrong, said something to me which I did not want to hear concerning man, concerning the life of man.

After the funeral, while I was downtown desperately celebrating my birthday, a Negro soldier, in the lobby of the Hotel Braddock, got into a fight with a white policeman over a Negro girl. Negro girls, white policemen, in or out of uniform, and Negro males—in or out of uniform—were part of the furniture of the lobby of the Hotel Braddock and this was certainly not the first time such an incident had occurred. It was destined, however, to receive an unprecedented publicity, for the fight between the policeman and the soldier ended with the shooting of the soldier. Rumor, flowing immediately to the streets outside, stated that the soldier had been shot in the back, an instantaneous and revealing invention, and that the soldier had died protecting a Negro woman. The facts were

somewhat different—for example, the soldier had not been shot in the back, and was not dead, and the girl seems to have been as dubious a symbol of womanhood as her white counterpart in Georgia usually is, but no one was interested in the facts. They preferred the invention because this invention expressed and corroborated their hates and fears so perfectly. It is just as well to remember that people are always doing this. Perhaps many of those legends, including Christianity, to which the world clings began their conquest of the world with just some such concerted surrender to distortion. The effect, in Harlem, of this particular legend was like the effect of a lit match in a tin of gasoline. The mob gathered before the doors of the Hotel Braddock simply began to swell and to spread in every direction, and Harlem exploded.

The mob did not cross the ghetto lines. It would have been easy, for example, to have gone over Morningside Park on the west side or to have crossed the Grand Central railroad tracks at 125th Street on the east side, to wreak havoc in white neighborhoods. The mob seems to have been mainly interested in something more potent and real than the white face, that is, in white power, and the principal damage done during the riot of the summer of 1943 was to white business establishments in Harlem. It might have been a far bloodier story, of course, if, at the hour the riot began, these establishments had still been open. From the Hotel Braddock the mob fanned out, east and west along 125th Street, and for the entire length of Lenox, Seventh, and Eighth avenues. Along each of these avenues, and along each major side street—116th, 125th, 135th, and so on—bars, stores, pawnshops, restaurants, even little luncheonettes had been smashed open and entered and looted—looted, it might be added, with more haste than efficiency. The shelves really looked as though a bomb had struck them. Cans of beans and soup and dog food, along with toilet paper, corn flakes, sardines and milk tumbled every which way, and abandoned cash registers and cases of beer leaned crazily out of the splintered windows and were strewn along the avenues. Sheets, blankets, and clothing of every description formed a kind of path, as though people had dropped them while running. I truly had not realized that Harlem *had* so many stores until I saw them all smashed open; the first time the word *wealth* ever entered my mind in relation to

Harlem was when I saw it scattered in the streets. But one's first, incongruous impression of plenty was countered immediately by an impression of waste. None of this was doing anybody any good. It would have been better to have left the plate glass as it had been and the goods lying in the stores.

It would have been better, but it would also have been intolerable, for Harlem had needed something to smash. To smash something is the ghetto's chronic need. Most of the time it is the members of the ghetto who smash each other, and themselves. But as long as the ghetto walls are standing there will always come a moment when these outlets do not work. That summer, for example, it was not enough to get into a fight on Lenox Avenue, or curse out one's cronies in the barber shops. If ever, indeed, the violence which fills Harlem's churches, pool halls, and bars erupts outward in a more direct fashion, Harlem and its citizens are likely to vanish in an apocalyptic flood. That this is not likely to happen is due to a great many reasons, most hidden and powerful among them the Negro's real relation to the white American. This relation prohibits, simply, anything as uncomplicated and satisfactory as pure hatred. In order really to hate white people, one has to blot so much out of the mind—and the heart—that this hatred itself becomes an exhausting and self-destructive pose. But this does not mean, on the other hand, that love comes easily: the white world is too powerful, too complacent, too ready with gratuitous humiliation, and, above all, too ignorant and too innocent for that. One is absolutely forced to make perpetual qualifications and one's own reactions are always canceling each other out. It is this, really, which has driven so many people mad, both white and black. One is always in the position of having to decide between amputation and gangrene. Amputation is swift but time may prove that the amputation was not necessary—or one may delay the amputation too long. Gangrene is slow, but it is impossible to be sure that one is reading one's symptoms right. The idea of going through life as a cripple is more than one can bear, and equally unbearable is the risk of swelling up slowly, in agony, with poison. And the trouble, finally, is that the risks are real even if the choices do not exist.

"But as for me and my house," my father had said, "we will serve

the Lord." I wondered, as we drove him to his resting place, what this line had meant for him. I had heard him preach it many times. I had preached it once myself, proudly giving it an interpretation different from my father's. Now the whole thing came back to me, as though my father and I were on our way to Sunday school and I were memorizing the golden text: *And if it seem evil unto you to serve the Lord, choose you this day whom you will serve; whether the gods which your fathers served that were on the other side of the flood, or the gods of the Amorites, in whose land ye dwell: but as for me and my house, we will serve the Lord.* I suspected in these familiar lines a meaning which had never been there for me before. All of my father's texts and songs, which I had decided were meaningless, were arranged before me at his death like empty bottles, waiting to hold the meaning which life would give them for me. This was his legacy: nothing is ever escaped. That bleakly memorable morning I hated the unbelievable streets and the Negroes and whites who had, equally, made them that way. But I knew that it was folly, as my father would have said, this bitterness was folly. It was necessary to hold on to the things that mattered. The dead man mattered, the new life mattered; blackness and whiteness did not matter; to believe that they did was to acquiesce in one's own destruction. Hatred, which could destroy so much, never failed to destroy the man who hated and this was an immutable law.

It began to seem that one would have to hold in the mind forever two ideas which seemed to be in opposition. The first idea was acceptance, the acceptance, totally without rancor, of life as it is, and men as they are: in the light of this idea, it goes without saying that injustice is a commonplace. But this did not mean that one could be complacent, for the second idea was of equal power: that one must never, in one's own life, accept these injustices as commonplace but must fight them with all one's strength. This fight begins, however, in the heart and it now had been laid to my charge to keep my own heart free of hatred and despair. This intimation made my heart heavy and, now that my father was irrecoverable, I wished that he had been beside me so that I could have searched his face for the answers which only the future would give me now.

WILLIAM OWENS
(1905–1990)

Born in Blossom, Texas, William Owens attended Southern Methodist University, and took his Ph.D. at Iowa State University. He taught English at Texas A&M University from 1937 to 1947.

During World War II he was a member of the U.S. Army's Counter-intelligence Corps in the Philippines and received the Legion of Merit. Owens later became a professor of English at Columbia University, retiring in 1974.

His memoir, This Stubborn Soil, *published in 1966, received the Texas Institute of Letters Award. In this extract, Maggie is his older sister.*

■ ■ ■

from THIS STUBBORN SOIL

Looking for a job in January was worse than I thought it could be, going from building to building, walking in cold or rain, hearing again and again that no more applications would be taken till spring, or that I did not have enough education and experience to apply. The money in my pocket ran out and I had to draw on the savings I had put away for Commerce. Some mornings I would have stayed at home but Maggie would not let me. Anybody staying at her house had to be out working, or out looking for work.

"You're eighteen," she said. "You've got to make out like you're a man."

Other mornings I went straight to the library, after telling myself that a job would not turn up that day.

In the middle of January there was a letter from Pat Swindle, mailed from Texarkana, the first word I had heard from him since the day he walked off from the cotton patch. He had a job with a lumber company in Texarkana, working on a timber crew in the woods of Arkansas. He wanted me to come and work with him.

"I'll meet you at the post office in Texarkana January 22. You've got to be there. You cain't let me down."

I looked at the calendar and studied his letter. If I left the next day, I would have four days to meet him in Texarkana. It was warm outside, the sun bright. It would be a good thing to hit the road and meet him, to get a job on my own and not have to tell anybody how much money I was making or what I was going to do with it. Pat was a good friend to me. I would be as good a friend to him.

I kept the letter from them and did not tell them what I meant to do. I knew Maggie would try to stop me, and I did not want to be stopped.

The next morning I went to look for a job but came back to the house in the middle of the day, when I knew they would all be out at work. I put on clean overalls and shirt, work shoes and socks, my black coat and cap. I could send for the rest after I got a job. I wanted to go without leaving a word, but could not. I wrote a note telling them I had gone to meet Pat. I did not say when or where. Then, with the two dollars I had left, I walked out the Santa Fe tracks away from Dallas.

It was a bright winter afternoon, just cool enough to make me feel good walking. For some miles I stayed on the Santa Fe track, stepping on crossties, singing old songs I had learned at Pin Hook. "Send me a letter, Send it by mail." All at once I was happier than I had been for months. What I was doing was right. I would go where I pleased, work when I pleased, and move on when I got tired of working. Pat was the right one to go with. He was younger, but he had been hoboing for months and knew how to get along.

When I came to where the highway crossed the tracks at Rinehart, I took the pavement. Better to try catching rides on the highway than riding the rods, when I had never been on the rods. I took the road and walked along, flagging rides, and glad for the ones I got. I knew that Paris was not on the direct road to Texarkana, but at the first turning off place I went toward Paris.

At sundown I walked into the town of Wylie, knowing I could not get another ride that night. I ate a bowl of chili in a café and went to the railroad station. When the stationmaster left, I stretched out on a bench by a warm coal stove and slept through the night.

The next day I made it to Paris and then to Blossom. It was late in the day when I walked past the Blossom school and the line of stores. I saw people I knew but they did not know me. It was hard

not to ask them for something to eat and a place to stay all night. "Don't steal, don't beg." My mother's words came to mind. It was harder to pass the road to Pin Hook and not turn down it. Somebody else lived in our house at Pin Hook. Somebody else would have to give me grub and bed if I went there.

The next morning I was on the road again, after sleeping at the house of people who had been our neighbors when we lived at Blossom, with eighty miles ahead of me to Texarkana and a day and a half to make it in. The skies were gray with clouds and I was beginning to get a cold. There were a few cars on the road between Blossom and Clarksville, but not many. By the middle of the day I was catching rides on wagons when I could, walking when I could not, and beginning to feel dragged down by the cold.

Out of Clarksville I missed the road and in the late afternoon came to English, a place with store and school and houses at the edge of the pine woods. At the store, men told me the road was too boggy for a wagon all the way to Avery. At the school I stopped to rest and watch the end of a basketball game. The school was like Pin Hook but bigger. When the game was over I walked along the road with children ahead of me, children behind me till the last ones stopped at a house out in a field. There was nothing left for me but to keep on walking.

It was late at night when I got to Avery. The last mile or so was on gravel. It rattled under my shoes but was easier to walk in than the bogging clay. The town was asleep and dark, and dogs barked at me from house to house as I went along. I looked for a place to buy supper but everything was closed. Almost to the other side of town I saw a light burning on a porch and a sign: "Rooms, Fifty Cents." Hungry, worried about my cold, I stood at the edge of the porch and yelled "Hello" till an old man came with a coal oil lamp.

"You want a room?" he asked.

"Yes, sir."

"Four bits, cash."

I gave him half a dollar and he took me to a room in another house. He set the lamp on a washstand and went to the door.

"Privy's out back," he said.

"Any grub anywhere?"

"No grub tonight."

After he had gone I went to bed with my clothes on and wrapped the thin quilts around me, with a layer over my head. I needed to breathe warm air to stop coughing. I slept some, but was awakened in between by the sound of wind and rain on the tin roof over me.

I left Avery in gray daylight, before anything had opened. There was a heavy cloud to the north and a strong wind was blowing from the northeast. In January that meant bad weather and I was still forty miles from Texarkana. In a few hours Pat would be waiting for me at the post office.

At the edge of town a touring car with the curtains up stopped beside me. A young man unbuttoned a curtain on the driver's side and looked out.

"You want a ride?" he asked.

"I sure do."

He opened the door on the other side and I got in. He was about my age. An older man and woman sat together on the back seat with a black lap rope pulled up to their waists. The car started moving and gravel ground under the wheels.

"Where are you going, boy?" the woman asked.

"Texarkana, ma'am."

"What are you going there for?"

"To get me a job. Work. Make me some money."

She looked at me, at the man beside her, and back at me, and I could see a change in her face.

"You're running away, aren't you?"

"No, ma'am. Nothing for me to run away from."

"There must be something. You've got to tell us so we'll know. We don't want to be helping boys run away from home."

Out of the wind and weather, with a ride all the way to Texarkana, I talked and answered their questions. Better to talk than walk. I told them about Pin Hook—mostly about school in Pin Hook—my job at Sears, Roebuck and why I lost it—the job I hoped to get in Texarkana cutting timber.

"You're a peart boy," the woman said. She looked at the man. "Don't you think he ought to go to school some more?"

"It never hurt anybody."

They were right but I had to say something.

"I quit school to work. All I need is a job."

They let me out in Texarkana, not far from the post office, and I had not told them how hungry I was or how little money I had. They might have given me something and that would have been begging.

Hungry as I was, I went straight to the post office and up the front steps. A cold wind shipped around the brick building. Pat would be inside where it was warm. I went the length of the building but did not see him. I went through again slowly, looking in every possible place. Pat was not there. For the first time I was scared. I asked at the general delivery window but there was no letter for me—nothing. That meant he would be there later in the day.

At an alley cafe I bought a bowl of chili. A girl set a bowl before me and shoved a tray of crackers and a bottle of catsup down the counter. The smell of chili made my mouth water and my stomach growl. With shaking fingers I crumbled in crackers and covered them with catsup. I could fill myself up with chili and crackers and catsup. But the waitress was watching me. She let me have crackers and catsup once and moved them out of reach. What I got was enough to hold me but not to fill me.

Back at the post office I sat in a corner waiting for Pat. There were men close to me, bums in to keep out of the cold, rod riders on the way south from places like Chicago to places like New Orleans. From them I learned that Texarkana was a tough town on hoboes. Police arrested hoboes and made them work out their fines.

"You better warm up and move on," they told each other. "The law'll get you if you don't keep moving."

Pat did not come. I walked up and down, keeping away from the bums, but he did not come.

A policeman came in one door and I went out another, into the cold and gathering darkness. There was no other place for me to go and I did not have enough money for a bed. Cold and afraid, I started walking out the street I had come in on that morning, with nothing in mind now but to get away from the police. I walked past the edge of town and out on the highway, and felt safe in the dark on the highway.

When I knew that I could not walk another mile the road passed through heavy woods. Build a fire, I thought. Build a fire and get

warm. I would feel better warm and not cough so much. Back from the road, I piled up leaves and sticks and struck a match to them. Soon I had a good fire going and bright flames whipped in the sharp wind.

The fire could warm my body, but it could not take the chill from me. I was sick, hungry, and with no place to go. It was not my fault; it was that I had been born poor, and at Pin Hook. Then I was warm through and I sat up looking into the fire. I was sick and hungry now, but, by God, the time had to come when I would not be. I had been soft—too soft. I had to be hard—hard enough to make what I needed to fill my belly and warm my back. I had to do it by myself, without Pat or anybody.

Before daylight a fine drizzle fell on my face and woke me. I put more wood on the fire but the rain turned heavy enough to wet me and put out the fire. I went back to the road and walked west till I came to a country store. The owner was building a fire in the stove. I bought a piece of candy and waited by the stove for the rain to stop.

"You mind if I stay awhile?" I asked.

"You ain't bothering me none."

I sat on a keg of nails with my head against a counter and slept through the morning. When I woke up the rain had stopped, and I went on the road again, walking west, thinking only of getting back to Dallas. There had to be a job of some kind for me in Dallas.

Water stood in ruts deep enough to bog a car. I got a ride on a wagon that took me half the way to Avery. At Avery I bought a loaf of bread and warmed myself in the railroad station. Then I walked on the tracks. I would not get lost in the dark if I kept on the tracks.

When daylight came I was still walking; it was not a night for the open. The sky was clear and a cold wind blew from the north. Rainwater froze where it stood on the road and in the fields. There would be no rides that day, maybe for three or four days. I could be in Dallas in that time, if I could hold up to walk forty miles a day.

I went from the Texas Pacific to the Santa Fe tracks at Paris, stopping only to buy a piece of cheese to go with the bread I had left. It took the last of my money, so I put half of each in my pockets for the next day. To keep down hunger and thirst, and to ease my burning throat, I broke pieces of ice from the ditches to suck on as I

walked. They helped my throat but not my cough. I had nothing for it or for the rawness in my armpits and crotch.

At Ben Franklin I warmed myself in the station and watched a train pull out for Dallas. I knew that hoboes rode the blinds and the rods. I found the blinds but was afraid to swing on when the train started moving. I watched it out of sight and then followed it down the tracks.

Somewhere in the darkness I saw the shape of a barn close to the tracks. Knowing I had to stop and rest, I went inside the barn and climbed up to the hayloft. There was no loose hay, and I was afraid to break the bales that stood in straight stacks. I could get in trouble breaking bales. I crawled between stacks of bales and shut myself in with others to keep out the wind and cold. It was not warm enough but I could rest and sleep a little.

By daylight I was on the track again, eating the last of my bread and cheese, knowing that I should keep some of it for the time when I would be hungrier. I felt weak and my legs wobbled when I stepped from tie to tie. I thought of trying to find a highway but the fields were sheets of ice and I could not see where to go. I took to the ditch when freight trains passed. Nobody riding the rods, I could see. Anybody would freeze to death riding the rods on a day like that.

At times I saw houses across icy fields and thought of going to them for help. "Don't steal. Don't beg." I had never lowered myself that much, and I was not ready to begin.

Sundown came and darkness, but I went on, finding it harder and harder to make my feet move. They were sore and swollen—too swollen for me to take off my shoes.

"A little piece more," I kept telling myself. Then I could rest in a barn or haystack. The next night I would be in Dallas.

It was bare prairie and there were no barns or haystacks, or a patch of woods where I could build a fire. I had to keep walking or freeze.

Then I stopped and rubbed my eyes. Ahead of me and off the tracks a light shone at the level of the barbed-wire fence. Without thinking, I started toward it. I crossed the ice-covered ditch, climbed a frozen bank, and rolled under the fence. After crossing a narrow stretch of prairie I came to a small house. The light was shining

through a window. Inside I could see people sitting in front of a fireplace.

"Hello," I called.

I could see them leave their chairs and look out the window.

"Hello."

A man came to the door and opened it.

"What you want this time of night?" he asked.

"I want to warm myself."

He might not let me. I had not thought before that he might not let me.

"Who are you?" he asked. "What's your name?"

I gave it, and then gave it again.

"Never heard tell of you. Where do you live?"

"Nowheres right now. I was walking down the tracks and saw your light. I've got to get warm."

He closed the door and I could see him with the others around the fireplace. Then he opened the door again.

"Come on in."

He held the door open for me to pass. I went past him and straight to the fire.

"You cold?"

A woman in a rocking chair asked the question.

"Yes'm."

"Don't stand too close. It'll hurt if you stand too close."

I stood back a little, on the other side from her chair. She was older than my mother, thin, and wrapped in quilts—sickly looking but friendly. The man sat beside her. On her other side there was a young man in a blue suit and a boy my age in a blue shirt and overalls. She handed each an apple from a bowl in her lap.

"Want an apple?" she asked me.

"Yes'm."

I took it and ate it down to the core without stopping, with all of them watching.

"You ain't et for a spell," the woman said.

"No'm."

"We've got bread and milk."

The young man brought a glass of milk and a piece of corn bread from the kitchen. The man pulled a chair up to the fire for me.

"Eat and warm yourself," he said. "Then tell us how you got to Celeste."

Celeste. Closer to Dallas than I thought.

While I ate they told me about themselves. The woman was a cripple and had to do most of her work from her chair. When she was by herself the man had to come in from the field to move her from one job to another. The young man was a teacher in a country school. The boy went to high school in Celeste.

"We could make a bed for you if you want to stay all night," the man said.

The way he said it, I was not begging. It was not like being a tramp coming in begging for a place to stay.

"I'd be thankful."

They gave me warm water for washing and cough syrup for my cold. Then they let me sit by the fire and talk. It was easy to tell them about Pin Hook and the jobs in Dallas. It was easy to talk to a teacher about how I wanted to go to school. I could not tell them about my days on the road. They could see that I was hungry and cold.

"What will you do tomorrow?" the man asked.

"Go on to Dallas."

"Walking?"

"It's not so far now."

But they would not let me walk. The man would let me have money for a ticket and pay him back when I could. The teacher would take me to the station and put me on the train.

When I could keep awake no longer they put a mustard plaster on my chest and put me to bed in a featherbed.

When I woke up again it was late morning and the man was in the kitchen helping the woman cook dinner. We ate and talked again of what I would do.

"You c'n work your way through school," the woman said. "Anybody can if he wants to bad enough."

After school the teacher came in his Ford and took me to Celeste. On the way he told me what it was like to go to school at Commerce, and what he said made me want to go there more than ever.

He bought my ticket and when the train came in he gave it to me and shook my hand.

"I'm glad you saw our light," he said.

I knew he meant it—they all meant it.

"Me, too."

Then I was on the train looking out at the ice-covered fields.

It was warm in the Union Station, cold and dark outside. I thought of sitting on a bench all night and going from there in the morning to look for a job, but I went out and walked down Commerce Street. They were going to fuss at me anyway. Better to get it over with.

When I got to the house, Maggie, Cain, and the two girls were sitting in front of an open gas stove in the front room. I could see them through the window and went in without knocking.

"Where've you been?" Maggie asked.

"Rambling."

I had made up my mind to tell them that and no more—nothing of the places I had been, the hard times on the road.

"Did you find Pat Swindle?"

"No'm."

"I don't see why you thought you would. You know how long he's been hoboing it. It's a good thing you didn't. Next thing you hear, he'll be behind bars. You could a been with him."

I thought of the bums in the Texarkana post office, and the policeman walking through. I knew better than to tell them how close I had come to being arrested because of Pat. It was bad enough to have to think of it myself.

As I got warm again my coughing got worse.

"You sure caught a cold all right," they said.

They gave me warm milk, soup, and salve to open my head and ease my throat.

"You want us to take you in again?" Cain asked.

"Yes, sir. For a little while—till I get a job."

"Or go off bumming agin?"

"I won't. Not any more. I'll get me a job and pay you every cent I owe you."

"What do you think, Cain?" Maggie asked.

"It's all right with me if he gets a job. I won't have him hanging around the house in the daytime."

"You c'n make your pallet tonight," Maggie said. "In the morn-

ing you've got to look for a job and you cain't be choosy."

The girls had got their laundry jobs from an employment agency on Lamar Avenue.

"I'll show you in the morning," one of them said. "They're bound to have something."

They helped me make my pallet. Then they went to bed.

"Get a good night's sleep," they said. "You've got to look peart in the morning."

RALPH ELLISON
(1914–1994)

Ralph Ellison was born and raised in Oklahoma City, Oklahoma, where a public library now bears his name. In 1933, he enrolled as a music major at Tuskegee Institute. After graduation, he worked for five years as a researcher and writer on the Federal Writers' Project in New York City. It was on this research job that he met the coal-shovelers he describes in this narrative.

In 1953, his novel, Invisible Man, *won the National Book Award. He was awarded the Medal of Freedom in 1969 and the National Medal of Arts in 1985. At New York University, he was Albert Schweitzer Professor of Humanities from 1970 to 1979.*

Shadow and Act, *a collection of biographical and critical essays, appeared in 1964. A second collection,* Going to the Territory *(1986), includes "The Little Man at the Chehaw Station," which first appeared in* The American Scholar. *This story comes from that autobiographical essay.*

Chehaw Station is a railroad stop near Tuskegee, Alabama. Hazel Harrison, a concert pianist, headed the piano department in Tuskegee's school of music. From her Ellison learned to expect high standards everywhere. In his essays and lectures he refers to her frequently.

■ ■ ■

from GOING TO THE TERRITORY

It was at Tuskegee Institute during the mid-1930s that I was made aware of the little man behind the stove. At the time I was a trumpeter majoring in music and had aspirations of becoming a classical composer. As such, shortly before the little man came to my attention, I had outraged the faculty members who judged my monthly student's recital by substituting a certain skill of lips and fingers for the intelligent and artistic structuring of emotion that was demanded in performing the music assigned to me. Afterward, still dressed in my hired tuxedo, my ears burning from the harsh negatives of their criticism, I had sought solace in the basement studio of

Hazel Harrison, a highly respected concert pianist and teacher. Miss Harrison had been one of Ferruccio Busoni's prize pupils, had lived (until the rise of Hitler had driven her back to a U.S.A. that was not yet ready to recognize her talents) in Busoni's home in Berlin, and was a friend of such masters as Egon Petri, Percy Grainger, and Sergei Prokofiev. It was not the first time that I had appealed to Miss Harrison's generosity of spirit, but today her reaction to my rather adolescent complaint was less than sympathetic.

"But, baby," she said, "in this country you must always prepare yourself to play your very best wherever you are, and on all occasions."

"But everybody tells you that," I said.

"Yes," she said, "but there's more to it than you're usually told. Of course you've always been taught to *do* your best, *look* your best, *be* your best. You've been told such things all your life. But now you're becoming a musician, an artist, and when it comes to performing the classics in this country, there's something more involved."

Watching me closely, she paused.

"Are you ready to listen?"

"Yes, ma'am."

"All right," she said, "you must *always* play your best, even if it's only in the waiting room at Chehaw Station, because in this country there'll always be a little man hidden behind the stove."

"A *what*?"

She nodded. "That's right," she said. "There'll always be the little man whom you don't expect, and he'll know the *music,* and the *tradition,* and the standards of *musicianship* required for whatever you set out to perform!"

Speechless, I stared at her. After the working-over I'd just received from the faculty, I was in no mood for joking. But no, Miss Harrison's face was quite serious. So what did she mean? Chehaw Station was a lonely whistle-stop where swift north- or southbound trains paused with haughty impatience to drop off or take on passengers; the point where, on homecoming weekends, special coaches crowded with festive visitors were cut loose, coupled to a waiting switch engine, and hauled to Tuskegee's railroad siding. I knew it well, and as I stood beside Miss Harrison's piano, visualizing the station, I told myself, *She has GOT to be kidding!*

For, in my view, the atmosphere of Chehaw's claustrophobic lit-

tle waiting room was enough to discourage even a blind street musician from picking out blues on his guitar, no matter how tedious his wait for a train. Biased toward disaster by bruised feelings, my imagination pictured the vibrations set in motion by the winding of a trumpet within that drab, utilitarian structure: first shattering, then bringing its walls "a-tumbling down"—like Jericho's at the sounding of Joshua's priest-blown ram horns.

True, Tuskegee possessed a rich musical tradition, both classical and folk, and many music lovers and musicians lived or moved through its environs, but—and my regard for Miss Harrison notwithstanding—Chehaw Station was the last place in the area where I would expect to encounter a connoisseur lying in wait to pounce upon some rash, unsuspecting musician. Sure, a connoisseur might hear the haunting, blues-echoing, train-whistle rhapsodies blared by fast express trains as they thundered past—but the classics? Not a chance!

So as Miss Harrison watched to see the effect of her words, I said with a shrug, "Yes, ma'am."

She smiled, her prominent eyes a-twinkle.

"I hope so," she said. "But if you don't just now, you will by the time you become an artist. So remember the little man behind the stove."

With that, seating herself at her piano, she began thumbing through a sheaf of scores—a signal that our discussion was ended.

So, I thought, *you ask for sympathy and you get a riddle.* I would have felt better if she had said, "Sorry, baby, I know how you feel, but after all, I was *there,* I *heard* you; and you treated your audience as though you were some kind of confidence man with a horn. So forget it, because I will not violate my own standards by condoning sterile musicianship." Some such reply, by reaffirming the "sacred principles" of art to which we were both committed, would have done much to supply the emotional catharsis for which I was appealing. By refusing, she forced me to accept full responsibility and thus learn from my offense. The condition of artistic communication is, as the saying goes, hard but fair. . . .

Three years later, after having abandoned my hope of becoming a musician, I had just about forgotten Miss Harrison's mythical little

man behind the stove. Then, in faraway New York, concrete evidence of his actual existence arose and blasted me like the heat from an internally combusted ton of coal.

As a member of the New York Writers' Project, I was spending a clammy, late fall afternoon of freedom circulating a petition in support of some now long-forgotten social issue that I regarded as indispensable to the public good. I found myself inside a tenement building in San Juan Hill, a Negro district that disappeared with the coming of Lincoln Center. Starting on the top floor of the building, I had collected an acceptable number of signatures and, having descended from the ground floor to the basement level, was moving along the dimly lit hallway toward a door through which I could hear loud voices. They were male Afro-American voices, raised in violent argument. The language was profane, the style of speech a southern idiomatic vernacular such as was spoken by formally uneducated Afro-American workingmen. Reaching the door, I paused, sounding out the lay of the land before knocking to present my petition.

But my delay led to indecision. Not, however, because of the loud, unmistakable anger sounding within; being myself a slum dweller, I knew that voices in slums are often raised in anger, but that the *rhetoric* of anger, being in itself cathartic, is not necessarily a prelude to physical violence. Rather, it is frequently a form of symbolic action, a verbal equivalent of fisticuffs. No, I hesitated because I realized that behind the door a mystery was unfolding. A mystery so incongruous, outrageous, and surreal that it struck me as a threat to my sense of rational order. It was as though a bizarre practical joke had been staged and its perpetrators were waiting for me, its designated but unknowing scapegoat, to arrive; a joke designed to assault my knowledge of American culture and its hierarchal dispersal. At the very least, it appeared that my pride in my knowledge of my own people was under attack.

For the angry voices behind the door were proclaiming an intimate familiarity with a subject of which, by all the logic of their linguistically projected social status, they should have been oblivious. The subject of their contention confounded all my assumptions regarding the correlation between educational levels, class, race, and

the possession of conscious culture. Impossible as it seemed, these foulmouthed black workingmen were locked in verbal combat over which of two celebrated Metropolitan Opera divas was the superior soprano!

I myself attended the opera only when I could raise the funds, and I knew full well that opera going was far from the usual cultural pursuit of men identified with the linguistic style of such voices. And yet, confounding such facile logic, they were voicing (and loudly) a familiarity with the Met far greater than my own. In their graphic, irreverent, and vehement criticism they were describing not only the sopranos' acting abilities but were ridiculing the gestures with which each gave animation to her roles, and they shouted strong opinions as to the ranges of the divas' vocal equipment. Thus, with such a distortion of perspective being imposed upon me, I was challenged either to solve the mystery of their knowledge by entering into their midst or to leave the building with my sense of logic reduced forever to a level of college-trained absurdity.

So challenged, I knocked. I knocked out of curiosity, I knocked out of outrage. I knocked in fear and trembling. I knocked in anticipation of whatever insights—malicious or transcendent, I no longer cared which—I would discover beyond the door.

For a moment there was an abrupt and portentous silence; then came the sound of chair legs thumping dully upon the floor, followed by further silence. I knocked again, loudly, with an authority fired by an impatient and anxious urgency.

Again silence—until a gravel voice boomed an annoyed "Come in!"

Opening the door with an unsteady hand, I looked inside, and was even less prepared for the scene that met my eyes than for the content of their loud-mouthed contention.

In a small, rank-smelling, lamp-lit room, four huge black men sat sprawled around a circular dining-room table, looking toward me with undisguised hostility. The sooty-chimneyed lamp glowed in the center of the bare oak table, casting its yellow light upon four water tumblers and a half-empty pint of whiskey. As the men straightened in their chairs I became aware of a fireplace with a coal

fire glowing in its grate, and leaning against the ornate marble facing of its mantelpiece, I saw four enormous coal scoops.

"All right," one of the men said, rising to his feet. "What the hell can we do for *you*?"

"And we ain't buying nothing, buddy," one of the seated men added, his palm slapping the table.

Closing the door, I moved forward, holding my petition like a flag of truce before me, noting that the men wore faded blue overalls and jumper jackets, and becoming aware that while all were of dark complexion, their blackness was accentuated in the dim lamplight by the dust and grime of their profession.

"Come on, man, speak up," the man who had arisen said. "We ain't got all day."

"I'm sorry to interrupt," I said, "but I thought you might be interested in supporting my petition," and began hurriedly to explain.

"Say," one of the men said, "you look like one of them relief investigators. You're not out to jive us, are you?"

"Oh, no, sir," I said. "I happen to work on the Writers' Project. . . ."

The standing man leaned toward me. "You on the Writers' Project?" he said, looking me up and down.

"That's right," I said. "I'm a writer."

"Now is that right?" he said. "How long you been writing?"

I hesitated. "About a year," I said.

He grinned, looking at the others. "Y'all hear that? Ole Homeboy here has done up and jumped on the *gravy* train! Now that's pretty good. Pretty damn good! So what did you do before that?" he said.

"I studied music," I said, "at Tuskegee."

"Hey, now!" the standing man said. "They got a damn good choir down there. Y'all remember back when they opened Radio City? They had that fellow William L. Dawson for a director. Son, let's see that paper."

Relieved, I handed him the petition, watching him stretch it between his hardened hands. After a moment of soundlessly mouthing the words of its appeal, he gave me a skeptical look and turned to the others.

"What the hell," he said, "signing this piece of paper won't do no good, but since Home here's a musician, it won't do us no harm to help him out. Let's go along with him."

Fishing a blunt-pointed pencil from the bib of his overalls, he wrote his name and passed the petition to his friends, who followed suit.

This took some time, and as I watched the petition move from hand to hand, I could barely contain myself or control my need to unravel the mystery that had now become far more important than just getting their signatures on my petition.

"There you go," the last one said, extending the petition toward me. "Having our names on there don't mean a thing, but you got 'em."

"Thank you," I said. "Thank you very much."

They watched me with amused eyes, expecting me to leave, but, clearing my throat nervously, I stood in my tracks, too intrigued to leave and suddenly too embarrassed to ask my question.

"So what'er you waiting for?" one of them said. "You got what you came for. What else do you want?"

And then I blurted it out. "I'd like to ask you just one question," I said.

"Like what?" the standing one said.

"Like where on earth did you gentlemen learn so much about grand opera?"

For a moment he stared at me with parted lips; then, pounding the mantelpiece with his palm, he collapsed with a roar of laughter. As the laughter of the others erupted like a string of giant firecrackers I looked on with growing feelings of embarrassment and insult, trying to grasp the handle to what appeared to be an unfriendly joke. Finally, wiping coal-dust-stained tears from his cheeks, he interrupted his laughter long enough to initiate me into the mystery.

"Hell, son," he laughed, "we learned it down at the Met, that's where . . ."

"You learned it *where*?"

"At the Metropolitan Opera, just like I told you. Strip us fellows down and give us some costumes and we make about the finest damn bunch of Egyptians you ever seen. Hell, we been down there

wearing leopard skins and carrying spears or waving things like palm leafs and ostrich-tail fans for *years!*"

Now, purged by the revelation, and with Hazel Harrison's voice echoing in my ears, it was my turn to roar with laughter. With a shock of recognition I joined them in appreciation of the hilarious American joke that centered on the incongruities of race, economic status, and culture. My sense of order restored, my appreciation of the arcane ways of American cultural possibility was vastly extended. The men were products of both past *and* present; were both coal heavers *and* Met extras; were both workingmen *and* opera buffs. Seen in the clear, pluralistic, melting-pot light of American cultural possibility there was no contradiction. The joke, the apparent contradiction, sprang from my attempting to see them by the light of social concepts that cast less illumination than an inert lump of coal. I was delighted, because during a moment when I least expected to encounter the little man behind the stove (Miss Harrison's vernacular music critic, as it were), I had stumbled upon four such men. Not behind the stove, it is true, but even more wondrously, they had materialized at an even more unexpected location: at the depth of the American social hierarchy and, of all possible hiding places, behind a coal pile. Where there's a melting pot there's smoke, and where there's smoke it is not simply optimistic to expect fire, it's imperative to watch for the phoenix's vernacular, but transcendent, rising.

GEOFFREY WOLFF
(1937–)

Geoffrey Wolff's The Duke of Deception: Memories of My Father *describes one of the most vital characters in American literature. A con man, grifter, thief, jailbird, drunk, and all-round fraud, Arthur Wolff ("Duke") passed himself off as whatever sort of man the occasion demanded. Usually he claimed to be a Yale graduate and a member of the Skull and Bones society. Memorably, he worked as a project engineer during and after the war at North American Aviation, Lockheed, Northrup, Bell Helicopter, Rohn Aviation, and Boeing. He was not an engineer. The* École *aeronautiques at the Sorbonne, where he claimed to have earned his engineering degree, never existed.*

The Duke of Deception *is a vigorous, dark, and warm book. "There was nothing to him but lies, and love," Geoffrey Wolff writes. "I had this from him always: compassion, care, generosity, endurance."*

Geoffrey Wolff is primarily a novelist, the author of Bad Debts *(1969),* The Sightseer *(1974),* Inklings *(1977),* Providence *(1986),* The Final Club *(1990), and* The Age of Consent *(1995). His essays are in* A Day at the Beach *(1992).*

In this memoir section, the author is a Princeton undergraduate who has a temporary job at Sikorsky helicopters in Connecticut. He needs tuition for the coming year. Alice is his rich stepmother, who periodically leaves.

■ ■ ■

from THE DUKE OF DECEPTION

My father was a mystery, or as crazy as crazy can be. His schemes were insane. He would go to law school, become an expert on wheat speculations, advise the Algerians or Venezuelans on oil refining. He decided the jazz pianist at The Three Bears in Wilton was a genius, as good as King Cole. During the early forties in California he had "discovered" Cole playing piano in a bowling alley, and the King, responding to my father's enthusiasm, asked the Duke to manage him. My father had laughed at the notion. *This* chance my father

wouldn't miss, he would produce a record for this pianist, they'd both have it made. He brought the man home, recorded his work on our out-of-tune upright using a top dollar Ampex, shot publicity snaps with a Rollei (white dinner jacket, pencil-line mustache, and rug), and led him to the mountain top. The man was my father's age, with more or less my father's prospects, with one greater skill and one greater vice. The piano player could play the piano better, but he was always drunk; my father was drunk only once—maybe twice—a week.

Duke charged ahead. He charged and charged ahead. There was something about him, what he wanted he got. Salesmen loved him, he was the highest evolution of consumer. Discriminating, too: he railed against shoddy goods and cheapjack workmanship. He would actually return, for credit, an electric blender or an alpine tent that didn't perform, by his lights, to specification. He demanded the best, and never mind the price. As for debts, they didn't bother him at all. He said that merchants who were owed stayed on their toes, aimed to please. Dunning letters meant nothing to him. He laughed off the vulgar thrustings of the book and record clubs, with their absurd threats to take him to law. People owed a bundle, who brought out their heavy artillery, got my father's Samuel Johnson remark: "Small debts are like small shot; they are rattling on every side, and can scarcely be escaped without a wound; great debts are like cannon, of loud noise but little danger." He was slippery: he used the telephone to persuade the telephone company he should be allowed a sixth month of non-payment without suffering disconnection, because he needed to call people long distance to borrow money from them to pay his telephone bills. He was cool, but not icy. He owed a Westport barkeep a couple of hundred, and when the man died in a car accident my father was sorry, and told his widow about the debt, not that he ever paid her.

Finally it got out of hand. It had nowhere to go but out of hand. I wearied of telling people on our stoop or through the phone that they had the wrong Arthur Wolff, that my father had just left for the hospital, or the Vale of Kashmir, or Quito. I tired of asking "How do I know you're who you say you are?" when people asked questions about my father's whereabouts and plans. I hated it, wanted to flee.

It was October; there were months still to get through, too many months but too few to cobble up a miracle of loaves and find the twenty-five hundred dollars to buy my way back into Princeton.

My father and I were watching the Giants play the Colts in the snow for the championship when two Connecticut State troopers arrived during the first sudden death overtime. They watched with us till the game ended, and then took my father to the lockup in Danbury. He had left a bad check at The Three Bears; they were pressing charges. I found a mouthpiece who went bail, made good the check and got the charges dropped. Duke had talked with him. The old man hadn't lost his touch at all, only with me. With me he had lost his touch.

A week before my birthday he wrecked my Delahaye. I loved the dumb car. I was in bed when I heard him climb the driveway cursing. He was blind drunk, drunker than I'd ever seen him. He railed at me as soon as he came in, called me a phony. I feigned sleep, he burst through the room, blinded me with the overhead light, told me I was full of crap, a zero, zed, cipher, blanko, double-zero.

"I'm leaving you," he said.

I laughed: "In what?"

A mistake. His face reddened. I sat up, pretending to rub sleep from my eyes while he swore at my car, said it had damned near killed him swerving into the ditch, it could rot there for all he cared. He was usually just a finger-wagger, but I still feared him. Now he poked my bare chest with his stiff yellow finger, for punctuation. It hurt. I was afraid. Then I wasn't afraid; I came off my bed naked, cocked my fist at my father, and said: "Leave me alone."

My father moved fast to his room, shut the door, and locked it. I was astounded. I don't believe he was afraid of me; I believe he was afraid of what he might do to me. I sat on the edge of my bed, shaking with anger. He turned on his television set loud: Jack Paar. He hated Paar. There was a shot, a hollow noise from the .45. I had heard that deep, awful boom before, coming from the black cellar in Birmingham, a bedroom in Saybrook. I thought my father would kill me. That was my first thought. Then that he would kill himself, then that he had already killed himself. I heard it again, again, again. He raged, glass broke, again, again. The whole clip. Nothing. Silence

from him, silence from Paar. A low moan, laughter rising to a crescendo, breaking, a howl, sobs, more laughter. I called to my father.

"Shit fire," he answered, "now I've done it, now I've *done* it!"

He had broken. No police, the phone was finally disconnected. I tried the door. Locked. Shook it hard. Locked fast. I moved back to shoulder through and as in a comic movie, it opened.

My father had shot out Jack Paar; bits of tubes and wires were strewn across the floor. He had shot out the pretty watercolors painted by Betty during their Mississippi rendezvous. He had shot out himself in the mirror. Behind the mirror was his closet, and he was looking into his closet at his suits. Dozens of bespoke suits, symmetrically hung, and through each suit a couple of holes in both pant-legs, a couple in the jacket. Four holes at least in each suit, six in the vested models.

"Hell of a weapon," my father said.

"Oh, yes," I said. "*Hell* of a weapon!"

November fifth I turned twenty-one. My father had a present for me, two presents really, a present and its wrapping. He gave me his gold signet ring, the one I wear today—lions and fleurs-de-lis, *nulla vestigium retrorsit*—wrapped in a scrap of white paper, a due bill signed *Dad*, witnessed and notarized by a Danbury real estate agent: *I.O.U. Princeton.*

"How?" I asked.

"Piece of cake," my father said, "done and done."

I was due at Princeton January 15th. By then the Abarth had been repossessed and the Delahaye was still and forever a junker. I rode to Sikorsky with Nick, who drove twenty miles out of his way to pick me up and return me in his Edsel. After work the day following New Year's I found a rented black Buick in the driveway. My father told me to help him pack it, we were leaving pronto and for good; what didn't come with us we'd never see again. I asked questions. I got no answers, except this:

"It's Princeton time. We're going by way of Boston."

I almost believed him. We packed, walked away from every thing. I wish I had the stuff now, letters, photographs, a Boy Scout

merit badge sash, Shep's ribbon: *Gentlest in Show* at the Old Lyme grade school fair. My father had had his two favorite suits rewoven; he left the rest behind with most of his shoes, umbrellas, hats, accessories. He left behind the model Bentley that cost him half a year to build. He brought his camera, the little Minox he always carried and never used ("handy if someone whacks you with his car, here's the old evidence machine," he'd say, tapping the silly chain on the silly camera). I brought my typewriter and my novel. While my father had watched television I had written a novel. I worked on it every night, with my bedroom door shut; my father treated it like a rival, which it was, a still, invented place safe from him. He made cracks about The Great Book, and resented me for locking it away every night when I finished with it, while he shut down the Late Show, and then the Late Late. I made much of not showing it to him.

On the way to Boston we stopped by Stratford, where Sikorsky had moved. I quit, told the personnel department where to send my final check, said goodbye to no one. When I returned to the car my father said to me:

"Fiction is the thing for you. Finish Princeton if you want, but don't let them turn you into a goddamned professor or a critic. Write make-believe. You've got a feel for it."

Had he read my stuff? "Why, do you think?"

"I know you."

We drove directly to Shreve, Crump & Low, Boston's finest silversmith. Duke double-parked on Boylston Street and asked me to help him unload two canvas duffels from the trunk. He called them "parachute bags"; maybe that's what they were, parachute bags. They were heavy as corpses; we had to share the load.

"What's going on?" I asked. "What's in here?"

"Never mind. Help me."

We sweated the bags into the store, past staring ladies and gentlemen to the manager. My father opened a zipper and there was Alice's flat silver: solid silver gun-handle knives, instruments to cut fish and lettuce, dessert spoons and lobster forks, three-tined forks and four-tined forks, every imaginable implement, service for sixteen. In the other bag were teapots, coffeepots, creamers, saltcellars,

Georgian treasure, the works polished by my father, piles gleaming dangerously in the lumpy canvas sacks.

The manager examined a few pieces. He was correct; he looked from my face to my father's while he spoke.

"These are very nice, as you know. I could perhaps arrange a buyer . . . This will take time. If you're in no rush . . ."

"I want money today," my father said.

"This will be quite impossible," the manager said.

"I won't quibble," my father said. "I know what the silver is worth, but I'm pinched, I won't quibble."

"You don't understand," the manager said.

"Let's not play games," my father said.

"This is quite impossible," the manager said. "I think you'd best take this all away now."

"Won't you make an offer?"

"No," the manager said.

"Nothing?" my father asked.

"Nothing."

"You're a fool," my father told the manager of Shreve, Crump & Low.

"I think not," said the manager of Shreve, Crump & Low. "Good afternoon, gentlemen."

We reloaded the car. I said nothing to my father, and he said nothing to me. There we were. It was simple, really, where everything had been pointing, right over the line. This wasn't mischief. This wouldn't make a funny story back among my college pals. This was something else. We drove to a different kind of place. This one had cages on the windows, and the neighborhood wasn't good. The manager here was also different.

"You want to pawn all this stuff?"

"Yes," my father said.

"Can you prove ownership?"

"Yes."

"Okay," the pawnbroker said. He sorted through it, scratched a few pieces and touched them with a chemical.

"It's solid silver," my father said.

"Yes," the man said, "it is."

"What will you loan us, about?"

I heard the *us*. I looked straight at my father, and he looked straight back.

"Will you reclaim it soon?" My father shrugged at this question. "Because if you don't really need it, if you'd sell it, I'd buy. We're talking more money now, about four times what I'd loan you."

"What would you do with it?" my father asked. "Sell it?"

"No," the man said. "I'd melt it down."

My father looked at me: "Okay?"

"Okay," I said.

My father nodded. While he signed something the man took cash from a huge floor safe. He counted it out, twenties bound in units of five hundred dollars. I looked away, didn't want to know the bottom line on this one. There were limits, for me, I thought.

We checked into the Ritz-Carlton. Looked at each other and smiled. I felt all right, pretty good, great. I felt great.

"What now?" I asked my father.

Years later I read about the Philadelphia cobbler and his twelve-year-old son said to have done such awful things together, robbing first, breaking and entering. Then much worse, rape and murder. I wondered if it could have kept screwing tighter that way for us, higher stakes, lower threshold of *this, but not that*. I thought that day in the Ritz, sun setting, that we might wind up with girls, together in the same room with a couple of girls. But as in Seattle I had misread my father.

"Let's get some champers and fish-eggs up here," he said.

So we drank Dom Perignon and ate Beluga caviar and watched night fall over Boston Common. Then we took dinner at Joseph's and listened to Teddy Wilson play piano at Mahogany Hall. Back at the Ritz, lying in clean linen in the quiet room, my father shared with me a scheme he had been a long time hatching.

"Here's how it works. I think I can make this work, I'm sure I can. Here's how it goes. Okay, I go to a medium-size town, check into a hotel, not the worst, not the best. I open an account at the local bank, cash a few small checks, give them time to clear. I go to a Cadillac showroom just before closing on Friday, point to the first car I see and say I'll buy it, no road test or questions, no haggling."

My father spoke deliberately, doing both voices in the dark.

When he spoke as an ingratiating salesman he flattened his accent, and didn't stammer:

"How would you care to pay, sir? Will you be financing your purchase? Do you want to trade in your present automobile?"

"This is a cash purchase. (The salesman beams.) I'm paying by check. (The salesman frowns a little.) On a local bank, of course. (The salesman beams again.)"

"Fine, sir. We'll have the car registered and cleaned. It'll be ready Monday afternoon."

"At this I bristle. I bristle well, don't you think?"

"You are probably the sovereign bristler of our epoch," I told my father.

He would tell the salesman he wanted the car now or not at all, period. There would be a nervous conference, beyond my father's hearing, with the dealer. The dealer would note Duke's fine clothes and confident bearing; now or never was this customer's way, *carpe diem*, here was an *easy* sale, car leaving town, maybe just maybe this was kosher. Probably not, but how many top-of-the-line cars can you sell right off the floor, no bullshit about price, color, or options? Now the dealer was in charge, the salesman wasn't man enough for this decision. The dealer would telephone Duke's hotel and receive lukewarm assurances. Trembling, plunging, he would take Duke's check. My father would drive to a used car dealer a block or two away, offer to sell his fine new automobile for whatever he was offered, he was in a rush, yeah, three thousand was okay. A telephone call would be made to the dealer. Police would arrive. My father would protest his innocence, spend the weekend in a cell. Monday the check would clear. Tuesday my father would retain the services of a shyster, if the dealer hadn't already settled. With the police he would never settle. False arrest would put him on Easy Street. How did I like it?

"Nice sting. It might work." The Novice.

"Of course it will work." The Expert.

The next morning we checked out and my father mailed the Buick's keys to a Hertz agent in Stamford, telling him where to find his car. Then a VW bus materialized. My father had taken it for a

test drive; maybe he paid for it later, and maybe he forgot to pay for it later. My father called this "freeloading."

We drove to Princeton in the bus, with my novel on the back seat beside a cooler filled with cracked ice and champagne, a cash purchase from S.S. Pierce. We reached Princeton about four and parked on Nassau Street, outside the Annex Grill, across from Firestone Library.

"How much did you give me last year?"

"About twenty-five hundred," I said, "but a lot of that was for my own keep."

"I don't charge my boy room and board," my father said. He pulled clumps of twenties from a manila envelope. Five packets, twenty-five hundred dollars, there it was, every penny, just as he had promised, precisely what I owed. "And here's another five hundred to get you started."

"Thanks," I said. "Where will you go now?"

"New York for a while. Then, I don't know. Maybe California. I always had luck in California."

"Sounds like a good plan," I said. "Stay in touch," I said.

"Sure," he said. "Do well, Geoffrey. Be good."

"Sure," I said. "I won't screw up this time."

"No," he said, "you probably won't. Now don't be *too* good. There's such a thing as too good."

"Don't worry," I said laughing, wanting this to end.

"Don't forget your book," my father said, while I unloaded the van. "I'll be reading it someday, I guess. I'll be in touch, you'll hear from me, hang in there."

He was gone. An illegal turn on Nassau headed him back where he had come from.

CHRIS OFFUTT
(1958–)

Chris Offutt grew up in the Appalachian Mountains of eastern Kentucky and now lives in western Montana with his wife, Rita, and their two sons. He has written a collection of short stories, Kentucky Straight *(1992), and a memoir,* The Same River Twice *(1993). Both works show a bizarre and dazzling strength.*

Offutt, who received his M.F.A. from the University of Iowa, has been awarded a James Michener grant and a Kentucky Arts Council grant. In 1994, he won the Jean Stein Award from the American Academy of Arts and Letters.

■ ■ ■

from THE SAME RIVER TWICE

Allowing oneself to sleep in rain is the mark of a soldier, an animal, and the consummate hitchhiker. It was a skill I never fully acquired. Water weight trebled the mass of my pack. Rain gathered in my brows and ran into my eyes at the slightest movement. There is a private understanding, even appreciation, of misery when one is cold and wet at four in the morning. Dawn never seemed so precious. Birdsong meant that soon you could watch the rising steam drawn from your clothes by sun. In this fashion, I began a summer in Alabama.

The sun hung low on the horizon when the leader of a convoy came traveling my way. Emblazoned along the truck in red curlicued letters were the words "Hendley Circus, Greatest Show on Earth." Truck after truck passed, each garishly advertising various sideshows. Horse droppings spilled from a trailer. A variety of campers and RVs followed, but none stopped and no one waved. The last vehicle trundled from sight and I felt as though I'd seen a mirage, a phantom wagon train that taunted hermits of the road.

From the west came the sound of another truck straining in low gear. The driver flung open the passenger door without stopping.

"Hurry," he said. "I can't stop or Peaches will get mad."

I used the mirror to vault onto the running board, and scrambled into the seat.

"Thanks," I said.

"No problem. I've been on the run plenty."

"It's not like that."

"It never is," he said. "You got five bucks to loan me?"

"I'm broke."

He slid a hand into his shirt pocket and handed me a five-dollar bill. He spat tobacco juice out the window.

"Little treat for Peaches," he said. "She loves 'backer."

"Who's Peaches?"

"My best friend of fifteen years. The circus is my mistress but Peaches is my wife."

The way the truck swayed at low speed, I figured he was married to the sideshow Fat Lady, who wouldn't fit up front. If he wanted to haul his wife in the back, it was his business.

Barney had been in the circus all his life, a case of "sawdust up my nose when I was a little pecker." He offered me a job, saying that I owed him a Lincoln already. Room and board were included in the wage. Four hours later we passed through a tiny town and joined the rest of the caravan, circled like a pioneer wagon train in a broad grassy vale. Barney hopped from the cab and handed me a rake.

"Clear the rocks from behind the truck, then make a path to the big top."

Barney climbed on the rear bumper and unhooked chains bigger than those used by professional loggers. He cranked down the gate, revealing the great gray flanks of an elephant. Barney spoke to Peaches in a soothing tone, apologizing for the long trip, offering her water and hay if she'd come out of the truck. A foot extended backwards. I scurried away so fast I fell. Raucous laughter erupted behind me.

"What a fall, what a fall! Sign him up!"

"Move over, Rover, he's mashing clover!"

A pair of dwarfs leered from giant heads on neckless bodies. One performed a handspring, then clambered onto the shoulders of his buddy. They advanced on me, my size now, flicking their tongues like snakes. I held the rake across my body.

"Rover's got a rake," said one.

"Let's throw him in the lake."

"There ain't no lake."

"How about a well?"

"That sounds good."

The top dwarf kicked the lower one in the head.

"Swell," the top one said. "You should have said swell for the rhyme."

"Don't kick me."

The lower dwarf bit his partner's ankle and they tumbled across the ground. Peaches aimed her trunk high, bellowing relief at standing on earth. Barney stepped around her with a long pole that ended in a hook.

"Hey, you fricking runts," he yelled. "Peaches favors tidbits like you."

The dwarfs scrambled away, hopping onto the metal steps of a camper.

"I'll make a suitcase out of her," one said.

"Planters from her feet."

"A dildo of her trunk."

Peaches regarded me from an eye the size of my fist. Thick stalks of hair poked from her body like weed clumps. Her back leg held a heavy manacle that chained her to the truck.

"Stay away from them shrimps," Barney said. "Watch out for the clowns, too. And don't even look at the Parrot Lady. Even from behind. She can tell."

I nodded, receiving information without the ability to process it.

"Go to the trucks and ask for Flathead. Tell him you're my First of May."

I moved across the field, listening to yelling and cursing everywhere. No one talked in normal tones. People were setting up sideshow games, running electric wires, unloading animals. A vast crew of men worked four trucks loaded with folded tents. Flathead's curly hair was very short, as if to display the fact that his head was indeed flat on top. He told me to dig a donicker.

"What?"

"The donicker hole. What's the matter, you no piss? Everybody piss. Dig two hole, you."

He handed me a shovel and sent me to an area at the edge of the

campers. Everyone ignored me. I finished my work and walked away. A man strode past me and calmly urinated into the hole.

I returned to Flathead, who sent me to a canvas crew that was short a pair of hands. Trucks circled the field, stopping at precise points aligned with iron stakes driven into the ground. Several men dragged the folded sections of tent from the back of the truck. I was a runner. When pulled fast, canvas becomes slightly airborne, not so heavy, and easier to handle. Another man and I held a corner of the canvas and ran as hard as we could to the extent of the fold, went back, grabbed the next corner and ran again. The canvas sandpapered my hands to blood.

When the sections were laid out, we laced them together while the more experienced men fastened the canvas to bail rings. Walking on the tent risked tearing it, so everyone crawled like bugs, even Flathead. Next came the complicated process of raising the top, one section at a time, to keep them even. My chore was to hold a guy line until Flathead yelled to tie it off. It reminded me of water-skiing—incredible exertion while standing still.

After nine hours, Peaches hoisted the final pole with ropes tied to her harness. The entire tent strained upward while everyone watched, feeling the increased tension in the lines. Flathead tied off the main pole. In the dim interior, we set up three tiers of collapsible bleachers, cursed by electricians and sound people. Flathead announced we were finished and everyone began asking if the flag was up. We staggered into an afternoon sunlight so brilliant we bumped against each other. The entire mass of exhausted men hurried away and I trailed behind, following the herd. Since I hadn't understood that an upright flag meant dinner was served, I was late. The only thing worse than the dregs of the stew was knowing that everyone else's sweat had fallen into the pot.

A cook sent me to the sleeper truck for canvas boys. Four levels of bunk beds lined each wall, with a thin corridor running the length of the truck. Our collective bedroom was a mobile lightless hall, extremely hot, that reeked of unwashed bodies. Snoring echoed back and forth between the metal walls. I found an empty bunk and lay on a mattress the width of a bookshelf.

We stayed three days in town, long enough for me to prove myself a fierce liability as a taffy seller. The candy was cut into tiny

plugs that could pull fillings from a molar. I was unable to hawk it aggressively enough to please the head of concessions, a bitter man who limped. He'd been an aerialist until a fall ruined his ankle. His performing monicker had been Colonel Kite but everyone called him Colonel Corn. After my dismal failure as a candy seller, he decided he liked me since I was less suited to employment than he was. The Colonel rather graciously gave me the lowest job of folding waxed paper around the candy.

The circus possessed a hierarchy with the complex simplicity of the military. Those who rode horses in a standing position were on top of the heap, followed by aerialists, live animal performers, clowns, and the ringmaster. Sideshow freaks made up the middle level. Everyone else drifted at the bottom, producing their own pecking order based on convincing their peers of personal prowess. Canvas boys were the lowest. We had no one to despise but minorities and homosexuals. Since circus people hated them already, the canvas boys were left with honing bigotry to a fine edge.

The technicians seemed to have the simplest job, and I approached Krain, the light man, about work. He led me up a precarious ladder to the booth. Protruding from slots in a metal board were several levers that controlled the intensity of the lights. Krain pulled an electrical wire from beneath the board, separated the two strands, and tucked each one in his jaws, clamped between his teeth. He gradually pushed the lever forward. His eyes got very wide and his lips pulled back in a macabre grin. At quarter power, his head and shoulders began quivering. He brought it back to the zero mark, calmly pulled the wires from his mouth, and offered them to me. I climbed down the ladder.

The aerialists and horse performers never deigned to speak with anyone. As Europeans, they considered themselves superior to the rest of us. The two clowns were hilarious in performance, making me laugh long after I knew their gags. On the occasional free day, they went fishing. I followed them once, hoping for some intangible insight into the private world of professional clowns. I watched from the bushes. They carried tackle boxes and baited their hooks like normal men. They cast and reeled and did not converse. When one caught a fish, the other nodded. The only

shift from standard behavior was their method of removing a fish from the line. With a ferocious motion, they ripped the hook free, usually trailing bits of the fish's interior. Often it was bleeding from the gills.

No one liked the dwarfs because they made more money than anyone else, and in violation of circus tradition, they didn't squander the loot. At each new town they inquired after the stock market.

In addition to Peaches, the circus boasted three bedraggled tigers that reared on their hind legs as if begging, perched on stools, and crowded together on a large box. A man dressed as a woman snapped the whip over their striped flanks. I was leery of him until the Colonel explained his clothing—an audience was more awed by a female tamer than a male. The tiger man's great enemy, due to her withering disdain, was the Parrot Lady. The dwarfs called her "an upper crustacean."

She was part of a sideshow that included a perpetually drunk magician, a trained walrus, and a skinny man, double-jointed at every junction, who could fold himself into knots. There was a strong man who was dying from steroid intake. His brother was a fire eater who told me the hardest part was controlling a sneeze.

The most popular act was the Parrot Lady. She'd begun as a common sword swallower, but like everyone, had wanted to increase her earnings by diversifying her act. Five years later she was the biggest sideshow draw. Women and children were not allowed in her tent. The huge MEN ONLY sign fostered quite a crowd, and on slow nights, teenage boys were admitted for double the price. I watched her performance every night. The tent was always packed, hot, and hazed by cigarette smoke.

She entered from stage left wearing a high-necked, long-sleeved, white formal gown, looking like an aristocrat. The audience gradually hushed beneath her unwavering stare. After a long spell of silence, she began speaking in a voice so low that everyone strained to hear. Each night she told the dirtiest joke imaginable, speaking of cocks, cunts, and fucking as casually as the men's wives might discuss children and meals. A palpable sense of guilt congealed with lust in the tent, and the men refused to look at one another.

The Parrot Lady stood very still. Her eyes fluttered to stage right

and she lifted a hand to her ear. Faint chamber music drifted through the tent. With the grace of a fashion model, she rose from her stool and began an excruciatingly slow strip—from the inside out. She removed a slip first, a petticoat, her shoes, stockings, and two more petticoats, each frillier than the last. She took off her bra and panties last. No one moved. Everyone knew she was naked beneath the dress, a fact more arresting than if she'd actually been nude.

She faced the audience and began to unbutton her dress, beginning at the top of the chin-high collar and working down. Holding the front closed, she continued to her lower belly. The men were leaning forward without awareness of their posture. When her arms could no longer reach the buttons, she turned her back. The long train concealed her legs. Nothing was visible except her slightly bowed head and the long dress that everyone knew was open in front. She remained standing this way a long time. Instead of building to a crescendo, the music faded to silence. The spotlight narrowed its focus. She let the dress fall from her shoulders. Breath came pouring from the men as if each had received a powerful blow in the guts.

Tattoos of brilliant tropical birds covered every inch of her body. Two parrots faced each other on her buttocks, beaks curving into the cleft, tail feathers running down the back of her legs. A swirling flock of bright plumage fluttered up her back and across her shoulders. Parakeets perched among toucans and birds of paradise. Lush jungle foliage peeped around the birds.

Slowly she turned, revealing a shaven yoni from which a pair of golden wings fanned along her hips. On top of each breast sat two enormous and lovely parrots. She rotated again, moving at a slow pace until she faced the men once more. She now held a long fluorescent light tube. An electric cord ran behind the black curtain. She spread her legs for balance and tipped her head back. Only her neck and the point of her chin were visible. She lifted the light tube above her head and very slowly slid it down her throat. She took her hands away, and pressed a switch on the cord that turned on the fluorescent tube. The spotlight went black. Her body glowed from within, illuminating the birds in an ethereal, ghostly light, like a jungle dawn. She flicked the switch off and the tent was dark save for sun-

light leaking beneath the canvas flaps. The houselights came on very bright. The stage was empty. She was gone.

The dazed men stumbled outside, blinking against the sun. I never missed her act and always tried to maneuver myself near the front. After ten or twelve shows, I was sufficiently familiar with the birds to begin watching her eyes. I expected a blank look but she gazed at the men with a blend of fury and desire. Eventually she saw me watching. I was embarrassed, as if caught peeping, a curious reverse of logic. The following day I stayed in the back but she found me. Her vision locked on me during the entire act. I left with the crowd, feeling devastated.

My tear-down job was pulling stakes, a chore relegated to the most useless worker. The stakes were car axles driven very deep into the earth. To pull them, I first had to loosen the dirt by pounding the ground with a sledgehammer. At times I worked in a rhythmic blur, grateful for the simple repetition. Other times I wore myself down in rage at my occupation.

I abandoned my bunk after a wave of lice spread among the workers, making us scratch like junkies. If our hands were full, we wiggled and shifted in vain attempts to relieve the itch. I boiled my clothes and the sight of swollen nits in the seams made me sick. Since I was being fed and housed, my pay was not enough to buy new clothes. When my toothbrush snapped at the handle, I decided to quit.

I told Barney, who said he'd speak to Flathead about my working as an all-purpose animal helper. For the next two weeks we traveled across the Deep South. In many of the smaller towns attendance at the circus included a black night and a white night. The Sunday matinees were the only integrated time, but the groups didn't mix. I swept manure, hauled feed and water, and hosed down Peaches twice a day. Barney lent me money against my raise. I bought clothes and a toothbrush. Luckily, I'd been keeping my journal in the glove box of Barney's pickup. Everything else had been stolen from the sleeper truck.

The new job gave me greater privacy. I slept under the truck and had time to write in my journal. I never reread an entry. They represented the past, and my journal was proof that I existed in the present. As an event unfolded around me, I was already anticipating

how I'd write about it later. A new entry began where the last one ended, continuing to the immediate, to the current act of writing. Each mark on the page was a gesture toward the future, a codification of the now. Through this, I learned to trust language.

The animal trainers were an odd lot who argued constantly, smoked hand-rolled cigarettes, and possessed only one friend apiece—their animal. Soon I began to roll my own cigarettes. During off-hours we sat in a circle debating the merits and dangers of various animals. Everyone teased Arnie, the gorilla trainer, about the simplicity of his job. Gabe the Gorilla was ancient and nearly blind.

One night the show was canceled due to a fire in town that destroyed four blocks. The entire circus left except the trainers who stayed to guard their animals. We passed a pint of whisky and began our usual bickering.

"Don't go getting the big head, Barney," the tiger man said. "Elephant ain't the worst to work."

"More of mine kill folks than yours ever did," Barney said.

"Killing ain't the mark," the man said. "Go a season with zebras and you'll wish you had a rogue. Zebras is the meanest there is."

"Bull smoke," said Arnie.

"Fact before God. Over in Africa the zebra's worst enemy is a lion. That makes them a mean fighter."

The others pushed a lower lip out and raised their eyebrows in the animal trainer's sign of acknowledgment.

"My opinion," the horse man said, "the all-time worstest is a camel. I purely loathe a camel. There ain't no safe place to work them from because they kick sideways. I never seen a sideways kick that didn't bust a leg to a compound. Humpy bastards are stubborn as a mule."

Barney drank from the bottle as it went past him.

"The elephant is the closest animal to a man there is," he said.

"Bull smoke," said Arnie.

"Telling it true," Barney said. "Its back legs bends forward like a human. They got tits up front, not in the back. They go off on their own to mate."

"Gorilla's ten times closer to human," Arnie said.

"Well, a cat ain't," said the tiger man. "I'm put right out of this talk. The only thing a cat's like is a damn cat."

"Horse is gabbier," the horse man said.

"Bull smoke," Arnie said. "Me and Gabe talk plenty."

"I heard something on a gorilla maybe you can clear up," Barney said. "But I ain't advising you to ask Gabe on it."

"What?"

"A gorilla's got a harem, don't it?"

Arnie nodded. "In the wild."

"Then it don't have to work too hard for company, if you know what I mean." Barney tipped his head to me. "I'm trying to talk nice in front of the squirt."

Everyone laughed and the tiger man handed me the bottle. "That boy knows what's what," he said. "He ain't missed the Parrot Lady since he joined on." The men chuckled again.

"Way I hear it," Barney said, "the gorilla's got the littlest balls of any creature on earth. They shrink up from not having to hunt no nookie."

"Bull smoke," Arnie said. "They're big as a man's."

"Damn cat's got his snuggled up to his butt-hole," the tiger man said. "I got to find me another animal to work if I want to keep up with this outfit."

"Is that true?" the horse man said. "About the gorilla?"

"No," Arnie said. "Gabe's balls are big as mine."

"That ain't saying much." Barney grinned at the men. "We might just have to get some proof on that."

"We got eighty proof right here," the tiger man said.

He opened another pint of local rotgut, took a hard drink, and sent it on its rounds.

"Might be tough to see Gabe's balls," Barney said. "Little as they are."

"All you got to do is get him to stand," Arnie said. "We can squat low and put a flashlight on him. They're a good size, you can take my word for it."

"Chris, there's a flashlight behind the truck seat. Get the elephant prod, too."

I walked through the warm summer darkness, rummaged for the light, and returned. The men were swaying on their feet.

"Gabe ain't going to like this much," Arnie said.

"He won't know," the horse man said.

"He will. He's smarter than any nag you run."

"All right," Barney said. "We'll make it so Gabe don't know what we're up to."

"Nobody better say nothing," Arnie said. "Promise?"

"Deal," Barney said.

The men nodded. We walked to the gorilla cage, which was bolted to a flatbed truck. Arnie fastened a banana to the end of the elephant prod.

"Gabe," he whispered. "You awake in there."

Gabe's tiny close-set eyes showed red in the flashlight's beam. Arnie waved the banana. "You hungry? I sneaked you a snack." He lifted the elephant prod until the banana was above the cage, just outside of the bars. "Come and get it, big boy."

Gabe moved to the front of the cage. We squatted for an up-angle view while Barney played the flashlight on Gabe's crotch. The gorilla used the bars to pull himself erect on legs that seemed permanently crooked. His big thighs were matted with fur.

"Up, Gabe," Arnie said. "You almost got it."

The gorilla stretched higher. He shifted his weight to one leg and reached his hand through the top of the cage, inches from the banana. He thrust his other leg out for balance. Clearly illuminated was a pair of testicles the size of chestnuts. The men collapsed on their haunches, laughing and hooting. Gabe quickly dropped to a crouch and backed into the shadows. The men laughed harder.

"Goddamn it!" Arnie yelled. "You promised to be quiet."

"You win," the horse man said. "By default."

He handed the bottle to Arnie, who knocked it aside. He snatched the flashlight and aimed the light through the bars. Gabe sat hunched in a corner, head bowed. He glanced at us with an expression of terrible humiliation, then hid his head. The men hushed and slowly moved away.

"You sons of bitches," Arnie said. "You promised!"

He continued cursing into the night until his voice broke and we heard a sob. He started talking to Gabe in low tones. I crawled under the elephant truck to sleep, remembering my former room-mates' preoccupation with the heft of Marduk's lingam. Men's tendency to take an interest in one another's genitals is not so much sexual as simply wondering how they stack up against everybody

else. Most men need confirmation that someone's equipment is smaller than theirs, even if it belongs to a gorilla.

After lunch, Flathead always strolled the grounds to ensure that everyone was ready for the afternoon show. Sometimes the clowns or the magician were so hung over they needed an injection of sucrose and Dexedrine. Flathead carried a small case of prepared syringes. That morning Gabe refused to eat breakfast, keeping his back turned in the cage. Flathead wanted to give him an injection but Arnie refused, promising to have his gorilla ready for the matinee. Gabe missed both performances and Flathead was furious. If Gabe didn't perk up, Flathead warned, they'd sell him to a Mexican zoo.

The animal trainers avoided each other all day. They took care of the animals and went to sleep without talking. Sometime late in the night, Barney woke me by rapping on my feet. The trainers stood in an awkward circle. The horse man pushed his shoes against the earth while the tiger man paced back and forth. Barney was very still and Arnie stood by himself, facing away.

Barney handed each of us a banana. He stepped to the gorilla cage and held the flashlight so that it shone on his face.

"I'm sorry, Gabe," he said. "I was a little drunk. When I was married, I cheated on my wife. Now you know something on me."

He peeled the banana and gently slid it into the cage. One by one, each of us took our turn apologizing to Gabe, who sat motionless in the shadows. Everyone told him something personal and gave him a banana. On my turn I faced the darkness and muttered my greatest secret—the transvestite in New York. Gabe didn't answer.

Arnie went last. He was crying. He opened his pants and said, "See, they ain't that much to mine either." Arnie stuffed four bananas through the cage and claimed credit for bringing all the men to apologize.

We slipped away, leaving them to talk in private. The next day, Gabe performed exceedingly well. After the show, the trainers sat in their customary circle, arguing the fine points of manure, each defending his animal.

The circus roamed deeper into the South and I was rewarded for my diligence with a promotion that, like most advances I've received, proved my undoing. Someone had quit and Flathead

offered me the job because of my size—the circus diet and strenuous labor had cost me several pounds. I was practically a wraith. Flathead introduced me to Mr. Kaybach, a dirty-haired man whose odor was a point of personal honor. As long as I stayed upwind, we got along well.

He showed me how to wriggle into my costume, an oilskin sheath with a hidden zipper. He warned that it was hot and I should wear only underwear. Tattered quilting padded the interior to swell my torso. Two flippers hung from my chest which I could operate by careful insertion of my hands. The back of the costume tapered to a pair of rubber flippers set close together. A surprisingly realistic mask completed my transformation into a walrus. I peeked through tiny slits between two tusks. Kaybach explained our routine and I waited eagerly inside the dark tent for my debut.

The audience encircled a pool of water containing fake ice floes and false rocks. The dark hump they saw was Louie the Great Trained Walrus, direct from the Bering Straits, the Smartest Walrus in Captivity. To further the illusion, Kaybach dumped a wheelbarrow load of ice cubes into the fetid water. He explained that Louie communicated with standard head shakes, and could clap his flippers in mathematical tally.

He called my name and I plunged off the rocks and through the shallow water. By squatting inside the oilskin bag, I could make Louie appear to rear on his haunches.

"Are you a girl walrus?"

I vigorously shook my head no.

"He's a male, folks! Take a look at those tusks. We lost three Eskimos capturing him. Very sad." A pause for the audience to consider their own danger. "Are you married, Louie?"

Again I shook my head.

"You got a girlfriend, Louie?"

I shook my head.

"Do you want one?"

This was my cue to launch myself across the pool toward the nearest woman in the audience. She usually screamed and people backed away. Kaybach yelled at me to settle down. I appeared to defy him momentarily before slinking back to the center of the pool. By this time, enough water had leaked in to make my skin slimy.

"You know how bachelors are, folks," Kaybach continued with a broad wink. "And everyone knows what seafood does to a fellow."

He asked a few more questions—what state we were in, who the local mayor was—arranging a multiple choice for me to answer yes or no. When I was correct, he threw a dead fish which I forced through the mouth flap to lie cold and smelly against my chest. Kaybach told the audience that I could only count to ten and invited them to stump me with problems of arithmetic. Someone asked the sum of five plus two. Kaybach yelled the question to me and I clapped my front flippers seven times. After a few more tests, a circus plant bullied his way to the front and shouted that he'd seen this on TV and it was a fake. He said the walrus was trained to respond only to the voice of its master, who spoke in code. Kaybach assured everyone that this was not true. He suggested that the man ask his own question, providing the answer didn't go past ten.

"Square roots," the plant said.

"What's that?" Kaybach asked.

"A number times itself." The plant turned to the crowd. "You know, from high school. The square root of a hundred is ten because ten times ten is a hundred."

The audience nodded and the plant faced me. "Okay, Louie, what's the square root of nine?"

He turned his back again and showed three fingers so that the audience could see, but not me. Kaybach began to stutter a protest. The plant shut him up and asked me again. To build suspense, I waited thirty seconds before clapping my flippers three times.

The audience always applauded, as much to see a bully get shut down by a walrus as for the answer. The plant shook his head in disbelief. Kaybach tossed a fish and asked the final question.

"Are you a walrus, Louie?"

I shook my head no.

"Oh, I guess you think you're human, then."

I nodded very fast.

"I'm sorry, Louie. You're nothing but a walrus. You'll never be a man."

I sank into the water, performed an awkward circling maneuver, and scuttled behind a rock. Kaybach thanked everyone and asked

for a big hand for a walrus so smart that he knew genuine sadness—he'd never be a human.

I had a half-hour break before beginning again with a new plant and a different fake question. I had become a circus performer, or in Barney's parlance, a kinker. The name came from the effects of the nightlong wagon rides in the old days, after which the performers spent a couple of hours stretching kinks from their bodies.

The various sideshows were tucked into a midway of carny games as crooked as a dog's hind leg. Even the benign ring toss and dart throw were rigged. The con operators allowed a few people to win large, highly visible prizes. They picked the winners carefully. The best investments were young couples, or a family that moved as a group. Forced to carry the prize the rest of their visit, the winners served as advertising. Many people won at the start of the day; none toward the end.

As a full-fledged kinker, I had access to the forbidden zone of performer alley. Here the clowns played chess, the aerialists disdained anyone confined to earth, and the dwarfs spent most of their time baiting the Parrot Lady. They constantly threatened to pluck her, and commented quite openly on her presumed skill at fellatio.

One Sunday, in a community so religious the circus wasn't allowed to admit the public until well past noon, the heat rose to ninety-eight. Only the aerialists and the Parrot Lady had trailers with air-conditioning. The rest of us sat semiclothed in available shade. The dwarfs began crooning a love song on the Parrot Lady's aluminum steps. She opened her door with enough force to smack it against the trailer. The dwarfs retreated like tumbleweed.

"A bird in hand," one said.

"Is worth a hand in the bush," said the other.

"I got a sword she can't swallow."

"Get lost, you little pissants," the Parrot Lady said. She leaned against the doorjamb in the shimmering heat. "Hey, Walrus Man," she called. "Come here."

All the kinkers blinked from a doze, staring at me, then at her. I stumbled to her trailer as if moving through fog. My clothes clung to me.

"Save me a sandwich," said one of the dwarfs.

The air-conditioned trailer made the sweat cold on my body.

She motioned me to a couch. Gingham curtains hung from each window, and an autographed picture of Elvis Presley sat on a tiny TV. The room was very small, very neat.

"Thirsty?" she said. "Like a drink?"

I nodded and she poured clear liquid from a pitcher into a glass, added ice and an olive.

"Nothing better in summer than a martini," she said.

Not wanting her to know that I'd never sampled such an exotic drink, I drank it in one chug and asked for another. She lifted her eyebrows and poured me one. I drank half for the sake of civility.

"The one thing I hate more than dwarfs," she said, "is the circus."

She wore a long white dress with a high collar and sleeves that ran to her wrists. No tattoos were visible. A rowing machine occupied a third of the trailer's space. She topped my drink and filled her own glass.

"This is my fourth circus," she said. "I've worked with fat ladies, bearded women, Siamese twins, rubber-skinned people, and midgets. The three-legged man. A giant. Freaks by nature, all freaks but me."

"Not you."

She offered her glass for a toast and I drained mine. She filled it again. We sat across from each other. The room was so narrow our knees touched.

"They hate me because they can't understand why someone would choose to be a freak. It took me five years to get tattooed. You can't do it all at once. I had the best artists in the country tattoo me."

"Did it hurt?"

"That's the main part of it. Freaks have to hurt and I wanted mine real. Everyone can see that I'm a freak now. I finally suffered for real to get there."

I nodded, confused. A row of dolls stood on a shelf bracketed to the wall. She poured more drinks and settled into the chair. Her ankles were primly crossed, exposing only her toes. She wore no jewelry.

"I hate them because they're what I was in secret, before the tattoos. I was a freak too. You just couldn't tell. I was tired of hurting on the inside, like them. I hate my tattoos and I hate the men who pay to see them. Nobody knows about my inside. The rest of the

freaks are the opposite. They're normal inside but stuck in a freak's body. Not me."

"I don't know what you're talking about."

"That's why I'm telling you."

"What?"

"I can't have children."

I sipped my drink. I wanted a cigarette but didn't see an ashtray. I didn't know what to say.

"Yes," I said.

"That's the sweetest thing anyone's ever said to me."

"You could adopt."

"Shut up!" she said. "I've seen ads in the paper for adoption. 'Call collect,' they say. 'All expenses paid.' I won't buy a baby. You better go. Don't tell anyone anything. Let them believe we fucked like minks."

I stood and fell sideways on the couch. Moving slowly, I got to the door and turned to say goodbye. Her pale hands covered her face. She was crying.

"I love those dwarfs," she said. "They're my kids."

I opened the door and made it to the bottom step before falling. The difference in temperature was swift and hard as a roundhouse blow. Someone helped me stand. The dust on my skin turned to mud from my abrupt sweating. An aerialist walked me to a truck and lay me in the shade.

An hour later Kaybach kicked me awake, berating me for being late, though he'd heard the reason. I staggered after him. Con men and kinkers wiggled their eyebrows, winked and grinned. A female equestrian caressed me with her gaze as if I were the last wild mustang out of the Bighorns. I barely had time to wriggle into my costume before Kaybach began herding the suckers in.

Our tent had no ventilation and was ten degrees hotter than outside. The water in the pool had a skin on the surface. When I lay down on the fake rocks, the world began spinning. Closing my eyes made me twice as dizzy. From a great distance Kaybach called his cue and I realized that he had been yelling for some time. I slid into the nasty water.

I managed to get through the preliminary routines with Kaybach's patient repetition of cue. He threw a fish as reward, which

I dutifully tucked inside the mouth flap. Its body was swollen from heat. Mixed with fish stink was the heavy odor of gin oozing from my pores. I clenched my teeth to quell nausea. While Kaybach spieled about my intelligence, I shoved the dead fish back into the water. The smell clung to my chin and face. Water had seeped through the eye slits, encasing me in an amnion of scum. My head throbbed. As long as I didn't move, my belly remained under control.

Kaybach asked the yes-or-no questions. I squatted to make the walrus rear on his haunches, each movement an effort. The mask felt welded to my head. Kaybach threw a fish that bounced off my torso. The thought of retrieving it ruined me. My belly folded in on itself, and I knew that the spew would suffocate me. Kaybach was yelling. My face poured sweat.

I pulled my hands from the flipper compartments, worked my arms into position, and treated the crowd to the rare sight of a walrus decapitating itself. The mask splashed into the water. I retched a stream that arced from Louie's neck. Kaybach stepped into the pool and yelled for everyone to leave. People were screaming and demanding refunds.

I swam to the safety of my fake ice floe. Water had gushed into the oilskin suit, and briefly I feared drowning. I left the costume in the water, crawled to the edge of the tent, lifted the canvas and inhaled. The hundred-degree air tasted sweet and glorious. Sideshow tents were butted against the big top with a small space in between for stakes and ropes. I fled down the alley in my underwear. Peaches and Barney were gone from the truck. I rinsed my body in a tub of her drinking water and dressed in my extra clothes. The parking lot was a rolling field with beat-down grass. Locals worked it for a few bucks and a free pass. The third car picked me up. Twenty minutes later I stood in a town, the name of which I didn't know.

I oriented myself so the setting sun lay on my left, and began walking north. The Drinking Gourd emerged at dusk. Kentucky produced both Abe Lincoln and Jeff Davis. Like Kentuckians of the Civil War, I was loyal to no direction. I was neither kinker nor freak, yankee nor reb, boss nor bum. I wasn't much of a playwright either.

LEFT HANDED
(1868?—at least 1948)

Left Handed was a Navajo herder who, on his reservation, dictated two autobiographies to Yale anthropologist Walter Dyk. These are day-to-day accounts like no others: Left Handed apparently recalled every word of every conversation he ever had, and recalled where he found every sheep and horse that ever strayed. Dyk described him as humorous and tolerant.

Son of Old Man Hat *covers his childhood until his marriage, at twenty.* Left Handed *covers the three years of his unhappy marriage to an unnamed woman of the Red Clay clan. Walter and Ruth Dyk edited* Left Handed *(down to 571 pages), and Columbia University Press brought it out in 1980.*

Left Handed rarely comments or describes feelings. In this incident, however, which concludes Left Handed, *he is full of sorrow; sorrow was "everything that was in" him. He is about twenty-three years old. He has just left his wife, and determined never again to marry a woman of the Red Clay clan.*

■ ■ ■

from LEFT HANDED

They used to say when you leave a woman, when you leave your wife, you turn around when you get on top of the hill. That's what they used to say. All at once I thought about that; when I got on top, I thought maybe I'd look back. That's what they used to say, whenever you leave a wife, if you get on top of a hill, you always look back. So there I thought about that; I turned my horse around and looked back to where I left my wife. I could see her home. I could see the hogan, the hogan that they used for shade. I could see those two; it was quite a distance. I could see that far; at that time, I had good eyesight. I looked back, and I could see the outline and the brush hogan too. There were some people walking around it; I could see them walking around the hogan. Then I just turned my horse around and went over this hill. When I went over, I don't

know what I was thinking. Maybe I was thinking, but I don't know. I was out of my mind, I guess. Looked like I couldn't even hear or see anything. It seemed to me that I wasn't going anyplace. It seemed to me like I was staying still at one place. That's the way I was. It looked like I wasn't going anyplace; but I knew I was going because I could see the herd going, and I knew I was behind them.

All that day I didn't have anything with me, that is, food. I just had a little jug for water and a little bucket and some salt. That was all I had with me when I was going along with my herd. When I was on this big flat, I could see my horses all scattered around. Then I started to go after them. I thought I would take them with me too. I rounded them up, and started with my herd. The horses were going along with the herd. They were all mixed up with the herd, and I just went along with them. I think it was a little over thirty horses that I had rounded up. I had that many horses, and there were many sheep. There must have been over one thousand head. I went down toward the northwest in this big flat, going along with my herd and my horses, and around about that time, the sun was pretty near down. And I got to a place where it was good for my herd to be that night. We were on a big hill, and I got my sheep on top of this hill, and the horses too. They couldn't get down because there was a high peak way on top. There was only one way that they could get out, one space where they could get out. But I wanted to watch them, I wanted to be up all night to watch them. When I got all my herd and horses on top of this hill, I took the saddle off of my horse, hobbled him, and chased him into the bunch. It was around dark then. There I was sitting, where I had laid my saddle. I sat there, watching them. Anytime when they wanted to get out I chased them back. That's what I did all night. It was a long night. Every time the horses went to get out, I just grabbed up my old blanket, and shook it toward them and chased them back. That's the way I had been doing all night.

It was about morning, and all at once I went to sleep, and I don't know how long I slept. I heard the horses running, right under the rock. As soon as I heard them running I got up and started after them. I tried my best to turn them back but I couldn't. I worked hard, and ran back and forth, but they just were running as hard as they could. I couldn't turn them back at all. There was my horse that

I was using, hobbled right against me too. But I stopped one horse. Then I put the rope on it and bridle, and I put my saddle on it, and I got on my horse and started after the rest of the horses. They were way down below, as far as they could go. I tried my best to get them back but I couldn't; they were going as hard as they could go. My horse wasn't fast enough to get them back so I just let them go. I turned around, and I looked up to where the sheep were. They were coming down off of this hill. I rode up there and I got back up on this hill where my things were. I put my things back on the saddle again, and went after the sheep. I started out with my herd again, down toward a place called Dry Spring, looking back every once in a while to see my horses going, making dust. Down I went to this place, the place called Dry Spring. I was just thinking about the horses and cattle; the cattle were up on the mountain, and I let them go too, because they were way up on the mountain. I just went ahead with my herd. All at once I came upon a lake, and I started toward that lake. I just kept going to this lake. I didn't know whether I was thinking or not. Maybe I was moving around, maybe not. I didn't know. I just couldn't tell what I was doing. All I knew was I was after my herd; that was all I knew. So I just kept on riding after my herd, down to this lake. Soon I got there and the herd was so thirsty they sure made a noise when they saw this lake. Running down, trying to get drink, they were just going as hard as they could go so they could get water. I got down there; I rode around them, saw them drinking, and looked around.

There was a hogan close by. This hogan was a little ways from this lake; it was just a brush hogan, I guess. On this hogan was nothing but rags, all over, so that must have been a brush hogan, with some people living there. Then I thought to myself, "I'll go over there to see who the people are." I rode over there, thinking I might get something to eat. I was without anything, so I was really hungry. After the sheep had drunk they stopped there at the lake. They lay around there in the shadows; it was pretty hot. When they were still there, I rode up to this hogan. There was a woman; her clan was Bitter Water, but her father was the same clan as my father. Her name was The War Split.

As soon as she saw me, she said to me, "Where are you from, my son?" I was thinking about her, why she said that to me, but then she

said to me again, "Where are you coming from? I am glad to see you, my father." That's what she said to me again. Her father was my father's clan; that's why she said to me, "my father." At first she said, "my son," to me; but I was really her father. Then I said to her, "I . . . I don't know what I am doing; I don't know where I am going; but I am going off someplace. I had a wife and she did a wrong thing with me so I left her." Then she said to me, "Well, my father, I am so sorry about this. I know that sometimes you will be in bad luck. And that's what you're in now. And a lot of them, a lot of those people, say the same bad things. Because those people (Red Clay) are bad. They can do anything with you; that's what they've done with you now. I know those people, and everybody knows them too. Those people who live there can do anything they want to with a man. That's why any man who is married to those people doesn't stay there long, because they do things like that. Even those with husbands go around with other men. That's the way they are, that's the way those people are who live there and that's the way all of the Red Clay people are. They go after another man, for a husband to them." And she said, "I just don't know what to do about you. I am so sorry that you are all alone now, and that you're going off away some place. Maybe you know where you are going, but even at that, I am sorry for you, because you are all alone now, with all those hurts. I have nothing for you; I can't get a woman for you; I've got three girls living here, but they are real small, and they are good for nothing, because they are small." That's what she said to me.

So she had some milk there, left over; she put that on the fire for me, and she added a little, just a little piece of mutton, dry mutton. She put that over on the charcoal and roasted it for me. That was all she had, but I got enough, and there wasn't any coffee at that time. There was coffee around but it was so scarce it was hard to get it. The stores were way off, far away. So that was all I had there, milk and a piece of meat, that was all. That's the way she spoke to me. Then she said, "You are the only one that has got things to live on. No other man lives the way you live. I know they can't find a man like you again. Maybe they will try their best to find a man like you, but they can't get him, because just a few men are like you. I know you've got a lot of things to live on. And this woman you left, I know she can't get another man just like you. But it's all right, my father,

you can just go ahead with your sheep; I know you'll get another woman soon. That's the way I am thinking about you, my father."

Then I left that place. I went on with my herd, even though it was a really hot day. When I got to a place called Baby Rock, there was shade around the foot of these rocks, and the sheep were around these rocks where there was shade. I took the saddle off and hobbled my horse and went under the rock where there was shade and I lay there. I turned my horse loose there, hobbled and eating up the grass, and I was there in the shade lying down. I went to sleep, oh, quite a while, I guess. I don't know how long I slept. When I woke up it was getting cool. Then I got my horse back to where the saddle was. I saddled up the horse and got on him and started up with my herd again. Down I went with my herd, going lower and lower all the time, toward Where The Green Valley Enters. There was a point there, I was just going straight for that point, a little ways above Where The Green Valley Enters. I was just going ahead for that point.

When I got to this point, on top of this high hill, the sun was pretty well down. I saw two riders coming up to this lower point. I saw them going up there. They went up to the foot of the upper rock point. They got down off their horses and they hobbled them there; I saw them coming down. It was a woman and a boy. They just kept coming towards me, and I was just going ahead with my herd. Soon they got down and they got behind the herd and they stopped there; I went up to them. I knew this woman. She was one of the clan of Red Clay again, and I knew her very well. When the herd went down, I went after them with my horse, and I put my horse in front of her. She stopped there, and stood there. I grabbed a hold of her dress, and asked her, "Are you the two who hobbled the horse way up on the cliff?" and she said, "Yes." I asked them, "Where are you living?" and she said, "Way over there, across that wash, way over, some hogans across, above those hogans where there's a brush hogan, that's where we live." And I said to her, "I hold you for good, and I mean it. I grab hold of you for good." That's what I said to her. And she said to me, "What do you mean by that?" Then I said to her, "We stay right here tonight. Then tomorrow we go back to your home." She said, "No, no I won't, because I am afraid of your wife. I know you've got a wife." "No, I don't have a wife, none at all. I don't

know where she went to. She went and left for good," that's what I said to her. "You're a liar. I know you're lying to me. I bet you she's coming right after you now." Again, I said, "I don't have any wife, none at all." And she said to me, "No, you've got a wife. I know it because you've got a sheep pelt with you. That means you've got a wife." That's what she said to me. "You've got a wife, because I know you've got a sheep pelt there with you. And a man who has a sheep pelt with him, that means he's got a wife, so I know you've got a wife."

So I just started to play with her there for a while and I had a good time there laughing and playing with her. I didn't do anything to her, so she didn't become my wife at all. And the boy was there standing by us, looking at us. I wanted him to go ahead, I told him to go home, but he just stayed there, standing there looking at us. He didn't go. Maybe if the boy had left, if the boy had gone home, maybe I could have done something to her, maybe we would have had a lot of fun. But the boy didn't go. We were there for quite a while. It was just about getting dark then, and I was thinking about her, and her clan; she was Red Clay again. Then I thought to myself, "I'd better not bother her, because she is Red Clay. If I married her, she might do just the same thing again to me." That's the way I thought about her. So then I just let her go, and she went home. Then everything that was in me, in my head, and in me, was out. All the sorrow and the sadness disappeared from me. From there on, I had my mind back and everything was back to me. I was all right from then on. That was because I spoke to this woman and played with her a little. That's what made me kind of happy again. I had all my mind back, and she was the one who brought everything back to me, because I had played with her there for a while, laughing and talking with her. So she chased everything away from me. While we were playing, the sheep were right there close to us. They lay there on the ground, and it was dark. After they left, then I started out with my sheep again, and I found that I was in good shape. I knew things then; I just went along from there in a happy way. Before that, I almost choked-like, my breast filled with something. And when I played with this woman, I don't know how but all at once it disappeared. Everything that was in me was gone.

ANNE MOODY
(1940–)

*Anne Moody was twenty-seven when she wrote the plainspoken
memoir* Coming of Age in Mississippi *(1969).*

 *Working as a maid and waitressing, Moody had earned enough
money to add to a basketball scholarship and enter Natchez College in
Mississippi; she transferred to Tougaloo College. She joined the
NAACP, organized and raised funds for the Congress of Racial
Equality, and took part in a Student Nonviolent Coordinating
Committee voter-registration drive. Her mother, back in Centerville,
Mississippi, feared retribution. In 1963, Moody took part in a sit-in at
a Woolworth's lunch counter in Jackson, Mississippi, just before
Medgar Evers was killed there.*

 Moody also wrote Mr. Death *(1975), a collection of short stories.
The Reverend King in this account is Ed King, a white man, the
chaplain at Tougaloo.*

■ ■ ■

from COMING OF AGE IN MISSISSIPPI

In mid-September I was back on campus. But didn't very much
happen until February when the NAACP held its annual conven-
tion in Jackson. They were having a whole lot of interesting speak-
ers: Jackie Robinson, Floyd Patterson, Curt Flood, Margaretta
Belafonte, and many others. I wouldn't have missed it for anything.
I was so excited that I sent one of the leaflets home to Mama and
asked her to come.

 Three days later I got a letter from Mama with dried-up tears on
it, forbidding me to go to the convention. It went on for more than
six pages. She said if I didn't stop that shit she would come to
Tougaloo and kill me herself. She told me about the time I last vis-
ited her, on Thanksgiving, and she had picked me up at the bus sta-
tion. She said she picked me up because she was scared some white
in my hometown would try to do something to me. She said the
sheriff had been by, telling her I was messing around with that

NAACP group. She said he told her if I didn't stop it, I could not come back there any more. He said that they didn't need any of those NAACP people messing around in Centreville. She ended the letter by saying that she had burned the leaflet I sent her. "Please don't send any more of that stuff here. I don't want nothing to happen to us here," she said. "If you keep that up, you will never be able to come home again."

I was so damn mad after her letter, I felt like taking the NAACP convention to Centreville. I think I would have, if it had been in my power to do so. The remainder of the week I thought of nothing except going to the convention. I didn't know exactly what to do about it. I didn't want Mama or anyone at home to get hurt because of me.

I had felt something was wrong when I was home. During the four days I was there, Mama had tried to do everything she could to keep me in the house. When I said I was going to see some of my old classmates, she pretended she was sick and said I would have to cook. I knew she was acting strangely, but I hadn't known why. I thought Mama just wanted me to spend most of my time with her, since this was only the second time I had been home since I entered college as a freshman.

Things kept running through my mind after that letter from Mama. My mind was so active, I couldn't sleep at night. I remembered the one time I did leave the house to go to the post office. I had walked past a bunch of white men on the street on my way through town and one said, "Is that the gal goin' to Tougaloo?" He acted kind of mad or something, and I didn't know what was going on. I got a creepy feeling, so I hurried home. When I told Mama about it, she just said, "A lotta people don't like that school." I knew what she meant. Just before I went to Tougaloo, they had housed the Freedom Riders there. The school was being criticized by whites throughout the state.

The night before the convention started, I made up my mind to go, no matter what Mama said. I just wouldn't tell Mama or anyone from home. Then it occurred to me—how did the sheriff or anyone at home know I was working with the NAACP chapter on campus? Somehow they had found out. Now I knew I could never go to Centreville safely again. I kept telling myself that I didn't really care

too much about going home, that it was more important to me to go to the convention.

I was there from the very beginning. Jackie Robinson was asked to serve as moderator. This was the first time I had seen him in person. I remembered how when Jackie became the first Negro to play Major League baseball, my uncles and most of the Negro boys in my hometown started organizing baseball leagues. It did something for them to see a Negro out there playing with all those white players. Jackie was a good moderator, I thought. He kept smiling and joking. People felt relaxed and proud. They appreciated knowing and meeting people of their own race who had done something worth talking about.

When Jackie introduced Floyd Patterson, heavyweight champion of the world, the people applauded for a long, long time. Floyd was kind of shy. He didn't say very much. He didn't have to, just his being there was enough to satisfy most of the Negroes who had only seen him on TV. Archie Moore was there too. He wasn't as smooth as Jackie, but he had his way with a crowd. He started telling how he was run out of Mississippi, and the people just cracked up.

I was enjoying the convention so much that I went back for the night session. Before the night was over, I had gotten autographs from every one of the Negro celebrities.

I had counted on graduating in the spring of 1963, but as it turned out, I couldn't because some of my credits still had to be cleared with Natchez College. A year before, this would have seemed like a terrible disaster, but now I hardly even felt disappointed. I had a good excuse to stay on campus for the summer and work with the Movement, and this was what I really wanted to do. I couldn't go home again anyway, and I couldn't go to New Orleans—I didn't have money enough for bus fare.

During my senior year at Tougaloo, my family hadn't sent me one penny. I had only the small amount of money I had earned at Maple Hill. I couldn't afford to eat at school or live in the dorms, so I had gotten permission to move off campus. I had to prove that I could finish school, even if I had to go hungry every day. I knew Raymond and Miss Pearl were just waiting to see me drop out. But something happened to me as I got more and more involved in the

Movement. It no longer seemed important to prove anything. I had found something outside myself that gave meaning to my life.

I had become very friendly with my social science professor, John Salter, who was in charge of NAACP activities on campus. All during the year, while the NAACP conducted a boycott of the downtown stores in Jackson, I had been one of Salter's most faithful canvassers and church speakers. During the last week of school, he told me that sit-in demonstrations were about to start in Jackson and that he wanted me to be the spokesman for a team that would sit-in at Woolworth's lunch counter. The two other demonstrators would be classmates of mine, Memphis and Pearlena. Pearlena was a dedicated NAACP worker, but Memphis had not been very involved in the Movement on campus. It seemed that the organization had had a rough time finding students who were in a position to go to jail. I had nothing to lose one way or the other. Around ten o'clock the morning of the demonstrations, NAACP headquarters alerted the news services. As a result, the police department was also informed, but neither the policemen nor the newsmen knew exactly where or when the demonstrations would start. They stationed themselves along Capitol Street and waited.

To divert attention from the sit-in at Woolworth's, the picketing started at J. C. Penney's a good fifteen minutes before. The pickets were allowed to walk up and down in front of the store three or four times before they were arrested. At exactly 11 A.M., Pearlena, Memphis, and I entered Woolworth's from the rear entrance. We separated as soon as we stepped into the store, and made small purchases from various counters. Pearlena had given Memphis her watch. He was to let us know when it was 11:14. At 11:14 we were to join him near the lunch counter and at exactly 11:15 we were to take seats at it.

Seconds before 11:15 we were occupying three seats at the previously segregated Woolworth's lunch counter. In the beginning the waitresses seemed to ignore us, as if they really didn't know what was going on. Our waitress walked past us a couple of times before she noticed we had started to write our own orders down and realized we wanted service. She asked us what we wanted. We began to read to her from our order slips. She told us that we would be served at the back counter, which was for Negroes.

"We would like to be served here," I said.

The waitress started to repeat what she had said, then stopped in the middle of the sentence. She turned the lights out behind the counter, and she and the other waitresses almost ran to the back of the store, deserting all their white customers. I guess they thought that violence would start immediately after the whites at the counter realized what was going on. There were five or six other people at the counter. A couple of them just got up and walked away. A girl sitting next to me finished her banana split before leaving. A middle-aged white woman who had not yet been served rose from her seat and came over to us. "I'd like to stay here with you," she said, "but my husband is waiting."

The newsmen came in just as she was leaving. They must have discovered what was going on shortly after some of the people began to leave the store. One of the newsmen ran behind the woman who spoke to us and asked her to identify herself. She refused to give her name, but said she was a native of Vicksburg and a former resident of California. When asked why she had said what she had said to us, she replied, "I am in sympathy with the Negro movement." By this time a crowd of cameramen and reporters had gathered around us taking pictures and asking questions, such as Where were we from? Why did we sit-in? What organization sponsored it? Were we students? From what school? How were we classified?

I told them that we were all students at Tougaloo College, that we were represented by no particular organization, and that we planned to stay there even after the store closed. "All we want is service," was my reply to one of them. After they had finished probing for about twenty minutes, they were almost ready to leave.

At noon, students from a nearby white high school started pouring in to Woolworth's. When they first saw us they were sort of surprised. They didn't know how to react. A few started to heckle and the newsmen became interested again. Then the white students started chanting all kinds of anti-Negro slogans. We were called a little bit of everything. The rest of the seats except the three we were occupying had been roped off to prevent others from sitting down. A couple of the boys took one end of the rope and made it into a hangman's noose. Several attempts were made to put it around our necks. The crowds grew as more students and adults came in for lunch.

We kept our eyes straight forward and did not look at the crowd except for occasional glances to see what was going on. All of a sudden I saw a face I remembered—the drunkard from the bus station sit-in. My eyes lingered on him just long enough for us to recognize each other. Today he was drunk too, so I don't think he remembered where he had seen me before. He took out a knife, opened it, put it in his pocket, and then began to pace the floor. At this point, I told Memphis and Pearlena what was going on. Memphis suggested that we pray. We bowed our heads, and all hell broke loose. A man rushed forward, threw Memphis from his seat, and slapped my face. Then another man who worked in the store threw me against an adjoining counter.

Down on my knees on the floor, I saw Memphis lying near the lunch counter with blood running out of the corners of his mouth. As he tried to protect his face, the man who'd thrown him down kept kicking him against the head. If he had worn hard-soled shoes instead of sneakers, the first kick probably would have killed Memphis. Finally a man dressed in plain clothes identified himself as a police officer and arrested Memphis and his attacker.

Pearlena had been thrown to the floor. She and I got back on our stools after Memphis was arrested. There were some white Tougaloo teachers in the crowd. They asked Pearlena and me if we wanted to leave. They said that things were getting too rough. We didn't know what to do. While we were trying to make up our minds, we were joined by Joan Trumpauer. Now there were three of us and we were integrated. The crowd began to chant, "Communists, Communists, Communists." Some old man in the crowd ordered the students to take us off the stools.

"Which one should I get first?" a big husky boy said.

"That white nigger," the old man said.

The boy lifted Joan from the counter by her waist and carried her out of the store. Simultaneously, I was snatched from my stool by two high school students. I was dragged about thirty feet toward the door by my hair when someone made them turn me loose. As I was getting up off the floor, I saw Joan coming back inside. We started back to the center of the counter to join Pearlena. Lois Chaffee, a white Tougaloo faculty member, was now sitting next to her. So Joan and I just climbed across the rope at the front end of

the counter and sat down. There were now four of us, two whites and two Negroes, all women. The mob started smearing us with ketchup, mustard, sugar, pies, and everything on the counter. Soon Joan and I were joined by John Salter, but the moment he sat down he was hit on the jaw with what appeared to be brass knuckles. Blood gushed from his face and someone threw salt into the open wound. Ed King, Tougaloo's chaplain, rushed to him.

At the other end of the counter, Lois and Pearlena were joined by George Raymond, a CORE field worker and a student from Jackson State College. Then a Negro high school boy sat down next to me. The mob took spray paint from the counter and sprayed it on the new demonstrators. The high school student had on a white shirt; the word "nigger" was written on his back with red spray paint.

We sat there for three hours taking a beating when the manager decided to close the store because the mob had begun to go wild with stuff from other counters. He begged and begged everyone to leave. But even after fifteen minutes of begging, no one budged. They would not leave until we did. Then Dr. Beittel, the president of Tougaloo College, came running in. He said he had just heard what was happening.

About ninety policemen were standing outside the store; they had been watching the whole thing through the windows, but had not come in to stop the mob or do anything. President Beittel went outside and asked Captain Ray to come and escort us out. The captain refused, stating the manager had to invite him in before he could enter the premises, so Dr. Beittel himself brought us out. He had told the police that they had better protect us after we were outside the store. When we got outside, the policemen formed a single line that blocked the mob from us. However, they were allowed to throw at us everything they had collected. Within ten minutes, we were picked up by Reverend King in his station wagon and taken to the NAACP headquarters on Lynch Street.

After the sit-in, all I could think of was how sick Mississippi whites were. They believed so much in the segregated Southern way of life, they would kill to preserve it. I sat there in the NAACP office and thought of how many times they had killed when this way of life was threatened. I knew that the killing had just begun. "Many

more will die before it is over with," I thought. Before the sit-in, I had always hated the whites in Mississippi. Now I knew it was impossible for me to hate sickness. The whites had a disease, an incurable disease in its final stage. What were our chances against such a disease? I thought of the students, the young Negroes who had just begun to protest, as young interns. When these young interns got older, I thought, they would be the best doctors in the world for social problems.

Before we were taken back to campus, I wanted to get my hair washed. It was stiff with dried mustard, ketchup and sugar. I stopped in at a beauty shop across the street from the NAACP office. I didn't have on any shoes because I had lost them when I was dragged across the floor at Woolworth's. My stockings were sticking to my legs from the mustard that had dried on them. The hairdresser took one look at me and said, "My land, you were in the sit-in, huh?"

"Yes," I answered. "Do you have time to wash my hair and style it?"

"Right away," she said, and she meant right away. There were three other ladies already waiting, but they seemed glad to let me go ahead of them. The hairdresser was real nice. She even took my stockings off and washed my legs while my hair was drying.

There was a mass rally that night at the Pearl Street Church in Jackson, and the place was packed. People were standing two abreast in the aisles. Before the speakers began, all the sit-inners walked out on the stage and were introduced by Medgar Evers. People stood and applauded for what seemed like thirty minutes or more. Medgar told the audience that this was just the beginning of such demonstrations. He asked them to pledge themselves to unite in a massive offensive against segregation in Jackson, and throughout the state. The rally ended with "We Shall Overcome" and sent home hundreds of determined people. It seemed as though Mississippi Negroes were about to get together at last.

Before I demonstrated, I had written Mama. She wrote me back a letter, begging me not to take part in the sit-in. She even sent ten dollars for bus fare to New Orleans. I didn't have one penny, so I kept the money. Mama's letter made me mad. I had to live my life as I saw fit. I had made that decision when I left home. But it hurt to have my family prove to me how scared they were. It hurt me more than any-

thing else—I knew the whites had already started the threats and intimidations. I was the first Negro from my hometown who had openly demonstrated, worked with the NAACP, or anything. When Negroes threatened to do anything in Centreville, they were either shot like Samuel O'Quinn or run out of town, like Reverend Dupree.

I didn't answer Mama's letter. Even if I had written one, she wouldn't have received it before she saw the news on TV or heard it on the radio. I waited to hear from her again. And I waited to hear in the news that someone in Centreville had been murdered. If so, I knew it would be a member of my family.

On Wednesday, the day after the sit-in, demonstrations got off to a good start. Ten people picketed shortly after noon on Capitol Street, and were arrested. Another mass rally followed the demonstrations that night, where a six-man delegation of Negro ministers was chosen to meet Mayor Thompson the following Tuesday. They were to present to him a number of demands on behalf of Jackson Negroes. They were as follows:

1. Hiring of Negro policemen and school crossing guards
2. Removal of segregation signs from public facilities
3. Improvement of job opportunities for Negroes on city payrolls—Negro drivers of city garbage trucks, etc.
4. Encouraging public eating establishments to serve both whites and Negroes
5. Integration of public parks and libraries
6. The naming of a Negro to the City Parks and Recreation Committee
7. Integration of public schools
8. Forcing service stations to integrate rest rooms

After this meeting, Reverend Haughton, the minister of Pearl Street Church, said that the Mayor was going to act on all the suggestions. But the following day, Thompson denied that he had made any promises. He said the Negro delegation "got carried away" following their discussion with him.

"It seems as though Mayor Thompson wants to play games with us," Reverend Haughton said at the next rally. "He is calling us liars

and trying to make us sound like fools. I guess we have to show him that we mean business."

When Reverend Charles A. Jones, dean and chaplain at Campbell College, asked at the close of the meeting, "Where do we go from here?" the audience shouted, "To the streets." They were going to prove to Mayor Thompson and the white people of Jackson that they meant business.

Around ten the next morning, an entire day of demonstrations started. A little bit of everything was tried. Some Negroes sat-in, some picketed, and some squatted in the streets and refused to move.

All of the five-and-ten stores (H. L. Green, Kress, and Woolworth) had closed their lunch counters as a result of the Woolworth sit-in. However, this did not stop the new sit-ins. Chain restaurants such as Primos Restaurant in downtown Jackson were now targets. Since police brutality was the last thing wanted in good, respectable Jackson, Mississippi, whenever arrested demonstrators refused to walk to a paddy wagon, garbage truck, or whatever was being used to take people to jail, Negro trusties from Jackson's city jail carted them away. Captain Ray and his men would just stand back with their hands folded, looking innocent as lambs for the benefit of the Northern reporters and photographers.

The Mayor still didn't seem to be impressed with the continuous small demonstrations and kept the streets hot. After eighty-eight demonstrators had been arrested, the Mayor held a news conference where he told a group of reporters, "We can handle 100,000 agitators." He also stated that the "good colored citizens are not rallying to the support of the outside agitators" (although there were only a few out-of-state people involved in the movement at the time) and offered to give Northern newsmen anything they wanted, including transportation, if they would "adequately" report the facts.

During the demonstrations, I helped conduct several workshops, where potential demonstrators, high school and college students mostly, were taught to protect themselves. If, for instance, you wanted to protect the neck to offset a karate blow, you clasped your hands behind the neck. To protect the genital organs you doubled up in a knot, drawing the knees up to the chest to protect your breasts if you were a girl.

The workshops were handled mostly by SNCC and CORE field secretaries and workers, almost all of whom were very young. The NAACP handled all the bail and legal services and public relations, but SNCC and CORE could draw teen-agers into the Movement as no other organization could. Whether they received credit for it or not, they helped make Jackson the center of attention throughout the nation.

During this period, civil rights workers who had become known to the Jackson police were often used to divert the cops' attention just before a demonstration. A few cops were always placed across the street from NAACP headquarters, since most of the demonstrations were organized there and would leave from that building. The "diverters" would get into cars and lead the cops off on a wild-goose chase. This would allow the real demonstrators to get downtown before they were noticed. One evening, a group of us took the cops for a tour of the park. After giving the demonstrators time enough to get to Capitol Street, we decided to go and watch the action. When we arrived there ourselves, we met Reverend King and a group of ministers. They told us they were going to stage a pray-in on the post office steps. "Come on, join us," Reverend King said. "I don't think we'll be arrested, because it's federal property."

By the time we got to the post office, the newsmen had already been informed, and a group of them were standing in front of the building blocking the front entrance. By now the group of whites that usually constituted the mob had gotten smart. They no longer looked for us, or for the demonstration. They just followed the newsmen and photographers. They were much smarter than the cops, who hadn't caught on yet.

We entered the post office through the side entrance and found that part of the mob was waiting inside the building. We didn't let this bother us. As soon as a few more ministers joined us, we were ready to go outside. There were fourteen of us, seven whites and seven Negroes. We walked out front and stood and bowed our heads as the ministers began to pray. We were immediately interrupted by the appearance of Captain Ray. "We are asking you people to disperse. If you don't, you are under arrest," he said.

Most of us were not prepared to go to jail. Doris Erskine, a student from Jackson State, and I had to take over a workshop the fol-

lowing day. Some of the ministers were in charge of the mass rally that night. But if we had dispersed, we would have been torn to bits by the mob. The whites standing out there had murder in their eyes. They were ready to do us in and all fourteen of us knew that. We had no other choice but to be arrested.

We had no plan of action. Reverend King and some of the ministers who were kneeling refused to move; they just kept on praying. Some of the others also attempted to kneel. The rest of us just walked to the paddy wagon. Captain Ray was using the Negro trusties. I felt so sorry for them. They were too small to be carrying all these heavy-ass demonstrators. I could tell just by looking at them that they didn't want to, either. I knew they were forced to do this.

After we got to jail we were mugged and fingerprinted, then taken to a cell. Most of the ministers were scared stiff. This was the first time some of them had seen the inside of a jail. Before we were mugged, we were all placed in a room together and allowed to make one call. Reverend King made the call to the NAACP headquarters to see if some of the ministers could be bailed out right away. I was so glad when they told him they didn't have money available at the moment. I just got my kicks out of sitting there looking at the ministers. Some of them looked so pitiful, I thought they would cry any minute, and here they were, supposed to be our leaders.

When Doris and I got to the cell where we would spend the next four days, we found a lot of our friends there. There were twelve girls altogether. The jail was segregated. I felt sorry for Jeanette King, Lois Chaffee, and Joan Trumpauer. Just because they were white they were missing out on all the fun we planned to have. Here we were going to school together, sleeping in the same dorm, worshipping together, playing together, even demonstrating together. It all ended in jail. They were rushed off by themselves to some cell designated for whites.

Our cell didn't even have a curtain over the shower. Every time the cops heard the water running, they came running to peep. After the first time, we fixed them. We took chewing gum and toilet tissue and covered the opening in the door. They were afraid to take it down. I guess they thought it might have come out in the newspaper. Their wives wouldn't have liked that at all. Peep through a hole to see

a bunch of nigger girls naked? No! No! They certainly wouldn't have liked that. All of the girls in my cell were college students. We had a lot to talk about, so we didn't get too bored. We made cards out of toilet tissue and played Gin Rummy almost all day. Some of us even learned new dance steps from each other.

There were a couple of girls in with us from Jackson State College. They were scared they would be expelled from school. Jackson State, like most of the state-supported Negro schools, was an Uncle Tom school. The students could be expelled for almost anything. When I found this out, I really appreciated Tougaloo.

The day we were arrested one of the Negro trusties sneaked us a newspaper. We discovered that over four hundred high school students had also been arrested. We were so glad we sang freedom songs for an hour or so. The jailer threatened to put us in solitary if we didn't stop. At first we didn't think he meant it, so we kept singing. He came back with two other cops and asked us to follow them. They marched us down the hall and showed us one of the solitary chambers. "If you don't stop that damn singing, I'm gonna throw all of you in here together," said the jailer. After that we didn't sing any more. We went back and finished reading the paper.

We got out of jail on Sunday to discover that everyone was talking about the high school students. All four hundred who were arrested had been taken to the fairgrounds and placed in a large open compound without beds or anything. It was said that they were getting sick like flies. Mothers were begging to have their children released, but the NAACP didn't have enough money to bail them all out.

The same day we went to jail for the pray-in, the students at Lanier High School had started singing freedom songs on their lunch hour. They got so carried away they ignored the bell when the break was over and just kept on singing. The principal of the high school did not know what to do, so he called the police and told them that the students were about to start a riot.

When the cops came, they brought the dogs. The students refused to go back to their classrooms when asked, so the cops turned the dogs loose on them. The students fought them off for a while. In fact, I was told that mothers who lived near the school had

joined the students in fighting off the dogs. They had begun to throw bricks, rocks, and bottles. The next day the papers stated that ten or more cops suffered cuts or minor wounds. The papers didn't say it, but a lot of students were hurt, too, from dog bites and lumps on the head from billy clubs. Finally, one hundred and fifty cops were rushed to the scene and several students and adults were arrested.

The next day four hundred of the high school students from Lanier, Jim Hill, and Brinkley High schools gathered in a church on Farish Street, ready to go to jail. Willie Ludden, the NAACP youth leader, and some of the SNCC and CORE workers met with them, gave a brief workshop on nonviolent protective measures and led them into the streets. After marching about two blocks they were met by helmeted police officers and ordered to disperse. When they refused, they were arrested, herded into paddy wagons, canvas-covered trucks, and garbage trucks. Those moving too slowly were jabbed with rifle butts. Police dogs were there, but were not used. From the way everyone was describing the scene it sounded like Nazi Germany instead of Jackson, USA.

On Monday, I joined a group of high school students and several other college students who were trying to get arrested. Our intention was to be put in the fairgrounds with the high school students already there. The cops picked us up, but they didn't want to put us so-called professional agitators in with the high school students. We were weeded out, and taken back to the city jail.

I got out of jail two days later and found I had gotten another letter from Mama. She had written it Wednesday the twenty-ninth, after the Woolworth sit-in. The reason it had taken so long for me to get it was that it came by way of New Orleans. Mama sent it to Adline and had Adline mail it to me. In the letter she told me that the sheriff had stopped by and asked all kinds of questions about me the morning after the sit-in. She said she and Raymond told them that I had only been home once since I was in college, that I had practically cut off all my family connections when I ran away from home as a senior in high school. She said he said that he knew I had left home. "He should know," I thought, "because I had to get him to move my clothes for me when I left." She went on and on. She told me he said I must never come back there. If so he would

not be responsible for what happened to me. "The whites are pretty upset about her doing these things," he told her. Mama told me not to write her again until she sent me word that it was O.K. She said that I would hear from her through Adline.

I also got a letter from Adline in the same envelope. She told me what Mama hadn't mentioned—that Junior had been cornered by a group of white boys and was about to be lynched, when one of his friends came along in a car and rescued him. Besides that, a group of white men had gone out and beaten up my old Uncle Buck. Adline said Mama told her they couldn't sleep, for fear of night riders. They were all scared to death. My sister ended the letter by cursing me out. She said I was trying to get every Negro in Centreville murdered.

I guess Mama didn't tell me these things because she was scared to. She probably thought I would have tried to do something crazy. Something like trying to get the organizations to move into Wilkinson County, or maybe coming home myself to see if they would kill me. She never did give me credit for having the least bit of sense. I knew there was nothing I could do. No organization was about to go to Wilkinson County. It was a little too tough for any of them. And I wasn't about to go there either. If they said they would kill me, I figured I'd better take their word for it.

Meantime, within four or five days Jackson became the hotbed of racial demonstrations in the South. It seemed as though most of the Negro college and high school students there were making preparations to participate. Those who did not go to jail were considered cowards by those who did. At this point, Mayor Allen Thompson finally made a decisive move. He announced that Jackson had made plans to house over 12,500 demonstrators at the local jails and at the state fairgrounds. And if this was not enough, he said, Parchman, the state penitentiary, 160 miles away, would be used. Governor Ross Barnett had held a news conference offering Parchman facilities to Jackson.

An injunction prohibiting demonstrations was issued by a local judge, naming NAACP, CORE, Tougaloo College, and various leaders. According to this injunction, the intent of the named organizations and individuals was to paralyze the economic nerve center of the city of Jackson. It used as proof the leaflets that had been dis-

tributed by the NAACP urging Negroes not to shop on Capitol Street. The next day the injunction was answered with another mass march.

The cops started arresting every Negro on the scene of a demonstration, whether or not he was participating. People were being carted off to jail every day of the week. On Saturday, Roy Wilkins, the National Director of NAACP, and Medgar Evers were arrested as they picketed in front of Woolworth's. Theldon Henderson, a Negro lawyer who worked for the Justice Department, and had been sent down from Washington to investigate a complaint by the NAACP about the fairgrounds facilities, was also arrested. It was said that when he showed his Justice Department credentials, the arresting officer started trembling. They let him go immediately.

Mass rallies had come to be an every night event, and at each one the NAACP had begun to build up Medgar Evers. Somehow I had the feeling that they wanted him to become for Mississippi what Martin Luther King had been in Alabama. They were well on the way to achieving that, too.

After the rally on Tuesday, June 11, I had to stay in Jackson. I had missed the ride back to campus. Dave Dennis, the CORE field secretary for Mississippi, and his wife put me up for the night. We were watching TV around twelve-thirty, when a special news bulletin interrupted the program. It said, "Jackson NAACP leader Medgar Evers has just been shot."

We didn't believe what we were hearing. We just sat there staring at the TV screen. It was unbelievable. Just an hour or so earlier we were all with him. The next bulletin announced that he had died in the hospital soon after the shooting. We didn't know what to say or do. All night we tried to figure out what had happened, who did it, who was next, and it still didn't seem real.

First thing the next morning we turned on the TV. It showed films taken shortly after Medgar was shot in his driveway. We saw the pool of blood where he had fallen. We saw his wife sobbing almost hysterically as she tried to tell what had happened. Without even having breakfast, we headed for the NAACP headquarters. When we got there, they were trying to organize a march to protest Medgar's death. Newsmen, investigators, and reporters flooded the

office. College and high school students and a few adults sat in the auditorium waiting to march.

Dorie Ladner, a SNCC worker, and I decided to run up to Jackson State College and get some of the students there to participate in the march. I was sure we could convince some of them to protest Medgar's death. Since the march was to start shortly after lunch, we had a couple of hours to do some recruiting. When we got to Jackson State, class was in session. "That's a damn shame," I thought. "They should have dismissed school today, in honor of Medgar."

Dorie and I started going down each hall, taking opposite classrooms. We begged students to participate. They didn't respond in any way.

"It's a shame, it really is a shame. This morning Medgar Evers was murdered and here you sit in a damn classroom with books in front of your faces, pretending you don't even know he's been killed. Every Negro in Jackson should be in the streets raising hell and protesting his death," I said in one class. I felt sick, I got so mad with them. How could Negroes be so pitiful? How could they just sit by and take all this shit without any emotions at all? I just didn't understand.

"It's hopeless, Moody, let's go," Dorie said.

As we were leaving the building, we began soliciting aloud in the hall. We walked right past the president's office, shouting even louder. President Reddix came rushing out. "You girls leave this campus immediately," he said, "You can't come on this campus and announce anything without my consent."

Dorie had been a student at Jackson State. Mr. Reddix looked at her. "You know better than this, Dorie," he said.

"But President Reddix, Medgar was just murdered. Don't you have any feelings about his death at all?" Dorie said.

"I am doing a job. I can't do this job and have feelings about everything happening in Jackson," he said. He was waving his arms and pointing his finger in our faces. "Now you two get off this campus before I have you arrested."

By this time a group of students had gathered in the hall. Dorie had fallen to her knees in disgust as Reddix was pointing at her, and some of the students thought he had hit her. I didn't say anything to him. If I had I would have been calling him every kind of fucking

Tom I could think of. I helped Dorie off the floor. I told her we'd better hurry, or we would miss the demonstration.

On our way back to the auditorium we picked up the Jackson *Daily News*. Headlines read JACKSON INTEGRATION LEADER EVERS SLAIN.

> Negro NAACP leader Medgar Evers was shot to death when he stepped from his automobile here early today as he returned home from an integration strategy meeting.
>
> Police said Evers, 37, was cut down by a high-powered bullet in the back of the driveway of his home.

I stopped reading. Medgar was usually followed home every night by two or three cops. Why didn't they follow him last night? Something was wrong. "They must have known," I thought. "Why didn't they follow him last night?" I kept asking myself. I had to get out of all this confusion. The only way I could do it was to go to jail. Jail was the only place I could think in.

When we got back to the auditorium, we were told that those who would take part in the first march had met at Pearl Street Church. Dorie and I walked over there. We noticed a couple of girls from Jackson State. They asked Dorie if President Reddix had hit her, and said it had gotten out on campus that he had. They told us a lot of students had planned to demonstrate because of what Reddix had done. "Good enough," Dorie said, "Reddix better watch himself, or we'll turn that school out."

I was called to the front of the church to help lead the marchers in a few freedom songs. We sang "Woke Up This Morning With My Mind on Freedom" and "Ain't Gonna Let Nobody Turn Me 'Round." After singing the last song we headed for the streets in a double line, carrying small American flags in our hands. The cops had heard that there were going to be Negroes in the streets all day protesting Medgar's death. They were ready for us.

On Rose Street we ran into a blockade of about two hundred policemen. We were called to a halt by Captain Ray, and asked to disperse. "Everybody ain't got a permit get out of this here parade," Captain Ray said into his bull horn. No one moved. He beckoned to the cops to advance on us.

The cops had rifles and wore steel helmets. They walked right up to us very fast and then sort of engulfed us. They started snatching the small American flags, throwing them to the ground, stepping on them, or stamping them. Students who refused to let go of the flags were jabbed with rifle butts. There was only one paddy wagon on the scene. The first twenty of us were thrown into it, although a paddy wagon is only large enough to seat about ten people. We were sitting and lying all over each other inside the wagon when garbage trucks arrived. We saw the cops stuff about fifty demonstrators in one truck as we looked out through the back glass. Then the driver of the paddy wagon sped away as fast as he could, often making sudden stops in the middle of the street so we would be thrown around.

We thought that they were going to take us to the city jail again because we were college students. We discovered we were headed for the fairgrounds. When we got there, the driver rolled up the windows, turned the heater on, got out, closed the door and left us. It was over a hundred degrees outside that day. There was no air coming in. Sweat began dripping off us. An hour went by. Our clothes were now soaked and sticking to us. Some of the girls looked as though they were about to faint. A policeman looked in to see how we were taking it. Some of the boys begged him to let us out. He only smiled and walked away.

Looking out of the back window again, we noticed they were now booking all the other demonstrators. We realized they had planned to do this to our group. A number of us in the paddy wagon were known to the cops. After the Woolworth sit-in, I had been known to every white in Jackson. I can remember walking down the street and being pointed out by whites as they drove or walked past me.

Suddenly one of the girls screamed. Scrambling to the window, we saw John Salter with blood gushing out of a large hole in the back of his head. He was just standing there dazed and no one was helping him. And we were in no position to help either.

After they let everyone else out of the garbage trucks, they decided to let us out of the paddy wagon. We had now been in there well over two hours. As we were getting out, one of the girls almost fell. A guy started to help her.

"Get ya hands off that gal. Whatta ya think, ya goin' to a prom or somethin'?" one of the cops said.

Water was running down my legs. My skin was soft and spongy. I had hidden a small transistor radio in my bra and some of the other girls had cards and other things in theirs. We had learned to sneak them in after we discovered they didn't search the women but now everything was showing through our wet clothes.

When we got into the compound, there were still some high school students there, since the NAACP bail money had been exhausted. There were altogether well over a hundred and fifty in the girls' section. The boys had been put into a compound directly opposite and parallel to us. Some of the girls who had been arrested after us shared their clothes with us until ours dried. They told us what had happened after we were taken off in the paddy wagon. They said the cops had stuffed so many into the garbage trucks that some were just hanging on. As one of the trucks pulled off, thirteen-year-old John Young fell out. When the driver stopped, the truck rolled back over the boy. He was rushed off to a hospital and they didn't know how badly he had been hurt. They said the cops had gone wild with their billy sticks. They had even arrested Negroes looking on from their porches. John Salter had been forced off some Negro's porch and hit on the head.

The fairgrounds were everything I had heard they were. The compounds they put us in were two large buildings used to auction off cattle during the annual state fair. They were about a block long, with large openings about twenty feet wide on both ends where the cattle were driven in. The openings had been closed up with wire. It reminded me of a concentration camp. It was hot and sticky and girls were walking around half dressed all the time. We were guarded by four policemen. They had rifles and kept an eye on us through the wired sides of the building. As I looked through the wire at them, I imagined myself in Nazi Germany, the policemen Nazi soldiers. They couldn't have been any rougher than these cops. Yet this was America, "the land of the free and the home of the brave."

About five-thirty we were told that dinner was ready. We were lined up single file and marched out of the compound. They had the cook from the city jail there. He was standing over a large garbage can stirring something in it with a stick. The sight of it nau-

seated me. No one was eating, girls or boys. In the next few days, many were taken from the fairgrounds sick from hunger.

When I got out of jail on Saturday, the day before Medgar's funeral, I had lost about fifteen pounds. They had prepared a special meal on campus for the Tougaloo students, but attempts to eat made me sicker. The food kept coming up. The next morning I pulled myself together enough to make the funeral services at the Masonic Temple. I was glad I had gone in spite of my illness. This was the first time I had ever seen so many Negroes together. There were thousands and thousands of them there. Maybe Medgar's death had really brought them to the Movement, I thought. Maybe his death would strengthen the ties between Negroes and Negro organizations. If this resulted, then truly his death was not in vain.

Just before the funeral services were over, I went outside. There was a hill opposite the Masonic Temple. I went up there to watch the procession. I wanted to see every moment of it.

As the pallbearers brought the body out and placed it in a hearse, the tension in the city was as tight as a violin string. There were two or three thousand outside that could not get inside the temple, and as they watched, their expression was that of anger, bitterness, and dismay. They looked as though any moment they were going to start rioting. When Mrs. Evers and her two older children got into their black limousine, Negro women in the crowd began to cry and say things like "That's a shame," . . . "That's a young woman," . . . "Such well-looking children," . . . "It's a shame, it really is a shame."

Negroes formed a seemingly endless line as they began the march to the funeral home. They got angrier and angrier; however, they went on quietly until they reached the downtown section where the boycott was. They tried to break through the barricades on Capitol Street, but the cops forced them back into line. When they reached the funeral home, the body was taken inside, and most of the procession dispersed. But one hard core of angry Negroes decided they didn't want to go home. With some encouragement from SNCC workers who were singing freedom songs outside the funeral home, these people began walking back toward Capitol Street.

Policemen had been placed along the route of the march, and

they were still there. They allowed the crowd of Negroes to march seven blocks, but they formed a solid blockade just short of Capitol Street. This was where they made everyone stop. They had everything—shotguns, fire trucks, gas masks, dogs, fire hoses, and billy clubs. Along the sidewalks and on the fringes of the crowd, the cops knocked heads, set dogs on some marchers, and made about thirty arrests, but the main body of people in the middle of the street was just stopped.

They sang and shouted things like "Shoot, shoot" to the police, and then the police started to push them back slowly. After being pushed back about a block, they stopped. They wouldn't go any farther. So the cops brought the fire trucks up closer and got ready to use the fire hoses on the crowd. That really broke up the demonstration. People moved back faster and started to go home. But it also made them angrier. Bystanders began throwing stones and bottles at the cops and then the crowd started too; other Negroes were pitching stuff from second- and third-story windows. The crowd drew back another block, leaving the space between them and the fire trucks littered with rocks and broken glass. John Doar came out from behind the police barricade and walked toward the crowd of Negroes, with bottles flying all around him. He talked to some of the people at the front, telling them he was from the Justice Department and that this wasn't "the way." After he talked for a few minutes, things calmed down considerably, and Dave Dennis and a few others began taking bottles away from people and telling them they should go home. After that it was just a clean-up operation. One of the ministers borrowed Captain Ray's bull horn and ran up and down the street telling people to disperse, but by that time there were just a few stragglers.

After Medgar's death there was a period of confusion. Each Negro leader and organization in Jackson received threats. They were all told they were "next on the list." Things began to fall apart. The ministers, in particular, didn't want to be "next"; a number of them took that long-promised vacation to Africa or elsewhere. Meanwhile SNCC and CORE became more militant and began to press for more demonstrations. A lot of the young Negroes wanted to let the whites of Jackson know that even by killing off Medgar they hadn't

touched the real core of the Movement. For the NAACP and the older, more conservative groups, however, voter registration had now become number one on the agenda. After the NAACP exerted its influence at a number of strategy meetings, the militants lost.

The Jackson *Daily News* seized the opportunity to cause more fragmentation. One day they ran a headline THERE IS A SPLIT IN THE ORGANIZATIONS, and sure enough, shortly afterward, certain organizations had completely severed their relations with each other. The whites had succeeded again. They had reached us through the papers by letting us know we were not together. "Too bad," I thought. "One day we'll learn. It's pretty tough, though, when you have everything against you, including the money, the newspapers, and the cops."

Within a week everything had changed. Even the rallies were not the same. The few ministers and leaders who did come were so scared—they thought assassins were going to follow them home. Soon there were rallies only twice a week instead of every night.

The Sunday following Medgar's funeral, Reverend Ed King organized an integrated church-visiting team of six of us from the college. Another team was organized by a group in Jackson. Five or six churches were hit that day, including Governor Ross Barnett's. At each one they had prepared for our visit with armed policemen, paddy wagons, and dogs—which would be used in case we refused to leave after "ushers" had read us the prepared resolutions. There were about eight of these ushers at each church, and they were never exactly the usherly type. They were more on the order of Al Capone. I think this must have been the first time any of these men had worn a flower in his lapel. When we were asked to leave, we did. We were never even allowed to get past the first step.

A group of us decided that we would go to church again the next Sunday. This time we were quite successful. These visits had not been publicized as the first ones were, and they were not really expecting us. We went first to a Church of Christ, where we were greeted by the regular ushers. After reading us the same resolution we had heard last week, they offered to give us cab fare to the Negro extension of the church. Just as we had refused and were walking away, an old lady stopped us. "We'll sit with you," she said.

We walked back to the ushers with her and her family. "Please let them in, Mr. Calloway. We'll sit with them," the old lady said.

"Mrs. Dixon, the church has decided what is to be done. A resolution has been passed, and we are to abide by it."

"Who are we to decide such a thing? This is a house of God, and God is to make all of the decisions. He is the judge of us all," the lady said.

The ushers got angrier then and threatened to call the police if we didn't leave. We decided to go.

"We appreciate very much what you've done," I said to the old lady.

As we walked away from the church, we noticed the family leaving by a side entrance. The old lady was waving to us.

Two blocks from the church, we were picked up by Ed King's wife, Jeanette. She drove us to an Episcopal church. She had previously left the other two girls from our team there. She circled the block a couple of times, but we didn't see them anywhere. I suggested that we try the church. "Maybe they got in," I said. Mrs. King waited in the car for us. We walked up to the front of the church. There were no ushers to be seen. Apparently, services had already started. When we walked inside, we were greeted by two ushers who stood at the rear.

"May we help you?" one said.

"Yes," I said. "We would like to worship with you today."

"Will you sign the guest list, please, and we will show you to your seats," said the other.

I stood there for a good five minutes before I was able to compose myself. I had never prayed with white people in a white church before. We signed the guest list and were then escorted to two seats behind the other two girls in our team. We had all gotten in. The church service was completed without one incident. It was as normal as any church service. However, it was by no means normal to me. I was sitting there thinking any moment God would strike the life out of me. I recognized some of the whites, sitting around me in that church. If they were praying to the same God I was, then even God, I thought, was against me.

When the services were over the minister invited us to visit again. He said it as if he meant it, and I began to have a little hope.

JAMES McCONKEY
(1921–)

James McConkey's Court of Memory *trilogy consists of three books:* Crossroads *(1968),* The Stranger at the Crossroads *(published in 1983 with* Crossroads *as* Court of Memory*), and* Stories from My Life with the Other Animals *(1993). Many of the full-formed segments of this understated memoir appeared in* The New Yorker *between 1962 and 1982.*

McConkey has written ten books. His novel The Treehouse Confessions *won an American Academy and Institute of Arts and Letters Award in Literature in 1979; "In Praise of Chekhov" won the National Endowment for the Arts Essay Award in 1967. Recently he edited* The Oxford Book of Memory *(1996). He taught at Cornell University.*

McConkey calls this chapter of Court of Memory *"Hector, Dick and I." Straightforward as it seems on the surface, it is as symbolic, crafted, and powerful a piece of literature as nonfiction can yield. Each of the three men—McConkey, his fellow graduate student, who is in medical school, and their landlord—confronts loss differently. One makes, one mends, one holds.*

■ ■ ■

Hector, Dick and I
from COURT OF MEMORY

Eighteen years ago I was a graduate student living with my wife in a trailer on an Iowa field. After a fruitless search for housing— we had arrived in the university town at the last minute, our decision to come a result, in those days before children and furniture and property, simply of our Ohio landlady's anger at a party we had given that she claimed had cracked the ceiling of the living room beneath ours—we had bought the trailer and rented space for it at the edge of town from Hector Bascomb and his wife Rowena. She was a cook at one of the fraternities; he was a retired, one-armed farmer. On successive Saturday afternoons of a sunny October, lis-

tening to vagrant bits of band music from the distant stadium, we dug water and sewer lines. Hector furnished us with advice, spades, pickaxes, and a flaring kit for making connections in copper tubing. I admired my wife for the way she lifted shovelfuls of dirt from the trench, and I imagined the pair of us to be out of some Russian novel, a sturdy peasant couple preparing our hovel against the Siberian blasts. Another student couple—the husband, Dick, was younger than I, an undergraduate taking pre-medical courses— bought a trailer exactly like ours, placing it between our trailer and the street. I had already put a flush toilet in the bedroom closet. Dick pushed back the overcoats to look at it and immediately decided to install a toilet in the same place in his trailer. He and his wife dug a ditch to meet ours so that the two trailers could have common sewer and water lines running across the field and into Hector's basement. Hector judged the frost line in that part of Iowa to be forty inches; we placed our copper tubing at forty-one inches, not wanting to do excess work on a project that, after all, would revert to Hector after we left. Dick and I already saw him as a shrewd old man, a farmer so obsessed with property that he was not distinguishable from what he owned; and we would give him no more than we had to.

An Army veteran studying for an advanced degree in English literature, I thought myself a writer preparing for his career under governmental patronage. Dick, also a veteran, was planning to be a surgeon. He had long and narrow fingers, and even then protected his hands with canvas gloves as he worked. His hands were capable of an agility and grace that mine were not; with my skull filled with arrogant notions of the supremacy and eternity of art, I thought it a pity he did not at the least give himself to the piano or violin. But he was a methodical and patient empiricist, most dubious of a spiritual reality or any subjective expression. Out of my imagination I would finally make something, I didn't know what, that would be beyond the corruption of my body; out of his training and skill he would bring diseased and mangled bodies back to health. Before each of us lay that mountain of time, that solid mass in which we would work out our pure and uncomplicated conceptions of what we were destined to be; it allowed us to enjoy the trembling of our trailers in the winter winds. A sense of transitoriness was our anchor, our rock, our bond.

Both of us were antithetical to old Hector, who, with his stump in a dirty sock, with his foul-smelling and nervous little rat terrier at his heels, puttered as if by habit in the debris of his field and barn. His field was a long, disorderly vista of his life. Beyond our trailers were chicken houses and dog kennels and a root beer stand, rotting remnants of enterprises he had taken up after the loss of his arm; beyond them a huge mound of dry and disintegrating manure. Beyond the manure lay rusted pieces of farm machinery from the days when harvesters were powered by steam; when plows and harrows were drawn by horses. Hector had given up only those possessions capable of bringing him better ones; in the year that I knew him, he managed, through an intricate series of barters, to exchange an old steam engine for a fairly new Ford tractor. Of course he had no use for it. He kept it locked in the barn, beside boxes of rags and bundles of paper and little kegs filled with bent nails and washers and screws; looking at it through a cobwebbed and grimy window, I thought it a perfect token of the meaninglessness of a life devoted to accumulation. He was inexorably placed by everything he had ever been or owned; placed by his dank stucco cottage and by the barn and the field to which, in his retirement, he had brought his past. Even his beliefs—time had turned most of them into superstitions— were possessions to be *used*. Professors of farming knew nothing, he told me one winter's day as he rocked his terrier in his lap by the kitchen fire, about the importance of phases of the moon in planting corn; and he had heard *with his own ears* one of them on the radio, disputing the indisputable fact that hairs from a horse's tail, dropped into a creek in early spring, will grow into worms by midsummer. He spat into the fire. "Do you believe me about the worms?"

"No," I said.

"I don't mind," he said, and looked at me shrewdly. "But if you ever write a book about me, I want a share out of your poke."

I was born only a few blocks away from Lake Erie, in a Cleveland suburb; as a child I connected the blue expanse of the lake with some still-to-be explored inner expanse, believing even then I would eventually be a writer. Lying in bed in spring and early fall, listening to the deep cry of the fog horn at the harbor entrance, I thought with pity of the suffocating multitudes who were land-

locked and held to some mundane occupation. Of course a field in Iowa is far from the Great Lakes; but I still had my dream of a destiny, and my trailer might well have been my boat, the vistas of rolling snow-covered fields the seas upon which I sailed to reach some harbor of the mind.

And what a comfortable little boat it was! Twenty-five feet from the tip of its hitch to the bulging red eye of its taillight, its generous center, its heart, was the galley. A cupboard door, hinged not at the side but at the bottom, dropped down to make a table. A recessed light above the stainless-steel sink illuminated the counter, the Coleman bottled-gas stove, the white Frigidaire. The living room was a sofa and an oil space heater. A plywood partition separated the bedroom from the rest of the trailer. One is aware of the trade names of all appliances in a trailer: the exhaust fan I installed in one of the ceiling hatches was a Homart, the little radio on the bookcase I built by the sofa was a Philco, borrowed for the year from my parents. While we ate dinner, my wife and I would listen to a sonorous-voiced professor reading his way in installments through *LaSalle and the Discovery of the Great West*. Late at night we would leave the galley light burning and walk in the snow, delighting in the graceful leaps over the high drifts of the rawboned dog who in the fall of the year had leaped through our flimsy screen door in a reckless and happy demand for bed and board. We lived near the airport, and as we walked the beacon would briefly illuminate patches of the somber clouds beyond us. We liked to walk to the railroad station to see the arrival of the day's final passenger train, its headlight burrowing a brilliant cone through the thick flakes. Back home and under covers—we slept on the narrow sofa, having turned the bedroom into a study—I would tune the radio just beyond my pillow to station after station, trying to find, especially on those frigid and still nights when distant signals are carried without distortion or fading, all the cities in which I had ever lived and all the cities I hoped some day to visit. The dog would jump on top of us to escape the draft from the door. That winter I read myself to sleep with *A Week on the Concord and Merrimac Rivers;* when I got to the end I started over. I thought it impossible to have more congenial trailer partners than my wife, a stray dog, Parkman, and Thoreau.

In that tiny space my energy was infinite. I studied and I wrote; I picked up a hammer and saw and attacked the trailer's interior. It pleased me to think of the trailer as the discipline, the form, within which my imagination had to invent; and, whenever a new and ingenious possibility for a cabinet or a shelf occurred to me, I would build it as hastily as I typed. Dick, who was having trouble with his calculus, often visited us in the evenings to get help from my wife. Before he left he would look thoughtfully at each new alteration in our trailer. He would rub his long fingers against the wood to see how well I had sanded it (usually I hadn't sanded at all). And then he would say, "Do you mind awfully if I copy this? I think I might improve on it a bit."

Memory simplifies, for its impulse is order; in playing upon a given relationship, it can erode the irrelevant and ambiguous to leave the bones of allegory. If I remember myself as the maker, the little God of a portable world circumscribed by quarter-inch plywood, Dick has become simply the rebuilder, the patient craftsman who, with his kit of immaculate tools, remedies the imperfect original conception. His trailer was the duplicate world of mine; where I had built a bookcase, he built a bookcase, and where I had managed to squeeze in a narrow cupboard for cans of soup and bars of soap, he did likewise. But his latches worked, his little doors were neatly trimmed with molding, his nails were recessed and hidden by putty, his wood contained a warm and flawless sheen. I am sure he thought me as careless as I thought him dull, and had it not been for Hector peering through the early-morning frost of our windows to get proof with his own eyes that we had left our faucets dripping, perhaps not even the bond that we had as transients would have held us together.

Hector, of course, was the preserver, the hoarder; even then I had the sense that he was acting, however perversely, some traditional human role, though one which in my youthful assurance and egoism I felt far beneath my dreams. A part of his mundane task was to be guardian of the water meter, the reckonings of which he had to pay. When the frost line—its rate of descent was announced on the radio each day of that severe winter—reached forty inches, Dick and I tried to let the water drip all night; but Hector, who

could hear the tick of the meter from his bed, would shut off the main valve in his basement. From our trailers we could see a dim glow in one of his casement windows as he descended the cellar steps in his nightshirt. Hector recouped any possible water loss by charging us fifty cents each to push our cars, which frequently would not start otherwise, in the mornings. He owned a 1924 Buick sedan; after each use of it, he would drain the contents of the radiator and crankcase into cans which he stored in the kitchen. A single flip of the hand crank—old Hector's one arm was still a mighty one—made the motor, warmed by its morning fluids, catch and purr. Dick and I, pressing fruitlessly on our frozen starter buttons, hated to look toward the house, that dismal cottage of the fairy tales; Hector would be waiting at the window between the tattered curtains, an expectant smile on his unshaven face.

The tenants' generous use of water plagued him even when spring came. In March he put up a sign on the basement shower stall he had built for the use of the trailer occupants. For Weekends Only, it said. All Families Will Shower Together.

Since Hector had contracted to supply us all the water we required in the trailer, I bought a huge second-hand tub. It was made of cast iron and had claw feet. I removed the feet and installed the tub in my study, beneath the sloping rear wall. I built a plywood enclosure for it, with a hinged and padded red plastic top. When the tub was not in use, the top became a window seat and a place for books and manuscripts. My wife or I, lolling in the luxury of hot water, looked disconcertingly like a corpse in an opened casket; but I had worked with care on the project, having become irritated with Dick's sense of superiority in his craftsmanship, and I was proud of it. One evening when Dick came over to get his usual help with an assignment, my wife and I lifted the lid to show him the tub. He stared at it bleakly. "I'd say it's too big for the hot water supply," he said; both our trailers had come equipped with three-gallon electric water heaters.

"We heat water for it on the stove, but we don't mind," I replied. "Personally, I like to use as much of Hector's water as I can."

"I see," he said. After my wife had helped him with his work, he came back to the study; I was working at my desk on a novel. "If you ever take your trailer off the blocks, be careful," he said. "That tub looks heavy enough to tilt your trailer on its hind end. Wouldn't it

be a thing, though, if you were to fill it with water and then jumped in and the trailer—"

"Thanks," I said, interrupting him. "Thanks for all your advice and all your praises."

"That's all right," he said; he always took my remarks literally.

"You're a very serious person," I told him.

"Thank you," he said, looking at his hands. "I want to be a surgeon, you know."

Looking out of our window a few evenings later, my wife and I saw Dick and his wife carrying a small porcelain tub from a rented truck into their trailer. It was the kind of tub one takes sit-baths in, and was, he later told me, just the right size for the hot water heater. He built an enclosure for it that had a hinged and padded red plastic top.

My growing irritation with Dick was connected with my awareness that both of us soon would be leaving Hector's field. Both Dick's wife and mine had become pregnant, and as a consequence we were eligible for university housing in converted army barracks. Because of a surfeit of student trailers in town, neither Dick nor I was able to sell ours there; I contacted a firm in Davenport that sold used trailers, and they hauled off our home. I followed it in my car for a few miles out of town, for I found it painful to let that little world, whatever its flaws, vanish in a moment. The weighted rear end swayed dangerously. A week later Dick—he asked me first if I minded—phoned the same Davenport firm. The two trailers were displayed side by side on the lot. My wife and I drove to Davenport to have a look at them. Ours, of course, was the shoddier; the sight of it, gathering dust inside and out, was dispiriting. Dick's trailer sold almost immediately, and for nearly as much money as a new one; at the summer's end I had to retrieve mine and return it to Hector's field in the hope that I could find a renter for it.

Hector helped me re-connect the water and sewer lines. The day was humid, and both of us became hot and thirsty. His wife made iced tea; the three of us sat in old wicker chairs on their front porch. The rat terrier, of course, jumped into his lap. Rowena to me had been a shadow, for Hector conducted all business matters while she stood behind him; I had thought of her simply as his wife, a woman with thick legs and varicose veins who wore shapeless dresses and

was really too old to be a fraternity cook. But it was she who now did most of the talking. "We've been proud to have a writer and a doctor with us for a year," she said.

I demurred. Dick and I had yet to prove ourselves, I said, and he was likelier than I to gain his goal. I said that I supposed Dick eventually would be a very successful surgeon.

"You both work hard!" Rowena cried. She had a high, expiring voice. "We could see your lights late at night! 'The doctor,' I would say to him"—and she nodded at Hector—"and he would say, 'And the writer.' *He* used to be the nicest whittler, carving little things out of wood! Toys I mean, for the children."

I expressed my surprise, for I hadn't known of their children. I had thought Hector and Rowena too ancient ever to have been parents.

Hector said that when children grow up, they leave. Both his boys lived to hell and gone, the other side of Cedar Rapids. His daughter had died so many years ago that he could no longer see her face. "Tell him," he said to his wife, "about my arm."

Trivial though it was, my misfortune with my trailer had made them sympathetic and friendly. It was apparent in the tone of Hector's voice that he was allowing me to enter, now that I was living elsewhere than his field, a part of his past that had previously been kept from me. Rowena's account was macabre. In his middle years Hector had caught his arm, as many farmers do, in a corn picker. The arm had been so mangled at the elbow that amputation was the only medical recourse possible. Hector demanded that the surgeon give him back the arm. He preserved it with formaldehyde in a glass container, which he kept on the kitchen table. When he regained some of his strength, he put a block of walnut between his legs and, looking at the embalmed arm, attempted to create it in wood. He wanted to capture precisely each wrinkle, vein line, and fingernail. He used three blocks of wood before fashioning an arm to his satisfaction; and then he built a harness of leather and steel to fasten the wood to his own stump. But of course he could not breathe life into it; it could never become the arm that lay uselessly in the formaldehyde.

Hector, Rowena went on in her high but gentle voice, had been unable to eat. He spent most of his waking hours in the kitchen simply staring at the container. She knew what she had to do! One night she had crept out of his bed and removed the arm from the

fluid. She found a wooden box and stuffed it with cotton. She tied the fingers down, for she knew that one who has lost an arm feels pain from the missing member when the flesh shrivels and the little bones clench up to make a fist. Oh, she wouldn't have hurt Hector for the world! With a lantern perched on a fence post to help her see, she had buried the box in a far corner of the field. To herself she vowed never to tell him what she had done. But she hadn't realized how terrible he would be to live with that spring! In his anger at her he splintered the wooden arm against the coal stove! Finally she had to tell him. He dug up the box and opened it to see his own bones. Everything was all right after that. Habit and routine took over.

Rowena smiled at me. Hector, too, was smiling; he was glad that I had heard his story. We were friends. It had not been his intention to bring me down to my mortal size or to suggest any limitations in the areas of medicine or art. And, though he had every opportunity before I left, he said nothing to me this time about a share out of my poke.

I saw Dick only once more before I moved from Iowa. We met by chance on a downtown street. He told me about his infant daughter, and I told him about my infant son. The novel upon which I had been working with such haste in the trailer had never managed to capture the purity of the idea behind it; I told him I had discarded it. He said he had been admitted to medical school. His last hurdle had been the personal interview. He frowned, as if hesitating to tell me about it; but then he spoke with frankness. I remember Dick as an exceptionally honest person. "I came into this room where the interviewer sat," he said. "I had bought a new suit, for I thought, you know, that this was an important thing. But he had only one question to ask." Dick took a breath. "He asked, 'Tell me, young man, what is *your* view about socialized medicine?'"

"What did you say?"

"God, I hadn't thought about it. It had never entered my mind that he would ask something like that. I've been thinking ever since that socialized medicine isn't so bad. You know, helping these poor people with their cataracts and cancers. But I knew what I had to say. 'Sir,' I said, 'I am firmly opposed to it.'" I had never seen Dick so agitated; he kept clenching his fists to make the knuckles crack. "Think of it," he said. "Even before you start, you've got to lie."

* * *

In the years since I left that trailer in an Iowa field, I have slowly and methodically become placed. I am as placed, as surrounded by my possessions, as Hector ever was. I now have three children, two horses, two dogs, two cats, two cars, a large field tractor and a small garden tractor and a Rototiller. I recently phoned my lawyer that I wish to buy the rest of the land—I particularly want the woods—that once belonged to my farmhouse; soon I will own nearly everything I can see from the front porch. Recently my wife and children and I ate our supper sitting on the living room floor before a log fire; and then, sprawled out on the wide pine planks, I drew a diagram for the fifteen-foot wall closet I will build some day in the large bedroom. My past is so littered with flaws in conception as well as execution that now, whenever I do anything, I go about it as carefully as I can.

Larry, the son born in Iowa, has practiced the piano ever since he was five, but he is not interested in music as a profession. His hands are just as agile as Dick's, and I wonder at times if he might not make a good surgeon. The thought pleases me.

Sometimes I have a dream. In this dream the morning is full of mist, the endless field covered with snow. I look into the opened grave, which is deep as a well, to see the dark gravedigger caressing an object that resembles a luminescent baseball. "Gravedigger," I call—and I can speak to him so preemptorily for he has but a bit part in an old play—"what are you handling?" "Alas," he says, "it is the skull of poor Jesus Christ." "It is too tiny and too perfectly round to be a skull, gravedigger," I say sternly. "Tiny and round it may be," he replies, "but do you know what this skull contains?" "What, gravedigger?" "In this little ball," he says, his every syllable twanging like a guitar string, "in this little ball lies all of Heaven and all of Hell. *Or so he thought.*"

It is one of those queer winter dreams that fill one both with foreboding and joy. Oh sweet Jesus! I say, waking, with my eyes in tears. You truly believed you could make and mend and hold! Carry on, you brave little baseball skull! And I love my wife and my children and my horses and my dogs and cats, and in my loneliness wish them all in bed with me. This is what it feels like, to be placed.

WILLIAM KITTREDGE
(1932–)

Following a tour in the U.S. Air Force, William Kittredge managed the
family ranch in Oregon for almost ten years. He studied writing at the
University of Iowa, and was a Stegner Fellow at Stanford University.
He is now Regents Professor of English at the University of Montana.

He has written two collections of stories: The Van Gogh Field and
Other Stories *(1978), and* We Are Not in This Together *(1984).*
Owning It All—*evocative narrative essays—appeared in 1987. His*
1992 memoir, Hole in the Sky, *takes place in the cattle country of*
southeastern Oregon. His crafted, thoughtful essays appeared in Best
American Essays *in both 1988 and 1989. He has won the Montana*
Governor's Award in both arts and humanities. The National
Endowment for the Humanities gave him its 1994 Frankel Award for
service to the humanities.

■ ■ ■

Who Owns the West?

After a half mile in soft rain on the slick hay-field stubble, I
would crouch behind the levee and listen to the gentle clatter of
the water birds, and surprise them into flight—maybe a half-dozen
mallard hens and three green-headed drakes lifting in silhouetted
loveliness against the November twilight, hanging only yards from
the end of my shotgun. This was called jump shooting or meat
hunting, and it almost always worked. But I wish someone had told
me reasons you should not necessarily kill the birds every time. I
wish I'd been told to kill ducks maybe only once or twice a winter,
for a fine meal with children and friends, and that nine times out of
ten I was going to be happier if I let the goddamned birds fly away.

In 1959, on the MC Ranch, in the high desert country of south-
eastern Oregon, an agricultural property my family owned, I was
twenty-seven, prideful with a young man's ambition, and happy as
such a creature can be, centered in the world of my upbringing, king
of my mountain, and certain I was deep into the management of

perfection. It was my responsibility to run a ranch-hand cookhouse and supervise the labors of from ten to twenty-five workingmen. Or, to put it most crudely, as was often done, "hire and fire and work the winos."

Think of it as a skill, learnable as any other. In any profession there are rules, the most basic being enlightened self-interest. Take care of your men and they will take care of you.

And understand their frailties, because you are the one responsible for taking care. Will they fall sick to death in the bunkhouse, and is there someone you can call to administer mercy if they do? What attention will you give them as they die?

Some thirty-six miles west of our valley, over the Warner Mountains in the small lumbering and ranching town of Lakeview, a workingman's hotel functioned as a sort of hiring hall. There was a rule of thumb about the men you would find there. The best of them wore a good pair of boots laced up tight over wool socks; this meant they were looking for a laboring job. The most hapless would be wearing low-cut city shoes, no socks, no laces. They were looking for a place to hide, and never to be hired. It was a rule that worked.

On bright afternoons when my people were scrambling to survive in the Great Depression, my mother was young and fresh as she led me on walks along the crumbling small-town streets of Malin, Oregon, in the Klamath Basin just north of the California border. This was before we moved to the MC Ranch; I was three years old and understood the world as concentric circles of diminishing glory centered on the sun of her smile. Outside our tight circle was my father, an energetic stranger who came home at night and before he touched anything, even me or my mother, rolled up his sleeves over his white forearms and scrubbed his hands in the kitchen sink with coarse lava soap. Out beyond him were the turkey herders, and beyond them lay the vast agricultural world, on the fringes of the Tule Lake Reclamation District, where they worked.

What the herders did in the turkey business, as it was run by my father, was haul crates full of turkeys around on old flatbed trucks. When they got to the backside of some farm property where nobody was likely to notice, they parked and opened the doors on those

crates and turned the turkeys out to roam and feed on grasshoppers. Sometimes they had permission, sometimes my father had paid a fee; and some of the time it was theft, grazing the turkeys for free. Sometimes they got caught, and my father paid the fee then. And once in a while they had to reload the turkeys into their crates and move on while some farmer watched with a shotgun.

The barnyard turkey, you have to understand, is a captive, bitter creature. (Some part of our alienation, when we are most isolated, is ecological. We are lonely and long to share in what we regard as the dignity of wild animals—this is the phantom so many of us pursue as we hunt, complicating the actual killing into a double-bind sort of triumph.) My upbringing taught me to consider the domesticated turkey a rapacious creature, eyes dull with the opaque gleam of pure selfishness, without soul. I had never heard of a wild one. The most recent time I had occasion to confront turkeys up close was in the fall of 1987, driving red scoria roads in the North Dakota badlands. I came across farmstead turkeys, and true or not, I took that as a sign we were where agriculture meant subsistence. No doubt my horror of turkeys had much to do with my fear of the men who herded them.

From the windows of our single-bedroom apartment on the second floor of the only brick building in Malin, where I slept on a little bed in the living room, we could look south across the rich irrigated potato- and barley-raising country of the Tule Lake basin and see to California and the lava-field badlands where the Modoc Indians had hidden out from the U.S. Army in the long-ago days of their rebellion. I wonder if my mother told me stories of those natives in their caves, and doubt it, but not because she didn't believe in the arts of make-believe. It's just that my mother would have told me other stories. She grew up loving opera. My grandfather, as I will always understand him, even though we were not connected by blood earned the money for her music lessons as a blacksmith for the California/Oregon Power Company in Klamath Falls—sharpening steel as he put it. So it is unlikely my mother was fond of stories about desperate natives and hold-out killings and the eventual hanging of Captain Jack, the Modoc war chief, at Fort Klamath. That was just the sort of nastiness she was interested in escaping; and besides, we were holding to defensive actions of our own.

After all, my father was raising turkeys for a living in a most haphazard fashion. So my mother told me stories about Christmas as perfection realized: candied apples glowing in the light of an intricately decorated tree, and little toy railroads which tooted and circled the room as if the room were the world.

But we live in a place more complex than paradise, some would say richer, and I want to tell a story about my terror on Christmas Eve, and the way we were happy anyhow. The trouble began on a sunny afternoon with a little snow on the ground, when my mother took me for my first barbershop haircut, a step into manhood as she defined it. I was enjoying the notion of such ceremony, and even the snipping of the barber's gentle shears as I sat elevated to manly height by the board across the arms of his chair—until Santa Claus came in, jerked off his cap and the fringe of snowy hair and his equally snowy beard, and stood revealed as an unshaven man in a Santa Claus suit who looked like he could stand a drink from the way his hands were shaking.

The man leered at my kindly barber and muttered something. I suppose he wanted to know how long he would have to wait for a shave. Maybe he had been waiting all day for a barbershop shave. A fine, brave, hung over sort of waiting, all the while entombed in that Santa Claus suit. I screamed. I like to think I was screaming against chaos, in defense of my mother and notions of a proper Christmas, and maybe because our Santa Claus who was not a Santa, with his corded, unshaven neck, even looked remotely like a turkey as this story turns edgy and nightmarish.

My father's turkeys had been slaughtered the week before Thanksgiving in a couple of box-cars pulled onto a siding in Tule Lake, and shipped to markets in the East. Everyone was at liberty and making ready to ride out winter on whatever he had managed to accumulate. So the party my parents threw on the night before Christmas had ancient ceremonial resonances. The harvest was done, the turkeys were slaughtered, and the dead season of cold winds was at hand. It was a time of release into meditation and winter, to await rebirth.

But it was not a children's party. It is difficult to imagine my father at a children's party. As I recall from this distance it was a party for the turkey herders, those men who had helped my father conspire

his way through that humiliating summer with those terrible creatures. At least the faces I see in my dream of that yellow kitchen are the faces of those men. Never again, my mother said, and my father agreed; better times were coming and everybody got drunk.

I had been put down to sleep on the big bed in my parents' bedroom, which was quite a privilege in itself, and it was only late in the night that I woke to a sense of something gone wrong. The sacred place where I lived with my mother had been invaded by loud laughter and hoedown harmonica music and people dancing and stomping. As I stood in the doorway looking into the kitchen in my pajamas, nobody saw me for a long moment—until I began my hysterical momma's-boy shrieking.

The harmonica playing stopped, and my mother looked shamefaced toward me from the middle of the room, where she had been dancing with my father while everyone watched. All those faces of people who are now mostly dead turned to me, and it was as if I had gotten up and come out of the bedroom into the actuality of a leering nightmare, vivid light and whiskey bottles on the table and those faces glazed with grotesque intentions.

Someone saved it, one of the men, maybe even my father, by picking me up and ignoring my wailing as the harmonica music started again, and then I was in my mother's arms as she danced, whirling around the kitchen table and the center of all attention in a world where everything was possible and good, while the turkey herders watched and smiled and thought their private thoughts, and it was Christmas at last in my mother's arms, as I have understood it ever since.

For years the faces of the turkey herders in their otherness, in that bright kitchen, were part of a dream I dreaded as I tried to go to sleep. In struggling against the otherness of the turkey herders I made a start toward indifference to the disenfranchised. I was learning to inhabit distance, from myself and people I should have cared for.

A couple of years later my family moved the hundred miles east to the MC Ranch. My grandfather got the place when he was sixty-two years old, pledging everything he had worked for all his life, unable to resist owning such a kingdom. The move represented an enormous change in our fortunes.

Warner Valley is that place which is sacred to me as the main staging ground for my imagination. I see it as an inhabited landscape where the names of people remind me of places, and the places remind me of what happened there—a thicket of stories to catch the mind if it might be falling.

It was during the Second World War that wildlife biologists from up at the college in Corvallis told my father the sandhill cranes migrating through Warner were rare and vanishing creatures, to be cherished with the same intensity as the ring-necked Manchurian pheasants, which had been imported from the hinterlands of China. The nests of sandhill cranes, with their large off-white speckled eggs, were to be regarded as absolutely precious. "No matter what," I heard my father say, "you don't break those eggs."

My father was talking to a tall, gray-faced man named Clyde Bolton, who was stuck with a day of riding a drag made of heavy timbers across Thompson Field, breaking up cow shit in the early spring before the irrigating started, so the chips wouldn't plug up the John Deere mowing machines come summer and haying. Clyde was married to Ada Bolton, the indispensable woman who cooked and kept house for us, and he had a damaged heart which kept him from heavy work. He milked the three or four cows my father kept, and tended the chickens and the house garden, and took naps in the afternoon. He hadn't hired out for field work, and he was unhappy.

But help was scarce during those years when so many of the able bodied were gone to the war, and there he was, take it or leave it. And anyway, riding that drag wouldn't hurt even a man with a damaged heart. Clyde was a little spoiled—that's what we used to say. Go easy on the hired help long enough, and they will sour on you. A man, we would say, needs to get out in the open air and sweat and blow off the stink.

This was a Saturday morning in April after the frost had gone out, and I was a boy learning the methodologies of field work. The cranes' nests my father was talking about were hidden down along unmowed margins—in the yellow remnants of knee-high meadow grass from the summer before, along the willow-lined sloughs through the home fields. "The ones the coons don't get," my father said.

I can see my father's gray-eyed good humor and his stockman's fedora pushed back on his head as he studied Clyde, and hear the

ironic rasp in his voice. At that time my father was more than ten years younger than I am now, a man recently come to the center of his world. And I can see Clyde Bolton hitching his suspenders and snorting over the idea of keeping an eye out for the nest of some sandhill crane. I can see his disdain.

This going out with Clyde was as close to any formal initiation as I ever got on the ranch. There really wasn't much of anything for me to do, but it was important I get used to the idea of working on days when I was not in school. It wouldn't hurt a damned bit. A boy should learn to help out where he can, and I knew it, so I was struggling to harness the old team of matched bay geldings, Dick and Dan, and my father and Clyde were not offering to help because a boy would never make a man if you helped him all the time.

"You see what you think out there," my father said, and he spoke to Clyde seriously, man to man, ignoring me. They were deeply serious all at once and absorbed into what I understood as the secret lives of men. It was important to watch them for clues.

My father acted like he was just beginning to detail Clyde's real assignment. You might have thought we faced a mindless day spent riding that drag behind a farting old team. But no, it seemed Clyde's real mission involved a survey of conditions, and experienced judgment.

"Them swales been coming to swamp grass," my father said. "We been drowning them out." He went on to talk about the low manure dams which spread irrigation water across the swales. Clyde would have the day to study those dams, and figure where they should be relocated.

Once we believed work done well would see us through. But it was not true. Once it seemed the rewards of labor would be naturally rationed out with at least a rough kind of justice. But we were unlettered and uninstructed in the true nature of our ultimate values. Our deep willingness to trust in our native goodness was not enough.

But we tried. This is what I am writing of here, that trying and also about learning to practice hardening of the heart. Even back then I might have suspected my father wasn't much worried about swamp grass in the swales, and that Clyde Bolton knew he wasn't, and that it wasn't the point of their negotiations. My father was concerned about dignity, however fragile, as an ultimate value.

"Your father was the damnedest son of a bitch," one of the ranch hands once told me. "He'd get you started on one thing, and make you think you were doing another thing which was more important, and then he would go off and you wouldn't see him for days, and pretty soon it was like you were working on your own place."

It was not until I was a man in the job my father perfected that I learned the sandhill cranes were not endangered at all. It didn't matter. Those birds were exotic and lovely as they danced their mating dances in our meadows, each circling the other with gawky tall-bird elegance, balanced by their extended fluttering wings as they seized the impulse and looped across the meadows with their long necks extended to the sky and their beaks open to whatever ecstasy birds can know. I think my father was simply trying to teach me and everyone else on the property that certain vulnerabilities should be cherished and protected at whatever inconvenience.

I have to wish there had been more such instruction, and that it had been closer to explicit in a philosophical sense. Most of all I wish my father had passed along some detailed notion of how to be boss. It was a thing he seemed to do naturally. I wish he had made clear to me the dangers of posturing in front of people who are in some degree dependent on your whims, posturing until you have got yourself deep into the fraud of maintaining distance and mystery in place of authenticity.

A man once told me to smoke cigars. "They see you peel that cellophane," he said, "and they know you don't live like they do."

My father set up the Grain Camp on a sagebrush hill slope, beneath a natural spring on the west side of Warner Valley. And it was an encampment, short on every amenity except running water in the early days—a double row of one-room shacks, eight in all, trucked in from a nearby logging camp abandoned in the late 1930s. There were also two shacks tacked across one another in a T shape to make a cookhouse, one cabin for the cooking and another for the long table where everyone ate.

The men, who lived two to a cabin in the busy seasons, sweltering on that unshaded hill slope in the summers, and waking in the night to the stink of drying work clothes as they fed split wood to

their little stoves in the winter, were a mix of transients and what we called homesteaders, men who stayed with us for more than an occasional season, often years in the same cabin, which became known as theirs. Those men have my heart as I write this, men who were my friends and my mentors, some of whom died at the Grain Camp and have been inconspicuously dead for many years. Louie Hanson, Vance Beebe, Jake O'Rourke, Lee Mallard, so many others. I would like the saying of their names to be an act of pure celebration.

When I came home from the air force in the fall of 1957, I was twenty-five years old and back to beginnings after most of eight years away, a woeful figure from American mythology, the boss's kid and heir to the property, soon to inherit, who didn't know anything. Then in the spring of 1958, the myth came directly home to roost. I found myself boss at the Grain Camp.

There was no choice but to plead ignorance and insinuate myself into the sympathies of the old hands. Ceremony demanded that I show up twice a day to sit at the head of the long table for meals, breakfast and noon, and in the course of those appearances negotiate my way through the intricacies of managing 8,000 acres of irrigated land. For a long time I was bluffing, playing a hand I didn't understand, risking disgrace and reaping it plenty enough. The man who saved my bacon mostly was an old alcoholic Swede in filthy coveralls named Louie Hanson, who sat at my right hand at the table.

About five-thirty on a routine morning, after a hot shower and instant coffee, I would drive the three or so miles from the house to the Grain Camp. The best cabin, walls filled with sawdust for insulation, belonged to Louie. He had worked for my father since our beginnings in Warner, hiring out in 1937 to build dikes with a secondhand Caterpillar RD-6, the first tracklayer my father bought, and made his way up to Cat mechanic, and into privileges, one of which was occasional drinking. Theoretically, we didn't allow any drinking. Period. Again, there were rules. You need to drink, go to town. Maybe your job will be waiting when you get back. Unless you were one of the old hands. Then your job was secure. But nobody was secure if he got to drinking on the job, or around camp.

Except for Louie. Every morning in winter he would go down to

the Cat shop to build his fire before breakfast, and dig a couple of beers from one of the bolt-rack cubbyholes, pop the tops, and set the bottles on the stove to heat. When they were steaming he would take them off, drink the beer in a few long draughts, and be set to seize the day.

So it would not be an entirely sober man I greeted when I came early to get him for breakfast and knocked on the door to his cabin. Louie would be resting back on the greasy tarp that covered his bed, squinting through the smoke from another Camel, sipping coffee from a filthy cup and looking up to grin. "Hell, you own the place," he would say, "you're in."

Louie would blink his eyes. "Chee-rist. You got enough water in Dodson Lake?" He was talking about one of the huge grain fields we flooded every spring. And I wouldn't know. Did I have enough water in Dodson Lake? Louie would look at me directly. "Get a south wind and you are going to lose some dikes." I knew what that meant: eroded levee banks, washouts, catastrophe, 450 acres of flooded alfalfa.

Up at the breakfast table, while Louie reached for the pounded round steak, I would detail a couple of men to start drawing down the water in Dodson Lake, a process involving the opening of huge valves, pulling headgate boards, running the eighteen-inch pump. All of which would have been unnecessary if I had known what I was doing in the first place. Which everybody knew and nobody mentioned. All in all a cheap mistake, easily covered—wages for the men and electricity to run the pump, wasted time and a little money, maybe a couple hundred bucks. Without Louie's intercession, maybe twenty thousand.

The deeply fearful are driven to righteousness, as we know, and they are the most fearsome fools we have. This is a story I have told as a tavern-table anecdote, in which I call our man the Murderer, since I have no memory of his real name. Call the story "The Day I Fired the Murderer." It is designed, as told in taverns, to make me appear winsome and ironic, liberated, guilty no more. Which of course implies there was guilt. And there was, in a way that cornered me into thinking it was anger that drove me, and that my anger was mostly justifiable.

I had been boss at the Grain Camp for four or five years, and I had come to understand myself as a young man doing good work, employing the otherwise unemployable (which was kind of true), and also as someone whose efforts were continually confounded by the incompetence of the men who worked for me. We were farming twenty-four hours a day through early May while the Canada honkers hatched their downy young and the tulips pushed up through the crusted flower beds and the Lombardy poplar broke their buds and the forsythia bloomed lurid yellow against the cookhouse wall. But I don't think of such glories when I remember those spring mornings. I remember the odor of dank peat turning up behind those disc Cats as we went on farming twenty-four hours a day, and how much I loved breaking ground.

Before sunrise on those mornings I would come awake and go piss, then stand in my undershorts on the screened-in veranda attached to the house where I lived with my wife and young children. I would shiver with chill and happiness as I smelled the world coming awake. Far out across our valley the lights on our D-7 disc Cats would flicker as lights do when seen through a screen, moving almost imperceptibly. I would take my binoculars and open the screen door and gaze out to those lights as if I might catch one of my night-shift Catskinners at some dog-fuckery, but really all I wanted to see was the machinery moving. Those Cats would clank along at two or three miles an hour all through the hours of darkness, turning a thirty-six-foot swath—a hundred acres every night and another hundred acres on the day shift. The upturned soil would mellow in the air for a day, and then we would harrow it and seal it with dust and drill it to barley. In ten days or so the seedlings would break earth, and those orderly drill-rows undulating over the tilled ground toward the sundown light were softly yellow-green and something alive I had seen to completion.

It came to a couple hundred acres of barley every day for fifteen days, three-thousand-some-odd acres in all. By the end of harvest in late September, at roughly a ton per acre, that came to 3,000 tons of barley at $50 a ton, or $150,000, real money in the early 1960s in our end of the world.

We drained the wetlands and thought that made them ours. We

believed the world was made to be useful; we ditched and named the intersections of our ditches: Four Corners, Big Pump, Center Bridge, Beatty Bridge. We thought such naming made the valley ours.

And we thought the people were ours.

The man I call the Murderer was one of those men who rode the disc Cats, circling toward the sunrise. My involvement with him that spring had started the previous fall, when someone from the Oregon Board of Parole called and asked if we would participate in what they called their Custody Release Program. They would send us a parolee if we would guarantee a job; in return we got an employee who was forbidden to drink or quit, on penalty of being sent back to prison. If there was "anything," we could call and the State Police would come take him away. It seemed like a correct idea; it had been twenty some years since the Murderer killed his wife in an act of drunken bewilderment he couldn't recall.

Frail and dark-eyed in a stiff new evergreen-colored workshirt, with the sleeves rolled to expose thin white arms, pensive and bruised and looking incapable of much beyond remorse, the Murderer spent the winter feeding bales to the drag at our feed mill, a cold, filthy job, and as monotonous an enterprise as it is possible to imagine this side of automation. So when it came time to go farming in the spring, I sat him up at the controls of a D-7, taught him to pull frictions and grease the rollers and called him a Catskinner, which is to say, gave him some power. The Murderer responded by starting to talk. Bright, misinformed chatter at the breakfast table.

All I remember is annoyance. Then it rained, and we couldn't work. My crew went off to town for a couple of days with my blessing, and the Murderer went with them. That was against our rules, his and mine. And he came back drunk, and I fired him on the spot. He came up to breakfast drunk, terribly frightened and unable to be sober, lowering himself into my mercies, which did not exist.

Only in the imagination can we share another person's specific experiences. I was the ice queen, which means no stories, please, there is no forgiveness for you and never will be, just roll your god-damned bed and be gone. If I fired him, he would go back to prison. I knew that. I am sure I imagined some version of his future—isola-

tion again in the wrecked recognition that in this life he was not to be forgiven.

Stories bind us by reminding us that our lives all participate in the same fragilities, and this should soften us so that we stay humane. But I didn't want to be humane; I wanted to be correct. If I had not ignored his devastation as I no doubt saw it, imagined it, I might have found a way to honor common sense and taken him riding around with me that day as he sobered up, and listened to his inane chatter. But I sent him down the road, and thought I was doing the right thing. There were rules. As I tell the story I mean to say, See, I am not like that anymore. See. But we know this is only another strategy.

I fired a lot of men, and Louie Hanson more than once, after on-the-job binges. But Louie wouldn't go away; he understood the true nature of our contract. I needed his assurances exactly as he needed his life at the Grain Camp. After a few days Louie would sober up, and one morning he would be at the breakfast table like nothing had happened. In fact he was fired the day he died.

He was too drunk to make sense by three in the afternoon, feeding shots of whiskey to the chore man, which meant I had to take some action. So I told him to clear out. What he did was go off to visit an old woman he had known years before in a small town just down into California.

"A fancy woman," Louie said after drawing himself up to fine old-man lewdness. "Screw you, I am going to see a woman I should have been seeing." He was seventy-seven years old and unkillable so far as I knew as he drove away in his old Plymouth, squinting through his cracked eyeglasses.

A stranger in a pickup truck hauled him home late in the night, and Louie, having wrecked the Plymouth, was ruined, a cut over one eye, hallucinating as he lay curled into himself like an old knot, reeking with vomit, sick on the floor, unwilling to even open his eyes, complaining that his eyeglasses were lost. This descent into nowhere had happened before. Let him lie. And he did, facing the wall for three days.

By then it was clear something extraordinary and terrible was afoot, but Louie refused to hear of the hospital in Lakeview. They'll

kill you, he said. Around the time of World War I, in the Imperial Valley of California near Calexico, his back had been broken when a bridge caved in under the weight of a steel-wheeled steam tractor. The doctors got him on morphine for the pain, and then fed him alcohol to get him off morphine, and that was it for the rest of his life, he said. Booze.

They just left me there, he would say, half drunk and grinning like it was a fine joke. Maybe he felt the doctors had already killed him. I called his son in Napa, California, who came overnight in an old car and talked Louie onto his feet, as I should have done, and into a trip over the Warner Mountains to the hospital.

All that should have been my responsibility. Days before, I should have ignored his wounded objections. The doctors wouldn't kill him, and I knew it. He would have lived some more, not for long maybe, but some more. But such obligations were a bit beyond my job description, and I fell back on excuses.

Louie Hanson died in the automobile, slumped sideways against his son—dead with a broken rib through one lung, which would have been fixable a day or so earlier. I went to the funeral but wouldn't look in the coffin. There was nothing I wanted to know about the look of things in coffins.

There had been an afternoon when I stood on a ditch bank with a dented bucket of carrot slices marinated in strychnine, poisoning badgers and dreading every moment I could foresee, all things equally unreal, my hand in the rubber glove, holding the slice of carrot which was almost luminous, clouds over Bidwell Mountain, the sound of my breathing. I would have to move soon if I was ever going to get home. I was numb with dread and sorrowed for myself because I felt nothing but terror, and I had to know this was craziness. There is no metaphor for that condition; it is precisely like nothing.

By craziness I mean nearly catatonic fearfulness generated by the conviction that nothing you do connects to any other particular thing inside your daily life. Mine was never real craziness, although some fracturing of ice seemed to lie just around the corner of each moment. It was easy to imagine vanishing into complete disorientation. My trouble could be called "paralyzed before existential realities," a condition I could name, having read Camus like any boy of

my time. But such insight was useless. Nothing was valuable unless it helped toward keeping the lid on my own dis-ease.

The Fee Point reaches into the old tule beds on the east side of Warner. A homesteader shack out there was my father's first Grain Camp cookhouse, in 1938. I see my mother at the Fee in a soft summery wind, a yellow cotton dress, a young woman on a summer day, gazing out to plow-ground fields being cut from the swamps.

Close to thirty years later my Catskinners crushed that shack into a pile of weathered gray junk lumber, dumped on the diesel, and burned it. It was January and we all warmed our hands on the flames, then drank steaming coffee and ate cold roast-beef sandwiches sent out from another cookhouse.

In Latin *familia* means residence and family, which I take to mean community, an interconnection of stories. As I lie down to sleep I can stand out at Fee Point and see my mother and those Catskinners and the old shack burning, although I have not lived on the ranch in Warner Valley for twenty years. It's a fact of no more than sentimental interest except as an example of the ways we are inhabited by stories, and the ways they connect.

Water birds were a metaphor for abundance beyond measure in my childhood. A story about water birds: On a dour November afternoon, my father sat on a wooden case of shotgun shells in the deep tules by Pelican Lake like a crown prince of shotgunning, and dropped 123 ducks for an Elks Club feed. The birds were coming north to water from the grain fields and fighting a stiff head wind. They flared and started to settle, just over him, and they would not stop coming into the long red flame from his shotgun as darkness came down from the east. The dead birds fell collapsed to the water and washed back to shore in the wind. Eventually it was too dark to shoot, and the dead birds were heaped in the back of his pickup and he hauled them to town; he dumped them off to the woman he had hired to do the picking and went on to a good clear-hearted night at the poker table, having discharged a civic duty.

When someone had killed too many birds, their necks would be strung together with baling twine, and they would be hung from spikes in an old crab-apple tree back of our house, to freeze and be given away to anyone who might come visiting. When time came to

leave, we would throw in three or four Canada honkers as a leave-taking gift, frozen and stiff as cordwood, and give you the name of the lady in town who did the picking.

What is the crime here?

It is not my father's. In later years men came to me and told me he was the finest man they ever worked for, and I envy that fineness, by which, I think, they meant fair and convivial—and just, in terms of an implied contract. From an old hand who had worked for room and board and no wages through the Great Depression, that was a kind of ultimate praise. They knew he hadn't broken any promises, and he had sense enough to know that finally you can't really help anybody die, no matter how much you owe them.

But there was an obvious string of crimes. Maybe we should have known the world wasn't made for our purposes, to be remodeled into our idea of an agricultural paradise, and that Warner Valley wasn't there to have us come along and drain the swamps, and level the peat ground into alfalfa land. No doubt we should have known the water birds would quit coming. But we had been given to understand that places we owned were to be used as we saw fit. The birds were part of all that.

What went wrong? Rules of commerce or cowardice or what? Bad thinking? Failure to identify what was sacred? All of the above? Did such failures lead me to treat men as if they were tools, to be used?

Probably. But that is no excuse for participating in the kind of cold-heartedness we see everywhere, the crime we commit while we all claim innocence.

One night in Lakeview I was dancing with a woman we all knew as the Crop Duster's Wife. She came to the taverns every night, and she was beautiful in an over-bruised sort of way, but she wouldn't go find a bed with any of us. She was, she claimed, married forever to a man who was off in Arkansas dusting cotton from an old Steerman biplane. She said she just hoped he didn't wreck that Steerman into some Arkansas church. We sat at the bar and I was drunk and started telling her about Louie Hanson and how he died, eager to confess my craziness. Maybe I thought a woman who waited for a man who flew crop-dusting aircraft would understand. Maybe I thought she would fall for a crazy man.

"There is nothing to dislike but the meanness," she said, picking at her words. "You ought to be glad you ever knew those old farts."

Failures of the sympathy, she was saying, if I read her right, originate in failures of the imagination, which is a betrayal of self. Like so many young men, I could only see myself in the mirror of a woman. Offering the utility of that reflection, and solace, was understood to be the work of women, their old job, inhabit the house and forgive, at least until they got tired of it.

In those days a woman who wanted to be done with such duties might do something like buy herself a wedding ring, and make up a story about a faraway romantic husband who flew his Steerman every morning to support her. This woman might say people like me were no cure for her loneliness. But she might excuse my self-centered sorrowing. She might say we don't have any choice, it's the creature we are. Or she might tell me to wise up and understand that sympathy can be useful only if it moves us to quit that coldness of the heart.

It is possible to imagine a story in which the Murderer does not return to prison, but lives on at the Grain Camp for years and years, until he has forgiven himself and is healed—a humorous old man you could turn to for sensible advice. In the end all of us would be able to forgive and care for ourselves. We would have learned to mostly let the birds fly away, because it is not necessarily meat we are hunting.

BARRY LOPEZ
(1945–)

In 1966, after graduate school at the University of Notre Dame, New York–born Barry Lopez moved to western Oregon and stayed. He writes about landscape and culture. He has written tales in Giving Birth to Thunder, Sleeping with His Daughter *(1978), and essays in* Crossing Open Ground *(1988).*

Of Wolves and Men (1978) won the John Burroughs Medal for distinguished natural history. Arctic Dreams: Imagination and Desire in a Northern Landscape *won the 1987 National Book Award in nonfiction. His recent* Field Notes *(1994) completes a trilogy of short, hieratic fiction; the others are* Desert Notes *(1976) and* River Notes *(1979).*

"Replacing Memory" first appeared in The Georgia Review.

■ ■ ■

Replacing Memory

I
Manhattan, 1976

The hours of coolness in the morning just before my mother died I remember for their relief. It was July and it had been warm and humid in New York City for several days, temperatures in the high eighties, the air motionless and heavy with the threat of rain.

I awoke early that morning. It was also my wife's thirtieth birthday, but our celebration would be wan. My mother was in her last days, and the lives of all of us in the family were contorted by grief and tension—and by a flaring of anger at her cancer. We were exhausted.

I felt the coolness of the air immediately when I awoke. I walked the length of the fourth-floor apartment, opened one side of a tall casement window in the living room, and looked at the sky. Cumulus clouds, moving to the southeast on a steady wind.

Ten degrees cooler than yesterday's dawn, by the small tin thermometer. I leaned forward to rest my arms on the sill and began taking in details of movement in the street's pale light, the city's stirring.

In the six years I had lived in this apartment as a boy, from 1956 until 1962, I had spent cumulative months at this window. At the time, the Murray Hill section of Manhattan was mostly a neighborhood of decorous living and brownstone row houses, many of them not yet converted to apartments. East 35th Street for me, a child newly arrived from California, presented an enchanting pattern of human life. Footbeat policemen began their regular patrol at eight. The delivery of residential mail occurred around nine and was followed about ten by the emergence of women on shopping errands. Young men came and went the whole day on three-wheel grocery cart bikes, either struggling with a full load up the moderate rise of Murray Hill from Gristede's down on Third Avenue, or hurtling back the other way, driving no-hands against light traffic, cartons of empty bottles clattering explosively as the bike's solid tires nicked potholes.

In the afternoon a dozen young girls in private-school uniforms swirled in glee and posed with exaggerated emotion across the street, waiting to be taken home. By dinner time the street was almost empty of people; then, around eleven, it was briefly animated again with couples returning from the theater or some other entertainment. Until dawn, the pattern of glinting chrome and color in the two rows of curbed automobiles remained unchanged. And from night to night that pattern hardly varied.

Overlaying the street's regular, diurnal rhythm was a more chaotic pattern of events, an unpredictability I would watch with unquenchable fascination for hours at a time. (A jog in the wall of The Advertising Club of New York next door made it impossible for me to see very far to the west on 35th Street. But if I leaned out as far as I dared, I could see all the way to the East River in the other direction.) I would study the flow of vehicles below: an aggressive insinuation of yellow taxis, the casual slalom of a motorcycle through lines of stalled traffic, the obstreperous lumbering of large trucks. The sidewalks, with an occasional imposing stoop jutting

out, were rarely crowded, for there were neither shops nor businesses here, and few tourists. But with Yeshiva University down at the corner of Lexington, the 34th Street Armory a block away, a Swedenborgian church midblock, and 34th Precinct police headquarters just up from Third Avenue, I still saw a fair array of dress and captivating expressions of human bearing. The tortoise pace of elderly women in drab hats paralleled the peeved ambling of a middle-aged man anxious to locate a cab. A naïf, loose-jointed in trajectory down the sidewalk, with wide-flung strides. A buttonhooking young woman, intently scanning door lintels and surreptitiously watching a building superintendent leaning sullenly against a service entrance. Two men in vested suits in conversation on the corner where, rotund and oblivious, they were a disruption, like a boulder in a creek. A boy running through red-lighted traffic with a large bouquet in his hand, held forth like a bowsprit.

All these gaits together with their kindred modulations seemed mysteriously revealing to me. Lingering couples embraced, separated with resolve, then embraced once more. People halted and turned toward each other in hilarious laughter. I watched as though I would never see such things again—screaming arguments, the other-worldly navigations of the deranged, and the haughty stride of single men dressed meticulously in evening clothes.

This pattern of traffic and people, an overlay of personality and idiosyncrasy on the day's fixed events, fed me in a wordless way. My eyes would drift up from these patterns to follow the sky over lower Manhattan, a flock of house sparrows, scudding clouds, a distant airplane approaching La Guardia or Idlewild with impossible slowness.

Another sort of animation drew me regularly to this window: weather. The sound of thunder. Or a rising hiss over the sound of automobiles that meant the streets were wet from a silent rain. The barely audible rattle of dozens of panes of glass in the window's leadwork—a freshening wind. A sudden dimming of sunshine in the living room. Whatever I was doing, these signals would pull me away. At night, in the isolating light cone of a streetlamp, I could see the slant, the density, and sometimes the exact size of raindrops. (None of this could I learn with my bare hands outstretched, in the penumbral dark under the building's cornices.) I watched rainwater

course east in sheets down the calico-patched street in the wake of a storm; and cascades of snow, floating and wind-driven, as varied in their character as falls of rain, pile up in the streets. I watched the darkness between buildings burst with lightning, and I studied intently the rattle-drum of hail on car roofs.

The weather I watched from this window, no matter how wild, was always comforting. My back was to rooms secured by family life. East and west, the room shared its walls with people I imagined little different from myself. And from this window I could see a marvel as imbued with meaning for me then as a minaret—the Empire State Building. The high windows of its east wall gleamed imperially in the first rays of dawn, before the light flared down 35th Street, glinting in bits of mica in the façades of brownstones. Beneath the hammer of winter storms, the building seemed courageous and adamantine.

The morning that my mother would die I rested my forearms on the sill of the window, glad for the change of weather. I could see more of the wind, moving gray clouds, than I could feel; but I knew the walk to the subway later that morning, and the short walk up 77th Street to Lenox Hill Hospital, would be cooler.

I had been daydreaming at the window for perhaps an hour when my father came downstairs. The faint odors in the street's air—the dampness of basements, the acrid fragrance of ailanthus trees, the aromatics in roof tar—had drawn me off into a dozen memories. My father paused, speechless, at the foot of the stairs by the dining table. As determined as he was to lead a normal life around Mother's last days, he was at the beck and call of her disease almost as much as she was. With a high salute of his right hand, meant to demonstrate confidence, and an ironic grimace, he went out the door. Downstairs he would meet my brother, who worked with him, and together they would take a cab up to the hospital. My brother, three years younger, was worn out by these marathon days but uncomplaining, almost always calm. He and my father would eat breakfast together at the hospital and sit with Mother until Sandra and I arrived, then leave for work.

I wanted an undisturbed morning, the luxury of that kind of time, in which to give Sandra her birthday presents, to have a conversation

not shrouded by death. I made breakfast and took it into the bedroom. While we sipped coffee I offered her what I had gotten. Among other things, a fossil trilobite, symbol of longevity. But we could not break the rind of oppression this terminal disease had created.

While Sandra showered, I dressed and returned to the window. I stood there with my hands in my pockets staring at the weathered surface of the window's wood frame, with its peeling black paint. I took in details in the pitted surface of the sandstone ledge and at its boundary, where the ledge met the color of buildings across the street. I saw the stillness of the ledge against the sluggish flow of early morning traffic and a stream of pedestrians in summer cloth-ing below. The air above the street was a little warmer now. The wind continued to blow steadily, briskly moving cloud banks out over Brooklyn.

I felt a great affection for the city, for its tight Joseph's coat of buildings, the vitality of its people, the enduring grace of its plane trees, and the layers of its history, all of it washed by a great tide of weather under maritime skies. Standing at the window I felt the insistence and the assurance of the city, and how I was woven in here through memory and affection.

Sandra touched my shoulder. It was time we were gone, uptown. But something stayed me. I leaned out, bracing my left palm against the window's mullion. The color I saw in people's clothes was now muted. Traffic and pedestrians, the start-up of myriad businesses, had stirred the night's dust. The air was more rank with exhaust. A flock of pigeons came down the corridor of the street toward me, piebald, dove gray, white, brindled ginger, ash black—thirty or more of them. They were turning the bottom of a long parabolic arc, from which they shot up suddenly, out over Park Avenue. They reached a high, stalling apex, rolled over it, and fell off to the south, where they were cut from view by a building. A few moments later they emerged much smaller, wings pounding over brownstones below 34th Street, on a course parallel to the wind's.

I left, leaving the window open.

When Sandra and I emerged a half-hour later from the hospital elevator, my brother was waiting to meet us. I could see by the high, wistful cast of his face that she was gone.

II
Arizona, 1954

Our train arrived at Grand Canyon Village on the South Rim late on a summer afternoon. With my brother Denny and a friend of my mother, a young woman named Ann, I had come up on the Santa Fe spur line from Williams, a town about thirty miles west of Flagstaff. We had left Los Angeles the evening before, making a rail crossing of the Sonoran Desert so magical I had fallen silent before it.

The train itself was spellbinding. I do not remember falling asleep as we crossed the desert, but I know that I must have. I only remember sitting alone in a large seat in the darkened observation car, looking at the stars and feeling nearly out of breath with fortune—being able to wander up and down the aisles of the streaking train, sitting in this observation car hour by hour staring at the desert's sheer plain, the silhouettes of isolated mountain ranges, and, above, the huge swath of the Milky Way.

Near midnight we stopped for a few minutes in Needles, a railroad town on the lower Colorado across the river from the Fort Mojave Indian Reservation. The scene on the platform was dreamlike, increasing my sense of blessing. The temperature was over one hundred degrees, but it was a dry heat, pleasant. I had never been up this late at night. Twenty or thirty Indians—I didn't know then, but they would have been Chemuwevis as well as Mojaves, and also Navajos, who worked on many of the Santa Fe repair crews—craned their necks, looking for disembarking passengers or cars to board. Mexican families stood tightly together, stolid, shy and alert. The way darkness crowded the platform's pale lamplight, the way the smoky light gleamed on silver bracelets and corn-blossom necklaces, leaving its sheen on the heavy raven hair of so many women—all this so late in the heated night made Needles seem very foreign. I wanted to stay. I could have spent all the time I had been offered at Grand Canyon right here.

But we left. I returned to my seat in the now completely empty observation car. I am sure I fell asleep shortly after we crossed the river, on the way to Kingman.

John, Ann's husband of only a few months and a seasonal ranger at the park, met the train at the canyon. My brother and I

were to have two weeks with them before Mother came up to join us. (The three of them taught together in the secondary school system in Southern California's San Fernando Valley.)

On the way up from Williams, the train had climbed through piñon and juniper savannah. As I descended the train car's steps, I saw fully for the first time the largest trees I had ever looked at—ponderosa pines. In the same moment, their fragrance came to me on the warm air, a sweet odor, less sharp than that of other pines.

John embraced Ann fiercely and said, "I will never be separated from you, ever again, for this long." Their passion and his words seemed wondrous to me, profound and almost unfathomable. I stared at the huge ponderosas, which I wanted to touch.

During those two weeks, Denny and I traveled the South and East rims of the canyon with Ann while John lectured daily to visitors. The four of us lived in a small log cabin with a high-pitched roof. Sometimes I rose early, before the sun, and went outside. I would just stand in the trees or wander nearby in the first light. I could not believe the stillness.

A short distance from the cabin was a one-room museum with an office. I spent hours there, looking at pinned insects, stuffed birds, and small animals. Some of these creatures seemed incredibly exotic to me, like the Kaibab squirrel with its tufted ears—perhaps a made-up animal.

I read pamphlets about the geology of the canyon and its Indian history, and I went with my brother to some of John's lectures. The most entrancing was one in which he described the succession of limestones, sandstones, and shales that make up the visible canyon walls. The precision and orderliness of his perception, the names he gave so easily to these thousands of feet of wild, unclimbable, and completely outsized walls, seemed inspired, a way to *grasp* it all. I think this was the first such litany I committed to memory:

Kaibab, Toroweap,
Coconiño, Hermit;
Supai, Redwall,
Temple, Muav.
Bright Angel.
Tapeats.

On John's days off we drove out to picnic at Shoshone Point, a place on the East Rim set aside by the Park Service for its employees. Here, far from the pressing streams of visitor traffic, the silence within the canyon reverberated like silence in the nave of a large cathedral. The small clearing with its few picnic tables was a kind of mecca, a place where the otherwise terrifying fall-off of the canyon seemed to comfort or redeem. I saw a mountain lion there one afternoon. It leaped the narrow road in one long bound, its head strangely small, its long tail strangely thick, a creature the color of Coconiño sandstone.

I did not go back to the canyon after that summer for twenty-six years. In the spring of 1980, I joined several other writers and editors at a workshop there in the Park Service's Albright Training Center. I arrived at night by plane, so did not see much until the next morning. I got up early, just after sunrise, thinking I would walk over to the El Tovar Lodge on the rim of the canyon for breakfast. The walk, I thought, would be a way to reenter the landscape, alone and quietly, before the activities of the workshop caught me up in a flow of ideas and in protracted discussions.

I didn't remember the area well enough that morning to know where I was, relative to the cabin we'd stayed in, but I set off through the woods toward what felt like the canyon's rim. The gentle roll of the land, the sponginess of ponderosa needles beneath my feet, familiar but nameless odors in the air, the soft twitter of chickadees up ahead—all this rounded into a pattern my body remembered.

At a certain point I emerged from the trees onto a macadam road, which seemed the one to take to the lodge. I'd not gone more than a few yards, however, before I was transfixed by the sight of a small building. It was boarded up, but it had once been the museum. An image of its interior formed vividly in my mind—the smooth, glass-topped display stands with bird eggs and prehistoric tools, the cabinets and drawers full of vials of seeds and insect trays.

I walked on, elated and curiously composed. I would come back.

At the foot of the road was a wide opening in the trees. Once it might have been a parking lot. I was only part-way across when I

realized that the young pines growing here were actually coming up between train rails. Again I stood transfixed. It was here, all those years ago, that I had gotten off the train. I held tightly to that moment and began stepping eastward along the tracks, looking up every few steps to pure stands of ponderosa growing a hundred feet away to the south. Then I recognized a pattern in the trees, the way a dozen of the untapered, cinnamon-colored trunks stood together on a shallow slope. It had been here exactly that I had stepped off. I stared at them for many minutes, wondering more than anything at the way memory, given so little, could surge so unerringly.

I walked up to the trees and put my fingers on the bark, the large flat plates of small, concave scales. Far above, the narrow crowns were still against the bluing sky.

On the other side of the tracks I walked past the entrance to the lodge and stood at the edge of the canyon before a low, broad wall of stone. The moment my knees touched the wall, my unbounded view was shot with another memory—the feel of this stone angle against my belly when I was nine, and had had to hoist myself up onto the wall in order to see deep into the canyon. Now, I stood there long after the desire to gaze at the canyon had passed. I recalled suddenly how young ponderosas, bruised, smell like oranges. I waited, anxious, for memories that came like bursts of light: the mountain lion in its leap; the odor and jingle of harness mules and saddle horses in the hot sun at the top of Bright Angel Trail; my brother, light footed as a doe, at the wall of an Anasazi ruin. These images brought with them, even in their randomness, a reassurance about time, about the unbroken duration and continuous meaning of a single human life. With that came a sense of joy, which I took with me to breakfast.

III
Bear River, Idaho, 1991

Cort bought a potted sulfur buckwheat in the Albertson's in Jackson and he and John and I left for Idaho by way of Afton, Wyoming, passing through Montpelier and then Paris, Idaho. We turned off the main road there, drove west through Mink Creek and then

Preston and swung north on US 91, crossing the bridge over Bear Creek, where we pulled off.

Cort had been here before. Neither John nor I had, but I had wanted to see the place for a long time. In this river bottom, rising away from me to the Bannock Range in the northwest and, more precipitously, to the Bear River Range behind me in the southeast, several hundred people had been violently killed on a bitter cold morning in January 1863. This obscure incident on the Bear River, once commonly called a "battle" by Western historians, has more often been referred to in recent years as a massacre, an unnecessary killing. Twenty-two men of the Second Cavalry and the Third Infantry, California Volunteers, under the command of a Col. Patrick Connor, were shot dead by Northern Shoshone. No one knows how many Shoshone were killed, but most estimate it was well over three hundred—more Indians than were killed in any other massacre in the West, including those at Sand Creek, Colorado (1864), Washita, Oklahoma (1868), or Wounded Knee, South Dakota (1890).

Connor's stated reason for bringing three hundred troops north from Salt Lake City that winter on a forced march was to protect the Overland Mail Route. The incident that triggered his decision was the death of a white miner in a skirmish involving several miners and Indians near Preston, a few days after Christmas, 1862. In his official report, Connor said he meant to "chastise" the Shoshone. He permitted a federal marshal to accompany him, carrying arrest warrants for three Shoshone men reputedly involved in the fatal incident with the miners, but Connor told the marshal it was not his intent to take any prisoners.

The Shoshone, 400 to 450 of them, were camped in willow thickets at the mouth of a ravine formed by Beaver Creek, several hundred yards short of its confluence with the Bear River. The spot was a traditional winter campsite, well protected from a prevailing north wind, with hot springs and with winter grazing for about two hundred horses. The night before the massacre, a man named Bear Hunter was in the nearby village of Franklin with his family, purchasing and loading sacks of wheat. He saw Connor's troops arriving, surmised their real purpose, and brought word back to the encampment.

Early the following morning, realizing he had lost the advantage of surprise, Connor massed his cavalry openly on the south side of the river, across from the Indian camp. The temperature was probably in the low teens. Connor then waited impatiently for his infantry, which had bogged in heavy snow on the road out of Franklin.

The Shoshone were by now all awake and digging in, for Connor's intentions had become plain. (Connor, of course, had no evidence that these particular Shoshone people had done anything wrong, only the suspicion that the men the US marshal wanted were among them.) One of the Shoshone men shouted out in perfect English, "Come on you California sons-of-bitches. We're ready for you." Provoked by the remark, Connor surged across the icy river and ordered the cavalry to charge. Fourteen of his soldiers were cut down almost instantly. Connor retreated to regroup and to help his foot soldiers, now arriving, get across the river.

Once they were over, Connor divided his forces, sending one column up the west slope of the ravine and another up the east slope, achieving a double flanking of the Indian camp. From these elevated positions the soldiers raked the camp with a furious, enfilading fire. The Shoshone, lightly armed, fought back with sporadic shots and in hand-to-hand combat for three or four hours, until late in the morning, by which time most of them were dead. Connor ordered his troops to kill every wounded Indian and to set fire to all seventy tepees, scattering, burning, or fouling all the food they could find as they did so. (Historians believe as many as sixty Shoshone might have escaped, most of them by swimming the partly frozen river.) In the final stages of the fight, Shoshone women were raped. Bear Hunter was tortured to death with a white-hot bayonet.

Connor reported 224 Indians killed. Residents of Franklin, six miles away, riding through the smoldering camp and into the willow thickets the next morning, counted many more dead, including nearly one hundred women and children. They took a few survivors back, housing them and treating their injuries. Connor, who returned immediately to Salt Lake City, denounced the Mormon people of Franklin in his official report as unhelpful and ungrateful. For their

part, the Mormons may only have been heedful of Brigham Young's official policy: it was better to feed Indians than to fight with them.

John and Cort and I read in silence the historical plaques on a stone obelisk at the roadside. I felt more grief than outrage, looking across at the mouth of what is no longer called Beaver Creek but Battle Creek. An interpretive sign, erected in October 1990 by the Idaho Historical Society, seeks to correct the assumption that the fight here was a battle. It calls the encounter "a military disaster unmatched in Western history." A 1990 National Park Service plaque, designating the undistinguished ravine across the river bottom as a National Historical Landmark, says with no apparent irony that the spot "possesses national significance in communicating the history of the United States of America."

We left the highway, drove up a dirt road, and parked at the site of the encampment, which is not signed or marked. Where the Shoshone tepees once stood, in fact, the creek is now clogged with debris and refuse—a school locker, a refrigerator, a mattress, scorched magazines and tin cans, lawn furniture riddled with bullet holes. Violet-green swallows swooped the muddy water, only eight or ten feet across. On what is today called Cedar Bluff—the west side of the ravine—an iron-wheel combine and a walking-beam plow stood inert in sage and buckbrush. Overhead we heard the mewing of Franklin's gulls. From bottom flats near the river came the lowing of beef cattle.

Cort took the sulfur buckwheat from the truck, and the three of us started up the east side of the creek. The ravine, crisscrossed with horse and cattle tracks, was badly eroded. A variety of exotic grasses barely held in place a fine, pale tan, friable soil. Suddenly we saw a red fox. Then a muskrat in the water. Then the first of nine beaver dams, each built with marginal materials—teasel stalks and shreds of buckbrush, along with willow sticks and a few locust limbs. As we moved farther up the creek we heard yellow-headed blackbirds and mourning doves. In the slack water behind each succeeding dam, the water appeared heavier—silt was settling out before the water flowed on to the next dam, a hundred feet or so downstream. The beaver were clarifying the watercourse.

We finally found a small, open point of land near the creek. Cort put the buckwheat down and began to dig. He meant the planting as a simple gesture of respect. When he finished, I filled a boot with water and came back up the steep embankment. I poured it through my fingers. Slowly, watching the small yellow flowers teeter in the warm air. Cort had gone on up the creek, but I met John's eye. He raised his eyebrow in acknowledgment, but he was preoccupied with his own thoughts and stepped away.

I climbed to the top of the ravine on the east side and walked north until I came to a high bluff above the creek where hundreds of bank swallows were nesting. I sat watching them while I waited for my friends to emerge from the willow thickets below. A few months before, Cort had lent me his copy of Newall Hart's scarce history, *The Bear River Massacre*, which contains reproductions of military reports and other primary materials. He recommended I read Brigham Madsen's *The Shoshoni Frontier and the Bear River Massacre*. Cort himself had written about the incident in his *Idaho for the Curious*. When he and John joined me, Cort said he wanted to cross the creek and look over a section of Cedar Bluff he'd not walked on an earlier visit. I wanted to watch the swallows a while longer. John essayed another plan, and we each went our way again.

I worked back south along the creek bottom, pausing for long moments to watch for beaver, which I did not see. Frogs croaked. I came on mule-deer tracks. The warm air, laced with creek-bottom odors, was making me drowsy. I climbed back to the top of the ravine at the place where we had planted the buckwheat. A road there paralleled the creek, and its two tracks were littered with spent 12-gauge shotgun shells, empty boxes of .308 Winchester ammunition, and broken lengths of PVC pipe. I followed a barb-wire fence past a bathtub stock tank to the place where we'd parked.

I opened Hart's book on the hood of the truck. Tipped against the back endsheet is a large, folded plat map of the "Connor Battle Field," made in 1926 by W. K. Aiken, the surveyor of Franklin County, Idaho. I oriented it in front of me and began matching its detail to the landscape—Aiken's elevations, the sketchy suggestion of an early road to Montana, and a spot to the south where Aiken thought Connor had caught his first glimpse of the Shoshone encampment that morning. In the upper-right corner of his map

Mr. Aiken had written, not so cryptically, "Not a Sparrow Falls."

The river's meander had since carried it nearly three-quarters of a mile to the south side of its flood plain. Otherwise the land— ranched and planted mostly to hay crops, dotted with farm houses and outbuildings, and divided by wire fences—did not, I thought, look so very different. You could see the cattle, and you could smell pigs faintly in the air.

John came back. He took a bird guide out of the truck and began slowly to page through it. Cort returned with the lower jaw of a young mule deer, which we took as a souvenir. We drove back out to the road and headed north for Pocatello.

IV
Southern California, 1988

Sandra and I were in Whittier, California, for a ceremony at the town's college. It was the sort of day one rarely sees in the Los Angeles basin anymore: the air gin-clear, with fresh, balmy winds swirling through the eucalyptus trees, trailing their aromatic odor. The transparency of the air, with a trace of the Pacific in it, was intoxicating.

As we left the campus, Sandra said she could understand now what I meant about the sunlight, the clear air of my childhood.

"Yes," I answered. "It was like this often in the spring, after the rains in February. Back then—well, it was a long time ago. Thirty years, thirty-five years ago."

It was obvious anyway, she said, how this kind of light had affected the way I saw things.

I told her something Wallace Stegner wrote: whatever landscape a child is exposed to early on, that will be the sort of gauze through which he or she will see all the world afterward. I said I thought it was emotional sight, not strictly a physical thing.

The spanking freshness of the afternoon encouraged a long drive. I asked Sandra if she wanted to go out to Reseda, where our family had lived in several houses, starting in 1948.

In November 1985 I had come down to Los Angeles from my home in Oregon. I was meeting a photographer who lived there,

and with whom I was working on a story about the California desert for *National Geographic*. Flying into Los Angeles usually made me melancholy—and indignant. What I remembered from my childhood here, especially a rural countryside of farms and orchards out toward Canoga Park and Granada Hills, was not merely "gone." It had been obliterated, as if by a kind of warfare, and the remnant earth dimmed beneath a hideous pall of brown air.

A conversation with people in Los Angeles about these changes never soothes anyone. It only leaves a kind of sourness and creates impedence between people, like radio static. On the way to eat dinner with my friend, ruminating nevertheless in a silent funk about the place, I suddenly and vividly saw a photograph in my mind. It was of a young boy, riding the cantilevered support of a mailbox like a horse. On the side of the mailbox was "5837." I wrote the numerals down on the edge of a newspaper in my lap. I was not sure what they meant, but I recognized the boy as myself.

During dinner, I just as suddenly remembered the words "Wilbur Avenue," a street in Reseda. We had lived in three different houses in that town, the last one on Calvert Street. I had visited it several times in the intervening years, but hadn't been able to remember where the other two houses were.

The next day I rented a car and drove out to the Calvert Street home. Some thirty citrus and fruit trees my brother and I had planted in the midfifties had been dug out, and the lot had been divided to accommodate a second house, but parts of the lawn we had so diligently watered and weeded were still growing. I had raised tumbler pigeons here, and had had my first dog, a Kerry Blue terrier.

I inquired at a gas station on Victory Boulevard and found I was only a few blocks from crossing Wilbur Avenue. I made the turn there but saw the house numbers were in the six thousands and climbing; coming back the other way, I pulled up tentatively in front of 5837. I got out slowly, stared at the ranch-style house, and was suffused with a feeling, more emotion than knowledge, that this had been my home. Oleander bushes that had once shielded the house from the road were gone, along with a white rail fence and about fifteen feet of the front yard. In the late forties, before flood-control projects altered the drainage of this part of the San Fernando Valley,

Wilbur Avenue had been a two-lane road with high, paved berms meant to channel flood water north to the Los Angeles River. In those days it also served as a corridor for sheep being moved to pasture. Now it was four lanes wide, with modest curbs.

One walnut tree remained in the yard, and a grapefruit tree closer to the house. I glimpsed part of the backyard through a breezeway but kept moving toward the front door, to knock and introduce myself.

There was no answer. I waited awhile and knocked again. When no one answered I walked around to the breezeway, where there was a kitchen door. I nearly collided with a small, elderly woman whose hands flew up involuntarily in defense. I quickly gave my name, explaining I had grown up here, that I only wished to look around a little, if I could. Fright still gripped her face.

"Do you know," I said to her, "how, from the family room, you have to take that odd step up to the hallway, where the bedrooms are?"

Her face relaxed. She waved off her anxiousness, seemingly chagrined. She explained that the owner of the house, a woman named Mrs. Little, was inside, dying of cancer. I remembered the name. She had lived out near Palmdale when we rented the house. I said that I was sorry, that there was no need for me to go inside.

"Well, please, have a look around," she said. She was relaxed now, serene, acting as though we were distant relatives. She walked into the backyard with me. At nearly each step, having difficulty stemming the pressure of memories, I blurted something—about a tree, about a cinder-block wall (still unfinished) around a patio. I pointed to some aging apricot and grapefruit trees, and to a massive walnut tree. We were standing on a concrete path, where I squatted down to peer at a column of ants going in and out of a crack. I had watched ants in this same crack forty years before. These were their progeny, still gathering food here. The mystery of their life, which had once transfixed me, seemed in no way to have diminished. I felt tears brim under my eyes and spill onto my cheeks. The woman touched my forearm deliberately but lightly, and walked away.

The horse stalls, a barn, and a row of chicken coops were gone, but I found scraps of green rolled roofing and splinters of framing

lumber from them in the tall grass. I remembered mischief I had created here as a five-year-old. And then, like a series of sudden inflorescences, came memories first of the texture of tomatoes I had raised in a garden beside the chicken coops, and then of the sound of bees—how my friends and I had dared each other to walk past a hive of feral honeybees behind the barn where it ran close to the back fence.

Tempted to pick apricots and a grapefruit, I decided I had no right to do so. I said goodbye to the woman and asked her to convey my good wishes to Mrs. Little, whom I could not think would remember me.

Driving straight from the house to Anza-Borrego State Park in the western Sonoran Desert, a hundred and fifty miles away, I felt a transcendent calm. I promised myself I would return and try to find the first house, the location of which was lost to me.

Sandra and I came over from Whittier on the freeways, turning north off the Ventura onto Reseda Boulevard, then cutting over to Wilbur, which ran parallel. The house could not hold for her what it held for me, and I felt selfish using our time like this. But I wanted to share the good feeling I had had. The neighborhood still has about it something of the atmosphere of a much older San Fernando Valley—a bit run-down, but with no large housing developments, no landscaped and overwatered lawns. I drove past the house and had to turn and come back. The mailbox with its number was gone. The lot was empty: the house and all the trees had been razed; the bare, packed, red-brown earth had been swept clean. Only the tread marks of a single tractor were apparent, where it had turned on soft ground.

I got out of the car and walked back and forth across the lot, silently. On the ground near a neighbor's cinder-block fence I saw an apricot pit. I put it in my pocket.

"I've been thinking," I said to Sandra, once I was standing beside the car again. "The first house may have been way out on Wilbur, toward the Santa Susannas." She looked off that way.

"Would you mind driving? That way I could look. I might get the pattern of something, the way it looked."

"Yes," she said. "Certainly."

We turned around and headed north on Wilbur, windows open to the fresh breeze. We drove past the house where my friend Leon had lived, where I had first bitten into the flesh of a pomegranate, and then slowly past other places that I knew but which I could not recognize. The air all around was brilliant.

ZORA NEALE HURSTON
(1891–1960)

Zora Neale Hurston grew up in the all-black town of Eatonville, Florida, where her father, a tenant farmer, was the mayor and a Baptist minister. Her mother, a seamstress, urged her to "jump at the sun." Hurston traveled north as maid to an actress; eventually she studied anthropology at Barnard College. She set out to recover the African American folklore of the South. Mules and Men *describes this period of her life. Receiving a Guggenheim Fellowship, she collected folklore in Haiti, Jamaica, and Bermuda. She figured largely in the Harlem Renaissance.*

Hurston wrote four novels and two books of folklore. Their Eyes Were Watching God *is a passionate and brilliant novel. It is the centerpiece of the Library of America's two-volume set of her major works.*

Her memoir, Dust Tracks on a Road, *is vexed and vexing; it is inconsistent and sometimes misleading. Here, however, she merely describes an unexpected hazard of anthropological fieldwork. She was collecting songs in Polk County, Florida.*

■ ■ ■

from DUST TRACKS ON A ROAD

Research is formalized curiosity. It is poking and prying with a purpose. It is a seeking that he who wishes may know the cosmic secrets of the world and they that dwell therein.

I was extremely proud that Papa Franz felt like sending me on that folklore search. As is well known, Dr. Franz Boas of the Department of Anthropology of Columbia University, is the greatest anthropologist alive, for two reasons. The first is his insatiable hunger for knowledge and then more knowledge; and the second is his genius for pure objectivity. He has no pet wishes to prove. His instructions are to go out and find what is there. He outlines his theory, but if the facts do not agree with it, he would not warp a jot or dot of the findings to save his theory. So knowing all this, I was proud that he trusted me. I went off in a vehicle made out of corona stuff. . . .

Polk County! Ah!
Where the water tastes like cherry wine.
Where they fell great trees with axe and muscle.

These poets of the swinging blade! The brief, but infinitely graceful, dance of body and axe-head as it lifts over the head in a fluid arc, dances in air and rushes down to bite into the tree, all in beauty. Where the logs march into the mill with its smokestacks disputing with the elements, its boiler room reddening the sky, and its great circular saw screaming arrogantly as it attacks the tree like a lion making its kill. The log on the carriage coming to the saw. A growling grumble. Then contact! Yeelld-u-u-ow! And a board is laid shining and new on a pile. All day, all night. Rumble, thunder and grumble. Yee-ee-ow! Sweating black bodies, muscled like gods, working to feed the hunger of the great tooth. Polk County! . . .

It was in a saw-mill jook in Polk County that I almost got cut to death.

Lucy really wanted to kill me. I didn't mean any harm. All I was doing was collecting songs from Slim, who used to be her man back up in West Florida before he ran off from her. It is true that she found out where he was after nearly a year, and followed him to Polk County and he paid her some slight attention. He was knocking the pad with women, all around, and he seemed to want to sort of free-lance at it. But what he seemed to care most about was picking his guitar, and singing.

He was a valuable source of material to me, so I built him up a bit by buying him drinks and letting him ride in my car.

I figure that Lucy took a pick at me for three reasons. The first one was, her vanity was rubbed sore at not being able to hold her man. That was hard to own up to in a community where so much stress was laid on suiting. Nobody else had offered to shack up with her either. She was getting a very limited retail trade and Slim was ignoring the whole business. I had store-bought clothes, a lighter skin, and a shiny car, so she saw wherein she could use me for an alibi. So in spite of public knowledge of the situation for a year or more before I came, she was telling it around that I came

and broke them up. She was going to cut everything off of me but "quit it."

Her second reason was, because of my research methods I had dug in with the male community. Most of the women liked me, too. Especially her sworn enemy, Big Sweet. She was scared of Big Sweet, but she probably reasoned that if she cut Big Sweet's protégée it would be a slam on Big Sweet and build up her own reputation. She was fighting Big Sweet through me.

Her third reason was, she had been in little scraps and been to jail off and on, but she could not swear that she had ever killed anybody. She was small potatoes and nobody was paying her any mind. I was easy. I had no gun, knife or any sort of weapon. I did not even know how to do that kind of fighting.

Lucky for me, I had friended with Big Sweet. She came to my notice within the first week that I arrived on location. I heard somebody, a woman's voice "specifying" up this line of houses from where I lived and asked who it was.

"Dat's Big Sweet" my landlady told me. "She got her foot up on somebody. Ain't she specifying?"

She was really giving the particulars. She was giving a "reading," a word borrowed from the fortune-tellers. She was giving her opponent lurid data and bringing him up to date on his ancestry, his looks, smell, gait, clothes, and his route through Hell in the hereafter. My landlady went outside where nearly everybody else of the four or five hundred people on the "job" were to listen to the reading. Big Sweet broke the news to him, in one of her mildest bulletins that his pa was a double-humpted camel and his ma was a grass-gut cow, but even so, he tore her wide open in the act of getting born, and so on and so forth. He was a bitch's baby out of a buzzard egg.

My landlady explained to me what was meant by "putting your foot up" on a person. If you are sufficiently armed—enough to stand off a panzer division—and know what to do with your weapons after you get 'em, it is all right to go to the house of your enemy, put one foot up on his steps, rest one elbow on your knee and play in the family. That is another way of saying play the dozens, which also is a way of saying low-rate your enemy's ancestors and him, down to the present moment for reference, and then

go into his future as far as your imagination leads you. But if you have no faith in your personal courage and confidence in your arsenal, don't try it. It is a risky pleasure. So then I had a measure of this Big Sweet.

"Hurt who?" Mrs. Bertha snorted at my fears. "Big Sweet? Humph! Tain't a man, woman nor child on this job going to tackle Big Sweet. If God send her a pistol she'll send him a man. She can handle a knife with anybody. She'll join hands and cut a duel. Dat Cracker Quarters Boss wears two pistols round his waist and goes for bad, but he won't break a breath with Big Sweet lessen he got his pistol in his hand. Cause if he start anything with her, he won't never get a chance to draw it. She ain't mean. She don't bother nobody. She just don't stand for no foolishness, dat's all."

Right away, I decided that Big Sweet was going to be my friend. From what I had seen and heard in the short time I had been there, I felt as timid as an egg without a shell. So the next afternoon when she was pointed out to me, I waited until she was well up the sawdust road to the Commissary, then I got in my car and went that way as if by accident. When I pulled up beside her and offered her a ride, she frowned at me first, then looked puzzled, but finally broke into a smile and got in.

By the time we got to the Commissary post office we were getting along fine. She told everybody I was her friend. We did not go back to the Quarters at once. She carried me around to several places and showed me off. We made a date to go down to Lakeland come Saturday, which we did. By the time we sighted the Quarters on the way back from Lakeland, she had told me, "You sho is crazy!" Which is a way of saying I was witty. "I loves to friend with somebody like you. I aims to look out for you, too. Do your fighting for you. Nobody better not start nothing with you, do I'll get my switch-blade and go round de ham-bone looking for meat."

We shook hands and I gave her one of my bracelets. After that everything went well for me. Big Sweet helped me to collect material in a big way. She had no idea what I wanted with it, but if I wanted it, she meant to see to it that I got it. She pointed out people who knew songs and stories. She wouldn't stand for balkiness on their part. We held two lying contests, story-telling contests to you, and

Big Sweet passed on who rated the prizes. In that way, there was no argument about it.

So when the word came to Big Sweet that Lucy was threatening me, she put her foot up on Lucy in a most particular manner and warned her against the try. I suggested buying a knife for defense, but she said I would certainly be killed that way.

"You don't know how to handle no knife. You ain't got dat kind of a sense. You wouldn't even know how to hold it to de best advantage. You would draw your arm way back to stop her, and whilst you was doing all dat, Lucy would run in under your arm and be done; cut you to death before you could touch her. And then again, when you sure 'nough fighting, it ain't enough to just stick 'em wid your knife. You got to ram it in de hilt, then you pull *down*. They ain't no more trouble after dat. They's *dead*. But don't you bother 'bout no fighting. You ain't like me. You don't even sleep with no mens. I wanted to be a virgin one time, but I couldn't keep it up. I needed the money too bad. But I think it's nice for you to be like that. You just keep on writing down them lies. I'll take care of all de fighting. Dat'll make it more better, since we done made friends."

She warned me that Lucy might try to "steal" me. That is, ambush me, or otherwise attack me without warning. So I was careful. I went nowhere on foot without Big Sweet.

Several weeks went by, then I ventured to the jook alone. Big Sweet let it be known that she was not going. But later she came in and went over to the cooncan game in the corner. Thinking I was alone, Lucy waited until things were in full swing and then came in with the very man to whom Big Sweet had given the "reading." There was only one door. I was far from it. I saw no escape for me when Lucy strode in, knife in hand. I saw sudden death very near that moment. I was paralyzed with fear. Big Sweet was in a crowd over in the corner, and did not see Lucy come in. But the sudden quiet of the place made her look around as Lucy charged. My friend was large and portly, but extremely light on her feet. She sprang like a lioness and I think the very surprise of Big Sweet being there when Lucy thought she was over at another party at the Pine Mill unnerved Lucy. She stopped abruptly as Big Sweet charged. The next moment, it was too late for Lucy to start again. The man who came in with Lucy tried to help her out, but two other men joined Big

Sweet in the battle. It took on amazingly. It seemed that anybody who had any fighting to do, decided to settle-up then and there. Switch-blades, ice-picks and old-fashioned razors were out. One or two razors had already been bent back and thrown across the room, but our fight was the main attraction. Big Sweet yelled to me to run. I really ran, too. I ran out of the place, ran to my room, threw my things in the car and left the place. When the sun came up I was a hundred miles up the road, headed for New Orleans.

MARGARET MEAD
(1901–1978)

Physicians told anthropologist Margaret Mead she was infertile. When she was thirty-eight, however, Mead and her third husband, Gregory Bateson, had a child, Mary Catherine. After a suitable interval, Mary Catherine Bateson had a child, and Mead became a grandmother. By then she had written ten major works of anthropology and ethnography, starting with her 1928 Coming of Age in Samoa. *She had written about tribes in New Guinea, Bali, and Nebraska. She taught at Columbia, worked in an office in New York's American Museum of Natural History, and so liked a public forum that for seventeen years she wrote a column for* Redbook.

This is from her 1972 memoir, Blackberry Winter. *Mary Catherine Bateson's memoir of her parents is* With a Daughter's Eye.

■ ■ ■

from BLACKBERRY WINTER

And so it came about that at thirty-eight, after many years of experience as a student of child development and of childbirth in remote villages—watching children born on a steep wet hillside, in the "evil place" reserved for pigs and defecation, or while old women threw stones at the inquisitive children who came to stare at the parturient woman—I was to share in the wartime experience of young wives all around the world. My husband had gone away to take his wartime place, and there was no way of knowing whether I would ever see him again. We had a little money, a recent bequest from Gregory's aunt Margaret, so I would not have to work until after the baby was born. But that was all. Initially, we had thought that I might join Gregory in England, but my mother-in-law wrote that they were sending away busloads of pregnant women. Obviously it was better to stay in America than to become a burden in Britain as the country girded itself for war. . . .

* * *

During these months I had all the familiar apprehensions about what the baby would be like. There was some deafness in my family, and there had been a child who suffered from Mongolism and a child with some severe form of cerebral palsy. There also were members of my family whom I did not find attractive or endearing, and I knew that my child might take after them. Distinguished forebears were no guarantee of normality. But what I dreaded most, I think, was dullness. However, I could do something about anxieties of this kind by disciplining myself not to expect the child to be any special kind of person—of my own devising. I felt deeply—as I still feel—that this is the most important point about bringing into the world a child that will have its own unique and clear identity.

So I schooled myself not to hope for a boy or a girl, but to keep an open mind. I schooled myself to have no image of what the child would look like and no expectations about the gifts he or she might, or might not, have. This was congenial to me, for I had already learned to watch carefully the power that my imagination could have over the thoughts and dreams of other people. People would come to me with some vague stirring of ambition, some vague glimpse of a possible future, and unless I was careful, I would find myself imagining a whole future and the course of action necessary to grasp it. As students or friends talked about what they wanted to be or do, a panorama would unfold before my eyes in which I could see how some special combination of talent and experience might make possible a unique contribution to the world. It was better, I had learned, to listen and occasionally suggest some alternatives or some of the complications of the course chosen by the other person. In the same way, I determined not to limit the child that was to be born—not to hope for it to be beautiful or intellectually gifted or temperamentally happy.

There was another problem, too, of which I was quite aware. I had been a "baby carriage peeker," as Dr. David Levy described the child with an absorbing interest in babies, and he identified this as one of the traits that predisposed one to become an overprotective mother. When I told him, in a telephone conversation, that I was expecting a baby, he asked, in that marvelous therapeutic voice which he could project even over the telephone, "Are you going to be an overprotective mother?" I answered, "I'm going to try not to

be." But I realized that whatever predisposition in this direction I might have must have been reinforced by hope that was so often disappointed, and I knew that I would have to work hard not to overprotect my child, but to ensure my child's freedom to find its own way of taking hold of life and becoming a person. . . .

Mary Catherine Bateson was born on December 8, 1939, and looked very much herself. . . .

We called her Cathy. She was fair-haired, her head was unmarred by a hard birth or the use of instruments, and her expression was already her own. I was completely happy.

As she was born on the Feast of the Immaculate Conception, it pleased the sisters at French Hospital that she was also named Mary. But she has never been called by this name. More recently, as she has grown older, she has wanted to be called Catherine. Try as I do to call people by whatever name they wish, I find this difficult. Perhaps it is because I have lived so long among peoples for whom names were too vital a part of the personality to be treated lightly, among whom true names were not pronounced. For me the name Catherine carries a heavy weight, compounded as it is not only of all the Katherines who preceded my daughter but of her complete self as well. Here we have compromised. I speak of her as Cathy when I refer to her as a child, but when I talk about her older years, she is Catherine.

My friend Margaret Fries, who did pioneering work on the propensities of the newborn, came to the hospital to give Cathy her tests and found her to be well on the quiet side. Although she did not fall asleep, as some newborn babies do when they are frustrated, she did not fight for the nipple when it was taken away from her. Margaret Fries' counsel was that she was just quiet enough so that it would be unwise to subject her to much frustration. Some babies can adapt to life only by occasional hard crying, but we saw to it that Cathy had as little occasion as possible to cry.

Inevitably her arrival was accompanied by a good deal of excitement. I had so many friends, and so many of them came from circles in which children were a major preoccupation—educators, child analysts, and child psychologists. They all shared my delight in

having a child. And so did my childless friends—Jane Belo, who had been so close to us in Bali and who had been with us in Kintamani when I lost a baby there, and Marie Eichelberger, who took Cathy as her special charge and became "Aunt Marie" forever. In England, Nora Barlow began to plan all over again for a Darwin-Bateson marriage as she visualized Cathy as a prospective bride for her grandson Jeremy, who was born four months earlier.

Cathy's paternal grandmother wrote that the baby's hands were like her own father's hands. He had been a surgeon at Guy's Hospital in London and it was fabled that when his students watched him operate they were hypnotized by the beauty of his hands. My mother-in-law added that "Margaret has nice hands, too, though small." This gave me a twinge of surprise, for I had always thought that small hands were embellishment in a woman, not to be dismissed with a "though." All the Batesons and Durhams were tall, and I had a momentary worry—that did recur from time to time—that Cathy might have my features, which are better in a small face, but that she might grow like a bean pole to match her paternal inheritance.

One of the most fascinating preoccupations when one has a child of one's own is watching for the appearance of hereditary traits and predispositions that can be attributed to—or blamed upon—one side of the family or the other. Like everything else about biological parenthood, it is a mixed blessing. The traits in which one takes pride and the traits of the other parent whom one loves are doubly endearing in the shared child. The child who is born with such a combination, as I was, starts off in life with a special blessing. But the child who displays repudiated parental traits starts life with a handicap. The parents have to make an extra effort not to respond negatively to those traits in their child which they dislike or fear in themselves.

Cathy inherited a felicitous combination of family traits. Her eyes were blue, bluer than her father's or mine, and her hair, blond that changed to light brown, was indistinguishable from ours. Her long fingers are her father's. When she is still, she uses her hands as her father does, with the fingers arranged asymmetrically; when she moves and talks, she uses her hands symmetrically, as I do. There is one photographic sequence, made when she was about three, in

which she shifts back and forth in just this way, a dozen times on one reel of film.

Bringing up Cathy was an intellectual as well as an emotionally exciting adventure. I believed that the early days of infancy were very important—that it made a difference how a child was born, whether it was kept close to its mother, whether it was breast-fed, and how the breast feeding was carried out. I also realized that when we began to regulate child feeding by the clock and a measured formula in a bottle, this was done with the best intentions. For if babies were to be fed cow's milk, milk that came in unlimited quantities from a dairy—and bottle feeding was initially an urban phenomenon—then a system had to be devised that somehow approximated the delicate self-regulating system that develops between a breast-feeding mother and her breast-fed baby. And if more babies were to be protected from weakening and dying because their mothers' milk was not adequate or because a particular child could not be well nourished by its own mother, then some babies—perhaps a majority—might have to be bottle-fed. But in 1939 I only vaguely understood these things.

At that time it was believed that the crucial thing for a child's survival and well-being was the mother's acceptance of her baby and her acceptance of breast feeding. Only later we heard about the rejecting baby—the baby that could not adapt to its mother. Still later we heard about the failed nursing couple—the mother and infant who, although they did not reject each other, were physiologically unadapted to each other.

I was trying to invent something new—to adapt breast feeding to modern living conditions and to use a clock in a situation in which the mother who constantly carried her baby under her breast or in a net bag on her back had no need of a clock. And I introduced the idea of taking notes on the progress of the breast feeding, so that I would know—and not retrospectively falsify, as it is so easy to do—what actually happened. My mother had expressed her love for me by taking voluminous notes on my development. And I myself had been watching and recording the behavior of children for many years. For me note-taking was, as it is, part of life.

From the moment we left the hospital and escaped from the hospital rhythm, I struggled to establish breast feeding in response

to Cathy's expressed need. Until then I could not know how much she cried and I could not have distinguished her spontaneous cry from the crying of all the babies segregated in the hospital nursery, where they suffered all the disadvantages—and lacked the advantage of having a mother nearby—of creatures born in a litter, kittens or puppies.

As so many war wives were to do, I took my newborn baby home to my father's house in Philadelphia. As there had been no baby there for thirty years, Mother had forgotten almost all the lore she had ever known. But she did remember that little babies cried because they were bored, and she recommended that we prop Cathy up on pillows so she could see the world. . . .

She learned to talk very early and began to use the intensive mode, which makes it very easy to transpose sentences. For example, when someone would ask her, "Did you sit on a rock in Central Park?" she would answer, "Yes, I did sit on a rock in Central Park." This gave an impression of enormous comprehension, and as a result, people talked with her using more and more difficult constructions. Her warm responsiveness, her trustingness, and her outgoing interest in people and things all evoked lively responses from others and set the stage for her expectation that the world was a friendly place.

When she was eighteen months old, we were asked to plan a film that dealt with the problem of childhood trust. This brought us up against the problem that bedevils all the news media—how to represent adequately something that is good. Fear and rage are easy to photograph, but trust is not. Finally we settled for pictures of Cathy, wearing a baby harness, hurling herself over the edge of a steep decline, completely secure in the knowledge that her father was firmly holding on to the leash. This film was never made.

Later, when she was almost three, a plan was made for a film of a child being given a routine physical examination. This was to be shown to working mothers who were shy of letting their children go to day-care centers. Cathy was chosen to portray the child because she was so unfrightened and so accustomed to photography. But no one considered the response of the pediatrician. The film turned into a sequence in which Cathy, smiling and nude, put the pediatri-

cian, who was shaking with stage fright, at his ease. But the film was never used.

How much was temperament? How much was felicitous accident? How much could be attributed to upbringing? We may never know. Certainly all a mother and father can claim credit for is that they have not marred a child in any recognizable way. For the total adult-child situation could be fully understood only if one also had the child's own interpretation of the parts that adults played in its life.

In the winter our household consisted of Nanny, her daughter Audrey, Cathy, Gregory, and myself. But in summer we went to Holderness, New Hampshire, and lived near the Franks. There we were joined by two English children, Philomena and Claudia Guillebaud, whom we had brought over at the time of Dunkirk and who lived with my parents during the winter. . . .

In the summer months I had an opportunity to realize what it had been like to bring up a child in a household in which there were many willing hands ready to hold the baby and someone to do the endless chores and to sleep with the baby at night, so that the mother's contacts with her child were both intense and relaxed. In a sense it was all anachronistic and war-determined. Without the war we would have had only one adolescent, Audrey, instead of three. And, of course, having a nanny was a survival from an earlier day. Even before the war, nannies were disappearing in England; often the older ones stayed on to be the only servants in great houses that had been built to be cared for by a large staff of men and maid servants. . . .

As the years went by, I had carefully not let myself hope that I would have grandchildren, as I knew before Catherine had children I would be old enough to be a great-grandmother. Great-grandmotherhood is something we do not think of as a likely possibility of the human condition, even now when it is becoming more common.

But I did think how delightful it would be, if it happened, to see my daughter with a child. And I wondered what kind of child Catherine and Barkev Kassarjian would have—she with her long ancestry from the British Isles and he with his long Armenian her-

itage in the Middle East, she with her English fairness and he with his dark eyes and black hair. Thinking back to my grandmother and my mother and the kind of mother I had tried to be and remembering all the different kinds of mothering people who had cared for my daughter in her childhood—her English nanny, her lovely young aunt Mary, and her devoted godmother, Aunt Marie, who brought in the generation of my grandmother's day when people respected heirlooms and passed their dolls on from generation to generation—I wondered what kind of child my daughter would have and what kind of mother she would be. . . .

When Catherine and Barkev lost their first baby in the Philippines—Martin, who was born too soon and lived only long enough to be christened and registered as a citizen—I knew that they both wanted a child very much. I knew also that bereavement had catapulted Catherine into the same position in which I had been placed by a long series of disappointed hopes; just as I had been, she was potentially an overprotective mother. And as I had done, she would have to school herself to give her child the freedom to take risks. I could feel again the terrible tingle in the calves of my legs that I had felt when Cathy became an intrepid climber of tall pine trees.

The baby they now expected was to be born in one of the best hospitals in the country, a hospital that had respect for fathers and one in which a mother had some hope of establishing breast feeding. Catherine had already selected as her pediatrician T. Berry Brazelton, who is playing an avant-garde role in his concern for child development. She had decided to combine motherhood with her work. During the summer before the baby was born she went to Austria to take part in a seminar organized by her father, and she planned to teach in the fall. The baby was due in September. Like so many other young people in the United States, Catherine and Barkev planned to move just before the baby was born, and so added to other complications all the confusion of making a new home.

When they moved in, the newly remodeled house—in which there was a small apartment for a baby-sitting young professional couple—was not finished. Teaching began, and the baby was not yet born. In the end, in spite of careful planning, something went wrong with the telephone connection to Barkev, a few blocks away,

and Catherine was taken to the hospital in the fire chief's car summoned from the concerned fire department across the street. It was a modern version of having the baby born while the mother is out fishing in a canoe, far from the village and the waiting midwife.

When the news came that Sevanne Margaret was born, I suddenly realized that through no act of my own I had become biologically related to a new human being. This was one thing that had never come up in discussions of grandparenthood and had never before occurred to me. In many primitive societies grandparents and grandchildren are aligned together. A child who has to treat his father with extreme respect may joke with his grandfather and playfully call his grandmother "wife." The tag that grandparents and grandchildren get along so well because they have a common enemy is explicitly faced in many societies. In our own society the point most often made is that grandparents can enjoy their grandchildren because they have no responsibility for them, they do not have to discipline them and they lack the guilt and anxiety of parenthood. All these things were familiar. But I had never thought how strange it was to be involved at a distance in the birth of a biological descendant.

I always have been acutely aware of the way one life touches another—of the ties between myself and those whom I have never met, but who read *Coming of Age in Samoa* and decided to become anthropologists. From the time of my childhood I was able to conceive of my relationship to all my forebears, some of whose genes I carry, both those I did not know even by name and those who helped to bring me up, particularly my paternal grandmother. But the idea that as a grandparent one was dealing with action at a distance—that somewhere, miles away, a series of events occurred that changed one's own status forever—I had not thought of that and I found it very odd.

I felt something like the shock that must be felt by those who have lived all their lives secure in their citizenship in the nation of their birth and who then, suddenly, by the arbitrary act of some tyrannical government, find that they are disenfranchised—as happened to the old aristocracy in Russia after the revolution, to the Jews in Germany in the 1930's, and to the Turkish Armenians in Turkey. But of course what happened to me was not an arbitrary denial of something I had regarded as irreversibly given, but rather

an arbitrary confirmation of a state which I felt that I myself had done nothing to bring about. Scientists and philosophers have speculated at length about the sources of man's belief that he is a creature with a future life or, somewhat less commonly, with a life that preceded his life on earth. Speculation may be the only kind of answer that is possible, but I would now add to the speculations that are more familiar another of my own: the extraordinary sense of having been transformed not by any act of one's own but by the act of one's child.

Then, as a new grandmother, I began both to relive my own daughter's infancy and to observe the manifestations of temperament in the tiny creature who was called Vanni—to note how she learned to ignore the noisy carpentry as the house was finished around her but was so sensitive to changes in the human voice that her mother had to keep low background music playing to mask the change in tone of voice that took place when someone who had been speaking then answered the telephone. I remarked how she responded to pattern in the brightly colored chintzes and the mobiles that had been prepared for her. I showed the movies of Cathy's birth and early childhood, to which my daughter commented, "I think my baby is brighter"—or prettier, or livelier—"than your baby!"

However, I felt none of the much trumpeted freedom from responsibility that grandparents are supposed to feel. Actually, it seems to me that the obligation to be a resource but not an interference is just as preoccupying as the attention one gives to one's own children. I think we do not allow sufficiently for the obligation we lay on grandparents to keep themselves out of the picture—not to interfere, not to spoil, not to insist, not to intrude—and, if they are old and frail, to go and live apart in an old people's home (by whatever name it may be called) and to say that they are happy when, once in a great while, their children bring their grandchildren to visit them.

Most American grandparents are supported in their laborious insistence on not being a nuisance by the way they felt toward their own parents and by the fierceness with which, as young adults, they resented interference by their parents and grandparents. But I had none of this. I had loved my grandmother and I had valued the way

my mother nursed and loved her children. My only complaint when I took Cathy home as a baby was that Mother could not remember as much as I would have liked about the things it was useful to know. And I had quite gladly shared my baby with her nurse and with my closest friends.

I had hoped that Helen Burrows could come back to Catherine to take care of the new baby. But she was ill. Instead, Tulia Sampeur, my godson's Haitian nurse, went up to Cambridge to look after the new baby with her sure and practiced hands. Watching her, Catherine was able to explore the tremendous suggestibility of a new mother, who initially learns to follow the procedures in the care of her baby to which she is exposed immediately after delivery with a rigidity that is strangely reminiscent of the way in which young ducklings are imprinted to follow whatever moving figure they see. Catherine learned, as I had learned, that having a baby teaches you a great deal about mothers, however much you already may know about babies.

JOHN EDGAR WIDEMAN
(1941–)

John Edgar Wideman grew up in Pittsburgh. He attended the
University of Pennsylvania, where he was a basketball star and was
elected to Phi Beta Kappa. He studied at Oxford as a Rhodes Scholar.

 Wideman's moving Homewood trilogy consists of Damballah
(1981); Hiding Place *(1981); and* Sent For You Yesterday *(1983),*
which received the PEN/Faulkner Award for fiction. In 1992, the
University of Pittsburgh Press brought out the trilogy under one cover
as The Homewood Books. *He has written several other novels,*
including Philadelphia Fire *(1990), and two collections of short*
stories. Fatheralong: A Meditation on Fathers and Sons, Race and
Society *(1994) is his most recent work.*

 Wideman's memoir, Brothers and Keepers, *was nominated for the*
National Book Award in 1984. It concerns his younger brother Robert,
who was then serving a life sentence at Western State Penitentiary.
Wideman addresses much of the book directly to "Robby," in speaking
tones.

■ ■ ■

from BROTHERS AND KEEPERS

When you were a chubby-cheeked baby and I stood you
upright, supporting most of your weight with my hands but
freeing you just enough to let you feel the spring and bounce of
strength in your new, rubbery thighs, when you toddled those first
few bowlegged, pigeon-toed steps across the kitchen, did the trouble
start then? Twenty-odd years later, when you shuffled through the
polished corridor of the Fort Collins, Colorado, courthouse drag-
ging the weight of iron chains and fetters, I wanted to give you my
hands again, help you make it across the floor again; I shot out a
clenched fist, a black power sign, which caught your eye and made
you smile in that citadel of whiteness. You made me realize I was
tottering on the edge, leaning on you. You, in your baggy jumpsuit,
three days' scraggly growth on your face because they didn't trust

you with a razor, manacled hand and foot so you were theatrically displayed as their pawn, absolutely under their domination; you were the one clinging fast, taking the weight, and your dignity held me up. I was reaching for your strength.

Always there. The bad seed, the good seed. Mommy's been saying for as long as I can remember: That Robby . . . he wakes up in the morning looking for the party. She's right, ain't she? Mom's nearly always right in her way, the special way she has of putting words together to take things apart. Every day God sends here Robby thinks is a party. Still up there on the third floor under his covers and he's thinking, Where's it at today? What's it gonna be today? Where's the fun? And that's how he's been since the day the Good Lord put him on this earth. That's your brother, Robert Douglas Wideman.

The Hindu god Venpadigedera returned to earth and sang to the people: Behold, the light shineth in all things. Birds, trees, the eyes of men, all giveth forth the light. Behold and be glad. Gifts wait for any who choose to see. Cover the earth with flowers. Shower flowers to the four corners. Rejoice in the bounty of the light.

The last time we were all together, cousin Kip took a family portrait. Mom and Daddy in a line with their children. The third generation of kids, a nappy-headed row in front. Five of us grown-up brothers and sisters hanging on one another's shoulders. Our first picture together since I don't remember when. We're all standing on Mom's about-to-buckle porch with cousin Kip down in the weeds of the little front yard pointing his camera up at us. I was half-scared those rickety boards would crack and we'd sink, arms still entwined, like some brown *Titanic*, beneath the rippling porch floor.

Before I saw the picture I had guessed how we'd look frozen in shades of black and white. I wasn't too far off. Tish is grinning ear to ear—the proud girl child in the middle who's survived the teasing and protections of her four brothers. Even though he isn't, Gene seems the tallest because of the way he holds that narrow, perfect head of his balanced high and dignified on his long neck. Dave's eyes challenge the camera, meet it halfway and dare it to come any closer,

and the camera understands and keeps its distance from the smoldering eyes. No matter what Dave's face seems to be saying—the curl of the lip that could be read as smile or sneer, as warning or invitation—his face also projects another level of ambiguity, the underground history of interracial love, sex, and hate, what a light-eyed, brown-skinned man like David embodies when he confronts other people. I'm grinning too (it's obvious Tish is my sister) because our momentary togetherness was a reprieve, a possibility I believed I'd forfeited by my selfishness and hunger for more. Giddy almost, I felt like a rescued prince ringed by his strong, handsome people, my royal brothers and sister who'd paid my ransom. Tickled even by the swell and pitch of the rotting porch boards under my sandals.

You. You are mugging. Your best side dramatically displayed. The profile shot you'd have demanded on your first album, the platinum million seller you'd never cut but knew you could because you had talent and brains and you could sing and mimic anybody and that long body of yours and those huge hands were instruments more flexible and expressive than most people's faces. You knew what you were capable of doing and knew you'd never get a chance to do it, but none of that defeat for the camera, no, only the star's three-quarter profile. Billy Eckstineing your eyes, the Duke of Earl tilting the slim oval of your face forward to emphasize the pout of your full lips, the clean lines of your temples and cheekbones tapering down from the Afro's soft explosion. Your stage would be the poolroom, the Saturday-night basement social, the hangout corner, the next chick's pad you swept into with all the elegance of Smokey Robinson and the Count of Monte Cristo, slowly unbuttoning your cape, inching off your kid gloves, everything pantomimed with gesture and eye flutters till your rap begins and your words sing that much sweeter, purer for the quiet cradling them. You're like that in the picture. Stylized, outrageous under your big country straw hat pushed back off your head. Acting. And Tish, holding up the picture to study it, will say something like, Look at you, boy. You ought to be 'shamed. And your mask will drop and you'll grin cause Tish is like Mom, and ain't no getting round her. So you'll just grin back and you are Robby again at about age seven, cute and everybody's pet, grin at Sis and say, "G'wan, girl."

Daddy's father, our grandfather, Harry Wideman, migrated

from Greenwood, South Carolina, to Pittsburgh, Pennsylvania, in 1906. He found a raw, dirty, double-dealing city. He learned its hills and rivers, the strange names of Dagos and Hunkies and Polacks who'd been drawn, as he had, by steel mills and coal mines, by the smoke and heat and dangerous work that meant any strong-backed, stubborn young man, even a black one, could earn pocketfuls of money. Grandpa's personal quest connected him with hordes of other displaced black men seeking a new day in the promised land of the North. Like so many others, he boarded in an overcrowded rooming house, working hard by day, partying hard at night against the keen edge of exhaustion. When his head finally hit the pillow, he didn't care that the sheets were still warm from the body of the man working nights who rented the bed ten hours a day while Harry pulled his shift at the mill.

Harry Wideman was a short, thick, dark man whose mahogany color passed on to Daddy, blended with the light, bright skin of John and Freeda French's daughter Bette to produce the brown we wear. Do you remember anything about him, or were you too young? Have you ever wondered how the city appeared through his eyes, the eyes of a rural black boy far from home, a stranger in a strange land? Have you ever been curious? Grandpa took giant steps forward in time. As a boy not quite old enough to be much help in the fields, his job was looking out for Charley Rackett, his ancient, crippled grandfather, an African, a former slave. Grandpa listened to Charley Rackett's African stories and African words, then lived to see white men on the moon. I think of Grandpa high up on Bruston Hill looking over the broad vista spreading out below him. He's young and alone; he sees things with his loins as much as his eyes. Hills rolling to the horizon, toward the invisible rivers, are breasts and buttocks. Shadowed spaces, nestling between the rounded hills, summon him. Whatever happens to him in this city, whatever he accomplishes will be an answer to the soft, insinuating challenge thrown up at him as he stares over the teeming land. This city will measure his manhood. *Our Father Who Art* . . . I hear prayer words interrupting his dreaming, disturbing the woman shapes his glance fashions from the landscape. The earth turns. He plants his seed. In the blink of an eye he's an old man, close to death. He has watched

the children of his children's children born in this city. Some of his children's children dead already. He ponders the wrinkled tar paper on the backs of his hands. Our Father. A challenge still rises from the streets and rooftops the way it once floated up from long-gone, empty fields. And the old man's no nearer now to knowing, to understanding why the call digs so deeply at his heart.

Wagons once upon a time in the streets of Pittsburgh. Delivering ice and milk and coal. Sinking in the mud, trundling over cobblestones, echoing in the sleep of a man who works all day in the mouth of a fiery furnace, who dreams of green fish gliding along the clear, stony bottom of a creek in South Carolina. In the twenty years between 1910 and 1930, the black population of Pittsburgh increased by nearly fifty thousand. Black music, blues and jazz, came to town in places like the Pythian Temple, the Ritz, the Savoy, the Showboat. In the bars on the North Side, Homewood, and the Hill you could get whatever you thought you wanted. Gambling, women, a good pork chop. Hundreds of families took in boarders to earn a little extra change. A cot in a closet in somebody's real home seemed nicer, better than the dormitories with their barracks-style rows of beds, no privacy, one toilet for twenty men. Snores and funk, eternal coming and going because nobody wanted to remain in those kennels one second longer than he had to. Fights, thieves, people dragged in stinking drunk or bloody from the streets, people going straight to work after hanging out all night with some whore and you got to smell him and smell her beside you while you trying to pull your shift in all that heat. Lawd. Lawdy. Got no money in the bank. Joints was rowdy and mean and like I'm telling you if some slickster don't hustle your money in the street or a party-time gal empty your pockets while you sleep and you don't nod off and fall in the fire, then maybe you earn you a few quarters to send home for that wife and them babies waiting down yonder for you if she's still waiting and you still sending. If you ain't got no woman to send for then maybe them few quarters buy you a new shirt and a bottle of whiskey so you can find you some trifling body give all your money to.

The strong survive. The ones who are strong and *lucky*. You can take that back as far as you want to go. Everybody needs one father,

two grandfathers, four great-grandfathers, eight great-great-grand-fathers, sixteen great-great-great-grandfathers, then thirty-two, then sixty-four, and that's only eight generations backward in time, eight generations linked directly, intimately with what you are. Less than 150 years ago, 128 men made love to 128 women, not all in the same hotel or on the same day but within a relatively short expanse of time, say twenty years, in places as distant as Igboland, New Amsterdam, and South Carolina. Unknown to each other, probably never even coming face to face in their lifetimes, each of these couples was part of the grand conspiracy to produce you. Think of a pyramid balanced on one of its points, a vast cone of light whose sides flare outward, vectors of force like the slanted lines kids draw to show a star's shining. You once were a pinprick of light, a spark whose radiance momentarily upheld the design, stabilized the ever-expanding V that opens to infinity. At some inconceivable distance the light bends, curves back on itself like a ram's horn or conch shell, spiraling toward its greatest compass but simultaneously narrowing to that needle's eye it must enter in order to flow forth bounteously again. You hovered at that nexus, took your turn through that open door.

The old people die. Our grandfathers, Harry Wideman and John French, are both gone now. The greatest space and no space at all separates us from them. I see them staring, dreaming this ravaged city; and we are in the dream, it's our dream, enclosed, enclosing. We could walk down into that valley they saw from atop Bruston Hill and scoop up the houses, dismantle the bridges and tall buildings, pull cars and trucks off the streets, roll up roads and highways and stuff them all like toys into the cotton-picking sacks draped over our shoulders. We are that much larger than the things that happen to us. Accidents like the city poised at the meeting of three rivers, the city strewn like litter over precipitous hills.

Did our grandfathers run away from the South? Black Harry from Greenwood, South Carolina, mulatto white John from Culpepper, Virginia. How would they answer that question? Were they running from something or running to something? What did you figure you were doing when you started running? When did

your flight begin? Was escape the reason or was there a destination, a promised land exerting its pull? Is freedom inextricably linked with both, running *from* and running *to*? Is freedom the motive and means and end and everything in between?

I wonder if the irony of a river beside the prison is intentional. The river was brown last time I saw it, mud-brown and sluggish in its broad channel. Nothing pretty about it, a working river, a place to dump things, to empty sewers. The Ohio's thick and filthy, stinking of coal, chemicals, offal, bitter with rust from the flaking hulls of iron-ore barges inching grayly to and from the steel mills. But viewed from barred windows, from tiered cages, the river must call to the prisoners' hearts, a natural symbol of flight and freedom. The river is a path, a gateway to the West, the frontier. Somewhere it meets the sea. Is it somebody's cruel joke, an architect's way of giving the knife a final twist, hanging this sign outside the walls, this river always visible but a million miles away beyond the spiked steel fence guarding its banks?

When I think of the distance between us in terms of miles or the height and thickness of walls or the length of your sentence or the deadly prison regimen, you're closer to me, more accessible than when I'm next to you in the prison visiting room trying to speak and find myself at the edge of a silence vaster than oceans. I turned forty-three in June and you'll be thirty-three in December. Not kids any longer by any stretch of the imagination. You're my little brother and maybe it's generally true that people never allow their little brothers and sisters to grow up, but something more seems at work here, something more damaging than vanity, than wishful thinking that inclines us to keep our pasts frozen, intact, keeps us calling our forty-year-old cronies "the boys" and a grown man "little brother." I think of you as little brother because I have no other handle. At a certain point a wall goes up and easy memories stop.

When I think back, I have plenty of recollections of you as a kid. How you looked. The funny things you said. Till about the time you turned a gangly, stilt-legged, stringbean thirteen, we're still family. Our lives connect in typical, family ways: holidays, picnics, births, deaths, the joking and teasing, the time you were a baby just home from the hospital and Daddy John French died and I was supposed

to be watching you while the grown-ups cleaned and cooked, ready-ing the house on Finance Street for visitors, for Daddy John to return and lie in his coffin downstairs. Baby-sitting you in Aunt Geraldine's room while death hovered in there with us and no way I could have stayed in that room alone. Needing you much more than you needed me. You just zzz'ed away in your baby sleep, your baby ignorance. You couldn't have cared less whether death or King Kong or a whole flock of those loose-feathered, giant birds haunting my sleep had gathered round your crib. If the folks downstairs were too quiet, my nerves would get jumpy and I'd snatch you up and walk the floor. Hold you pressed in my arms against my heart like a shield. Or if the night cracks and groans of the house got too loud, I'd poke you awake, worry you so your crying would keep me com-pany.

After you turned thirteen, after you grew a mustache and fuzz on your chin and a voluminous Afro so nobody could call you "Beanhead" anymore, after girls and the move from Shadyside to Marchand Street so you started Westinghouse High instead of Peabody where the rest of us had done our time, you begin to get separate. I have to struggle to recall anything about you till you're real again in prison. It's as if I was asleep for fifteen years and when I awakened you were gone. I was out of the country for three years then lived in places like Iowa City and Philly and Laramie, so at best I couldn't have seen much of you, but the sense of distance I'm try-ing to describe had more to do with the way I related to you than with the amount of time we spent together. We had chances to talk, opportunities to grow beyond the childhood bonds linking us. The problem was that in order to be the person I thought I wanted to be, I believed I had to seal myself off from you, construct a wall between us.

Your hands, your face became a man's. You accumulated scars, a deeper voice, lovers, but the changes taking place in you might as well have been occurring on a different planet. The scattered images I retain of you from the sixties through the middle seventies form no discernible pattern, are rooted in no vital substance like child-hood or family. Your words and gestures belonged to a language I was teaching myself to unlearn. When we spoke, I was conscious of a third party short-circuiting our conversations. What I'd say to you

came from the mouth of a translator who always talked down or up or around you, who didn't know you or me but pretended he knew everything.

Was I as much a stranger to you as you seemed to me? Because we were brothers, holidays, family celebrations, and troubles drew us to the same rooms at the same time, but I felt uncomfortable around you. Most of what I felt was guilt. I'd made my choices. I was running away from Pittsburgh, from poverty, from blackness. To get ahead, to make something of myself, college had seemed a logical, necessary step; my exile, my flight from home began with good grades, with good English, with setting myself apart long before I'd earned a scholarship and a train ticket over the mountains to Philadelphia. With that willed alienation behind me, between us, guilt was predictable. One measure of my success was the distance I'd put between us. Coming home was a kind of bragging, like the suntans people bring back from Hawaii in the middle of winter. It's sure fucked up around here, ain't it? But look at me, I got away. I got mine. I didn't want to be caught looking back. I needed home to reassure myself of how far I'd come. If I ever doubted how good I had it away at school in that world of books, exams, pretty, rich white girls, a roommate from Long Island who unpacked more pairs of brand-new jockey shorts and T-shirts than they had in Kaufmann's department store, if I ever had any hesitations or reconsiderations about the path I'd chosen, youall were back home in the ghetto to remind me how lucky I was.

Fear marched along beside guilt. Fear of acknowledging in myself any traces of the poverty, ignorance, and danger I'd find surrounding me when I returned to Pittsburgh. Fear that I was contaminated and would carry the poison wherever I ran. Fear that the evil would be discovered in me and I'd be shunned like a leper.

LOREN EISELEY
(1907–1977)

Loren Eiseley, an anthropologist, was born in Lincoln, Nebraska, and received his B.A. from the University of Nebraska. He took his Ph.D. at the University of Pennsylvania, and in 1944 he returned to Philadelphia to teach there.

The best of his narrative essays appear in The Immense Journey *(1957),* The Unexpected Universe *(1969), and* The Night Country *(1971). His autobiography,* All the Strange Hours, *shows why his friend Wright Morris called him "Schmerzy"—for* Weltschmerz. *W. H. Auden—who wrote the approving introduction for* The Star Thrower *(1978), Eiseley's own collection of his works—called him "a melancholic." Eiseley named his collection after this autobiographical essay, which first appeared in* The Unexpected Universe.

"The Star Thrower" shows Eiseley's versatility and symbolic power. For all its Weltschmerz, *it is a great essay. It clearly takes place on Sanibel Island, Florida. (Eiseley claimed he picked up the name Costabel by listening to a seashell.)*

■ ■ ■

The Star Thrower

I

It has ever been my lot, though formally myself a teacher, to be taught surely by none. There are times when I have thought to read lessons in the sky, or in books, or from the behavior of my fellows, but in the end my perceptions have frequently been inadequate or betrayed. Nevertheless, I venture to say that of what man may be I have caught a fugitive glimpse, not among multitudes of men, but along an endless wave-beaten coast at dawn. As always, there is this apparent break, this rift in nature, before the insight comes. The terrible question has to translate itself into an even more terrifying freedom.

If there is any meaning to this book [*The Unexpected Universe*], it began on the beaches of Costabel with just such a leap across an

unknown abyss. It began, if I may borrow the expression from a Buddhist sage, with the skull and the eye. I was the skull. I was the inhumanly stripped skeleton without voice, without hope, wandering alone upon the shores of the world. I was devoid of pity, because pity implies hope. There was, in this desiccated skull, only an eye like a pharos light, a beacon, a search beam revolving endlessly in sunless noonday or black night. Ideas like swarms of insects rose to the beam, but the light consumed them. Upon that shore meaning had ceased. There were only the dead skull and the revolving eye. With such an eye, some have said, science looks upon the world. I do not know. I know only that I was the skull of emptiness and the endlessly revolving light without pity.

Once, in a dingy restaurant in the town, I had heard a woman say: "My father reads a goose bone for the weather." A modern primitive, I had thought, a diviner, using a method older than Stonehenge, as old as the arctic forests.

"And where does he do that?" the woman's companion had asked amusedly.

"In Costabel," she answered complacently, "in Costabel." The voice came back and buzzed faintly for a moment in the dark under the revolving eye. It did not make sense, but nothing in Costabel made sense. Perhaps that was why I had finally found myself in Costabel. Perhaps all men are destined at some time to arrive there as I did.

I had come by quite ordinary means, but I was still the skull with the eye. I concealed myself beneath a fisherman's cap and sunglasses, so that I looked like everyone else on the beach. This is the way things are managed in Costabel. It is on the shore that the revolving eye begins its beam and the whispers rise in the empty darkness of the skull.

The beaches of Costabel are littered with the debris of life. Shells are cast up in windrows; a hermit crab, fumbling for a new home in the depths, is tossed naked ashore, where the waiting gulls cut him to pieces. Along the strip of wet sand that marks the ebbing and flowing of the tide, death walks hugely and in many forms. Even the torn fragments of green sponge yield bits of scrambling life striving to return to the great mother that has nourished and protected them.

In the end the sea rejects its offspring. They cannot fight their way home through the surf which casts them repeatedly back upon the shore. The tiny breathing pores of starfish are stuffed with sand. The rising sun shrivels the mucilaginous bodies of the unprotected. The seabeach and its endless war are soundless. Nothing screams but the gulls.

In the night, particularly in the tourist season, or during great storms, one can observe another vulturine activity. One can see, in the hour before dawn on the ebb tide, electric torches bobbing like fireflies along the beach. This is the sign of the professional shellers seeking to outrun and anticipate their less aggressive neighbors. A kind of greedy madness sweeps over the competing collectors. After a storm one can see them hurrying along with bundles of gathered starfish, or, toppling and overburdened, clutching bags of living shells whose hidden occupants will be slowly cooked and dissolved in the outdoor kettles provided by the resort hotels for the cleaning of specimens. Following one such episode I met the star thrower.

As soon as the ebb was flowing, as soon as I could make out in my sleeplessness the flashlights on the beach, I arose and dressed in the dark. As I came down the steps to the shore I could hear the deeper rumble of the surf. A gaping hole filled with churning sand had cut sharply into the breakwater. Flying sand as light as powder coated every exposed object like snow. I made my way around the altered edges of the cove and proceeded on my morning walk up the shore. Now and then a stooping figure moved in the gloom or a rain squall swept past me with light pattering steps. There was a faint sense of coming light somewhere behind me in the east.

Soon I began to make out objects, up-ended timbers, conch shells, sea wrack wrenched from the far-out kelp forests. A pink-clawed crab encased in a green cup of sponge lay sprawling where the waves had tossed him. Long-limbed starfish were strewn everywhere, as though the night sky had showered down. I paused once briefly. A small octopus, its beautiful dark-lensed eyes bleared with sand, gazed up at me from a ragged bundle of tentacles. I hesitated, and touched it briefly with my foot. It was dead. I paced on once more before the spreading whitecaps of the surf.

The shore grew steeper, the sound of the sea heavier and more

menacing, as I rounded a bluff into the full blast of the offshore wind. I was away from the shellers now and strode more rapidly over the wet sand that effaced my footprints. Around the next point there might be a refuge from the wind. The sun behind me was pressing upward at the horizon's rim—an ominous red glare amidst the tumbling blackness of the clouds. Ahead of me, over the projecting point, a gigantic rainbow of incredible perfection had sprung shimmering into existence. Somewhere toward its foot I discerned a human figure standing, as it seemed to me, within the rainbow, though unconscious of his position. He was gazing fixedly at something in the sand.

Eventually he stooped and flung the object beyond the breaking surf. I labored toward him over a half-mile of uncertain footing. By the time I reached him the rainbow had receded ahead of us, but something of its color still ran hastily in many changing lights across his features. He was starting to kneel again.

In a pool of sand and silt a starfish had thrust its arms up stiffly and was holding its body away from the stifling mud.

"It's still alive," I ventured.

"Yes," he said, and with a quick yet gentle movement he picked up the star and spun it over my head and far out into the sea. It sank in a burst of spume, and the waters roared once more.

"It may live," he said, "if the offshore pull is strong enough." He spoke gently, and across his bronzed worn face the light still came and went in subtly altering colors.

"There are not many come this far," I said, groping in a sudden embarrassment for words. "Do you collect?"

"Only like this," he said softly, gesturing amidst the wreckage of the shore. "And only for the living." He stooped again, oblivious of my curiosity, and skipped another star neatly across the water.

"The stars," he said, "throw well. One can help them."

He looked full at me with a faint question kindling in his eyes, which seemed to take on the far depths of the sea.

"I do not collect," I said uncomfortably, the wind beating at my garments. "Neither the living nor the dead. I gave it up a long time ago. Death is the only successful collector." I could feel the full night blackness in my skull and the terrible eye resuming its indifferent journey. I nodded and walked away, leaving him there

upon the dune with that great rainbow ranging up the sky behind him.

I turned as I neared a bend in the coast and saw him toss another star, skimming it skillfully far out over the ravening and tumultuous water. For a moment, in the changing light, the sower appeared magnified, as though casting larger stars upon some greater sea. He had, at any rate, the posture of a god.

But again the eye, the cold world-shriveling eye, began its inevitable circling in my skull. He is a man, I considered sharply, bringing my thought to rest. The star thrower is a man, and death is running more fleet than he along every seabeach in the world.

I adjusted the dark lens of my glasses and, thus disguised, I paced slowly back by the starfish gatherers, past the shell collectors, with their vulgar little spades and the stick-length shelling pincers that eased their elderly backs while they snatched at treasures in the sand. I chose to look full at the steaming kettles in which beautiful voiceless things were being boiled alive. Behind my sunglasses a kind of litany began and refused to die down. *"As I came through the desert thus it was, as I came through the desert."*

In the darkness of my room I lay quiet with the sunglasses removed, but the eye turned and turned. In the desert, an old monk had once advised a traveler, the voices of God and the Devil are scarcely distinguishable. Costabel was a desert. I lay quiet, but my restless hand at the bedside fingered the edge of an invisible abyss. "Certain coasts"—the remark of a perceptive writer came back to me—"are set apart for shipwreck." With unerring persistence I had made my way thither.

II

There is a difference in our human outlook, depending on whether we have been born on level plains, where one step reasonably leads to another, or whether, by contrast, we have spent our lives amidst glacial crevasses and precipitous descents. In the case of the mountaineer, one step does not always lead rationally to another save by a desperate leap over a chasm, or by an even more hesitant tiptoeing across precarious snow bridges.

Something about these opposed landscapes has its analogue in the mind of man. Our prehistoric life, one might say, began amidst

enforested gloom with the abandonment of the protected instinctive life of nature. We sought, instead, an adventurous existence amidst the crater lands and ice fields of self-generated ideas. Clambering onward, we have slowly made our way out of a maze of isolated peaks into the level plains of science. Here, one step seems definitely to succeed another, the universe appears to take on an imposed order, and the illusions through which mankind has painfully made its way for many centuries have given place to the enormous vistas of past and future time. The encrusted eye in the stone speaks to us of undeviating sunlight; the calculated elliptic of Halley's comet no longer forecasts world disaster. The planet plunges on through a chill void of star years, and there is little or nothing that remains unmeasured.

Nothing, that is, but the mind of man. Since boyhood I had been traveling across the endless coordinated realms of science, just as, in the body, I was a plains dweller, accustomed to plodding through distances unbroken by precipices. Now that I come to look back, there was one contingent aspect of that landscape I inhabited whose significance, at the time, escaped me. "Twisters," we called them locally. They were a species of cyclonic, bouncing air funnel that could suddenly loom out of nowhere, crumpling windmills or slashing with devastating fury through country towns. Sometimes, by modest contrast, more harmless varieties known as dust devils might pursue one in a gentle spinning dance for miles. One could see them hesitantly stalking across the alkali flats on a hot day, debating, perhaps, in their tall, rotating columns, whether to ascend and assume more formidable shapes. They were the trickster part of an otherwise pedestrian landscape.

Infrequent though the visitations of these malign creations of the air might be, all prudent homesteaders in those parts had provided themselves with cyclone cellars. In the careless neighborhood in which I grew up, however, we contented ourselves with the queer yarns of cyclonic folklore and the vagaries of weather prophecy. As a boy, aroused by these tales and cherishing a subterranean fondness for caves, I once attempted to dig a storm cellar. Like most such projects this one was never completed. The trickster element in nature, I realize now, had so buffeted my parents that they stoically rejected planning. Unconsciously, they had arrived at the philosophy that

foresight merely invited the attention of some baleful intelligence that despised and persecuted the calculating planner. It was not until many years later that I came to realize that a kind of maleficent primordial power persists in the mind as well as in the wandering dust storms of the exterior world.

A hidden dualism that has haunted man since antiquity runs across his religious conceptions as the conflict between good and evil. It persists in the modern world of science under other guises. It becomes chaos versus form or antichaos. Form, since the rise of the evolutionary philosophy, has itself taken on an illusory quality. Our apparent shapes no longer have the stability of a single divine fiat. Instead, they waver and dissolve into the unexpected. We gaze backward into a contracting cone of life until words leave us and all we know is dissolved into the simple circuits of a reptilian brain. Finally, sentience subsides into an animalcule.

Or we revolt and refuse to look deeper, but the void remains. We are rag dolls made out of many ages and skins, changelings who have slept in wood nests or hissed in the uncouth guise of waddling amphibians. We have played such roles for infinitely longer ages than we have been men. Our identity is a dream. We are process, not reality, for reality is an illusion of the daylight—the light of our particular day. In a fortnight, as aeons are measured, we may lie silent in a bed of stone, or, as has happened in the past, be figured in another guise. Two forces struggle perpetually in our bodies: Yam, the old sea dragon of the original Biblical darkness, and, arrayed against him, some wisp of dancing light that would have us linger, wistful, in our human form. "Tarry thou, till I come again"—an old legend survives among us of the admonition given by Jesus to the Wandering Jew. The words are applicable to all of us. Deep-hidden in the human psyche there is a similar injunction, no longer having to do with the longevity of the body but, rather, a plea to wait upon some transcendent lesson preparing in the mind itself.

Yet the facts we face seem terrifyingly arrayed against us. It is as if at our backs, masked and demonic, moved the trickster as I have seen his role performed among the remnant of a savage people long ago. It was that of the jokester present at the most devout of ceremonies. This creature never laughed; he never made a sound. Painted in black, he followed silently behind the officiating priest,

mimicking, with the added flourish of a little whip, the gestures of the devout one. His timed and stylized posturings conveyed a derision infinitely more formidable than actual laughter.

In modern terms, the dance of contingency, of the indeterminable, outwits us all. The approaching fateful whirlwind on the plain had mercifully passed me by in youth. In the moment when I witnessed that fireside performance I knew with surety that primitive man had lived with a dark message. He had acquiesced in the admission into his village of a cosmic messenger. Perhaps the primitives were wiser in the ways of the trickster universe than ourselves; perhaps they knew, as we do not, how to ground or make endurable the lightning.

At all events, I had learned, as I watched that half-understood drama by the leaping fire, why man, even modern man, reads goose bones for the weather of his soul. Afterward I had gone out, a troubled unbeliever, into the night. There was a shadow I could not henceforth shake off, which I knew was posturing and would always posture behind me. That mocking shadow looms over me as I write. It scrawls with a derisive pen and an exaggerated flourish. I know instinctively it will be present to caricature the solemnities of my deathbed. In a quarter of a century it has never spoken.

Black magic, the magic of the primeval chaos, blots out or transmogrifies the true form of things. At the stroke of twelve the princess must flee the banquet or risk discovery in the rags of a kitchen wench; coach reverts to pumpkin. Instability lies at the heart of the world. With uncanny foresight folklore has long toyed symbolically with what the nineteenth century was to proclaim a reality—namely, that form is an illusion of the time dimension, that the magic flight of the pursued hero or heroine through frogskin and wolf coat has been, and will continue to be, the flight of all men.

Goethe's genius sensed, well before the publication of the *Origin of Species*, the thesis and antithesis that epitomize the eternal struggle of the immediate species against its dissolution into something other: in modern terms, fish into reptile, ape into man. The power to change is both creative and destructive—a sinister gift, which, unrestricted, leads onward toward the formless and inchoate void of the possible. This force can only be counterbalanced by an equal impulse toward specificity. Form, once arisen, clings to its identity. Each species and each individual holds tenaciously to its present

nature. Each strives to contain the creative and abolishing mael-strom that pours unseen through the generations. The past van-ishes; the present momentarily persists; the future is potential only. In this specious present of the real, life struggles to maintain every manifestation, every individuality, that exists. In the end, life always fails, but the amorphous hurrying stream is held and diverted into new organic vessels in which form persists, though the form may not be that of yesterday.

The evolutionists, piercing beneath the show of momentary sta-bility, discovered, hidden in rudimentary organs, the discarded rub-bish of the past. They detected the reptile under the lifted feathers of the bird, the lost terrestrial limbs dwindling beneath the blubber of the giant cetaceans. They saw life rushing outward from an unknown center, just as today the astronomer senses the galaxies fleeing into the infinity of darkness. As the spinning galactic clouds hurl stars and worlds across the night, so life, equally impelled by the centrifu-gal powers lurking in the germ cell, scatters the splintered radiance of consciousness and sends it prowling and contending through the thickets of the world.

All this devious, tattered way was exposed to the ceaselessly turning eye within the skull that lay hidden upon the bed in Costabel. Slowly that eye grew conscious of another eye that searched it with equal penetration from the shadows of the room. It may have been a projection from the mind within the skull, but the eye was, nevertheless, exteriorized and haunting. It began as some-thing glaucous and blind beneath a web of clinging algae. It altered suddenly and became the sand-smeared eye of the dead cephalopod I had encountered upon the beach. The transformations became more rapid with the concentration of my attention, and they became more formidable. There was the beaten, bloodshot eye of an animal from somewhere within my childhood experience. Finally, there was an eye that seemed torn from a photograph, but that looked through me as though it had already raced in vision up to the steep edge of nothingness and absorbed whatever terror lay in that abyss. I sank back again upon my cot and buried my head in the pillow. I knew the eye and the circumstance and the question. It was my mother. She was long dead, and the way backward was lost.

* * *

III

Now it may be asked, upon the coasts that invite shipwreck, why the ships should come, just as we may ask the man who pursues knowledge why he should be left with a revolving search beam in the head whose light falls only upon disaster or the flotsam of the shore. There is an answer, but its way is not across the level plains of science, for the science of remote abysses no longer shelters man. Instead, it reveals him in vaporous metamorphic succession as the homeless and unspecified one, the creature of the magic flight.

Long ago, when the future was just a simple tomorrow, men had cast intricately carved game counters to determine its course, or they had traced with a grimy finger the cracks on the burnt shoulder blade of a hare. It was a prophecy of tomorrow's hunt, just as was the old farmer's anachronistic reading of the weather from the signs on the breastbone of a goose. Such quaint almanacs of nature's intent had sufficed mankind since antiquity. They would do so no longer, nor would formal apologies to the souls of the game men hunted. The hunters had come, at last, beyond the satisfying supernatural world that had always surrounded the little village, into a place of homeless frontiers and precipitous edges, the indescribable world of the natural. Here tools increasingly revenged themselves upon their creators and tomorrow became unmanageable. Man had come in his journeying to a region of terrible freedoms.

It was a place of no traditional shelter, save those erected with the aid of tools, which had also begun to achieve a revolutionary independence from their masters. Their ways had grown secretive and incalculable. Science, more powerful than the magical questions that might be addressed by a shaman to a burnt shoulder blade, could create these tools but had not succeeded in controlling their ambivalent nature. Moreover, they responded all too readily to that urge for tampering and dissolution which is part of our primate heritage.

We had been safe in the enchanted forest only because of our weakness. When the powers of that gloomy region were given to us, immediately, as in a witch's house, things began to fly about unbidden. The tools, if not science itself, were linked intangibly to the subconscious poltergeist aspect of man's nature. The closer man and the natural world drew together, the more erratic became the

behavior of each. Huge shadows leaped triumphantly after every blinding illumination. It was a magnified but clearly recognizable version of the black trickster's antics behind the solemn backs of the priesthood. Here, there was one difference. The shadows had passed out of all human semblance; no societal ritual safely contained their posturings, as in the warning dance of the trickster. Instead, unseen by many because it was so gigantically real, the multiplied darkness threatened to submerge the carriers of the light.

Darwin, Einstein, and Freud might be said to have released the shadows. Yet man had already entered the perilous domain that henceforth would contain his destiny. Four hundred years ago Francis Bacon had already anticipated its dual nature. The individuals do not matter. If they had not made their discoveries, others would have surely done so. They were good men, and they came as enlighteners of mankind. The tragedy was only that at their backs the ritual figure with the whip was invisible. There was no longer anything to subdue the pride of man. The world had been laid under the heavy spell of the natural; henceforth, it would be ordered by man.

Humanity was suddenly entranced by light and fancied it reflected light. Progress was its watchword, and for a time the shadows seemed to recede. Only a few guessed that the retreat of darkness presaged the emergence of an entirely new and less tangible terror. Things, in the words of G. K. Chesterton, were to grow incalculable by being calculated. Man's powers were finite; the forces he had released in nature recognized no such limitations. They were the irrevocable monsters conjured up by a completely amateur sorcerer.

But what, we may ask, was the nature of the first discoveries that now threaten to induce disaster? Pre-eminent among them was, of course, the perception to which we have already referred: the discovery of the interlinked and evolving web of life. The great Victorian biologists saw, and yet refused to see, the war between form and formlessness, chaos and antichaos, which the poet Goethe had sensed contesting beneath the smiling surface of nature. "The dangerous gift from above," he had termed it, with uneasy foresight.

By contrast, Darwin, the prime student of the struggle for existence, sought to visualize in a tangled bank of leaves the silent and

insatiable war of nature. Still, he could imply with a veiled complacency that man might "with some confidence" look forward to a secure future "of inappreciable length." This he could do upon the same page in the *Origin of Species* where he observes that "of the species now living very few will transmit progeny to a far distant futurity." The contradiction escaped him; he did not wish to see it. Darwin, in addition, saw life as a purely selfish struggle, in which nothing is modified for the good of another species without being directly advantageous to its associated form.

If, he contended, one part of any single species had been formed for the exclusive good of another, "it would annihilate my theory." Powerfully documented and enhanced though the statement has become, famine, war, and death are not the sole instruments biologists today would accept as the means toward that perfection of which Darwin spoke. The subject is subtle and intricate; let it suffice to say here that the sign of the dark cave and the club became so firmly fixed in human thinking that in our time it has been invoked as signifying man's true image in books selling in the hundreds of thousands.

From the thesis and antithesis contained in Darwinism we come to Freud. The public knows that, like Darwin, the master of the inner world took the secure, stable, and sunlit province of the mind and revealed it as a place of contending furies. Ghostly transformations, flitting night shadows, misshapen changelings existed there, as real as anything that haunted the natural universe of Darwin. For this reason, appropriately, I had come as the skull and the eye to Costabel—the coast demanding shipwreck. Why else had I remembered the phrase, except for a dark impulse toward destruction lurking somewhere in the subconscious? I lay on the bed while the agonized eye in the remembered photograph persisted at the back of my closed lids.

It had begun when, after years of separation, I had gone dutifully home to a house from which the final occupant had departed. In a musty attic—among old trunks, a broken aquarium, and a dusty heap of fossil shells collected in childhood—I found a satchel. The satchel was already a shabby antique, in whose depths I turned up a jackknife and a "rat" of hair such as women wore at the beginning of the century. Beneath these lay a pile of old photographs and

a note—two notes, rather, evidently dropped into the bag at different times. Each, in a thin, ornate hand, reiterated a single message that the writer had believed important. "This satchel belongs to my son, Loren Eiseley." It was the last message. I recognized the trivia. The jackknife I had carried in childhood. The rat of hair had belonged to my mother, and there were also two incredibly pointed slippers that looked as though they had been intended for a formal ball, to which I knew well my mother would never in her life have been invited. I undid the rotted string around the studio portraits.

Mostly they consisted of stiff, upright bearded men and heavily clothed women equally bound to the formalities and ritual that attended upon the photography of an earlier generation. No names identified the pictures, although here and there a reminiscent family trait seemed faintly evident. Finally I came upon a less formal photograph, taken in the eighties of the last century. Again no names identified the people, but a commercial stamp upon the back identified the place: Dyersville, Iowa. I had never been in that country town, but I knew at once it was my mother's birthplace.

Dyersville, the thought flashed through my mind, making the connection now for the first time: the dire place. I recognized at once the two sisters at the edge of the photograph, the younger clinging reluctantly to the older. Six years old, I thought, turning momentarily away from the younger child's face. Here it began, her pain and mine. The eyes in the photograph were already remote and shadowed by some inner turmoil. The poise of the body was already that of one miserably departing the peripheries of the human estate. The gaze was mutely clairvoyant and lonely. It was the gaze of a child who knew unbearable difference and impending isolation.

I dropped the notes and pictures once more into the bag. The last message had come from Dyersville: "my son." The child in the photograph had survived to be an ill-taught prairie artist. She had been deaf. All her life she had walked the precipice of mental breakdown. Here on this faded porch it had begun—the long crucifixion of life. I slipped downstairs and out of the house. I walked for miles through the streets.

Now at Costabel I put on the sunglasses once more, but the face from the torn photograph persisted behind them. It was as though I, as man, was being asked to confront, in all its overbearing weight,

the universe itself. "Love not the world," the Biblical injunction runs, "neither the things that are in the world." The revolving beam in my mind had stopped, and the insect whisperings of the intellect. There was, at last, an utter stillness, a waiting as though for a cosmic judgment. The eye, the torn eye, considered me.

"But I *do* love the world," I whispered to a waiting presence in the empty room. "I love its small ones, the things beaten in the strangling surf, the bird, singing, which flies and falls and is not seen again." I choked and said, with the torn eye still upon me, "I love the lost ones, the failures of the world." It was like the renunciation of my scientific heritage. The torn eye surveyed me sadly and was gone. I had come full upon one of the last great rifts in nature, and the merciless beam no longer was in traverse around my skull.

But no, it was not a rift but a joining: the expression of love projected beyond the species boundary by a creature born of Darwinian struggle, in the silent war under the tangled bank. "There is no boon in nature," one of the new philosophers had written harshly in the first years of the industrial cities. Nevertheless, through war and famine and death, a sparse mercy had persisted, like a mutation whose time had not yet come. I had seen the star thrower cross that rift and, in so doing, he had reasserted the human right to define his own frontier. He had moved to the utmost edge of natural being, if not across its boundaries. It was as though at some point the supernatural had touched hesitantly, for an instant, upon the natural.

Out of the depths of a seemingly empty universe had grown an eye, like the eye in my room, but an eye on a vastly larger scale. It looked out upon what I can only call itself. It searched the skies and it searched the depths of being. In the shape of man it had ascended like a vaporous emanation from the depths of night. The nothing had miraculously gazed upon the nothing and was not content. It was an intrusion into, or a projection out of, nature for which no precedent existed. The act was, in short, an assertion of value arisen from the domain of absolute zero. A little whirlwind of commingling molecules had succeeded in confronting its own universe.

Here, at last, was the rift that lay beyond Darwin's tangled bank. For a creature, arisen from that bank and born of its contentions, had stretched out its hand in pity. Some ancient, inexhaustible, and patient intelligence, lying dispersed in the planetary fields of force

or amidst the inconceivable cold of interstellar space, had chosen to endow its desolation with an apparition as mysterious as itself. The fate of man is to be the ever-recurrent, reproachful Eye floating upon night and solitude. The world cannot be said to exist save by the interposition of that inward eye—an eye various and not under the restraints to be apprehended from what is vulgarly called the natural.

I had been unbelieving. I had walked away from the star thrower in the hardened indifference of maturity. But thought mediated by the eye is one of nature's infinite disguises. Belatedly, I arose with a solitary mission. I set forth in an effort to find the star thrower.

IV

Man is himself, like the universe he inhabits, like the demoniacal stirrings of the ooze from which he sprang, a tale of desolations. He walks in his mind from birth to death the long resounding shores of endless disillusionment. Finally, the commitment to life departs or turns to bitterness. But out of such desolation emerges the awesome freedom to choose—to choose beyond the narrowly circumscribed circle that delimits the animal being. In that widening ring of human choice, chaos and order renew their symbolic struggle in the role of titans. They contend for the destiny of a world.

Somewhere far up the coast wandered the star thrower beneath his rainbow. Our exchange had been brief because upon that coast I had learned that men who ventured out at dawn resented others in the greediness of their compulsive collecting. I had also been abrupt because I had, in the terms of my profession and experience, nothing to say. The star thrower was mad, and his particular acts were a folly with which I had not chosen to associate myself. I was an observer and a scientist. Nevertheless, I had seen the rainbow attempting to attach itself to earth.

On a point of land, as though projecting into a domain beyond us, I found the star thrower. In the sweet rain-swept morning, that great many-hued rainbow still lurked and wavered tentatively beyond him. Silently I sought and picked up a still-living star, spinning it far out into the waves. I spoke once briefly. "I understand," I said. "Call me another thrower." Only then I allowed myself to think, He is not alone any longer. After us there will be others.

We were part of the rainbow—an unexplained projection into the natural. As I went down the beach I could feel the drawing of a circle in men's minds, like that lowering, shifting realm of color in which the thrower labored. It was a visible model of something toward which man's mind had striven, the circle of perfection.

I picked and flung another star. Perhaps far outward on the rim of space a genuine star was similarly seized and flung. I could feel the movement in my body. It was like a sowing—the sowing of life on an infinitely gigantic scale. I looked back across my shoulder. Small and dark against the receding rainbow, the star thrower stooped and flung once more. I never looked again. The task we had assumed was too immense for gazing. I flung and flung again while all about us roared the insatiable waters of death.

But we, pale and alone and small in that immensity, hurled back the living stars. Somewhere far off, across bottomless abysses, I felt as though another world was flung more joyfully. I could have thrown in a frenzy of joy, but I set my shoulders and cast, as the thrower in the rainbow cast, slowly, deliberately, and well. The task was not to be assumed lightly, for it was men as well as starfish that we sought to save. For a moment, we cast on an infinite beach together beside an unknown hurler of suns. It was, unsought, the destiny of my kind since the rituals of the Ice Age hunters, when life in the Northern Hemisphere had come close to vanishing. We had lost our way, I thought, but we had kept, some of us, the memory of the perfect circle of compassion from life to death and back again to life—the completion of the rainbow of existence. Even the hunters in the snow, making obeisance to the souls of the hunted, had known the cycle. The legend had come down and lingered that he who gained the gratitude of animals gained help in need from the dark wood.

I cast again with an increasingly remembered sowing motion and went my lone way up the beaches. Somewhere, I felt, in a great atavistic surge of feeling, somewhere the Thrower knew. Perhaps he smiled and cast once more into the boundless pit of darkness. Perhaps he, too, was lonely, and the end toward which he labored remained hidden—even as with ourselves.

I picked up a star whose tube feet ventured timidly among my fingers while, like a true star, it cried soundlessly for life. I saw it

with an unaccustomed clarity and cast far out. With it, I flung myself as forfeit, for the first time, into some unknown dimension of existence. From Darwin's tangled bank of unceasing struggle, selfishness, and death, had arisen, incomprehensibly, the thrower who loved not man, but life. It was the subtle cleft in nature before which biological thinking had faltered. We had reached the last shore of an invisible island—yet, strangely, also a shore that the primitives had always known. They had sensed intuitively that man cannot exist spiritually without life, his brother, even if he slays. Somewhere, my thought persisted, there is a hurler of stars, and he walks, because he chooses, always in desolation, but not in defeat.

In the night the gas flames under the shelling kettles would continue to glow. I set my clock accordingly. Tomorrow I would walk in the storm. I would walk against the shell collectors and the flames. I would walk remembering Bacon's forgotten words "for the uses of life." I would walk with the knowledge of the discontinuities of the unexpected universe. I would walk knowing of the rift revealed by the thrower, a hint that there looms, inexplicably, in nature something above the role men give her. I knew it from the man at the foot of the rainbow, the starfish thrower on the beaches of Costabel.

HENRY ADAMS
(1838–1918)

Henry Adams wrote The Education of Henry Adams *in 1905 as a companion volume to his* Mont-Saint-Michel and Chartres, *which in his own mind he subtitled "A Study of Thirteenth-Century Unity." The* Education, *in turn, was "A Study of Twentieth-Century Multiplicity." Its subject is his tongue-in-cheek search for an education in a world increasingly complex. The more this intellectual historian and student of science learns, the more puzzled he gets. By the beginning of the twentieth century, he is puzzled indeed. On this one simple joke, Adams builds a magnificent book.*

Unsatisfied with the last chapters, Adams never published the book, and he hoped it would disappear. Instead, it persists. Its analyses please; its ironies bring joy. "Peevish," one critic called it, with approval.

This chapter describes Adams in 1901. He was sixty-three years old then, just back from the 1900 Great Exposition in Paris, which inspired the famous "Virgin and the Dynamo" chapter. He was at home in Washington, D.C. Throughout his adult life he was one of a trio of friends; the others were Clarence King, an energetic Western geologist, and John Hay, who became secretary of state in 1898. By 1901, all of these men were in their twilight years.

Throughout The Education, *Adams refers to himself in the third person, as "Adams" or "the historian." Here he has been describing the resistance that John Hay's State Department met as it urged the Senate to respond to disturbances in China and Europe.*

■ ■ ■

from THE EDUCATION OF HENRY ADAMS

To one who, at past sixty years old, is still passionately seeking education, these small, or large, annoyances had no great value except as measures of mass and motion. For him the practical interest and the practical man were such as looked forward to the next election, or perhaps, in corporations, five or ten years. Scarcely half-

a-dozen men in America could be named who were known to have looked a dozen years ahead; while any historian who means to keep his alignment with past and future must cover a horizon of two generations at least. If he seeks to align himself with the future, he must assume a condition of some sort for a world fifty years beyond his own. Every historian—sometimes unconsciously, but always inevitably—must have put to himself the question: How long could such-or-such an outworn system last? He can never give himself less than one generation to show the full effects of a changed condition. His object is to triangulate from the widest possible base to the furthest point he thinks he can see, which is always far beyond the curvature of the horizon.

To the practical man, such an attempt is idiotic, and probably the practical man is in the right to-day; but, whichever is right—if the question of right or wrong enters at all into the matter—the historian has no choice but to go on alone. Even in his own profession few companions offer help, and his walk soon becomes solitary, leading further and further into a wilderness where twilight is short and the shadows are dense. Already Hay literally staggered in his tracks for weariness. More worn than he, Clarence King dropped. One day in the spring he stopped an hour in Washington to bid good-bye, cheerily and simply telling how his doctors had condemned him to Arizona for his lungs. All three friends knew that they were nearing the end, and that if it were not the one it would be the other; but the affectation of readiness for death is a stage rôle, and stoicism is a stupid resource, though the only one. *Non dolet, Paete!* One is ashamed of it even in the acting.

The sunshine of life had not been so dazzling of late but that a share of it flickered out for Adams and Hay when King disappeared from their lives; but Hay had still his family and ambition, while Adams could only blunder back alone, helplessly, wearily, his eyes rather dim with tears, to his vague trail across the darkening prairie of education, without a motive, big or small, except curiosity to reach, before he too should drop, some point that would give him a far look ahead. He was morbidly curious to see some light at the end of the passage, as though thirty years were a shadow, and he were again to fall into King's arms at the door of the last and only log cabin left in life. Time had become terribly short, and the

sense of knowing so little when others knew so much, crushed out hope.

He knew not in what new direction to turn, and sat at his desk, idly pulling threads out of the tangled skein of science, to see whether or why they aligned themselves. The commonest and oldest toy he knew was the child's magnet, with which he had played since babyhood, the most familiar of puzzles. He covered his desk with magnets, and mapped out their lines of force by compass. Then he read all the books he could find, and tried in vain to make his lines of force agree with theirs. The books confounded him. He could not credit his own understanding. Here was literally the most concrete fact in nature, next to gravitation which it defied; a force which must have radiated lines of energy without stop, since time began, if not longer, and which might probably go on radiating after the sun should fall into the earth, since no one knew why—or how—or what it radiated—or even whether it radiated at all. Perhaps the earliest known of all natural forces after the solar energies, it seemed to have suggested no idea to any one until some mariner bethought himself that it might serve for a pointer. Another thousand years passed when it taught some other intelligent man to use it as a pump, supply-pipe, sieve, or reservoir for collecting electricity, still without knowing how it worked or what it was. For a historian, the story of Faraday's experiments and the invention of the dynamo passed belief; it revealed a condition of human ignorance and helplessness before the commonest forces, such as his mind refused to credit. He could not conceive but that some one, somewhere, could tell him all about the magnet, if one could but find the book— although he had been forced to admit the same helplessness in the face of gravitation, phosphorescence, and odors; and he could imagine no reason why society should treat radium as revolutionary in science when every infant, for ages past, had seen the magnet doing what radium did; for surely the kind of radiation mattered nothing compared with the energy that radiated and the matter supplied for radiation. He dared not venture into the complexities of chemistry, or microbes, so long as this child's toy offered complexities that befogged his mind beyond X-rays, and turned the atom into an endless variety of pumps endlessly pumping an endless variety of ethers. He wanted to ask Mme. Curie to invent a motor attachable

to her salt of radium, and pump its forces through it, as Faraday did with a magnet. He figured the human mind itself as another radiating matter through which man had always pumped a subtler fluid.

In all this futility, it was not the magnet or the rays or the microbes that troubled him, or even his helplessness before the forces. To that he was used from childhood. The magnet in its new relation staggered his new education by its evidence of growing complexity, and multiplicity, and even contradiction, in life. He could not escape it; politics or science, the lesson was the same, and at every step it blocked his path whichever way he turned. He found it in politics; he ran against it in science; he struck it in everyday life, as though he were still Adam in the Garden of Eden between God who was unity, and Satan who was complexity, with no means of deciding which was truth. The problem was the same for McKinley as for Adam, and for the Senate as for Satan. Hay was going to wreck on it, like King and Adams.

All one's life, one had struggled for unity, and unity had always won. The National Government and the national unity had overcome every resistance, and the Darwinian evolutionists were triumphant over all the curates; yet the greater the unity and the momentum, the worse became the complexity and the friction. One had in vain bowed one's neck to railways, banks, corporations, trusts, and even to the popular will as far as one could understand it—or even further; the multiplicity of unity had steadily increased, was increasing, and threatened to increase beyond reason. He had surrendered all his favorite prejudices, and foresworn even the forms of criticism—except for his pet amusement, the Senate, which was a tonic or stimulant necessary to healthy life; he had accepted uniformity and *Pteraspis* and ice age and tramways and telephones; and now—just when he was ready to hang the crowning garland on the brow of a completed education—science itself warned him to begin it again from the beginning.

Maundering among the magnets he bethought himself that once, a full generation earlier, he had begun active life by writing a confession of geological faith at the bidding of Sir Charles Lyell, and that it might be worth looking at if only to steady his vision. He read it again, and thought it better than he could do at sixty-three; but elderly minds always work loose. He saw his doubts grown

larger, and became curious to know what had been said about them since 1870. The Geological Survey supplied stacks of volumes, and reading for steady months; while, the longer he read, the more he wondered, pondered, doubted what his delightful old friend Sir Charles Lyell would have said about it.

Truly the animal that is to be trained to unity must be caught young. Unity is vision; it must have been part of the process of learning to see. The older the mind, the older its complexities, and the further it looks, the more it sees, until even the stars resolve themselves into multiples; yet the child will always see but one. Adams asked whether geology since 1867 had drifted towards unity or multiplicity, and he felt that the drift would depend on the age of the man who drifted.

Seeking some impersonal point for measure, he turned to see what had happened to his oldest friend and cousin the ganoid fish, the *Pteraspis* of Ludlow and Wenlock, with whom he had sported when geological life was young; as though they had all remained together in time to act the Mask of Comus at Ludlow Castle, and repeat "how charming is divine philosophy!" He felt almost aggrieved to find Walcott so vigorously acting the part of Comus as to have flung the ganoid all the way off to Colorado and far back into the Lower Trenton limestone, making the *Pteraspis* as modern as a Mississippi gar-pike by spawning an ancestry for him, indefinitely more remote, in the dawn of known organic life. A few thousand feet, more or less, of limestone were the liveliest amusement to the ganoid, but they buried the uniformitarian alive, under the weight of his own uniformity. Not for all the ganoid fish that ever swam, would a discreet historian dare to hazard even in secret an opinion about the value of Natural Selection by Minute Changes under Uniform Conditions, for he could know no more about it than most of his neighbors who knew nothing; but natural selection that did not select—evolution finished before it began—minute changes that refused to change anything during the whole geological record—survival of the highest order in a fauna which had no origin—uniformity under conditions which had disturbed everything else in creation—to an honest-meaning though ignorant student who needed to prove Natural Selection and not assume it, such sequence brought no peace. He wished to be shown that changes in

form caused evolution in force; that chemical or mechanical energy had by natural selection and minute changes, under uniform conditions, converted itself into thought. The ganoid fish seemed to prove—to him—that it had selected neither new form nor new force, but that the curates were right in thinking that force could be increased in volume or raised in intensity only by help of outside force. To him, the ganoid was a huge perplexity, none the less because neither he nor the ganoid troubled Darwinians, but the more because it helped to reveal that Darwinism seemed to survive only in England. In vain he asked what sort of evolution had taken its place. Almost any doctrine seemed orthodox. Even sudden conversions due to mere vital force acting on its own lines quite beyond mechanical explanation, had cropped up again. A little more, and he would be driven back on the old independence of species.

What the ontologist thought about it was his own affair, like the theologist's view on theology, for complexity was nothing to them; but to the historian who sought only the direction of thought and had begun as the confident child of Darwin and Lyell in 1867, the matter of direction seemed vital. Then he had entered gaily the door of the glacial epoch, and had surveyed a universe of unities and uniformities. In 1900 he entered a far vaster universe, where all the old roads ran about in every direction, overrunning, dividing, subdividing, stopping abruptly, vanishing slowly, with side-paths that led nowhere, and sequences that could not be proved. The active geologists had mostly become specialists dealing with complexities far too technical for an amateur, but the old formulas still seemed to serve for beginners, as they had served when new.

So the cause of the glacial epoch remained at the mercy of Lyell and Croll, although Geikie had split up the period into half-a-dozen intermittent chills in recent geology and in the northern hemisphere alone, while no geologist had ventured to assert that the glaciation of the southern hemisphere could possibly be referred to a horizon more remote. Continents still rose wildly and wildly sank, though Professor Suess of Vienna had written an epoch-making work, showing that continents were anchored like crystals, and only oceans rose and sank. Lyell's genial uniformity seemed genial still, for nothing had taken its place, though, in the interval, granite had grown young, nothing had been explained, and a bewildering sys-

tem of huge overthrusts had upset geological mechanics. The text-books refused even to discuss theories, frankly throwing up their hands and avowing that progress depended on studying each rock as a law to itself.

Adams had no more to do with the correctness of the science than the gar-pike or the Port Jackson shark, for its correctness in no way concerned him, and only impertinence could lead him to dispute or discuss the principles of any science; but the history of the mind concerned the historian alone, and the historian had no vital concern in anything else, for he found no change to record in the body. In thought the Schools, like the Church, raised ignorance to a faith and degraded dogma to heresy. Evolution survived like the trilobites without evolving, and yet the evolutionists held the whole field, and had even plucked up courage to rebel against the Cossack ukase of Lord Kelvin forbidding them to ask more than twenty million years for their experiments. No doubt the geologists had always submitted sadly to this last and utmost violence inflicted on them by the Pontiff of Physical Religion in the effort to force unification of the universe; they had protested with mild conviction that they could not state the geological record in terms of time; they had murmured *Ignoramus* under their breath; but they had never dared to assert the *Ignorabimus* that lay on the tips of their tongues.

Yet the admission seemed close at hand. Evolution was becoming change of form broken by freaks of force, and warped at times by attractions affecting intelligence, twisted and tortured at other times by sheer violence, cosmic, chemical, solar, super-sensual, electrolytic—who knew what?—defying science, if not denying known law; and the wisest of men could but imitate the Church, and invoke a "larger synthesis" to unify the anarchy again. Historians have got into far too much trouble by following schools of theology in their efforts to enlarge their synthesis, that they should willingly repeat the process in science. For human purposes a point must always be soon reached where larger synthesis is suicide.

Politics and geology pointed alike to the larger synthesis of rapidly increasing complexity; but still an elderly man knew that the change might be only in himself. The admission cost nothing. Any student, of any age, thinking only of a thought and not of his thought, should delight in turning about and trying the opposite

motion, as he delights in the spring which brings even to a tired and irritated statesman the larger synthesis of peach-blooms, cherry-blossoms, and dogwood, to prove the folly of fret. Every schoolboy knows that this sum of all knowledge never saved him from whipping; mere years help nothing; King and Hay and Adams could neither of them escape floundering through the corridors of chaos that opened as they passed to the end; but they could at least float with the stream if they only knew which way the current ran. Adams would have liked to begin afresh with the *Limulus* and *Lepidosteus* in the waters of Braintree, side by side with Adamses and Quincys and Harvard College, all unchanged and unchangeable since archaic time; but what purpose would it serve? A seeker of truth—or illusion—would be none the less restless, though a shark!

AFTERWORD

Many excellent memoirs fall outside the scope of this volume. Those published before 1917 appeared too early, and those published after 1992 appeared too late. Many, of course, are not American in setting; many are, by genre, more properly travel or nature writing, or strictly accounts of other people, or accounts of specific events or ordeals. Some few, like John Updike's *Self-Consciousness* and Wilfred Sheed's *Frank and Maisie,* lose flavor in excerpts. Some, like Alfred Kazin's *A Walker in the City,* are too expensive to reprint.

Among the following are many personal favorites.

Edward Abbey, *Desert Solitaire*
Chinua Achebe, *No Longer at Ease*
Maya Angelou, *I Know Why the Caged Bird Sings*
Mary Austin, *Earth Horizon; Land of Little Rain*
Kim Barnes, *In The Wilderness*
Judith Barrington, "Initiation"
Mary Catherine Bateson, *With a Daughter's Eye*
Elizabeth Bishop, "The Tinshop of Uncle Neddy"
Louise Bogan, *Journey Around My Room*
Margaret Bourke-White, *Portrait of Myself*
John Malcolm Brinnen, *Dear Heart, Dear Buddy; Dylan Thomas in America; Sextet*
Anatole Broyard, *Kafka Was the Rage*
June Burn, *Living High*
Franklin Burroughs, *Billy Watson's Croker Sack*
William de Buys, *River of Traps*
Mary Cantwell, *An American Girl*
Mary Chesnut, *A Diary from Dixie*
Joan Colebrook, *A House of Trees*
Chen Congwen, *Recollections of West Hunan*
Joseph Conrad, *The Mirror of the Sea*
Jill Ker Conway, *The Road from Coorain*
Bernard Cooper, *Maps to Anywhere*

Edward Dahlberg, *Because I Was Flesh*

Richard Henry Dana, *Two Years Before the Mast*

Peter Davison, *Half Remembered*

Clarence Day, *Life with Father*

Dorothy Day, *The Long Loneliness*

Sarah and A. Elizabeth Delany, with Amy Hill Hearth, *Having Our Say*

Nicholas Delbanco, *Running in Place: Scenes from the South of France*

Deborah Digges, *Fugitive Spring*

Izak Dinesen, *Out of Africa*

Ivan Doig, *This House of Sky; Heart Earth*

Frederick Douglass, *Narrative of the Life of Frederick Douglass*

Andre Dubus, *Broken Vessels*

Katherine Dunham, *A Touch of Innocence*

Gerald Durrell, *My Family and Other Animals*

Lawrence Durrell, *Bitter Lemons*

Charles A. Eastman, *Indian Boyhood*

Gretel Ehrlich, *The Solace of Open Spaces; A Match to the Heart*

Annie Ernaux, *A Man's Place; A Woman's Story*

A. B. Facey, *A Fortunate Life*

Wendy W. Fairey, *One of the Family*

Steve Fishman, *A Bomb in the Brain*

Robert Fitzgerald, *The Third Kind of Knowledge*

Ford Madox Ford, *Your Mirror to My Times*

Benjamin Franklin, *Autobiography*

James Galvin, *The Meadow*

George Garrett, "My Two One-Eyed Coaches"

Henry Louis Gates, Jr., *Colored People*

Ellen Glasgow, *The Woman Within*

Albert Goldbarth, *A Sympathy of Souls*

Marita Golden, *Migrations of the Heart*

Ray Gonzales, *Memory Fever*

Maxim Gorky, *My Childhood; My Apprenticeships; My Universities*

Ulysses S. Grant, *Personal Memoirs of U. S. Grant*

John Graves, *Goodbye to a River*

Robert Graves, *Good-bye to All That*

Lucy Grealy, *Autobiography of a Face*

Henry Green, *Pack My Bag*

Graham Greene, *A Sort of Life; Ways of Escape*

Doris Grumbach, *Coming into the End Zone; Extra Innings*

Alec Guinness, *Blessings in Disguise*

Donald Hall, *String Too Short to Be Saved; Their Ancient Glitt'ring Eyes; Life Work*

Edward T. Hall, *An Anthropology of Everyday Life*

Patricia Hampl, *A Romantic Education; Virgin Time*

Curtis Harnack, *We Have All Gone Away; The Attic*

Moss Hart, *Act One*

Ben Hecht, *A Child of the Century*

Samuel Heilman, *The Gate Behind the Wall*

Lillian Hellman, *Pentimento; An Unfinished Woman*

Ernest Hemingway, *Green Hills of Africa*

Michael Herr, *Dispatches*

Edward Hoagland, *Walking the Dead Diamond River; The Tugman's Passage; Balancing Act*

Garrett Hongo, *Volcano*

Paul Horgan, *Tracings: A Book of Partial Portraits*

W. H. Hudson, *Faraway and Long Ago; The Purple Land*

Langston Hughes, *The Big Sea*

John Hull, *Touching the Rock*

Charlayne Hunter-Gault, *In My Place*

Elspeth Huxley, *The Flame Trees of Thika*

Harriet Jacobs, *Incidents in the Life of a Slave Girl*

Henry James, *A Small Boy and Others; Notes of a Son and Brother*

James Weldon Johnson, *Along This Way*

Teresa Jordan, *Riding the White Horse Home*

Alice Kaplan, *French Lessons*

Susanna Kaysen, *Girl, Interrupted*

Nikos Kazantzakis, *Report to Greco*

Alfred Kazin, *A Walker in the City*

Garrison Keillor, *Lake Wobegon Days*

Helen Keller, *The Story of My Life*

Jack Kerouac, *The Dharma Bums*

James Kilgo, *Deep Enough for Ivorybills*

David Lavender, *One Man's West*

T. E. Lawrence, *Seven Pillars of Wisdom*
Primo Levi, *Survival in Auschwitz; The Reawakening*
Harry Levin, *Memories of the Moderns*
Claude Lévi-Strauss, *Tristes Tropiques*
C. S. Lewis, *Surprised by Joy*
Jacques Lusseyran, *And There Was Light*
Robert MacNeil, *Wordstruck*
William Manchester, "Okinawa: The Bloodiest Battle of All"
Robert Mason, *Chickenhawk*
Hilary Masters, *Last Stands*
Mark Mathabane, *Kaffir Boy*
Gavin Maxwell, *Ring of Bright Water*
William Maxwell, *Ancestors*
David McKain, *Spellbound*
Jean McKay, *Gone to Grass*
Rollie McKenna, *Rollie McKenna: A Life in Photography*
Tim McLaurin, *Keeper of the Moon*
Ved Mehta, *Vedi; Face to Face; Up at Oxford; Daddyji; Mamaji*
James Merrill, *A Different Person*
Thomas Merton, *The Seven Storey Mountain*
John Hanson Mitchell, *Living at the End of Time*
Joseph Mitchell, *McSorley's Wonderful Saloon*
Susan Mitchell, "Dreaming in Public"
N. Scott Momaday, *The Way to Rainy Mountain; The Names*
Paul Monette, *On Becoming a Man*
Susanna Moodie, *Roughing It in the Bush*
Edwin Muir, *An Autobiography*
John Muir, *The Story of My Boyhood and Youth; My First Summer in the Sierra; Travels in Alaska*
Pauli Murray, *Song in a Weary Throat; Proud Shoes*
Vladimir Nabokov, *Speak, Memory*
V. S. Naipaul, *Finding the Center; The Enigma of Arrival*
Richard K. Nelson, *The Island Within*
Eric Newby, *Love and War in the Apennines*
Michael Ondaatje, *Running in the Family*
Gayle Pemberton, *The Hottest Water in Chicago*
Brendan Phibbs, *The Other Side of Time*
Mary Helen Ponce, *Hoyt Street*

Gene Stratton Porter, *Moths of the Limberlost*
Dennis Puleston, *Blue Water Vagabond*
Marjorie Kinnan Rawlings, *Cross Creek*
Richard Rhodes, *A Hole in the World*
Richard Rodriguez, *Hunger of Memory*
Antoine de Saint-Exupéry, *Wind, Sand and Stars*
Mari Sandoz, *Old Jules*
Jean-Paul Sartre, *The Words*
Evelyn Scott, *Escapade*
Mary Lee Settle, "London—1944"
Anton Shammas, *Arabesques*
Wilfred Sheed, *Frank and Maisie; My Life as a Fan; People Will Always Be Kind; In Love with Daylight*
Eileen Simpson, *Poets in Their Youth*
Annick Smith, *Homestead*
Lillian Smith, *Killers of the Dream*
William Jay Smith, *Army Brat*
Wole Soyinka, *Ake*
Muriel Spark, *Curriculum Vitae*
Art Spiegelman, *Maus*
Brent Staples, *Parallel Time*
Gertrude Stein, *The Autobiography of Alice B. Toklas*
Don Talayesva, *Sun Chief*
Lewis Thomas, *The Youngest Science*
Flora Lewis Thompson, *Lark Rise to Candleford*
Henry David Thoreau, *Walden; Cape Cod; The Maine Woods*
Susan Allen Toth, *Blooming: A Small Town Girlhood; Ivy Days: Making My Way Out East*
Katharine Trevelyan, *Through Mine Own Eyes*
Calvin Trillin, *Remembering Denny*
Diana Trilling, *The Beginning of the Journey*
Anthony Trollope, *An Autobiography*
John Updike, *Self-Consciousness*
Gloria Wade-Gayles, *Pushed Back to Strength*
David Foster Wallace, "The Awakening of My Interest in Annular Systems"
Ethel Waters, *His Eye Is on the Sparrow*
Eudora Welty, *One Writer's Beginnings*

Edith Wharton, *A Backward Glance*
Bailey White, *Mama Makes Up Her Mind*
E. B. White, "Once More to the Lake"
Terry Tempest Williams, *Refuge*
William Carlos Williams, *Autobiography*
Edward O. Wilson, *Naturalist*
Kimberley Wozencraft, *Notes from the Country Club*

For an intelligent consideration of classic American memoirs, read Herbert A. Leibowitz's *Fabricating Lives*.

Readers might especially enjoy certain selections among the above list from around the world: Edwin Muir's *An Autobiography*, Sartre's *The Words*, Nabokov's *Speak, Memory*, Chen Congwen's *Recollections of West Hunan*, Naipaul's *The Enigma of Arrival*, Kazantzakis's *Report to Greco*, Dinesen's *Out of Africa*, Gorky's trilogy beginning with *My Childhood*, Antoine de Saint-Exupéry's *Wind, Sand and Stars*, Jill Ker Conway's *The Road from Coorain*, Conrad's *The Mirror of the Sea*, Susanna Moodie's *Roughing It in the Bush*, Primo Levi's *Survival in Auschwitz* and *The Reawakening*, Flora Lewis Thompson's *Lark Rise to Candleford*, and Claude Lévi-Strauss's *Tristes Tropiques*.

A.D.

ACKNOWLEDGMENTS

Grateful acknowledgment is made to the following for permission to reprint previously published material:

Don Asher: "Shoot the Piano Player" by Don Asher. Copyright © 1981 by Don Asher. "Shoot the Piano Player" originally appeared in *Harper's* magazine.

Beacon Press: Excerpt from *Notes of a Native Son* by James Baldwin. Copyright © 1955, 1983 by James Baldwin. Reprinted by permission of Beacon Press.

Contemporary Books: Excerpt from *Growing Up* by Russell Baker. Copyright © 1982 by Russell Baker. Used with permission of Congdon & Weed, Inc., and Contemporary Books, Inc., Chicago.

Harry Crews: Excerpt from *A Childhood* by Harry Crews. Copyright © 1978 by Harry Crews. Published in 1978 by Harper & Row. Reprinted by permission of John Hawkins & Associates, Inc.

Columbia University Press: Excerpt from *Left Handed* by Walter and Ruth Dyk. Copyright © 1980 by Columbia University Press.

The Dial Press, Inc.: Excerpt from *Coming of Age in Mississippi* by Anne Moody. Copyright © 1968 by Anne Moody. Reprinted by permission of Dial Press, a division of Bantam Doubleday Dell Publishing Group, Inc.

Farrar, Straus & Giroux, Inc.: Excerpts from *Fierce Attachments,* by Vivian Gornick. Copyright © 1987 by Vivian Gornick. Reprinted by permission of Farrar, Straus & Giroux, Inc.

David R. Godine Publisher, Inc.: Excerpt from *Court of Memory* by James McConkey. Copyright © 1983 by James McConkey. Reprinted by permission of David R. Godine Publisher, Inc.

Grove/Atlantic, Inc.: Excerpt from *This Boy's Life* by Tobias Wolff. Copyright © 1989 by Tobias Wolff.

HarperCollins Publishers, Inc.: Excerpts from *Dust Tracks on a Road* by Zora Neale Hurston. Copyright © 1942 by Zora Neale Hurston. Copyright renewed 1970 by John C. Hurston. Reprinted by permission of HarperCollins Publishers, Inc. Excerpt from *The Sacred Journey* by Frederick Buechner. Copyright © 1982 by Frederick Buechner. Reprinted by permission of HarperCollins Publishers, Inc. Excerpt from *Black Boy* by Richard Wright. Copyright © 1937, 1942, 1944, 1945 by Richard Wright. Copyright renewed 1973 by Ellen Wright. Reprinted by permission of HarperCollins Publishers, Inc.

Henry Holt and Company, Inc.: Excerpt from *Brothers and Keepers* by John Edgar Wideman. Copyright © 1984 by John Edgar Wideman. Reprinted by permission of Henry Holt and Company, Inc.

William Kittredge: "Who Owns the West?" by William Kittredge. Copyright © 1988 by William Kittredge. "Who Owns the West" originally appeared as "Who Won the West" in *Harper's* magazine.

Alfred A. Knopf, Inc.: Excerpt from *The Woman Warrior* by Maxine Hong Kingston. Copyright © 1975, 1976 by Maxine Hong Kingston. Reprinted by permission of Alfred A. Knopf, Inc. Excerpt from *Art and Ardor* by Cynthia Ozick. Copyright © 1983 by Cynthia Ozick. Reprinted by permission of Alfred A. Knopf, Inc.

Little, Brown and Company: Excerpt from *Facts of Life* by Maureen Howard. Copyright © 1975 by Maureen Howard. Reprinted by permission of Little, Brown and Company.

Barry Lopez: "Replacing Memory" by Barry Lopez. Copyright © 1993 by Barry Holstun Lopez. "Replacing Memory" first appeared in *The Georgia Review*. Reprinted by permission of Sterling Lord Literistic, Inc.

Lyons & Burford Publishers: Excerpt from *This Stubborn Soil* by William A. Owens. Copyright © 1966, renewed 1989, by William A. Owens. Reprinted by permission of Nick Lyons Books.

Macmillan Publishing Company: Excerpt from *Clear Pictures* by Reynolds Price. Copyright © 1989 by Reynolds Price. Reprinted by permission of Atheneum Publishers, an imprint of Macmillan Publishing Company.

Wright Morris: Excerpt from *Will's Boy* by Wright Morris. Copyright © 1980 by Wright Morris. Reprinted by permission of Russell & Volkening as agents for the author.

William Morrow and Company, Inc.: Excerpts from *Blackberry Winter* by Margaret Mead. Copyright © 1972 by Margaret Mead. Reprinted by permission of Greenwillow Books, a division of Penguin Books USA, Inc.

Penguin Books USA, Inc.: Excerpt from *Stop-time* by Frank Conroy. Copyright © 1965, 1966, 1967 by Frank Conroy. Used by permission of Viking Penguin, a division of Penguin Books USA, Inc. Excerpt from *Memoir of a Modernist's Daughter* by Eleanor Munro. Copyright © 1988 by Eleanor Munro. Used by permission of Viking Penguin, a division of Penguin Books USA, Inc. Excerpt from *Bronx Primitive* by Kate Simon. Copyright © 1982 by Kate Simon. Used by permission of Viking Penguin, a division of Penguin Books USA, Inc.

Random House, Inc.: Excerpt from *The Star Thrower* by Loren Eiseley. Copyright © 1978 by Loren Eiseley. Reprinted by permission of Times Books, a division of Random House, Inc. Excerpts from *Going to the Territory* by Ralph Ellison. Copyright © 1977 by Ralph Ellison. Originally published in *The American Scholar*. Reprinted by permission of Random House, Inc. Excerpt from *The Autobiography of Malcolm X* by Malcolm X, with the assistance of Alex Haley. Copyright © 1964 by Alex Haley and Betty Shabazz. Reprinted by permission of Random House, Inc. Excerpt from *The Duke of Deception: Memories of My Father* by Geoffrey Wolff. Copyright © 1979 by Geoffrey Wolff. Reprinted by permission of Random House, Inc.